# Making
# Renaissance Art

Volume 1

# Making Renaissance Art

*Edited by Kim W. Woods*

Yale University Press, New Haven and London
in association with The Open University

Yale University Press
47 Bedford Square
London
WC1B 3DP

The Open University
Walton Hall
Milton Keynes
MK7 6AA

First published 2007 by Yale University Press in association with The Open University.

Edited, designed and typeset by The Open University.

Printed in the United Kingdom by The Westdale Press Limited.

This book forms part of an Open University course, AA315 *Renaissance Art Reconsidered*. Details of this and other Open University courses can be obtained from the Student Registration and Enquiry Service, The Open University, PO Box 197, Milton Keynes, MK7 6BJ, United Kingdom: tel. +44 (0)870 333 4340, email general-enquiries@open.ac.uk, http://www.open.ac.uk

Library of Congress Cataloging-in-Publication Data

Woods, Kim
    Making Renaissance Art/Kim W. Woods.
        p. cm.
    Includes bibliographical references and index.
    ISBN 0-300-12189-X (cl : alk. paper) 1. Art, Renaissance.
    2. Art–Technique–History. I. Title.
    N6370.W65 2006
    709.02'4–dc22
                                    2006021242

ISBN-10: 0-300-12189-X
ISBN-13: 978-0-300-12189-6

1.1

# Contents

# List of plates

# Preface

This book on the making of Renaissance art is the first of a series of three volumes that form the core of a Level 3 Open University course entitled *Renaissance Art Reconsidered* (AA315). The other two volumes are *Locating Renaissance Art* and *Viewing Renaissance Art*, also published by Yale.

These three books aim to familiarise readers with art produced in the fifteenth and early sixteenth centuries, a historical period conventionally associated with the Italian Renaissance and with Florence in particular. In line with contemporary art-historical study, this series reconsiders the traditional bias towards Italian centres of production and its exclusive focus on the so-called 'fine arts' of painting, sculpture and architecture. Hence, although some chapters deal exclusively with Italian art, others broaden the boundaries by considering the art of Italy alongside that produced in northern Europe or focus exclusively on the Netherlands, England, France or Crete. The so-called 'crafts' of printmaking, tapestry weaving and manuscript illumination are also explored.

Each of the three volumes of the series takes a different approach towards Renaissance art. The first volume examines the theory and practice of making art. Beginning around the year 1400, it explores the processes of drawing, painting, sculpture, architecture and printmaking in relation to themes traditionally associated with the Renaissance, including perspective, the gradual assimilation of the literary and artistic revival of classical antiquity, the illusion of life, the status of the artist, and theoretical and biographical writing on art. The second volume, on locating Renaissance art, looks at some of the differing geographical models for the production and distribution of European Renaissance art from around 1450, and considers issues of cultural exchange and the transmission and assimilation of ideas or motifs. The third volume deals with issues surrounding the viewing of Renaissance art, introducing varying patterns of commissioning, marketing and consuming works of art across the social classes and in the period leading up to the Reformation.

Those who have contributed essays to this volume are all members of the Art History department of The Open University. It is also the result of many other important – if less visible – contributors. In particular, we would like to thank Mike Franklin (Course Manager) and Sheila Page (Project Manager). Nancy Marten, the Production Editor, has worked tirelessly to bring everything together. It stands as a testament to her thoroughness. Liam Baldwin conducted the picture research with patience and professionalism. The Tutor Assessors, Vicky Ley and Lyn Rodley, have provided invaluable feedback and advice. Caroline Elam, our external adviser, has generously lent us her experience and considerable expertise throughout.

The course to which this book belongs forms part of the Open University's humanities degree programme. For readers interested in the Renaissance or in pursuing their study of art history, other relevant Open University books are available also published by Yale, including the six volumes of the Level 2 course *Art and its Histories* (A216), the four volumes of the Level 3 course *Art of the Twentieth Century* (AA318), and the three volumes of the Level 3 course *The Renaissance in Europe* (AA305).

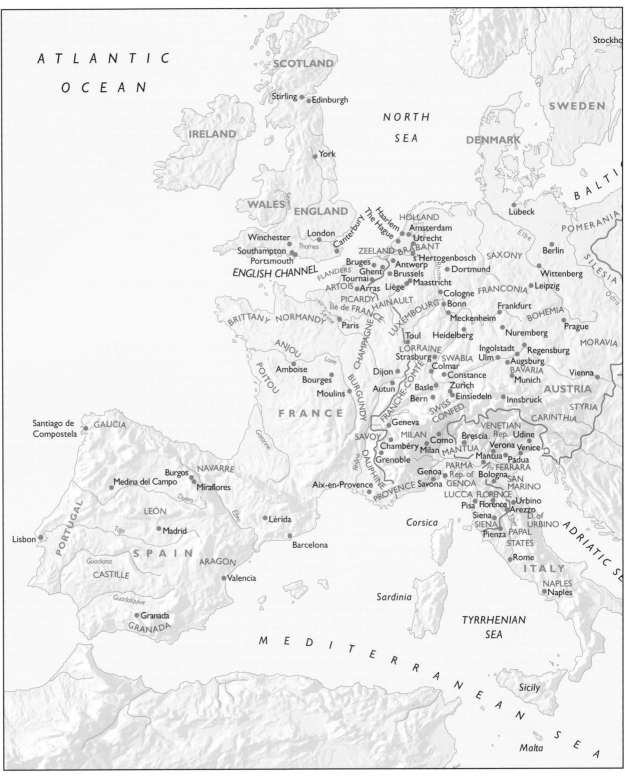

Europe in the fifteenth century.

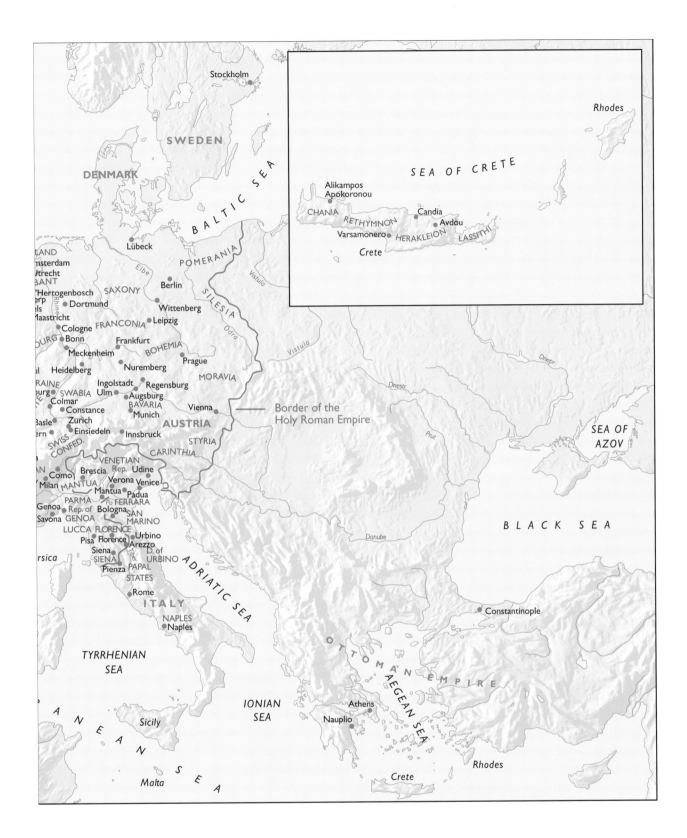

SWEDEN

Stockholm

DENMARK

BALTIC SEA

LAND
Amsterdam
Utrecht
BANT
Antwerp
Maastricht
BURG
Bonn
Meckenheim
Heidelberg
RAINE
burg
Colmar
Basle
Constance
Zurich
Bern
Einsiedeln
SWISS
CONFED.

Lübeck

POMERANIA

Elbe

Berlin

SAXONY

Dortmund

Wittenberg

Cologne
FRANCONIA
Leipzig

Frankfurt

BOHEMIA

Nuremberg

Prague

MORAVIA

Ingolstadt
Regensburg
SWABIA
Ulm
Augsburg
BAVARIA
Munich

Vienna

AUSTRIA

Innsbruck

STYRIA

CARINTHIA

SILESIA

Odra

Vistula

Vistula

Dnepr

Dnestr

Border of the
Holy Roman Empire

SEA OF
AZOV

VENETIAN
Rep.
Como
Brescia
Udine
Milan
Verona
Venice
MANTUA
Mantua
Padua
PARMA
Po
FERRARA
Genoa
Rep. of
Bologna
Savona
GENOA
SAN
MARINO
LUCCA FLORENCE
Pisa
Florence
Urbino
Siena
Arezzo
SIENA
D. of
Pienza
URBINO
PAPAL
STATES
Rome

ITALY

Prut

Danube

BLACK SEA

Corsica

ADRIATIC SEA

NAPLES
Naples

TYRRHENIAN
SEA

Sicily

IONIAN
SEA

OTTOMAN EMPIRE

AEGEAN SEA

Constantinople

Athens
Nauplio

ANEAN
SEA

Malta

Crete

Rhodes

Cyprus

SEA OF CRETE

Rhodes

Alikampos
Apokoronou

CHANIA
RETHYMNON
Candia
Avdou
Varsamonero
HERAKLEION
LASSITHI

Crete

13

# Introduction

*Kim W. Woods*

A reader may be forgiven for expecting a book entitled *Making Renaissance Art* to be concerned specifically with artistic materials and techniques, an approach that has had such a positive effect within the last few decades on art history's traditional preoccupation with artistic style. Conservators and scientists now offer the discipline a range of hitherto unheard-of possibilities, such as pigment analysis, the scientific identification of the medium used in painting, and infra-red reflectography, by which underdrawings may be detected. Combined with the expertise of art historians, these methods have a wider application in helping to identify how works of art were produced, why they look the way they do, and what they might originally have meant.[1] This book is indebted to the materials and techniques approach and it does include some quite detailed analysis of technical procedures, but it is not primarily a book on technical processes. Nor is it narrowly concerned with authorship or workshop practice, though it touches on these issues as well. The stance on 'making' taken here is more elusive and wider ranging, and it includes taking a fresh look at priorities and values in the making of Renaissance art, reviewing some common assumptions that live on even though they have faced challenge for decades within the academic world.

## 1 Vasari and the Italian Renaissance

The classic account of the making of Renaissance art is Giorgio Vasari's *Lives of the Painters, Sculptors and Architects*, first published in 1550, revised and expanded in a new edition of 1568, and hugely influential. Vasari's *Lives* are biographies, but they contain information and anecdotes of varying degrees of reliability relating to artists' different approaches to making art, like the painter Uccello's purported obsession with mathematical perspective (see Chapter 2). It was also Vasari's meta-narrative or overall account of what was at stake in the making of art during those crucial years from the late fourteenth to the mid-sixteenth centuries that proved so crucial to modern understanding of the making of Renaissance art.

Vasari's view was that in the early fifteenth century the Renaissance art of Tuscany (the area of Italy in which Florence is to be found) represented a decisive break with what he termed the 'Greek Manner', that is, a non-realistic style of painting emanating from the art of the Christian Byzantine Empire that had replaced the highly naturalistic art of Greek and Roman antiquity. Vasari believed that the revival in the arts began considerably before the start of the fifteenth century and reached its peak in his own day, the mid-sixteenth century. Implicit in this view was a decisive and incontrovertible 'improvement' in the arts as artists came to understand and apply 'correct' principles, such as accurate anatomy and ideal proportions culled from the 'ancients' and learned from nature itself. The architect Brunelleschi, he said, 'recovered the measures and proportions of the ancients', and he even surpassed their achievements in designing and building the dome over the crossing of Florence Cathedral.[2] The painter Masaccio was commended for the lifelike nature of his frescoes at Santa Maria del Carmine in Florence, for his foreshortening and perspective, for his nudes and for the improvements he made to design in painting, whereas the work of the sculptor Donatello was judged so accomplished as to bear comparison with the ancients themselves: 'for he brought his figures to actual motion, giving them such vivacity and liveliness that they can stand beside the works of to-day [the mid-sixteenth century], and, as I have said, beside the ancient as well'.[3]

For Vasari, then, this break with the past was characterised by truth to nature, the observance of correct rules of working and a revived interest in the ancients, by which he meant the art and artists of ancient Rome. Vasari, however, was an advocate of Florentine art, and although he mentions artists active in other parts of Italy and even in northern Europe, the focus of his writing is firmly on Florence. According to Vasari, it was Florentine artists who spearheaded the Renaissance, notably

Brunelleschi, Masaccio, Ghiberti and Donatello. Traditional art-historical accounts of the Italian Renaissance have tended to begin with these men ever since, like the standard text of Frederick Hartt, first published in 1970 but at the time of writing still a bestseller.[4]

As Catherine King points out in the final chapter of this book, the revival of art, its close relationship with the art and artists of ancient Greece and Rome, and the concept of art imitating nature were strong themes in the writings of fifteenth and early sixteenth-century commentators on art. Vasari was in fact building on an established tradition of writing about art and artists that began as early as 1380 and was by no means always as focused on Florentine art as he was. For all that some fifteenth-century Florentine art is indeed remarkable, innovative art was produced not only in Florence or by Florentines but in many other parts of Italy and indeed in other parts of Europe. The content of this volume reflects this diversity of making. Florentine art is certainly not ignored, but it is always considered alongside art produced elsewhere in Italy and in northern Europe. While Vasari's preoccupations serve as underlying themes for the book, his particular views on the making of Renaissance art have not been allowed to dictate the agenda. For the purposes of contextualisation, it is nevertheless worth taking a critical look at two of his main themes in this introductory section.

## 2  The revival of the antique

Interest in 'the antique' (taken here to signify the art and culture of ancient Greece and Rome) was in itself not new; a similar fascination had inspired a less extensive renaissance in the twelfth century, for example. Since the fall of the Roman Empire, ancient manuscripts, art, architecture and artefacts had always been accessible in Europe and beyond. The philosophy of Plato and Aristotle had dominated medieval thought for centuries, so reverence for the authority of ancient Greek (and Roman) thinkers was in itself nothing new. The revival of antiquity associated with the fifteenth century, particularly in Italy, must be weighed against this strong continuity in the themes and ideas of the classical past in both northern and southern Europe.

Crucial developments did occur, however. The so-called humanists such as the fourteenth-century

Italian poet Petrarch sought out little-known ancient Roman manuscripts lying forgotten in European libraries and disseminated them within the academic community, initially in manuscript form but from the mid-fifteenth century increasingly in print. Greek manuscripts became more widely available as Byzantine intellectuals and nobility took refuge in the West when the Christian Byzantine Empire was eclipsed by the Ottoman Turks, culminating in the fall of Constantinople in 1453 and the consolidation of the Ottoman Empire. At the same time, whereas scholars hitherto had been generally skilled only in Latin, and corrupted medieval Latin at that, these new Greek texts were translated into Latin by the Byzantine scholar Manuel Chrysoloras and humanists like Leonardo Bruni and the Camaldolese monk Ambrogio Traversari. Through the active civic life maintained by some humanists like Bruni, who was chancellor of Florence from 1427, and the education offered by others like Vittorino da Feltre at the Gonzaga court of Mantua, ancient culture and ideas were disseminated further than the confines of academic life.

While a philological interest in antique texts was perhaps not so strong in northern Europe until the later fifteenth century, it would be wrong to suppose that classical learning was ignored in the north or that Greek was entirely unknown. Greeks congregated at the court of Philip the Good, ruler of Burgundy and the Netherlands, from the time that he initiated an ultimately abortive campaign to liberate Constantinople from Islamic invaders in the 1450s.[5] Just as humanists instructed young Italian heirs at the provincial courts of Italy, so Philip's son Charles the Bold was taught by a scholar from Leuven University skilled in the liberal arts of grammar and rhetoric. Pretensions to classical ancestry were made in both north and south: just as Florence claimed to be founded by Julius Caesar, so the poet Olivier de la Marche claimed that the Dukes of Burgundy were descendents of Alexander the Great.[6] Among the 1,000 books of the enormous library of the Burgundian dukes were standard classical texts such as the writings of the first-century CE Roman historian Valerius Maximus, which, although hardly the diet of the average humanist, were considered essential reading for the Christian prince.[7] Mythological subjects drawn from antiquity were a favourite choice for Netherlandish

tapestries, and before the turn of the fifteenth century the castle at Hesdin of Philip the Bold, first Duke of Burgundy and the Netherlands, had been decorated with the narrative of Jason and the Golden Fleece.

How far this primarily literary and scholarly interest in antique literature, culture and language – or humanism as it was called – extended to artists is a moot point. Very few fifteenth-century artists were highly educated, though most could read and write: witness the Flemish notes scribbled on Jan van Eyck's drawing of Cardinal Albergati (Plate 1.2, p.32) or the letters written to prospective patrons by several Italian artists including Filippo Lippi and Domenico Veneziano.[8] A knowledge of Latin was very rare among the fifteenth-century Italian artistic community, however, and still rarer in northern Europe. Brunelleschi knew some Latin, but then his social status was higher than most of his associates. Learned inscriptions within works of art were usually the province of the patron and are not necessarily an indication of erudition on the part of the artist; they could simply be copied out from elsewhere on the patron's instructions. Only occasionally do inscriptions appear to reflect on the artist's own status and learning. Jan van Eyck used Greek letters for his transliterated motto 'Als ich kan' or 'As I am able', found on what is believed to be a self-portrait (National Gallery, London), on the tiny *Virgin and Child at the Fountain* (Plate 0.2) and on a portrait of the artist's wife.[9] Presumably this device was intended to increase the cachet of this already prestigious painter, but it need not imply that van Eyck himself knew Greek. A knowledge of the language was unheard of among fifteenth-century artists. Towards the end of the century, Botticelli and Mantegna both included Greek inscriptions in their work, again presumably partially for the cachet. It remains a general rule that the vast majority of fifteenth-century artists enjoyed only a modest education and might by no means be classed as scholars, classical or otherwise, but then they did not need to be capable of reading classical texts to take an interest in the antique.

Artists might encounter humanist scholars through commissions or while working at Italian courts. The programme for Ghiberti's second set of baptistery doors was drawn up by Leonardo Bruni and discussed by Traversari and another Florentine humanist, Niccolò Niccoli. Whether through them or other sources, Ghiberti certainly knew the 'Lives' of ancient Greek artists included by the first-century CE Roman Pliny the Elder in his *Natural History*. Ghiberti, in turn, included in his own *Commentaries* a section on ancient artists directly culled from Pliny. Sculptor Nanni di Banco might have encountered humanists during his period of office in the Florentine government. The interest of humanists was primarily literary and ethical, and their enthusiasm for ancient art was variable. Some were frankly indifferent, but the humanist architect and theorist Leon Battista Alberti was passionately interested; the Florentine humanist Poggio Bracciolini was collecting antique statues as early as the 1430s, and evidently consulted Donatello about his purchases.[10] The prestige of antique sculpture had increased by the end of the fifteenth century, when Michelangelo famously passed his own carvings off as antique remains. Writing more than 100 years after the time of Masaccio, Brunelleschi and Donatello, Vasari may well have been reading the values of his own time into the past, but this is not to deny the importance of ancient art to some fifteenth-century Italian artists and indeed patrons.

Italy differed from northern Europe in a crucial respect. Ancient remains were far more readily available, whether Roman, Roman copies of Greek art, or Romanesque work resembling Roman architecture and later confused with it, like the baptistery in Florence. Ancient Roman sarcophagi (tomb chests) were, it is claimed, the most ubiquitous antique artefact remaining, and were reused in several different ways ranging from modern tombs to water troughs or fountains.[11] Several such sarcophagi were to be found around the Campo Santo in Pisa, which was effectively a medieval graveyard attached to the cathedral, and Pisa in turn was the shipping point for marble from the Carrara quarries to be taken along the River Arno to Florence and to other parts of Italy. Sculptors journeying to the quarries to select materials could hardly fail to encounter this ancient Roman art en route. Rome boasted not only ancient Roman remains but intact ancient structures such as the Pantheon, the Arch of Constantine and the Arch of Titus, while statues like the equestrian figure of Marcus Aurelius, or the narrative reliefs decorating Trajan's column, were available to any who cared to look. Antique stellae, or funerary reliefs, often involving figurative carving or portrait busts, were also

relatively abundant and were sometimes built into medieval houses. The odd surviving antique remain in northern Europe looks paltry in comparison with these riches, though there is no evidence that northern European artists were much troubled by their lack of access to the antique until the early years of the sixteenth century, nor that this absence was considered to have adversely affected their art.

The appeal of ancient Rome is evident in the purported trips of Brunelleschi and Donatello to Rome to study antique remains, in Donatello's apparent expertise in antique statuary on which Poggio Bracciolini drew, and in the classicising appearance of some early fifteenth-century Florentine sculpture, such as Nanni di Banco's *Four Crowned Saints* (Plate 3.8, p.114) and Donatello's *Cavalcanti Annunciation* and equestrian portrait of *Gattamelata* (Plates 3.11 and 3.29, pp.118, 134). In the fifteenth century at least, however, artists were not straightforward imitators of the antique. Donatello's celebrated bronze statue of the boy *David* with the head of the vanquished Philistine king Goliath at his feet (Plate 0.1) is first recorded in the house of Piero de' Medici, at which time the statue bore an inscription, now lost: 'The victor is whoever defends the fatherland. All powerful God crushed the angry enemy. Behold! A boy overcame a great tyrant. Conquer, O citizens.'[12] The date of the statue has been disputed and remains uncertain. *David* is represented nude, as were so many ancient Roman statues, and made of bronze, again a prestigious sculptural material in antique times; yet the sinuous grace of this figure, his naturalistic rather than ideally proportioned body, his military boots and strange hat defy explanation by reference to ancient Rome, however much the statue appears to invite such explanations. There was, it seems, a difference between appearance and substance. The reality was much more complex, combining elements of the past and the present, and taking account of a specific political and cultural context. As Martin Kemp points out, *David* served as a civic role model – as a youth who rejected the armour offered to him and went 'naked' into battle (1 Samuel 17:39), and his victory is hence all the more remarkable for the contrast between the victor and his far more formidable foe.[13] According to this view, David's apparently classicising nudity might also have narrative importance.

If Donatello, Poggio Bracciolini's consultant on ancient sculpture, was no mere imitator of the antique, then still less was Brunelleschi, whose work combined the creative adaptation of antique forms with resolutely medieval building practices, as Tim Benton demonstrates in Chapter 4. Vasari's third artistic hero, Masaccio, does include some antique references in his work, but on Vasari's own admission is remarkable primarily for his intense naturalism. In these circumstances, the making of Renaissance art cannot be understood simply in terms of the revival of the antique, even in Vasari's Florence let alone in a wider context. The revival of the antique must certainly be classed as a theme of fifteenth-century Renaissance art but scarcely as an explanation for it, least of all in northern Europe.

## 3   Imitating nature

The rather obvious point made above that antique art was readily available in many parts of Italy does not, of course, explain why artists might have taken a renewed interest in it. One suggestion is that they might have done so in a quest for more effective ways to make works of art appear lifelike. According to Phyllis Bober and Ruth Rubinstein, the scholars who catalogued the ancient sculpture accessible to Renaissance artists, nature and the antique were 'but two sides of the same coin … ancient art served as nature's surrogate'.[14] It is unlikely that antique art alone prompted this move towards the lifelike, however, for it was a pan-European movement just as evident in the Low Countries, where it is much more difficult to attribute the impulse to the influence of ancient Rome. Quite what prompted the shift towards intensely lifelike figures, narratives and pictorial spaces that characterised so much fifteenth-century art both north and south of the Alps is unclear, and it is unlikely that it had a single origin. In fact, the principle of imitating nature was not one that automatically won approval in philosophical and theoretical terms. Plato disparaged the artist as a mere copyist. The emphasis of Renaissance theorists on the necessity to select from and perfect nature must surely have been prompted by the desire to deliver art from the stigma of manual craft and copying as much as by the inspiration the study of antique models might have offered. It

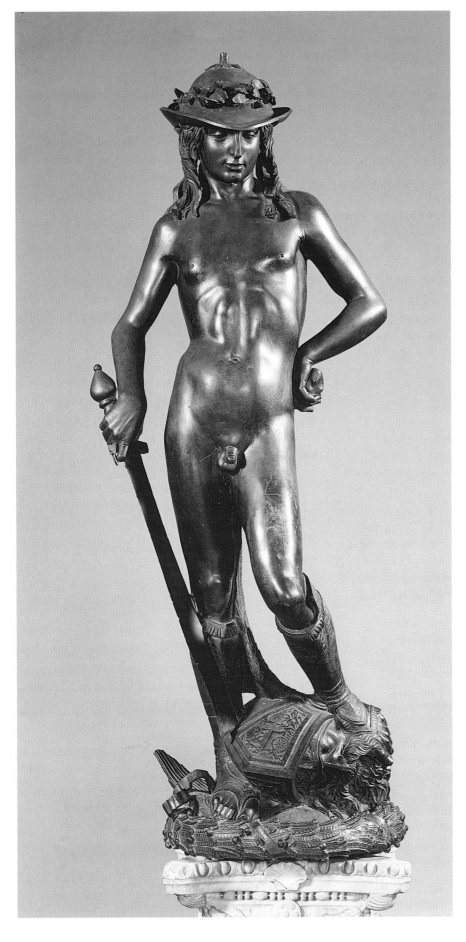

Plate 0.1  Donatello, *David*, date unknown, bronze, height 158 cm, Bargello, Florence. Used with the permission of the Ministero Beni e Attività Culturali. Photo: © 1990 Scala, Florence.

remains true, however, that antique art did offer a model for such an approach.

In order for figures to look real, the proportions and anatomy do indeed need to be plausible though not necessarily perfect, yet in *De statua* or *On Sculpture* Alberti included a long list of measurements for the ideally proportioned human figure. The primary aim of the *istoria*, or narrative painting that he earlier championed in his treatise on painting, *De pictura*, has been construed as the desire to persuade or convince the viewer through what he sees in the work of art.[15] Here too Alberti recommended 'correct' proportions and disguising ugliness, despite recommending variety of age, gender and pose in the pursuit of the illusion of reality. The impulse to persuade or convince, whatever its origin, appears to apply equally to the lifelike art of much of fifteenth-century Europe, but decoupled from the pursuit of ideal proportions. Outside Italy and even sometimes within it, the ideal human form took on a very different appearance, dictated by fashion and decorum rather than the mores of ancient Rome. Hence the contrast between Masaccio's mighty women (Plate 2.6, p.69) and the bulbous abdomens and slight physique of van Eyck's (Plate 5.17, p.191), and between the robust, classicising male figures in the frescoes of Piero della Francesca (Plates 2.22–2.23, pp.86–7) and the emaciated elegance of Dieric Bouts's men (Plates 2.24 and 2.33, pp.89, 99). Whatever the theory or fashion in anatomy and proportions, in each of these works of art the tacit aim appears to be to create a plausible illusion of a 'real' scene and 'real' figures that will convince the viewer.

Implicit in Vasari's notion that a convincingly lifelike style was the hard-won achievement of Giotto (*c.*1270–1337) and his successors is the assumption that predecessors were unable as well as unwilling to work in a lifelike manner. Byzantine artists eschewed a plausible illusion of the natural world for religious reasons, and this example alone suggests that the case was more complex than a mere absence of technical expertise. Although the intensely lifelike art of Jan van Eyck appears to suggest that in the Netherlands, too, non-realistic art was being superseded, the reality was far more complicated. Van Eyck's painting of *The Virgin and Child at the Fountain* (Plate 0.2)

was signed and dated 1439, only two years before his death. This is a surprising painting. In terms of spatial recession the picture is modest, and there are few lifelike qualities in the figures: the arms of the Virgin seem unnaturally short, her hands small and the way that she grasps the Christ Child unconvincing. Yet van Eyck includes a rendering of a fountain of astonishing verisimilitude, the more so because of its tiny dimensions. That the career of one of the most illustrious of Renaissance painters should draw to a close with such a paradoxical painting demands explanation. *The Virgin and Child at the Fountain* is a tiny work and hence portable, designed perhaps for private devotion. Although full length rather than half length, the format of the Virgin and Child is otherwise reminiscent of the Byzantine icon convention of the Virgin with the Playful Child. Far from repudiating the 'Greek Manner', this work appears to constitute van Eyck's own Netherlandish response to a Byzantine icon that he might have seen within the Low Countries or on his travels, and for which there was presumably a demand within the Netherlandish patron classes.[16] Interestingly, van Eyck may have been called upon to make a copy of his *Virgin and Child at the Fountain*, for a contemporary copy survives, perhaps attributable to his workshop, and this suggests that his complex blend of innovation and homage to Greek artistic conventions was not a one-off experiment but an approach that found favour with fifteenth-century audiences.[17]

There is a modest amount of evidence that paintings executed in a non-realistic 'Greek' style were in fact highly valued in the Netherlands, and Netherlandish artists are known to have encountered them. In 1450 a celebrated painting of the Virgin and Child was installed in Cambrai Cathedral, and survives still. This was no lifelike image but the sort of stylised, relatively two-dimensional 'Greek'-style painting that Vasari so despised, and quite unlike the pioneering naturalism of van Eyck and his contemporaries. Eminent artists including Petrus Christus were promptly commissioned to produce no fewer than 15 copies of it.[18] The Netherlandish taste for the lifelike was evidently neither exclusive nor relentless.

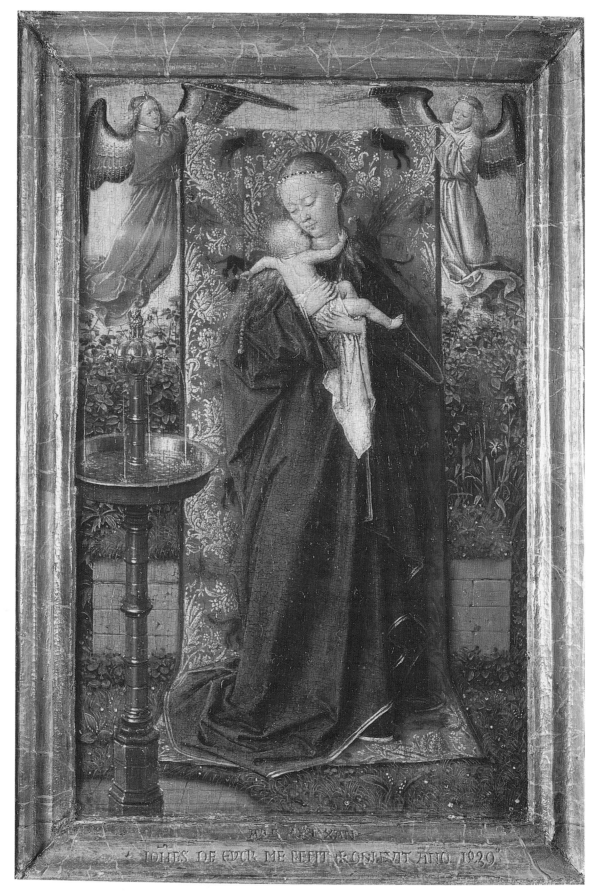

Plate 0.2    Jan van Eyck, *The Virgin and Child at the Fountain*, 1439, oil on panel, 19 × 12 cm, Koninklijk Museum voor Schone Kunsten, Antwerp. Photo: akg-images.

# 4 Conclusion

It would have been possible to approach the subject of Renaissance art in terms of the dispute over a catch-all definition of what 'Renaissance' means, or indeed whether there really was an episode that might be called the Renaissance at all. Another valid starting point might have been an attempt to identify the defining characteristics of Renaissance art in a way that could withstand the scrutiny of modern scholarship. In an effort to avoid putting the proverbial cart before the horse, this book chooses a different and more modest path, leaving definitions aside and working from the premise that it is unlikely that Renaissance art will be properly understood unless we also understand how it was made.

Making is not simply a matter of wood or pigment, though the character and availability of materials certainly defined what was possible and what was not (Chapter 3). Making also implies procedure, from the nature and function of drawing (Chapter 1) to the relative impact of mathematical perspective (Chapter 2), the production of prints (Chapter 6) and the emergence of written theory as against workshop practice (Chapter 7). While issues of patronage and viewing will be examined in the third volume of this series, *Viewing Renaissance Art*, practical considerations of function, location and convention were part and parcel of artistic practice, and all fifteenth-century artists producing commissioned art like altarpieces operated within these constraints (Chapter 5). Assumptions over the degree to which artistic practice did or did not change are re-evaluated in the chapter on architectural theory and practice (Chapter 4). These different approaches to the making of Renaissance art raise some vexed questions central to the notion of the Renaissance: notably change and continuity, the importance of antique art, the relative balance of theory and practice, and the priority given to the imitation of nature and what this really meant. The questions may be old ones, but the way they are approached here is sometimes unorthodox and the conclusions sometimes unexpected.

# Chapter 1
# introduction

From the Renaissance onwards, the making of paintings, sculptures, buildings and prints – the four art forms explored in this book – all traditionally began with the preparatory drawing or design. It is logical, therefore, to begin this book on the making of Renaissance art with a re-evaluation of the practice of drawing over the fifteenth and early sixteenth centuries.

By his death in 1580, Willibald Imhoff, grandson of Dürer's friend Willibald Pirckheimer, had amassed a large collection of works of art by Dürer, partly by inheritance and partly through his own activities. In addition to paintings and woodcuts, this collection is thought to have included drawings, probably those later acquired by Rudolph II of Prague (Holy Roman Emperor from 1576 to 1612). For all that they awarded Dürer commissions half a century earlier during the artist's lifetime, it is difficult to imagine Frederick, Elector of Saxony or Emperor Maximilian I coveting his drawings as well. Within half a century, collecting habits had changed markedly. From being workshop tools, drawings became key items in the rising cult of the artist as a creative individual associated with the Renaissance.

The practice of drawing has been closely associated with the rise in status of the Renaissance artist from that of jobbing manual worker, the simplified stereotype of the late medieval artist. Vitruvius, author of an influential treatise on architecture to be discussed in Chapter 4, wrote in the first century BCE that drawing was an integral part of an artistic training involving the application of the intellect rather than just the acquisition of skills: 'let him be educated, skilful with the pencil, instructed in geometry, know much history'.[1] According to Pliny the Elder, the main written source of information for Renaissance artists on antique art, drawing was an occupation worthy of gentlemen, and as such was recommended by Baldassare Castiglione (1478–1529) in his influential book *Il cortegiano* or *The Courtier* (published 1528).

In this chapter, Catherine King explores a wide spectrum of surviving drawings from the early Renaissance period and the variety of purposes for making them; she then compares them with Dürer's and Leonardo's drawings made around the turn of the sixteenth century. Although she shows that in some respects drawing practice did indeed change over this period, she does not go along with a standard view that associates the extensive practice of drawing – like the collecting of drawings by others – as part of a distinctively Renaissance outlook, instead stressing the continuity of practice with the late medieval past. She attributes the sparse survival of drawings from the earliest years of the fifteenth century not to a more restricted pursuit of drawing, but to the expense and hence reuse of drawing surfaces, to their disintegration through constant use, and to their negligible value as collectors' items at this early date.

*Kim W. Woods*

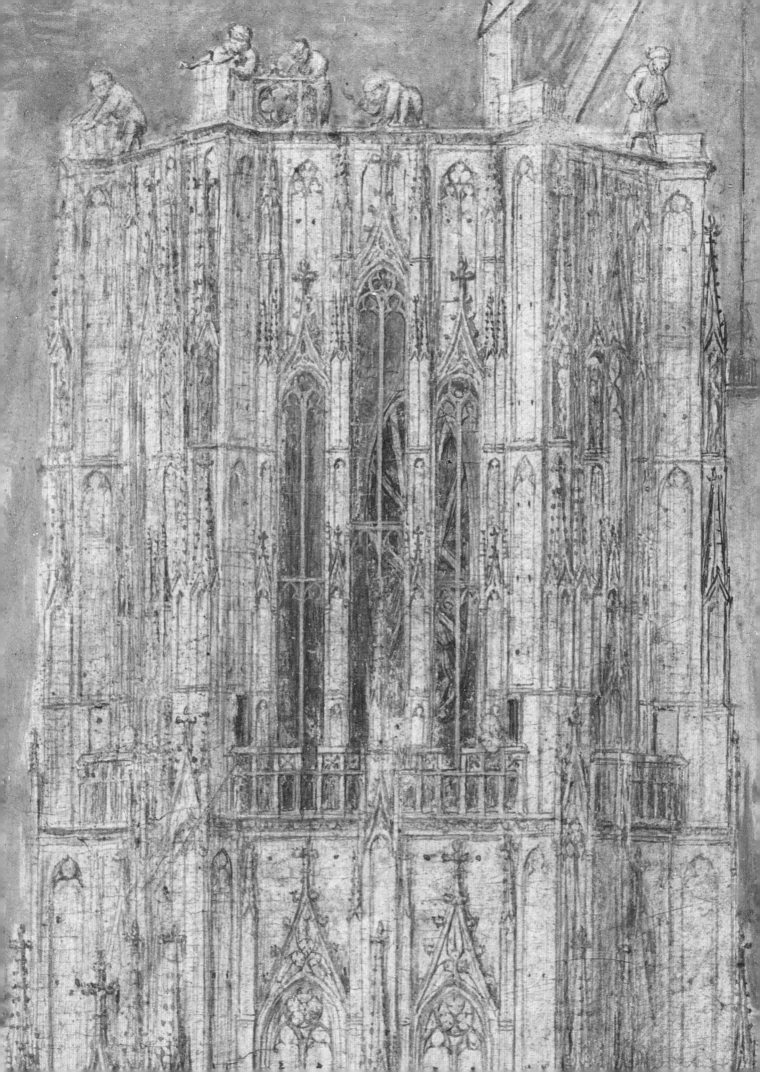

# Chapter 1

# Drawing and workshop practices

*Catherine King*

There was born a boy of wonderful talent, who was drawing a sheep from life [when] the painter Cimabue, passing by on the road to Bologna, saw the lad seated on the ground, drawing on a slab of rock. Struck with great admiration for the boy, who though so young, did so well, and perceiving his skill came from nature, Cimabue asked him what he was named. The lad answered, 'I am called by the name Giotto.'[1]

So Lorenzo Ghiberti, the Florentine sculptor, began his story of the revival of painting in Tuscany and, in his account (*c*.1450) of an event happening in the late thirteenth century, revealed that skill in drawing was considered to be the prime criterion for predicting artistic prowess. This chapter examines various ways in which drawings and underdrawings were used by painters in Flemish, German and Italian-speaking workshops. Studying this evidence can help us understand how painters were trained, how they ran their workshops, how they put together and developed compositions, and how ideas were transmitted. In addition, comparing completed works with associated drawings or underdrawings enables art historians to deduce something of the priorities of artists and patrons in specific commissions. While sculptors and architects also used drawings, the fact that they were dealing with three dimensions meant they made more use of plastic models, and their employment of drawings will be considered elsewhere.

In this chapter I consider definitions of drawings as well as some of the debates about the significance of their survival. I present archival evidence to show how drawings were valued, and I sample texts by the three professional artists whose written advice on drawing from this period has been preserved: Cennino Cennini, whose paintings have not survived, and Leonardo da Vinci and Albrecht Dürer, both of whose drawings and paintings are extant. In order to discuss change and continuity, I focus first on drawings made between 1420 and 1470, and second between 1470 and 1520. As my guide for picking the first group to examine, I have taken the earliest text written in western Europe to acclaim painters working north as well as south of the Alps. This landmark text was composed between 1453 and 1457 by Bartolomeo Facio (*c*.1410–57), a scholar working at the court of King Alfonso of Naples; it was entitled *De viris illustribus* or *On Famous Men*. Facio selected four artists for praise, alternating Italian with Netherlander: Gentile da Fabriano, Jan van Eyck, Antonio Pisano and Rogier van der Weyden. I compare the approaches of this earlier group with those of Leonardo and Dürer, whose work is approximately coterminous with the second half of the period.

## 1 Defining drawings and underdrawings

It is important to stress that the term 'drawings' covers a range of media, functions and styles relating to the completion of paintings or other art works. One criterion for defining a work as a drawing relates to the use of relatively cheap, portable and sometimes fragile *media*: paper, parchment, cloth, small wood tablets, brushes,

Plate 1.1   (Facing page) Jan van Eyck, *The Winding Gear for Building a Tower* (detail from Plate 1.4).

25

pens, metal points, charcoal, chalks, watercolours, bodycolours – that is, opaque watercolours – and inks. Drawings have also been connected with distinctive *functions*: practising skills, undertaking research projects and archiving visual libraries. These might entail the studies of a young apprentice, but they could also include studies undertaken to complete a specific commission. Drawings were used to collect and store one's own and other people's visual ideas, and to demonstrate to patrons what completed designs might look like. Another criterion relates to the use of particular *styles* of representation: that is to say, employing linear designs and a narrow range of hues. However, many drawings studied the distribution of light and shade on various kinds of objects, using techniques like washes and smudging, and some presented colour studies, such as observing landscape in specific light conditions. I will be looking at examples of most of these media, functions and styles.

Drawings may also be defined in terms of the underdrawings made on the prepared grounds of wooden panel, cloth or dry plaster which were then covered with the final painted surface. Underdrawings could represent the stage of thinking through a design. Alternatively, they might sum up ideas developed quite fully on paper and parchment and then transferred to the surface to be painted. Most underdrawings show evidence of experiment with the design before the painted surfaces were completed (with and without the use of further separate drawings on paper or parchment to assist that development).

## 2  The survival of drawings and changes in their use

Fewer drawings survive from the period before the fifteenth century than from the fifteenth century itself. Historians have interpreted this phenomenon variously. For example, in a study of fifteenth-century Italian murals, Robert Oertel argued that the Italian Renaissance was characterised as the time when creative approaches to design developed by means of new, exploratory kinds of drawing. He proposed that in the medieval period drawing types were confined to 'pattern books' which stored records of compositions and parts of compositions to be copied; drawings linked to legal contracts which summed up what a patron would pay for

on delivery; line illustrations for manuscripts; and underdrawings on parchment, murals and panels.[2] Oertel characterised medieval drawing as fulfilling functions which were imitative and conventional, in keeping with his view of medieval society as authoritarian and traditional. However, Bernard Degenhart opposed this interpretation and searched out evidence that in the medieval period there was a wider range of drawings than Oertel had listed, including some 'after nature' and some working out ideas for compositions. According to this view, more evidence survives the closer in time we get to the present day, with steadily increasing survival of fragile media occurring during the fourteenth to the sixteenth centuries.[3] It is worth pointing out in addition that there may be many ways of making effective designs, some of which employ drawings and others which entail training one's visual imagination and relying on deft pictorial skills exercised on the surface to be painted. Much music and poetry has been created in the heads of composers and poets and has been written down only when the work is finished, so it seems plausible that artists could think out visual solutions fully before executing them. It is important to emphasise that lack of evidence of drawings cannot be taken as indicating that artists lacked interest in exploring new designs. Different methods of thinking out one's compositions should be considered as just that, *different*, rather than as more or less effective. Negative attitudes to artists who cannot be shown to have been prolific draughtsmen, such as those displayed by Oertel towards medieval practitioners, are, in my view, best avoided.

Fewer drawings survive from the earlier period *c.*1420–70 than the later period *c.*1470–1520, and more drawings are attributable to artists working in the Italian-speaking peninsula. One suggestion to explain this pattern of evidence has been that the use of more and different sorts of drawings was required in the development of new approaches to representation.[4] According to this argument, painters increasingly employed drawings to make studies from the visual world so as to produce more credible pictorial illusions. These studies extended in some cases to recording the results of anatomical investigation. Some painters drew out linear perspectival diagrams so as to produce believable pictorial space in which their convincingly observed actors, props and costumes could be situated.

Equally, artists became more interested in researching the forms of ancient Roman sculpture and architecture as sources for setting scenes from the New Testament and early Christian history in persuasive ways. Ancient sculpture was also recorded in drawings with the view to researching what were held to be ideal proportions for figures that could provide painters with appropriate forms for the representation of revered persons in biblical, religious and secular history. More drawings also survive which show painters exploring different ways of representing events, allegories or persons for specific commissions, and undertaking detailed research studies to make every element in each composition convincing. In this sense, the increasing survival of drawings may be part and parcel of the changes associated with a 'Renaissance'.

Several other factors help to explain the increasing survival of drawings. One was the growing availability of paper made from pulped linen, especially from the 1460s onwards as the printing industry prospered.[5] Francis Ames-Lewis and Joanna Wright noted that early on expensive parchment was kept for drawings attached to a legal contract or for a pattern book of polished exemplars. For more experimental work painters may have employed prepared wooden tablets which for economy's sake could be used over and over again. As paper became more widely available, it allowed experiments to be stored.[6] However, as with early cookery books and early maps, paper and parchment drawings were probably used so intensively that they disintegrated (see Plates 1.23–1.24 for damaged sheets despite careful preservation).

## Archival evidence and the advent of collecting

There is archival evidence that painters valued drawings as visual 'store cupboards'. Drawings were willed to sons who were painters, as for instance in 1489 with Vrancke van der Stockt of Brussels (active 1444–95) and his two sons.[7] Or they were left to a pupil in lieu of a son, as in the case of Pierrart Macheclier at Tournai in 1461:

> I give to Haquinet de Haulterue, son of Thomas, to the end that he may hold me in his prayers, all the useful things which serve my craft along with the patterns, papers and portrayals belonging to me.[8]

The Paduan painter Francesco Squarcione (c.1395–1468) itemised drawings and reliefs along with paintings in his inventory when he made his apprentice Marco, son of Antonio di Ruggiero, his heir in 1455:

> One large studio in the house with the reliefs, drawings and other things in it and one little studio in the said house with the reliefs and all things in it relating to the art of painting and the existing paintings in the studios not itemised here.[9]

In 1471 Anna Rinversi, widow of Jacopo Bellini (c.1400–70/1), painter of Venice, willed her son, the painter Gentile (c.1429–1507), 'all works of plaster, marble and relief, drawn pictures and all books of drawings and all else pertaining to the pictorial art'.[10] In 1506 Gentile willed the 'book of drawings which came from our late father' to his brother Giovanni (c.1431–1516) on condition that the latter completed a work which Gentile had begun for San Marco, and divided equally between his two assistants 'all my drawings made in Rome'.[11] The 1519 inventory of the possessions of the Florentine painter Fra Bartolommeo (Baccio della Porta, 1472–1517) listed over a thousand *charte*, meaning sheets of paper or parchment:

> 109 nudes; 141 heads of saints, women and men of many hair styles; 275 saints and angels dressed; 70 babies in red and black; 40 drawings of landscapes, 10 coloured, 30 not coloured and drawn with a pen; 19 animals and heads of animals; 55 sketches of compositions; 60 sketches of various things; 28 pen sketches; 42 babies, figures and heads touched up with red; and 12 books of drawings –180 in all – touched up with pen and charcoal.[12]

In the same year in Bruges the Lombard painter Ambrosius Benson (late fifteenth century – before 1550) is recorded as treasuring 'a small book full of heads and nude figures'.[13] Yet it was only when drawings began to be bought by collectors and patrons that they were safe from being worn to tatters.

The watershed came in the 1520s, when there is evidence that collectors were beginning to treasure drawings as well as ancient sculpture and fifteenth-century paintings. Albrecht Dürer, for example, recorded in his diary in 1521 that he sold drawn portraits to patrons in Antwerp. Drawings were also being treated as works of art in collections such as that of the Venetian patrician Antonio

Pasqualino, recorded by Marcantonio Michiel in 1532.[14] In 1529 the Aretine painter and historian Giorgio Vasari (1511–74) bought his first drawings from the heirs of the Florentine sculptor Lorenzo Ghiberti (1378–1455). Vasari's collection eventually displayed examples of the draughtsmanship of artists whose biographies he published as *Le vite de' più eccellenti pittori, scultori e architettori* or *Lives of the Most Eminent Painters, Sculptors and Architects* (first edition 1550 and second edition 1568). He bound his collection of drawings in five albums, each framed with his own decorative border.[15] Following such precedents, other collectors valued drawings as autographs of that personal inventiveness which was established during the sixteenth century as the guarantee of quality; they prized drawings, whether polished or not, which could be interpreted as showing the processes of an individual's thought.

## 3 Teaching apprentices in workshop practice

Drawing seems to have played an important role in training young artists. Although practices varied from city to city, as a rough guide boys were legally bound to a master usually at some point after leaving school (aged about 11), and remained in the household of their teacher for up to six years, until they had met the requirements of their guild and reached the status of master. The boy promised to obey and work for the master, and the master promised to teach him. The father or other guardian usually paid the master at least for the first years before the boy had started earning his keep. The will by Macheclier quoted above suggests how intimate the learning experience might be that bound master and boy. Some newly qualified masters were able to set up workshops in their own right and take on one or two apprentices themselves. Others bound themselves to work for agreed periods for a master as assistants or painted as 'journeymen' in a workshop – meaning that they were hired *al giorno* or by the day. As befits this organisation, some drawings might be devoted to researching a style that would make the workshop stand out from the crowd or developing ideas for specific commissions; others would relate to learning the trade, while some enabled masters to guide assistants to work successfully in collaboration.

Few young painters treasured their early drawings (though see Plate 1.27 for a surviving exception). However, a text – *Il libro dell'arte* or *The Craftsman's Handbook* by the Florentine Cennino Cennini (*c.*1370–1440), written probably in Padua in the late 1390s – provides information on one painter's regime for the use of drawing in teaching. Since it was last copied in 1437 in Florence, the manuscript has relevance for the early decades of the fifteenth century. Cennino stated of painting: 'The basis of the profession, the very beginning of all these manual operations, is drawing and painting.'[16] Apprentices should first practise drawing 'on a little boxwood panel' coated with bone dust with a silver stylus, pressing very lightly and working in diffused light. For a year they should practise on this panel or on parchment or paper sized with bone in the same way. To emphasise shading they might apply a little ink wash with a brush.[17] After this they were allowed to draw with a pen on paper so as to be capable of 'much drawing out of your own head'.[18] Next they were permitted to represent more delicately modulated relief using papers and parchment coloured with tempera, that is paint made using egg yolk as the binding medium. They were taught to trace using oiled paper or thin parchment, but the stress was on developing the skills to draw after a 'model' – meaning exemplary – drawing. Having sketched in charcoal, they could fix the outline of their design with the stylus and brush off the charcoal. Using the colour of the tinted paper as their mid-tone value, they were to suggest three-dimensionality with a brush employing dark tones in ink or paint and light tones in paint.[19] They were told to 'represent always the best things which you can find done by the hand of great masters'.[20] Cennino went on to argue that by thoroughly understanding and absorbing one artist's style – or *maniera* – the apprentice 'will eventually acquire a style individual to yourself'.[21] Only at this stage in their second year did Cennino advise them to start 'representing from nature':

> this outdoes all other exemplars; and always rely on this with a stout heart, especially as you begin to gain some feeling for drawing. Do not fail as you go on to draw something every day.[22]

Apprentices were told to buy a portfolio so as to transport their work flat when they drew outside the workshop in churches or other places where paintings were on public view:

When you are in churches or in chapels, and beginning to draw, consider in the first place, from what section you think you wish to copy a scene or figure; and notice where its darks and half tones and high lights come; and this means you have to apply your shadow with washes of ink; so as to leave the natural ground in the half tones; and to apply the high lights with white lead.[23]

While Cennino stated that 'nature' was the best exemplar, he gave most advice on representing the work of others, and his attitude to direct observation was ambiguous:

If you want to acquire a good style for mountains, and to have them look natural, get some large stones, rugged, and not cleaned up; and copy them from nature, applying the lights and the dark as the system requires.[24]

Another suggestion entailed taking plaster casts from the human body: 'which is very useful and gains you great reputation in drawing, for copying and imitating things from nature'.[25] *The Craftsman's Handbook* therefore recommended a repertoire of activities for the young artist from tracing drawings, drawing casts of bodies and rocks, to drawing after paintings by others and observing 'nature' – activities which may well have been found in other workshops.

# 4  Theoretical advice on drawing for apprentices: continuity and change

The first professional painter after Cennino to theorise about the ways in which an apprentice should be trained by drawing was another Florentine, Leonardo da Vinci (1452–1519). While his writings were not made public, they indicate both continuity and change in the curriculum. Leonardo was apprenticed in Florence to the sculptor and painter Andrea del Verrocchio (1435–88) from about 1464 until 1472, when he was first recorded as master in the Confraternity of Saint Luke attached to the painters' guild. He was still documented as an assistant in Verrocchio's workshop in 1476, aged 24. He worked in Florence until 1483 and during short periods from 1499 onwards, but spent much of his career as a court artist – first in Milan and later in the service of the King of France.

Leonardo wrote parts of a treatise on painting, including passages on training, from the 1490s onwards. The fact that Leonardo was planning to communicate good practice to a wider audience – and Cennino actually did so – is telling. Leonardo had apprentices and so in all probability did Cennino, yet rather than keeping their secrets of draughtsmanship to the confines of their workshops, they both envisaged a common study programme and wrote of teaching theory as well as practice. That this was still relatively unusual is underlined by Ascanio Condivi's report of Ghirlandaio's unwillingness in the 1490s to let his apprentice Michelangelo borrow his drawing books and copy them.[26]

Leonardo outlined various drawing regimes for young artists. In one passage he recalls the approach of Cennino when he advised:

The painter ought first to exercise his hand by copying drawings by good masters and having acquired facility in this under the advice of his instructor he ought to set himself to copy good reliefs.[27]

In another passage, however, he attributed this view to 'my opponent' and stated instead that to begin one's studies by drawing after the best compositions 'on sheets of paper and walls' would be good, but:

since such masters are so rare that few are to be found, it is safer to go direct to the works of nature than to those which have been imitated from her originals with great deterioration and thereby to acquire a bad method.[28]

In a third passage Leonardo showed how seriously he took observation studies by the detailed instruction he gave on how to pursue them. While Cennino wrote vaguely of drawing after nature, Leonardo demanded anatomical analysis followed by designing compositions and researching them in 'field studies':

I say that one first ought to learn about the limbs and how they are worked, and after having completed this knowledge one ought to study their actions in the different conditions in which men are placed, and thirdly to devise figure compositions, the studies for these being taken from natural actions made on occasion as opportunities [are] offered; and one should be on the watch in the streets and the squares and fields, and there make sketches with rapid strokes to

represent features, that is for the head one may make an o and for an arm a straight or curved line, and so on in like manner for the legs and trunk, afterwards when back at home working up these notes in completed form.[29]

Leonardo did not recommend students to accept any 'slice of life' they encountered but to select what would fit their composition, and when drawing from the human figure to choose a model with 'natural bearing and make him go through various graceful and elegant movements'.[30] For Leonardo the aim was to produce a convincing pictorial representation of idealised imagined persons.

Leonardo outlined yet another syllabus, this time beginning with perspective and proportions:

> The youth ought first to learn perspective, then the proportions of everything, then he should learn from the hand of a good master in order to accustom himself to good limbs; then from nature in order to confirm for himself the reasons for what he has learnt; then for a time he should study the works of different masters; then make it a habit to practise and work at his art.[31]

In these passages we recognise the concern for drawing after good masters and nature which also characterised Cennino's programme. However, what is different is the way Leonardo goes into some detail about observation studies and emphasises the importance of learning the rules of perspective, anatomy and proportion.

Leonardo's new programmes had their roots in the generation of Florentine artists who had been working in the 1430s and whose ideas had formed the generation which gave him his training. The new ideals being practised by artists had been summed up in written form by the scholar, architect and amateur painter Leon Battista Alberti in his treatise, *On Painting*. Alberti described painting in a way which was suitable for patrons like Gianfrancesco Gonzaga, first Marquis of Mantua (1395–1444), to whom he dedicated the 1435 Latin version, so it was not particularly intended for apprentices. However, the 1436 Italian translation – dedicated to the Florentine architect Filippo Brunelleschi – made the text available to artists. Alberti began by praising the value of a linear perspectival construction which could be drawn so as to define credible pictorial space; this allowed objects of appropriate sizes to be positioned to indicate how far away they were supposed to be from the viewer (see Chapter 2). He then discussed

ways in which painters could invent a well-proportioned figure to be placed in pictorial space: 'we should take one member of it by which the rest [of the members] are measured'. He added this advice on studying anatomy and the nude:

> just as for a clothed figure we first have to draw the naked body beneath, and then cover it with clothes, so in painting a nude the bones and muscles must be arranged first and then covered with appropriate flesh and skin in such a way that it is not difficult to perceive the position of the muscles.[32]

## 5 Drawing and workshop practices *c*.1420–70

What is known of the drawings and underdrawings of the earliest painters working in Europe to be acclaimed in a literary text? The artists in question were Gentile da Fabriano, Jan van Eyck, Antonio Pisano and Rogier van der Weyden, and they were praised for their realistic skills by Facio in his treatise, *On Famous Men*.[33] All of them were being trained between the writing of Cennino's text and the date when it was last copied.

With the exception of Gentile (*c*.1385–1427), there is evidence that drawings and underdrawings played a variety of roles in the workshops of these painters. Drawings were used in commissions to make a careful record as the basis for a portrait (Plates 1.2 and 1.3) or to sketch ideas for a composition (Plate 1.7). Following the mapping out of a composition, 'observation studies' from reality might be made of parts of the design so as to suggest a convincing pictorial illusion (Plate 1.10), or painters might look through their visual library to find an image to fit into the composition (Plate 1.7). Drawings of complete compositions might be produced, possibly to show to the patron and to act as guides for painting the panel or mural on a large scale (Plate 1.4). Underdrawings for panel and mural painting were made to transfer the designs from small to large scale. These underdrawings guided painting but were also used to make further adjustments (Plates 1.6 and 1.16). They could coordinate the work of a team over a long period (Plate 1.12). Detailed studies made for one client could be stored in the workshop 'archive' and subsequently adapted for future commissions (Plate 1.14). Successful compositions could be copied on demand (Plate 1.13). Drawings could

be used for general 'research and development' to enhance representational skills and enrich the visual library of the workshop, as when painters collected interesting images by other artists both ancient and contemporary (Plates 1.8–1.9) or filed related observation studies on one sheet (Plate 1.7). In the following account I locate this evidence in the context of specific artistic careers.

## Jan van Eyck

There are only two drawings connected with the workshop of Jan van Eyck (c.1395–1441), although the fine graphic skills they present indicate that he was a practised draughtsman. One portrays a client from life to enable a painting to be made when the sitter was absent, since van Eyck made detailed colour notes on the drawing (Plate 1.2). This drawing presents a relentless observational accuracy which is somewhat suppressed – possibly for reasons of social decorum – in the eventual painting (Plate 1.3). The drawing derives from late in van Eyck's career and used the technique of silverpoint, which produced fine lines of silver when pressed into paper prepared with a paste of bone or chalk dust. The technique required confidence since there was no way of correcting a mistake. Van Eyck may have been born at Maaseyck near Maastricht, and is first recorded in the service of the Bishop of Liège at The Hague from 1422 to 1424. In 1425 he was appointed court painter to Philip the Good, Duke of Burgundy (1396–1467), a status he retained for life. He was in Lille from 1425 until at least 1429, but by 1431 he had moved to Bruges, where he remained until his death in 1441. The drawing represents Cardinal Niccolò Albergati (1375–1443), who had been sent by the pope as papal legate to participate in peace negotiations in 1435 which were ratified in the Treaty of Arras. This ended conflict between Philip the Good and Charles VII of France (ruled 1422–61) over the murder of the duke's father. Possibly the duke ordered the portrait as a political record. Or perhaps the cardinal himself placed the commission. He is represented in a pose which is aloof and thoughtful. The drawing suggests a low source of light from the left highlighting the chin and cheekbones. Grouped lines in tonally dark areas suggest shadow. Line is also employed with bold strokes to circumscribe the edges of forms and to suggest texture, rendering the hair formation. Massed lines even suggest the darker colour of the cardinal's nose, mercilessly inscribed

on the drawing itself by van Eyck as 'blood red – sanguineous'. Here is an excerpt from his description:

> The hair in the front
> Ochreous [ash] grey
>
> The lower part of the forehead
> Between the eyes sanguineous
> Close to the hair palish
> The wart purplish
>
> The apple of the eye
> Around the pupil
> Dark yellowish[34]

The wrinkles, prominent veins, sagging flesh and balding hairline of someone who was probably 60 at the time of the portrayal are all indicated, yet the delicacy of the medium allows the suggestion of a smile. The painting (which can only be dated broadly as made between 1435 and 1441, when van Eyck died) presented a portrait which was larger in scale than the drawing. It ignored the red nose, tidied up the hair and evened out the fall of the light so that the brow is no longer slightly shaded. The painting may give the appearance of a likeness 'warts and all', but the drawing indicates that some of the warts have been smoothed over in the process of representing the dignity of an eminent churchman.

The value placed on graphic skills is evident in the highly finished drawing inscribed on the frame as having been made by van Eyck – 'Johannes de Eyck me fecit 1437' – which shows Saint Barbara seated before her attribute in the form of a tower (Plate 1.4). The drawing was executed employing a brush in black watercolour on a panel prepared with a white ground. The panel was inserted into the grooved mouldings of the frame, and both it and the frame were treated with the same white ground, so presumably it was intended for display from the start. A stylus and ruler have been used to incise guidelines for the tower. The stylus has also been used freehand with silverpoint effects – for instance, to delineate the palm frond. Some touches of whitish oil paint have been added to accentuate a few forms such as the hat of the man entering the tower and the ribs of the main window. The ultramarine sky was painted after the frame was decorated with a marbling effect.[35] Although no completed painting of this composition survives, it may be a presentation drawing to show a patron

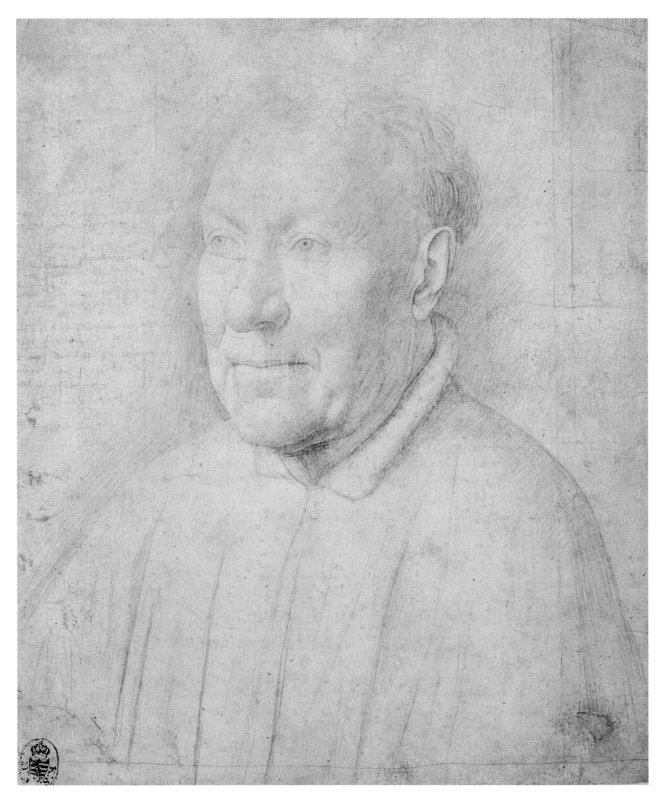

Plate 1.2   Jan van Eyck, drawing for *Portrait of Niccolò Albergati*, *c.*1435, silverpoint on paper prepared with chalk, 21 × 18 cm, Kupferstichkabinett, Staatliche Kunstsammlungen, Dresden.

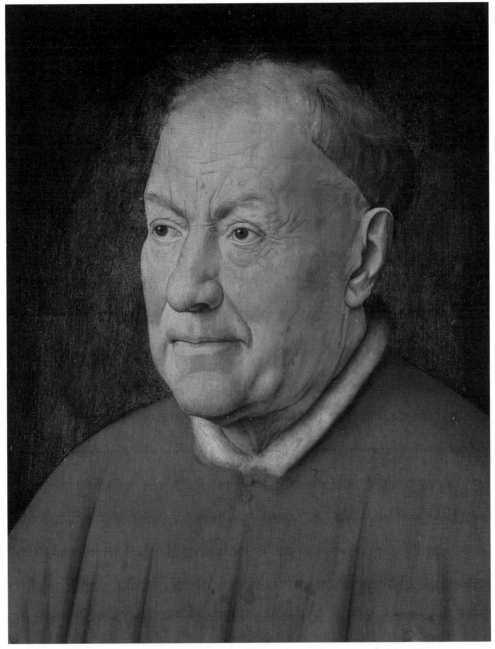

Plate 1.3   Jan van Eyck, *Portrait of Niccolò Albergati*, c.1435–41, panel, 34 × 27 cm
(including frame), Kunsthistorisches Museum, Wien oder KHM, Vienna.

what a large painted version would contain. Or
it might have been planned as a completed art
work showing graphic virtuosity. At any rate it
demonstrates the skills required for developing
complex narrative compositions.

Van Eyck laid out a scheme where the saint seated
on a hill seems to be in the foreground, while her
tower appears behind and as if a little below. In
the distance he represents a fertile terrain divided
into many fields along with a hill town perched
above a river. This is a feast for the eye in laying

out the artist's virtuosity with line. The lower third
of the drawing describes the complex folds of an
ample skirt, allocating areas to remain lightest and
therefore appear more prominent. The drawing
suggests where the bent knees are beneath the
skirt and uses clustered strokes to imply shading
from a light source top left. The central band of
the drawing shifts the mood from contemplative
to active. The acuity with which tiny figures are
delineated to represent building work implies
careful observation. The top third of the design

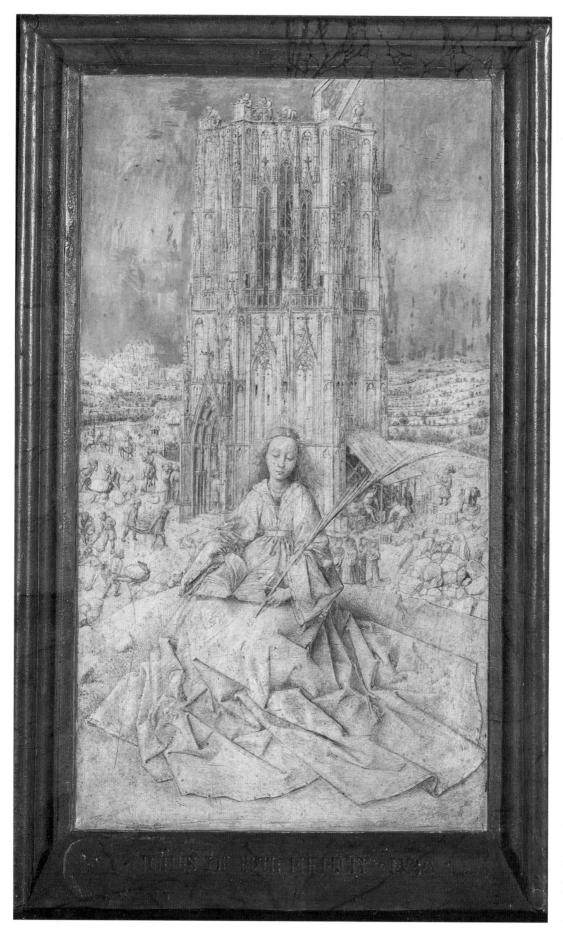

Plate 1.4 Jan van Eyck, *Saint Barbara Seated before her Tower*, 1437, watercolour, oil and stylus on panel, 31 × 18 cm, Koninklijk Museum voor Schone Kunsten, Antwerp.

analyses the formations of a hexagonal tower adorned with pinnacles and traceried windows. In a graphic tour de force the winding gear used to lift building materials is subtly indicated within (see Plate 1.1). Where the silverpoint portrait of Cardinal Albergati records an intensive session of observation in front of a model, the Saint Barbara is a deeply thought out composition which we can only surmise derives from sessions of observation and probably referring to a well-stocked 'library' of drawings.

In addition to these documents, paintings by van Eyck have been examined using infrared radiation capable of reaching below the upper layers of paint to examine underdrawings. The findings are turned into monochrome images which are called 'infrared reflectograms'.[36] The underdrawings were executed with a brush on the surface to be painted as a guide. Whereas it might be assumed that planning was so advanced by the painting stage that little was left to be decided, the reflectograms show significant changes of mind. For example, in *The Virgin and Child with Chancellor Nicolas Rolin* (Plate 1.5), van Eyck was still making decisions about the positioning of the left hand of the Virgin and the left fingers and forearm of the Christ Child (Plate 1.6). Such attention suggests how nuanced were interpretations of expression and gesture. Contemplating the design seems to have led to further changes as he painted. For instance, in the painting he elided the purse which he had drawn at the chancellor's waist. This seems an important revision which could indicate consultation with the patron. Perhaps associations between purses and the vice of avarice proved too problematic. In addition, he shifted the landscape horizon up – presumably so that it would not clutter the reading of the chancellor's profile. The underdrawing also implies technical priorities. The shape of the Virgin's shoulder is more carefully mapped than that of her hair, perhaps indicating that it is the underlying structure of the figure which it is the business of the underdrawing to confirm.[37] These comparisons show something of the thinking which the process of trying out the design on the panel allowed – about the way the design would be most clearly perceived, about the way the feelings and thoughts of the figures would best be represented, and about the way the image would serve the desires of the patron. The panel seems to have been commissioned by Rolin (Chancellor of Philip

of Burgundy from 1422 to 1461) for his parish church, Notre Dame du Chastel at Autun. For such a location it would be important that the image display the chancellor's devoutness as well as his power.

To sum up, there is evidence for the use of drawing by van Eyck to design a composition and to make observation studies as well as for underdrawing to refine his ideas.

## Pisanello

The third artist whose painting Facio praised was Antonio Pisano (before 1394–*c*.1455), who founded virtually single-handed the genre of commemorative bronze medals, as well as painting portraits, murals and devotional panels. He was named Pisanello – 'the little Pisan' – after the city of his father, but was taken by his widowed mother to her home town of Verona. He worked in Verona, where he was presumably trained, as well as in Venice, Mantua, Rome and Naples. Attributed to him and his workshop is the largest number of surviving drawings – between 200 and 300 – for any artist in the first half of the fifteenth century. They include meticulous studies direct from life and 'file' drawings which stored images – a page of nudes, or dogs, or bits of horses – gathered together from direct observation or other contemporary artists' work and from the work of ancient Roman artists. Such drawings could be adapted to fit into new compositions. As if to balance this precision, there is evidence also that Pisanello made sketchy preparatory drawings noting ideas for compositions, as well as improvising in underdrawings for murals.

Pisanello started his career by completing work begun by Gentile da Fabriano (the first of the painters to be praised by Facio) in the Doge's Palace in Venice on the walls of the Sala del Gran Consiglio – the hall for the deliberations of the Great Council. His scene (later destroyed in a fire) depicted the Holy Roman Emperor Barbarossa and his son doing homage to the doge in the company of Pope Alexander III.[39] A drawing showing the doge and pope seated on a dais has been identified as a preparatory sketch for this large mural (Plate 1.7).[40] A figure kneels on some steps below them, and the homage is witnessed by rows of seated figures as if in an audience chamber. The canopied enclosure is adorned with heraldic shields.

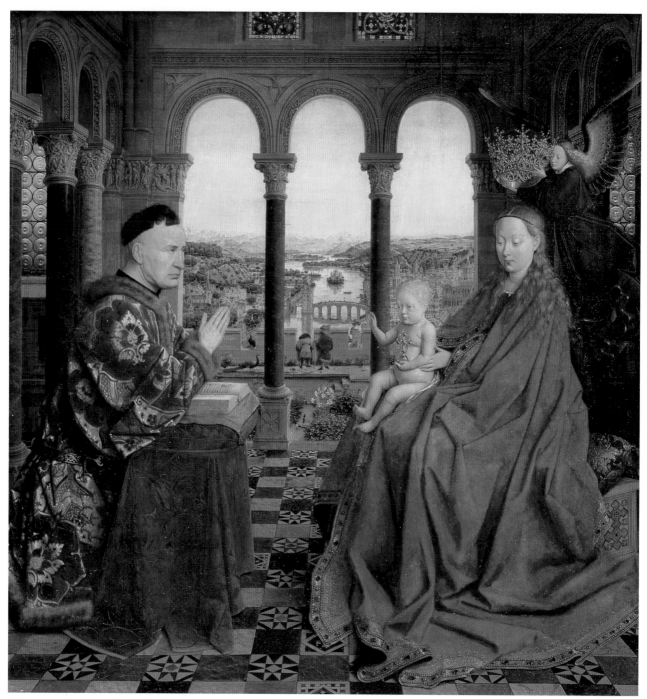

Plate 1.5   Jan van Eyck, *The Virgin and Child with Chancellor Nicolas Rolin*, c.1436, oil on panel, 66 × 62 cm, Louvre, Paris. Photo: © RMN/Hervé Lewandowski.

The sketch was fitted into a space between earlier and more attentively worked drawings of dogs on a page of a drawing book in which Pisanello had 'filed' images of three different sorts of dog. The dense use of the page documents frugal attitudes to paper. The media used are pen and ink on paper whose surface has been tinted, recalling Cennino's recommendations to the young artist. Two views of a small dog seem to have been drawn first, followed

by the profiles of two hounds, lower left, whose fuller delineation was halted to avoid overlaying the lower view of the small dog. Another dog in the centre seems to have been drawn next, as its hatched 'background' was brought up short at the neck lines of one of the hounds. The mural sketch was added last, presumably at a date between 1415 and 1419 when it is recorded that Pisanello was involved in the Venetian scheme. The 'dog file' could

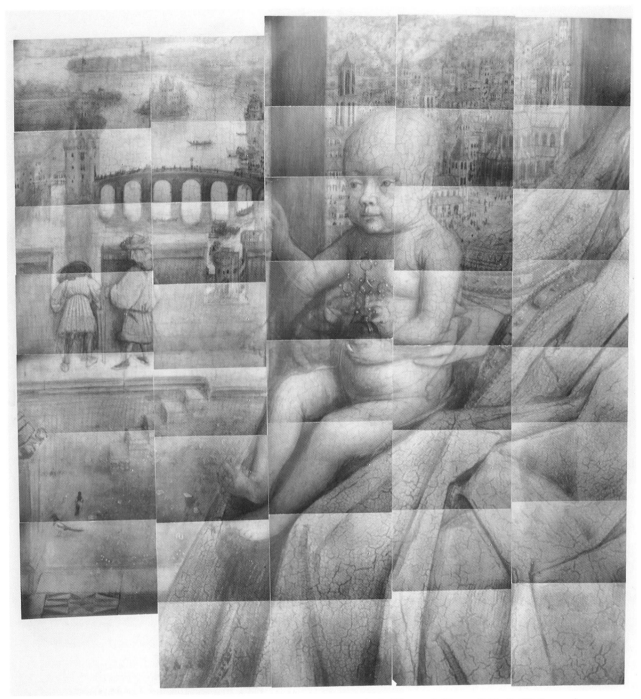

Plate 1.6   Infrared reflectogram of the Christ Child held by the Virgin in Plate 1.5. Photo: © Prof. J.R.J. van Asperen de Boer/Stichting RKD.[38]

date from the period close to his training as he practised representational skills. The careful finish of all but the two hounds suggests that these images are studied or even copied, rather than being the equivalents of direct 'snapshots' of the animals.

Young artists were advised to copy the work of recent artists. Presumably mature artists did so too. However, the evidence we have of Pisanello copying others' work is confined to his interest

in ancient Roman sculpture – a trend which was increasing during the early fifteenth century. From the late 1430s onwards, Pisanello was making bronze commemorative medals in an antique style, and he was interested in the way Roman artists had portrayed their dignitaries. In one drawing Pisanello developed ideas for a portrait of Faustina, wife of Emperor Antoninus, based on antique sculpture.[41] The drawing, which is in

Plate 1.7 Pisanello, composition sketch and study of dogs and later a sketch for the mural of the emperor kneeling to the pope and doge, pen and ink on red-tinted paper, 25 × 18 cm, DAG, Louvre, Paris. Photo: © RMN/ Gérard Blot.

Plate 1.8 Pisanello, Empress Faustina (inscribed 'Diva Faustina Pisanus hoc opus'); battlemented walls; two sketches in left profile, probably of Niccolò III d'Este, pen and ink on red-tinted paper, 25 × 18 cm, DAG, Louvre, Paris, RF 519 recto. Photo: © RMN/Michèle Bellot.

ink with traces of chalk on paper whose surface has been painted red, framed the profile bust in a niche adorned with Gothic tracery. Since he added the inscription in Roman capitals, 'To the divine Faustina' (empresses being deified like their husbands), and inscribed it 'Pisanello his work', he appears to have been planning a project (Plate 1.8).[42] It is similar to Imperial Roman coins which used the former inscription (Plate 1.9). Roman Republican and Imperial sculptors had employed highly realistic modes of portraiture which provided prestigious models. Pisanello's interest in antique art could have been encouraged by his stay in Rome during 1431–2 when he was completing another of Gentile da Fabriano's mural schemes, this time for the papacy.

Pisanello's interest in observation of reality is displayed in drawings connected with the narrative of Saint George and the Dragon which he painted for a member of the Pellegrini family in the church of Sant'Anastasia in Verona between 1437 and 1439.

Plate 1.9 Coin portrait of the Empress Faustina, silver denarius of Antoninus Pius (inscribed 'DIVA FAUSTINA'), British Museum, London, BMC 393 C196.109. Photo: © The Trustees of the British Museum.

These drawings represent hanged men (Plate 1.10). He used a stylus followed by ink to fix what were considered definitive images.[43] Three men are represented in side view, and either a front or a back view. (They are to be distinguished by their clothing and level of decomposition.) These views would allow flexible use in the future. In addition, a female profile has been 'collected' – possibly for the interesting headgear – as well as a young boy. Tonal modulation is used sparingly, and the emphasis is on line. Some or all may have been copied from 'direct' observation

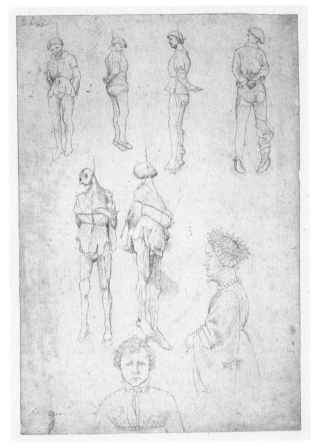

Plate 1.10 Pisanello, *Hanged Men*, *c*.1438, pen and ink over black chalk on paper, 28 × 19 cm, British Museum, London. Photo: © The Trustees of the British Museum.

drawing – a form of mirroring which was a byproduct of tracing from one sheet to another. Outlines were pricked and chalk dusted through onto a sheet beneath, or they were indented with a stylus to mark the sheet below. Either way, the original could be turned over to obtain the reversed image.

The exuberant underdrawing for Pisanello's mural in the Palazzo Ducale at Mantua suggests that the careful preparation implied in his use of drawings was the foundation for executing large works in a way which enabled improvisation and sustained excitement in graphic description as the design was expanded to full size (Plate 1.12). The imposing mural presented a chivalric panorama covering all four walls of an audience hall belonging to Ludovico Gonzaga, ruler of Mantua. It may date from 1439–42 or from between 1447 and Pisanello's death *c*.1455. It depicted scenes from Arthurian romance dressed in modern armour. The frieze was adorned with emblems of the Gonzaga family, while below were narrated the deeds of the Knights of the Round Table. Such chivalric narratives were attractive to rulers who were keen to climb away from their social origins as citizens who had gained power by force, and to present themselves as emulating those who held noble status through service to a feudal lord in King Arthur.

Mural painting entailed plastering the wall with a relatively rough layer on which Cennino instructed in *The Craftsman's Handbook* that plumb lines should first be used to mark verticals and horizontals.[44] An underdrawing in black charcoal was then made and recorded in red paint as a guide for completing the design on the final plastered surface – in this case, a stage only achieved on one wall. According to Cennino, each day enough smooth plaster was freshly laid – hence the term *fresco* – to be painted with water-soluble paints before the wet surface dried out. Once this final layer was put on, artists worked from memory, perhaps with the guidance of small drawings and the need to fit onto the visible parts of the underdrawings. Further painting took place on the dry – or *secco* – surface where colours which were not water soluble were required, such as certain types of blue. In her analysis of Pisanello's techniques, Joanna Woods-Marsden showed that he ignored Cennino's advice to use plumb lines and instead divided his walls into a few irregular areas.[45] These were then divided into patches about a metre square for each day's painting. Pisanello

drawings. Pisanello selected the second and fourth views from the left for his painting. The mural was placed high up on the exterior of the triumphal arch of the Pellegrini Chapel. It depicted on the right Saint George ready to ride off and kill the dragon which is terrorising the citizens of the princess (Plate 1.11). In the legend the dragon is linked with the wilderness outside the city. Indeed, the dragon is shown on the left spandrel of the arch surrounded by bones. Since gibbets were placed outside city gates, his decision to show hanged men beyond the town perimeter perhaps had a narrative role in setting the scene in the danger zone. This choice also paraded skill in representing things which were rarely depicted, and relates to the way the mural displays other kinds of artistic prowess – in, for example, showing horses in steep foreshortening, expensive textiles and armour. The two dogs lower left in the mural seem to be adapted from exemplars in Pisanello's drawing archive (Plate 1.7). The muzzle design of the foreground hound in the drawing has been used for the painted hound. The head of the smaller dog in the painting relates to a reversed version of the dog in the

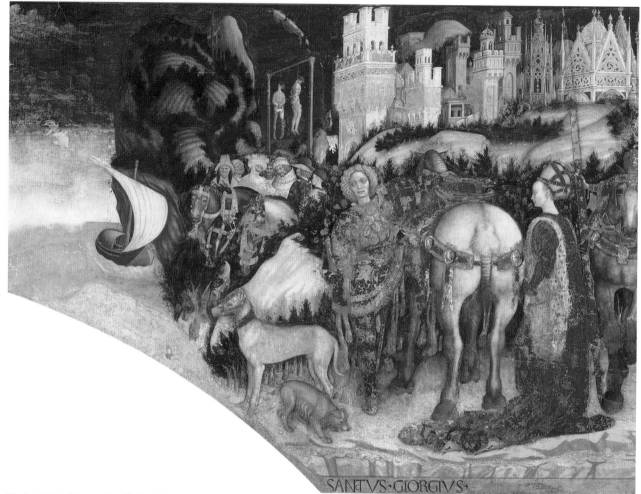

Plate 1.11   Pisanello, *Saint George about to Slay the Dragon*, *c.*1438, fresco transferred to canvas, 223 × 620 cm, formerly Cappella Pellegrini, now Cappella Giusti, Sant'Anastasia, Verona. Photo: © 1990 Scala, Florence.

did not plan each wall precisely in composition drawings, but made many studies of groups which he then put together at the underdrawing stage, adjusting them on the wall. He did use red paint but he also employed black underdrawings, possibly to distinguish his final from his initial thoughts. In some sections the plaster was moulded, incised and then painted and gilded or silvered to suggest knightly armour. This evidence suggests that underdrawing could be used in an improvisatory manner and that the instructions in treatises need to be treated with caution.

## Rogier van der Weyden

The fourth painter whom Facio praised was Rogier van der Weyden (*c.*1399–1464), who was born at Tournai and settled in Brussels in 1435. He was made official painter to the town in 1436, where he died in 1464 having visited Rome in 1450. Paintings attributed to Rogier van der Weyden and

his workshop confirm his use of drawings of various sorts, though no such examples on parchment or paper have yet been identified.[46] Lorne Campbell showed that Rogier's drawings were treasured by his grandson Goswijn and were still being used by him in *his* paintings in 1510.[47]

Although no drawings survive from his workshop, he and his assistants seem to have been the first painters to introduce the new subject of Saint Luke drawing portraits of the Virgin and Child as a theme for altarpieces in the 1430s (Plate 1.13). Already from the mid-fourteenth century painters in the western segment of Christendom had represented the legend that Saint Luke was an artist who portrayed the Virgin and Child. However, they had pictured him painting a panel or holding a panel painting of his sitters. It is a token of the importance accorded to drawing by the 1430s that four versions of an innovative composition depicting Luke as draughtsman are attributed to

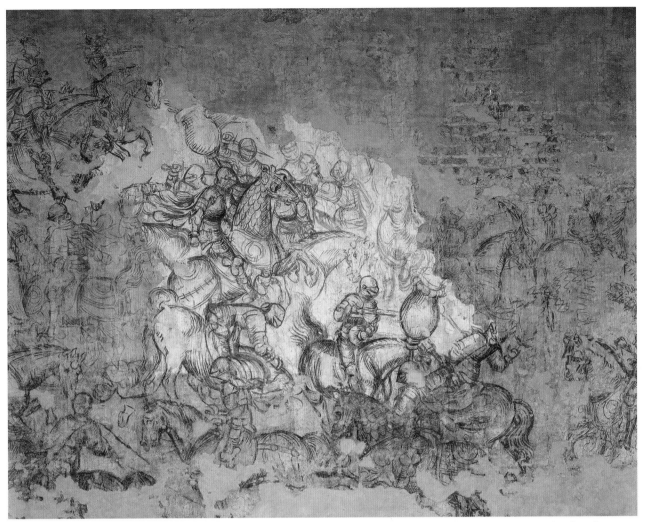

Plate 1.12   Pisanello, fresco underpainting for a mural, 1439–42 or 1447–c.1455, charcoal with brush and red and black paint, Sala del Pisanello, Palazzo Ducale, Mantua. Photo: Soprintendenza per Il Patrimonio Storico Artistico e d'Etnoantropologico di Brescia, Cremona e Mantova/Eberhardt 2003.

Rogier van der Weyden and his assistants dating from c.1435–40. The saint uses a silverpoint stylus on a small sheet of white paper: the message seems to be that good painters make portraits by drawing. Numerous portrayals of the Virgin and Child were venerated as actually being by the hand of Luke, and Luke was also the patron saint of guilds to which painters and other professions belonged, so the copies could have met demand from individual and guild patrons.[48]

Comparative evidence and underdrawings can be used to deduce something of Rogier's practice. The existence of several painted versions of the same composition indicates that they derive from 'blueprint' drawings recording the successful design. Drawings for compositions could have formed a 'pattern book' shown to clients from which they could choose.[49] The four versions of altarpieces

depicting Luke as draughtsman are important evidence that drawings – possibly at the scale of the panel – could satisfy multiple orders. Following infrared examination, Molly Faries concluded that as the panel underdrawing now in a museum in Boston was the only one to show changes of mind, it must be the original.[50] She reported that two of the versions showed evidence that their designs had been traced from drawings using the method of pricking through lines in the paper and dusting through holes to leave dots on the surface to be painted. As well as using 'pattern books' of whole compositions, Campbell proved that the van der Weyden workshop had an archive of observation studies; he noted, for example, the similarity between the feet of the Christ Child in *Saint Luke Drawing the Virgin* (Plate 1.13) and his feet in the *Adoration of the Magi* (Plate 1.14). Campbell

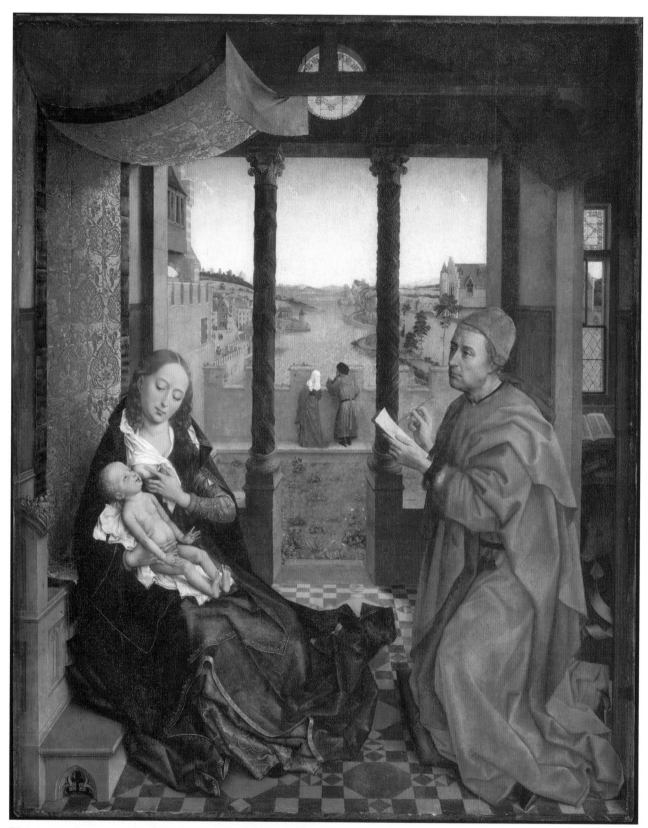

Plate 1.13   Rogier van der Weyden, *Saint Luke Drawing the Virgin*, *c.*1435–40, oil and tempera on panel, 138 × 111 cm, Museum of Fine Arts, Boston. Photo: © 2007, Museum of Fine Arts, Boston. Gift of Mr and Mrs Henry Lee Higginson, 93.153.

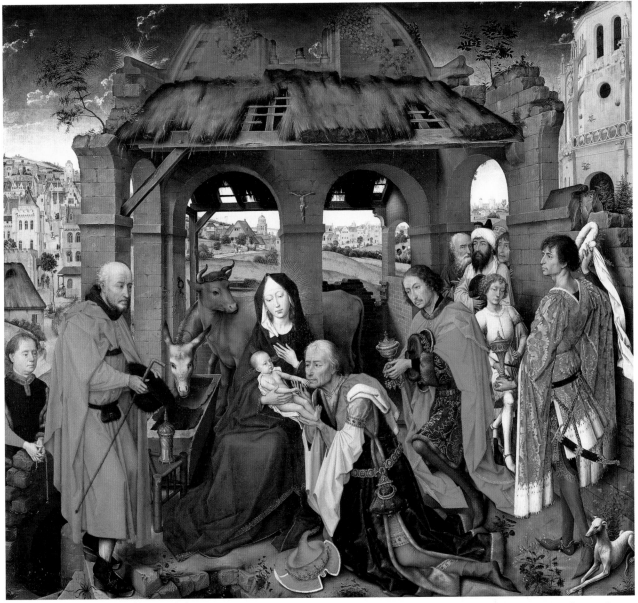

Plate 1.14  Rogier van der Weyden, *Adoration of the Magi*, central panel of the Columba Triptych, 1458–9, oak panel, 138 × 153 cm, Alte Pinakothek, Munich. Photo: Joachim Blauel–Artothek. Owned by Wittelsbacher Ausgleichsfonds, Munich.

deduced that the workshop held one drawing of a child's feet on which both paintings relied.

Other underdrawings on panels attributed to Rogier van der Weyden and his workshop have been examined by means of infrared reflectograms (Plates 1.15–1.16). Compared with the underdrawing for the mural (Plate 1.12), there is less indication of changes of mind – although note the draughtsman thinking through the lines of the chin here as he drew (Plate 1.16). Comparison of the underdrawing and the panel display further adjustment. The underdrawing marks quite bold patches of highlighting on the brow, cheek and neck. It stresses the dark line of eyelashes and

charts a pointed nose. These features are toned down in the painting. Also in the painting the folds of the veil to the left of the Magdalene's face were simplified. Perhaps fussy detail in the clothing – even if the artist had carefully observed it in some study – was felt to draw attention away from the saint's features.

Drawings and underdrawings provided flexible vehicles whose value lay in their sheer adaptability. Artists could experiment with ideas for a composition and make detailed observation studies for their design. They could archive successful composition drawings or useful studies from nature and store images culled from other

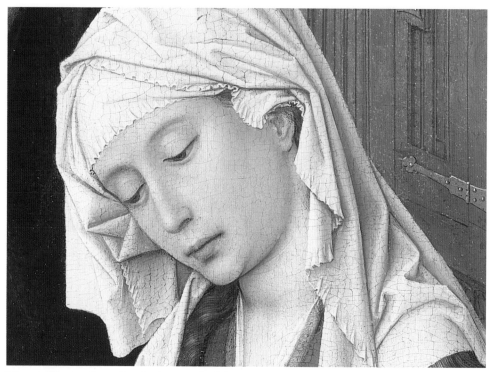

Plate 1.15   Attributed to Rogier van der Weyden, detail from *Saint Mary Magdalene Reading* (fragment), oil on panel (transferred to mahogany), 62 × 55 cm, National Gallery, London. Photo: © The National Gallery, London.

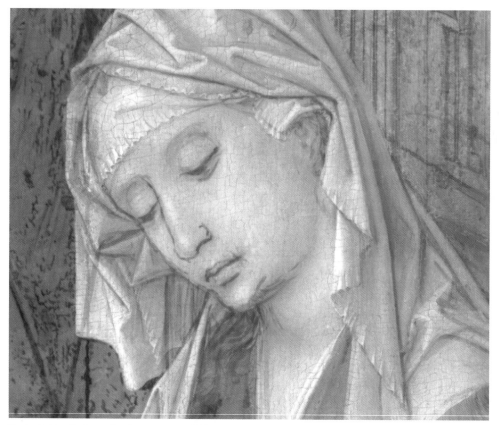

Plate 1.16   Infrared reflectogram of Plate 1.15. Photo: © The National Gallery, London.[51]

artists. Contrary to expectations, perhaps, that the inventive stages in drawings were confined to the early plans for a painting, the mural and panels examined here suggest that underdrawing made it possible for some, or even many, experiments to operate safely at the final stages of the process. I turn now to compare this evidence with that provided on the uses of drawing and underdrawing during the second half of the period according to the practices of Leonardo and Dürer.

# 6 Drawing and workshop practices c.1470–1520

## Leonardo da Vinci

Over 200 drawings associated with paintings and sculpture by Leonardo survive quite apart from those illustrating the thousands of pages in which he demonstrated his ideas about art, anatomy and technology. This corpus includes drawings in all the media discussed so far, as well as media special to the workshop of Verrocchio in which he trained (that is, brush drawings on cloth) and the new medium that Leonardo pioneered in the 1490s – red chalk drawings.[52] It also includes types not yet considered: a drawing of a linear perspectival construction, a cartoon, an underdrawing on a panel which was never painted over, analytical and theoretical studies of human proportions and anatomy and of movement, as well as composition studies in which all the figures are nude. Leonardo left most of the drawings and manuscripts in 1519 to his former pupil and assistant Francesco Melzi (1493–1570), who managed to keep them together in Milan for much of the sixteenth century.

Leonardo was highly acclaimed by contemporaries. Paolo Giovio, Bishop of Nocera, in his brief biographies of artists composed 1523–7, began with Leonardo, rating Michelangelo (1475–1564) second and Raphael (1483–1520) third. Whereas Facio had praised his favourites for their truth to nature, Giovio highlighted Leonardo's theoretical approach and use of drawings as well as his impressive paintings and sculpture:

> Leonardo regarded nothing more worthy of respect than the rules of optics by whose aid he observed exactly the laws of light and shade. He learned to dissect the bodies of criminals in the schools of medicine – an inhuman and horrible task undertaken in order to paint according to the pattern of nature the pulling and pushing of the various limbs by the force of the muscles and joints. He represented in his notebooks with marvellous diligence the shape of every particular even to the smallest veins and the interior of the bones, so that as the result of so many years' work infinite prints by means of copperplates might be engraved for the utility of art.[53]

Evidence survives of Leonardo drawing after 'nature and small draped models', dating from about the time when he had completed his apprenticeship in 1472 and the next four years when he was a paid assistant to Verrocchio. His earliest certain work is a drawing made when he was 21 showing a landscape in ink on paper inscribed 'di di santa maria della neve addi 5 daghossto 1473': of the [feast] day of Santa Maria della Neve on 5 August 1473 (Plate 1.17). Feast days were holidays – 5 August fell on a Thursday in 1473 – so he was free to leave town.[54] Distance is suggested by diminution in the size of objects and by overlapping forms in the outlines of mountainous promontories. It seems likely that this was drawn on the spot because of the hurried technique in which the pen nib hardly left the paper and some blobbing of ink. Leonardo may have ignored the rules of the single vanishing point construction: compare the orthogonals of the fortress and those apparently indicating fields on the plain below (the rules of single-point perspective are explained in Chapter 2). Or he may have been recording the digging of irrigation channels.[55] This may have been a training drawing, though there was a limit to what it could practise in terms of recording the weather, lighting effects and colouring of the mountains. He might have envisaged it as ready to fit into a holy scene or the background of a portrait. An altarpiece commissioned from Verrocchio to which it is likely that Leonardo contributed shows the importance of the representation of landscape in rendering narratives convincingly and in performing a devout role (Plate 1.18). Here landscape skills visualised the setting for baptism in the River Jordan, and also perhaps provided a metaphor for the possibilities of salvation opened up to humanity through baptism – evoking the beauties of a 'promised land'.

Drawing landscapes was a good investment. So was drawing draperies. On the basis of Vasari's information, a group of drawings of drapery painted on cloth have been assigned to Leonardo's youth (Plate 1.19). As so often, it is difficult to attribute

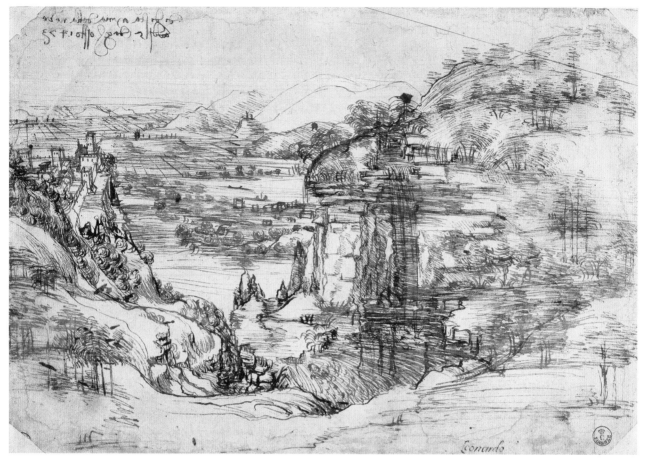

Plate 1.17 Leonardo da Vinci, drawing of a landscape, 1473, pen and ink on buff paper, 19 × 29 cm, Gabinetto dei Disegni e delle Stampe degli Uffizi, Uffizi Gallery, Florence. Photo: © 1990 Scala, Florence.

the drawing because it cannot be related exactly to a known painting. Vasari described Leonardo's practice shortly after his apprenticeship:

> He would make clay models of figures, draping them with soft rags dipped in plaster, and would then draw them patiently on thin sheets of cambric or linen, in black and white, with the point of a brush. He did these admirably, as may be seen in my book of designs.[56]

Vasari saw Leonardo's drawings in Milan in 1566 in the possession of Melzi. Whether the distinctive drawings on cloth are all by Leonardo or by co-pupils such as Domenico Ghirlandaio (c.1448/9–94), they indicate the diligent procedures required by his generation to paint figures such as those of the angels in the *Baptism of Christ* (Plate 1.18). The evidence therefore suggests that Leonardo's training entailed study outside and inside the workshop.

Throughout his career Leonardo used drawings intensively in the research for commissions. They include sketches searching for compositional ideas

(Plate 1.22) such as Pisanello produced, studies for parts of a composition (Plate 1.20), a cartoon of the type used to transfer designs to the painted surface (Plate 1.23) and the resulting underdrawing on the panel (Plate 1.21).

A composition study and the underdrawing survive for Leonardo's earliest documented commission of an altarpiece of the *Adoration of the Magi* for the church of San Donato at Scopeto near Florence, contracted in March 1483 but unfinished seven months later when he departed for Milan (Plates 1.20–1.21).[57] The composition study researched the staging for the top third of the altarpiece as a subplot displaying the train of the kings. The single vanishing point construction was drawn and the figures sized according to the rules to suggest nearer and more distant positions on the chequerboard 'floor'. The underdrawing shows that while he has transferred the information that the horizon or viewer's eye level is supposedly at the level of the eighth step up on the staircase, he ignores the consequence that we as spectators

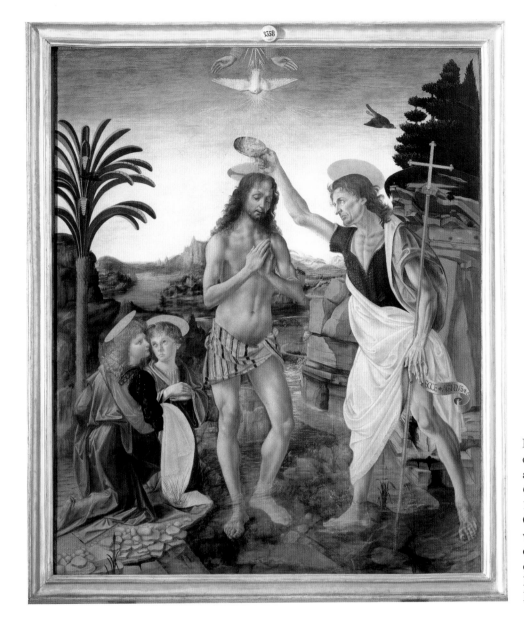

Plate 1.18  Andrea del Verrocchio and assistants, *Baptism of Christ*, *c.*1470, panel, 177 × 151 cm, Uffizi Gallery, Florence. Used with the permission of the Ministero Beni e Attività Culturali. Photo: © 2000 Scala, Florence.

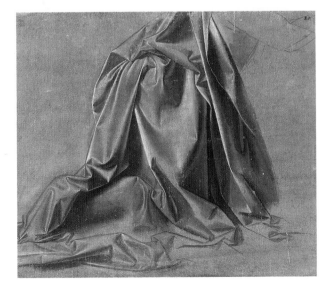

Plate 1.19  Attributed to Leonardo da Vinci, *Drapery Study*, *c.*1470, bodycolour with white heightening applied with brush over traces of black chalk on linen coated with grey bodycolour, 18 × 23 cm, DAG, Louvre, Paris. Photo: © RMN/ Jean-Gilles Berizzi.

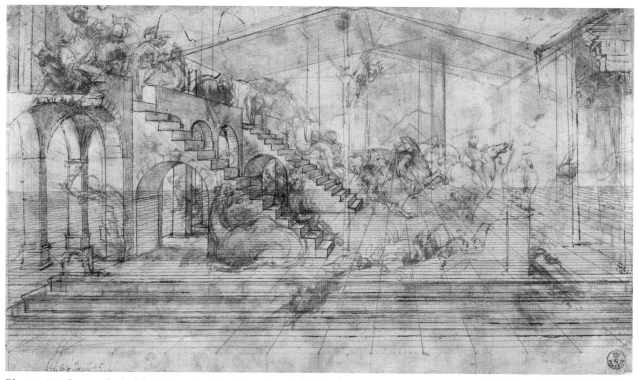

Plate 1.20  Leonardo da Vinci, drawing for *Adoration of the Magi*, c.1482–3, pen and ink over silverpoint with wash on pink prepared paper, 17 × 29 cm, Gabinetto dei Disegni e delle Stampe degli Uffizi, Uffizi Gallery, Florence. Photo: © 1990 Scala, Florence.

should be looking down on all the figures in the foreground. The subplot and the main scene appear then to have been planned separately, except that the vanishing point of the background scene has been placed – presumably with symbolic significance – above the arm of the Christ Child stretched out to bless a king. As with Pisanello's underdrawing (Plate 1.12), there is a lively sense of problems still being posed as the design was tested at full scale. The underdrawing retains the theme of the entourage of the kings rampaging around the ruin, including an equestrian fight to the right, but has abandoned evoking the roof of the stable. The camel was replaced with women, who may be reproving the fighting. Conceivably it was considered indecorous for the courtiers to fight unchecked at the Nativity. By the stage of the underpainting (Plate 1.21), many of the figures visible in the earlier drawing have been suppressed, perhaps for legibility. All figures in the drawing and some in the underdrawing (at the 'back' on the ruined building) were studied nude, a practice which had been approved in Alberti's *On Painting*.

A 'first idea' sketch as well as a cartoon survive which relate to designs depicting the Virgin and Child seated on the lap of Saint Anne with the Christ Child blessing the infant Saint John the Baptist, dating from about 1500 to 1516 (Plates 1.22–1.23).[58] They provide further information about how artists imagined compositions and enlarged them for painting. The sketches used black chalk to think out a variety of poses to represent family relationships between grandmother, mother, Christ and his cousin. Ink was then used to select forms. From the start the main sketch conceived a tight fit of figures to frame – also found in the cartoon – which is so intimate for spectators. The outlines were scored with a stylus for transferring the design on the same scale, and the picture field was also measured along the base for a grid used in transposing designs to a larger size. Experiment with poses, especially with Christ, seems to have been so extensive as to become illegible. Five small drawings in black chalk below tried out poses; these smaller figures are imagined nude.

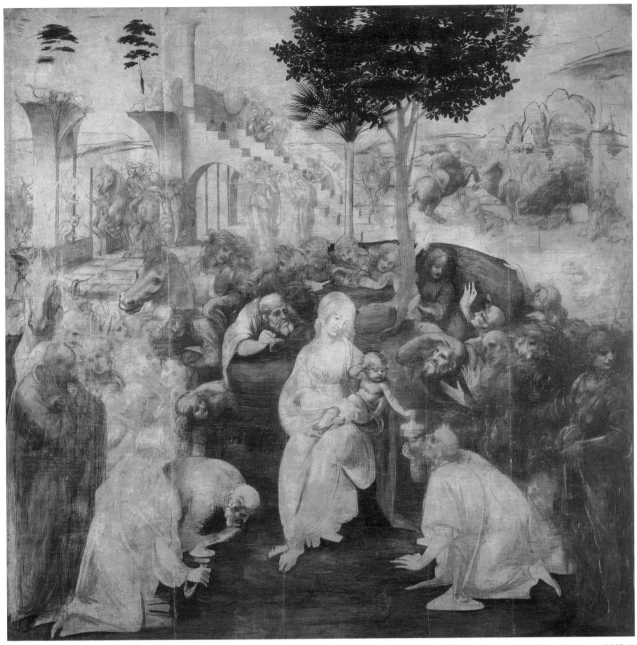

Plate 1.21   Leonardo da Vinci, *Adoration of the Magi*, 1483, monochrome oil underpainting on panel, 258 × 243 cm, Uffizi Gallery, Florence. Used with the permission of the Ministero Beni e Attività Culturali. Photo: © 1990 Scala, Florence.

The cartoon – from *cartone* or 'large sheet' – shows figures life size and despite the impression of monumentality presents many areas in which poses are tentative: for example, the vague forms of Christ's left foot and his left hand, the Baptist's right leg and arm, and the placing of Anne's left leg. Decisions seem to have been reached about the overall relationship of the figure group and the landscape. Charcoal has been used to indicate the edges of forms and also textures such as hair, as

well as areas in shade. The buff paper provided a mid-tone to produce the effect of 'relief modelling' while white paint indicates highlights. The spotlight is focused on the heads and shoulders of the protagonists, and the delicate modulations of light to dark suggest softness of skin and nuanced expressions. The cartoon may be read as a statement of priorities – that is, getting the four heads and shoulders and the blessing hand 'right'. These elements arguably indicate what

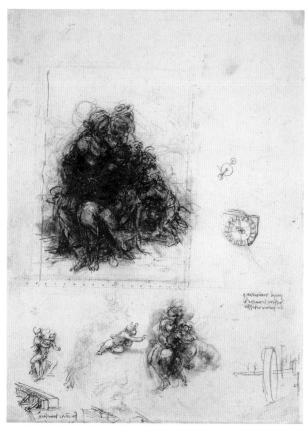

Plate 1.22   Leonardo da Vinci, study for *Virgin and Child with Saint Anne, Saint John the Baptist and Christ*, c.1500–16, pen and ink and grey wash with some white heightening over black chalk on paper, 27 × 20 cm, British Museum, London. Photo: © The Trustees of the British Museum.[59]

Leonardo took to matter for the devout message of the altarpiece. Leonardo had assistants and apprentices, and common graphic documents of this sort could allow different artists' contributions to be coordinated as well as versions to be executed for several clients. However, this cartoon has not been pricked through. Nor are there stylus indentations for transfer. As so often with drawings, we are left debating the history of this cartoon, which was valued sufficiently to be preserved.[60]

As well as researching compositions, Leonardo carried on building up picture libraries of observational studies of the sort he had made when young (Plates 1.17 and 1.19). However, Leonardo also set out to analyse and theorise the visual world and its underlying structures, using drawings to demonstrate rules for himself and other painters (see Chapter 7). He planned treatises on the proportions of horses and humans and on the movement of animals as well as on painting as a whole. This theoretical bent is evident in a

drawing which shows ways of representing Saint George and the Dragon from various viewpoints and a cat in a fighting position (Plate 1.24). At first sight it looks as if it is a file of compositions for representing combat comparable to Pisanello's dog file (Plate 1.7). Perhaps it does collect ways of representing fights. However, the inscription implies that the drawings also demonstrate the proposition that:

> serpentine postures comprise the principal action in the movements of animals and this action is double: the first is along the length and the second across the breadth.[61]

The study may be part of his enquiry into animal movement. From the 1490s onwards Leonardo undertook anatomical research to deliver a systematic study without precedent or parallel (Plate 1.25). In this drawing, for example, he compares the structure of humans and dogs. He uses red chalk on paper painted red: a new medium which he pioneered. Leonardo also developed theories on correct figural proportions; in another drawing he sought to demonstrate modular relationships between standing, seated and kneeling figures (Plate 1.26). This drawing is inscribed: 'In kneeling down a man will lose the fourth part of his height. When a man is kneeling down with his hands folded on his breast, the navel will mark half of his height and, likewise, the points of his elbows.'[62] Plans for the treatises were arguably extensions of his role as workshop teacher.

The Leonardo corpus presents evidence of innovations in media associated with his and his teacher's workshop which seem to be related to interest in new design emphases: in representing drapery as if in three-dimensional relief and in conveying the movements of the human body. There is also new emphasis on applying and investigating theories of perspective, anatomy and proportion. However, there is continuity of interest in observation studies and workshop short cuts. For we should note that even as drawing small rocks was being abandoned for 'field studies', new studio substitutes for the real thing were being produced in the draped clay models. The challenge of making ever more illusionistic images was met in part by taking a fresh look at the particularities of the visual world. However, it was also met by seeking new generalisations about that world – ultimately new conventions – to guide himself and others in producing expressive and convincing compositions.

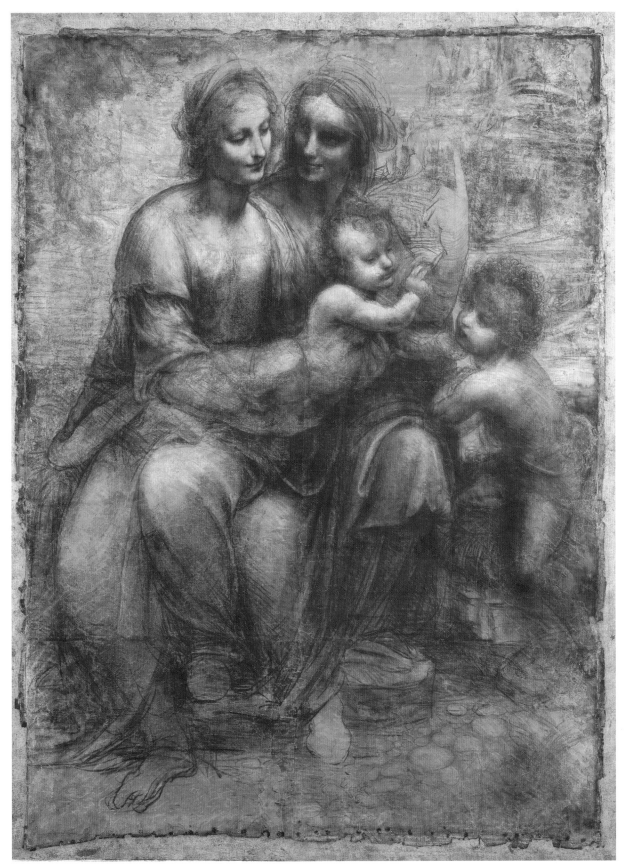

Plate 1.23    Leonardo da Vinci, *Virgin and Child with Saint Anne, Saint John the Baptist and Christ, c.*1500–16, charcoal on brown paper heightened with white paint, 142 × 105 cm, National Gallery, London. Photo: © The National Gallery, London.

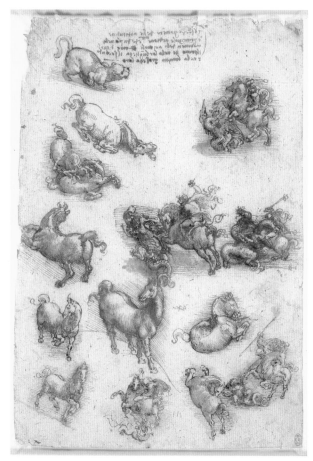

Plate 1.24    Leonardo da Vinci, seven horses in different poses, five views of Saint George and Dragon, two horses fighting and a snarling cat, 1513–17 or earlier, pen and ink with touches of wash over traces of black chalk, 30 × 21 cm, The Royal Collection. Photo: © 2004 Her Majesty Queen Elizabeth II.

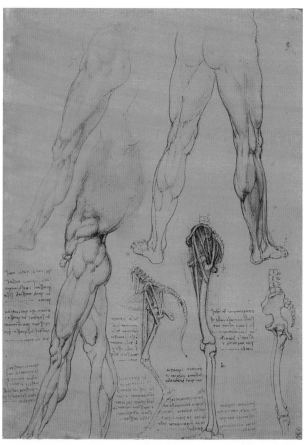

Plate 1.25    Leonardo da Vinci, studies of a comparison of the legs of a man and a dog, c.1504, pen and ink over red chalk on red washed paper, 29 × 21 cm, The Royal Collection. Photo: © 2004 Her Majesty Queen Elizabeth II.

Plate 1.26    Leonardo da Vinci, studies of the relationship between the proportions of standing, seated and kneeling figures, c.1490, pen and ink on paper, 16 x 21 cm, The Royal Collection. Photo: © 2004 Her Majesty Queen Elizabeth II.

## Albrecht Dürer

Albrecht Dürer of Nuremberg (1471–1528) was nearly a generation younger than Leonardo though he died only a decade after him. The fact that he was trained in Nuremberg and worked there for most of his career, was a prolific draughtsman and wrote about his practice means that his works provide a useful comparison with which to end this enquiry. As with Pisanello and Leonardo, a large corpus of drawings by Dürer and his workshop survive – numbering around 2,000. They are distinctive in a variety of ways. In common with Leonardo, the evidence of his use of drawing as a young learner is relatively rich. However, it highlights his distinctive interest in self-portraiture to practise skills in representing feelings and poses, and provides evidence of a new source for the learner in copying engravings. Drawings associated with a number of projects show something of his working routines, from sketches to detailed full-size drawings for transferring ideas onto a panel. There is also evidence of his employment of drawings to practise his skills in representation, to build his visual library, and (like Leonardo) to research and present theories about proportion and perspective for teaching purposes (though not to pursue the anatomical studies for which Leonardo is so famous). In addition, Walter Strauss drew attention to the way he began to sell drawings as art works in their own right in the early sixteenth century. Dürer left his drawings to his widow Agnes and his brother Endres, and their heirs eventually sold many of them to a collector, Willibald Imhoff, the grandson of Dürer's scholarly friend Willibald Pirckheimer (1470–1530).[63]

Dürer was regarded as the outstanding painter of his day: hailed by a scholar from Nuremberg, Conrad Celtis, about 1500 as 'the most famous painter in German lands'.[64] Another native scholar, Joachim Camerarius,[65] treated him as an artistic leader: 'All these perfections he attained by reducing mere practice to art and method, in a way new at least to German painters.'[66] Like so many artists, Dürer was initially trained by his father, who was a goldsmith. Because of his interest in painting, he was apprenticed for three years at the age of 16 to a local painter and engraver, Michael Wolgemut (c.1434/7–1519). In 1490, at 19, he was sent by his father to travel and learn from various masters. At this point he visited the heirs of the painter-engraver Martin Schongauer in Colmar.

In 1494 he returned to be married and set up as an independent master with his own assistants, and in that year he travelled to Venice. Dürer developed a successful career as an engraver and painter, basing himself in Nuremberg apart from short periods in Venice and the Netherlands. He achieved recognition as a painter in Venice when in 1506 he was offered a civic post, and when in 1515 he was made court painter by the Holy Roman Emperor Maximilian I (ruled 1493–1519). In his successful pursuit of retaining this post from Charles V (ruled 1519–58), Dürer visited the Netherlands in 1520–1. He died in 1528.

A drawing he made under the supervision of his father indicates the skills he was practising at the age of 12 (Plate 1.27). This is the earliest surviving self-portrait by a young artist in the western European tradition. As well as marking an interest in presenting an individual persona, using oneself as the sitter could be easier than finding a model. A decade later in 1494, he dated a drawing which traced the outlines of an engraving by the Mantuan painter and engraver Andrea Mantegna. He copied the rest freehand. In this way he could learn about the latest mythological subject matter and Italianate styles of representing the nude (Plate 1.28). The fact that engravings could now make available exemplars previously confined, as drawings, to an artist's workshop marks an important shift (see Plate 6.21 for a similar exemplar). The strategy was also adopted by Italian apprentices. Michelangelo's approved biographer, Ascanio Condivi, reported in 1553 that the young Michelangelo, instructed by his then master Ghirlandaio, had copied an engraving by Martin Schongauer of the *Temptation of Saint Antony*.[67]

Like other painters, Dürer employed drawings for the development of specific commissions, but because he was a printmaker he also made research drawings for engravings and woodcuts. For example, he used pen and ink for initial explorations of the setting for a narrative of the *Birth of the Virgin* about 1503 – sometimes termed a 'project drawing' (Plate 1.29). He began with a single-point perspectival diagram and suggestions for the furnishings of an interior.[68] Then he indicated the figures which would fit onto the 'staging' and blocked out the shading. At the same time, he was thinking about the formal symmetries in the design; the shape of the bold swathe of bed curtaining to the right has been continued via the fall and the pleating imagined

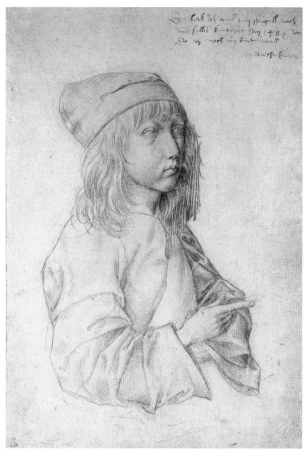

Plate 1.27    Albrecht Dürer, *Self-Portrait* (inscribed 'Here I portrayed myself in the year 1484 in a mirror when I was still a child Albrecht Dürer'), 1484, silverpoint on a cream ground paper, 28 × 20 cm, Albertina, Vienna.

for the rumpled bedcover on the right, and these join to the shapes of the women bathing the baby to make a 'U' shape – perhaps a latent cradling form, echoed above in the hooked-up bed curtain itself. The bits of 'business' are quite important (see the woman drinking water to the right), but the drawing concentrated on trying out broad decisions of staging and lighting. However, no completed composition has been identified following this sketch.

For a number of altarpieces Dürer employed studies of the hands and faces of the main figures. These were of the size to be shown in the panel itself and so may have functioned in ways similar to cartoons. The examples made in Venice for *The Madonna of the Rose Garlands* (1506), for instance, originally belonged to one drawing book of blue paper. The altarpiece was for San Bartolomeo, the national church of German merchants in Venice, and is assumed to have been connected with their two confraternities based at the church, since Dürer reported that it was commissioned by the 'Germans'.[69] In one of the drawings Dürer portrayed a man kneeling in devotion to the Madonna holding his rosary (Plate 1.30). He used black and grey paint with white highlights on blue paper so as to provide a subtle range of tone to suggest modelling. Although it is unlikely that he had assistants in Venice, he did report using them

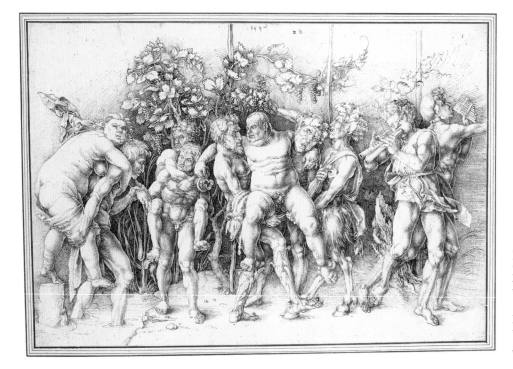

Plate 1.28    Albrecht Dürer, after Andrea Mantegna, *Bacchanal with Silenus*, 1494, pen and brown ink on white paper, 29 × 38 cm, Albertina, Vienna.

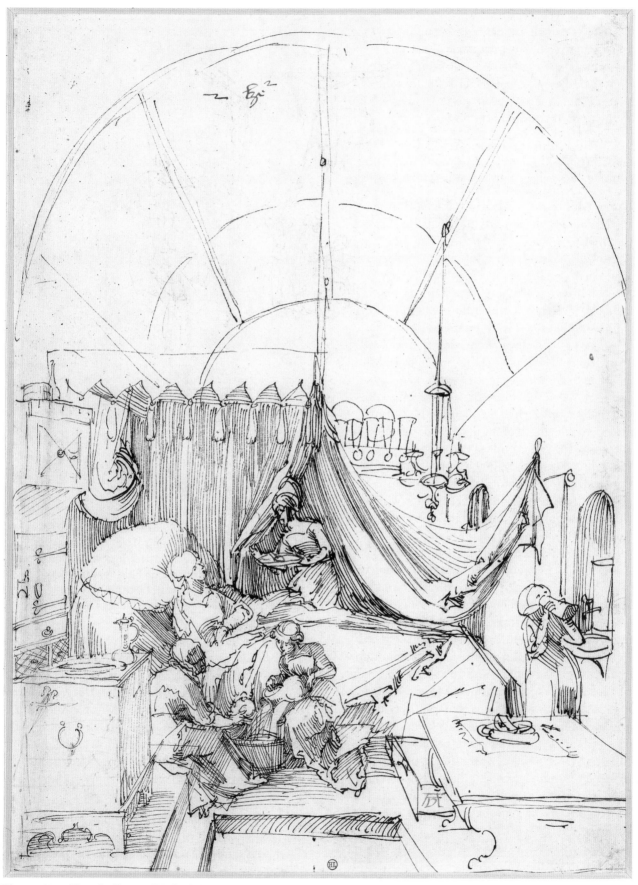

Plate 1.29   Albrecht Dürer, *Birth of the Virgin*, *c.*1503, pen and black ink on paper, 29 × 21 cm, Kupferstichkabinett, Staatliche Museen, Berlin, KdZ 7 recto. © 2007 bpk/Kupferstichkabinett, Staatliche Museen zu Berlin/Jörg P. Anders.

for other altarpieces painted in Nuremberg, and this type of drawing could have been handed to assistants to complete particular areas. In a letter concerning his progress on an altarpiece for the Heller family in Nuremberg in 1508, for example, he protested that assistants would only be working on the underdrawings of the wings:

> I will be sure carefully to paint the middle panel with my own hand. The outer wings of the altarpiece are already sketched in – they will be in stone colour.[70]

Throughout his career Dürer pursued a course of 'professional development', gathering a gallery of visual ideas. Studies representing difficult subjects – fur, reflections on water, different atmospheric conditions – might be especially worth storing. A brush drawing of a hare demonstrates his virtuosity. The usual conventions whereby outlines define the shape of a body, and shading (made of groups of lines) denotes the side of an object away from a light source, have had to be radically modified to describe a creature covered in light- and dark-toned fur, each strand of which could be rendered with a line. Lines map the varying direction and length of fur and whiskers, and white patches of fur appear under the belly or inside the ears – areas which 'should be' dark (Plate 1.31). Camerarius told the story of how Giovanni Bellini admired the 'fineness and delicacy' with which Dürer drew hair with a brush.[71] Dürer did not use this study in a composition, although the back view of a hare does appear in an engraving of Adam and Eve. Twelve copies of this drawing by other sixteenth-century artists survive, some of which were used in their paintings. The inclusion of watercolour 'paintings' of Dürer landscapes in drawings departments such as that of the British Museum demonstrates that one of the definitions of a 'drawing' is that of being a research document. In a series of landscape studies Dürer collected information on ways of depicting weather, lighting and such subtle effects as the reflections of a house on an island at sunset or sunrise (Plate 1.32). Although never used in a painting, it appears in summary form in a woodcut. Like Pisanello and Leonardo, Dürer sometimes collected different ways of presenting some object or person on one page (Plates 1.7, 1.24 and 1.33). Dürer was generous with the 'Saint Christopher file', as he recorded in his diary in Antwerp on 19 May 1521:

> For Master Joachim I have drawn four small Saint Christophers on gray paper.[72]

Plate 1.30   Albrecht Dürer, portrait study for *The Madonna of the Rose Garlands*, 1506, brush and black ink, grey wash, heightened with white bodycolour, with accents in pen and dark ink on blue Venetian paper, 32 × 20 cm, Pierpont Morgan Library, New York, I, 157c. Photo: © 2004 Pierpont Morgan Library/Art Resource/ Scala, Florence.

The present seems to have been a tribute for the assistance of the landscape painter Joachim Patinir (active 1515–*c*.1524) during Dürer's visit to Antwerp. He also collected views of towns, rare animals, art works of what he thought 'subtle talent' from America, plants, studies of the nude, interesting faces and clothing: indeed anything which might make intriguing designs in the future.

Like Leonardo, Dürer had a theoretical bent and used drawings to demonstrate rules of linear perspective and to research canons of proportion for the human figure as well as to present those findings in printed form. He had been much impressed by the proportional theories which had been shown, but not fully explained, to him by

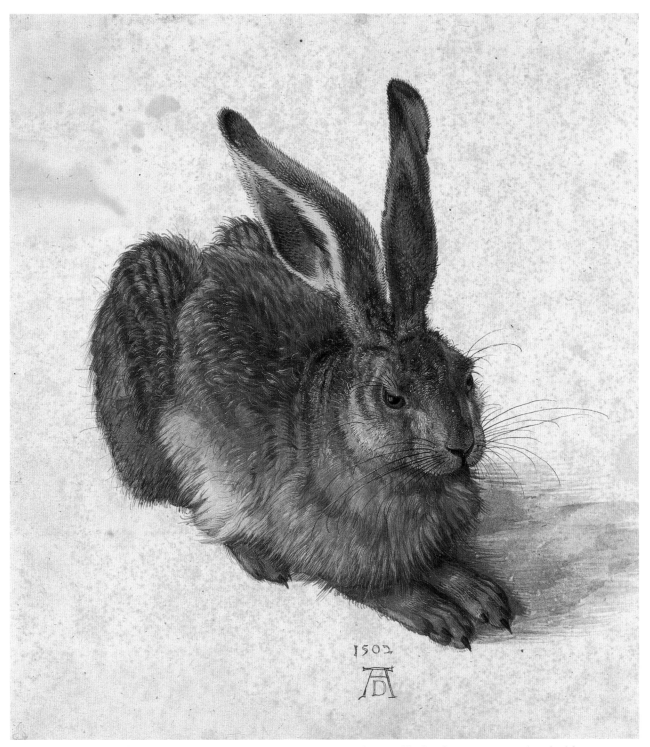

Plate 1.31 Albrecht Dürer, *A Hare*, 1502, black and brown watercolour and bodycolour on paper painted with cream wash, 25 × 22 cm, Albertina, Vienna.

the Venetian artist Jacopo de' Barbari (*c.*1460/80 – before July 1516) a little before 1500, and he determined to derive his own theories from raw data. From around 1504 he began measuring a large number of different human bodies in order to derive rules for representing imagined persons convincingly.[73] To secure good proportions for his figure of Adam in the 1504 engraving of *Adam and Eve*, for example, he devised a way of using one side of a sheet of paper to study his figure nude, while the other side mapped correct proportions for the figure using compass and ruler (Plate 1.34). His illustrated treatises, *Underweyssung der Messung* or *Course in the Art of Measurements* (Nuremberg,

Plate 1.32    Albrecht Dürer, *The 'Weierhaus' (Fisherman's House on a Lake)*, c.1496, watercolour on paper, 21 × 22 cm, British Museum, London. Photo: © The Trustees of The British Musuem.

1525) and the *Vier Bücher von menschlicher Proportion* or *Four Books on Human Proportions* (Nuremberg, 1528), were aimed at teaching mature artists, as he wrote in the *Four Books*, 'not being well taught beforehand'.[74] However, understanding of theory needed to be accompanied by study from nature. Like Leonardo and Cennino he valued observation studies, writing in the *Four Books*:

> He therefore, who by right understanding, hath attained a good style hath it ever in his power to make something good, as far as that is possible to us; yet he will do so still better if he study from the life.[75]

Dürer's reliance on drawing suggests that he considered it a key skill for training a young artist. In his notes towards a treatise on painting composed about 1512, however, he made one recommendation as to the way apprentices should first learn:

> He must copy much of the work of great artists until he attain a free hand. What is painting? To paint is to be able to portray upon a flat surface any one – whichever

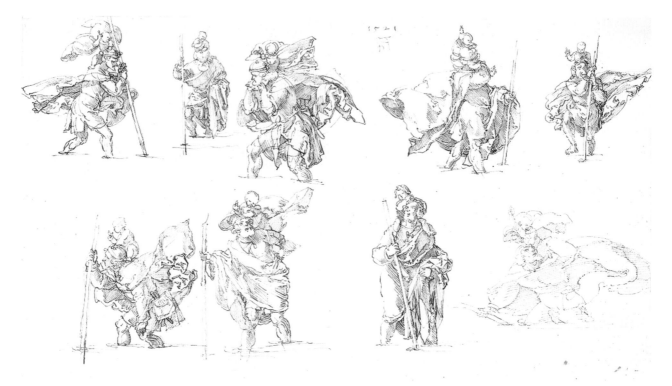

Plate 1.33    Albrecht Dürer, *Nine Ways to Represent Saint Christopher*, 1521, pen and black ink on grey paper, 23 × 41 cm, Kupferstichkabinett, Staatliche Museen, Berlin, KdZ 4477. © 2007 bpk/Kupferstichkabinett, Staatliche Museen zu Berlin/ Jörg P. Anders.

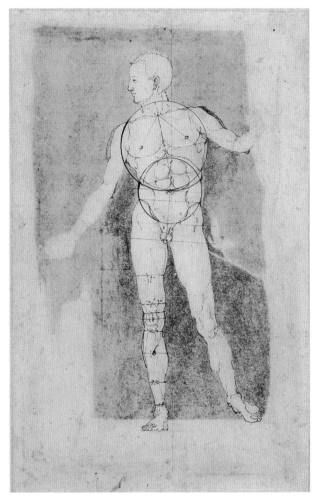

Plate 1.34   Albrecht Dürer, *Adam*, 1504, pen with brown ink on paper, 26 × 17 cm, Albertina, Vienna.

he chooses, of all visible things, howsoever they may be. It is well for anyone first to learn how to divide and reduce to measure the human figure, before learning anything else.[76]

Dürer was quite aware that drawing was used to appropriate others' ideas – as he related in Venice on 6 February 1506 how artists were copying his paintings and engravings:

they copy my work in the churches and wherever they can find it; and then they revile it and say that the style is not antique and so not so good.[77]

Like Leonardo, Dürer used drawings for general research and specific projects. As his Netherlandish diaries relate, he gave drawings to artists for favours granted and used them to pay day-to-day expenses as he drew portraits and sold them to sitters on the spot.[78] Perhaps in token of the importance that drawing had come to hold by the early sixteenth century, Camerarius highlighted Dürer's graphic skill in the pen portrait he wrote for his translation of the *Four Books*:

his hand so closely followed the ideas of his mind that, in a moment, he often dashed upon paper, or as painters say, composed, sketches of every kind of thing with reed or quill pen … Sometimes he would draw separately, not only the different parts of a composition, but even the different parts of bodies, which when joined together agreed with one another so well that nothing could have fitted better. In fact this consummate artist's mind, endowed with all knowledge and understanding of the truth and of the agreement of the parts with one another, governed and guided his hand and bade it trust to itself without any other aids. With like accuracy he held the brush, wherewith he drew the smallest things on canvas or wood without sketching them in beforehand.[79]

## 7   Conclusion

Increasing evidence is available during the fifteenth century concerning the uses of and attitudes to drawings. Media such as red chalk and new forms such as cartoons are recorded for the first time. Artists were drawing after different exemplars in the workshop (clay models, engravings) and they were drawing outside (the landscapes of Leonardo and Dürer). Drawings were being used to conduct research initially on perspective (see Chapter 2) and then in anatomy (as pioneered by Leonardo) and proportion (in, for example, Dürer's exhaustive studies). At the end of the period, drawings were beginning to be collected by patrons and praised by scholars. With the illustrated treatises planned or published, drawing started to play a didactic role as art education nudged into a public sphere beyond the rules taught in a single workshop. Yet while the evidence has sometimes been interpreted as marking progress, I argue that it is best read as registering the pursuit of different, not improved, goals.

# Chapter 2 introduction

'A youth should first learn perspective, then the proportions of things'; so declared Leonardo da Vinci in writings later compiled as a treatise on art, and Francis Ames-Lewis claims that he was doing no more than state what had become standard workshop practice in Italy by the end of the fifteenth century.[1] At the turn of the fifteenth century, Filippo Brunelleschi attained fame as the pioneer in mathematical perspective, something that even antique painters are alleged not to have grasped. Leon Battista Alberti set out the basics of mathematical perspective in his Latin treatise on painting of 1435, translated into Italian for the benefit of artists in 1436. Detailed technical instruction on the principles of perspective was offered by Piero della Francesca in his treatise *On Perspective for Painting*, written before 1474, which Martin Kemp calls a 'sort of geometrical "cook-book" for the dedicated beginner'.[2] For all that Piero's treatise seems to have been little read, by the turn of the sixteenth century there may indeed have been few Italian painters working in the main artistic centres who did not understand the absolute basics of how to construct a painting around a unified perspectival system. In this chapter, Carol Richardson explains the development of mathematical perspective in terms of both theory and practice.

Rightly or wrongly, correct mathematical perspective has now become a touchstone for the making of Italian Renaissance art. In his seminal essay of 1976, 'Light, form and texture in fifteenth-century painting', Ernst Gombrich divided optics into 'the development of central perspective' and 'the reaction of light to various surfaces'. The first he associated with the Italian Renaissance, the second with northern European painters, specifically Netherlandish artists, almost as if 'the two schools of painting appeared thus to have divided the kingdom of appearances between them'.[3] In this chapter, however, Carol Richardson challenges this privileging of mathematical perspective, and shows instead that in the interests of pictorial effect, perspective was something artists could choose to set aside as well as observe. If even the Renaissance paradigm artist Masaccio could modify mathematical perspective in pursuit of visual coherence in his fresco of the *Trinity* (see Plates 2.6 and 2.8), it becomes more difficult to pass negative judgement on the empirically convincing but mathematically imperfect perspectival system in Jan van Eyck's *Arnolfini Portrait* (Plate 2.28). And for all that the perspective of Dieric Bouts's *Last Supper* is mathematically correct, it is visually very odd (Plate 2.33). The floor seems to tip up, and it is in fact less spatially convincing than the mathematically flawed *Arnolfini Portrait*. Only when mathematical perspective is still regarded as a formal requirement of a progressive and intellectually respectable Renaissance work of art do such apparent inconsistencies matter. Carol Richardson argues that perspective should be seen for what it really was: simply one illusionistic pictorial tool among many.

*Kim W. Woods*

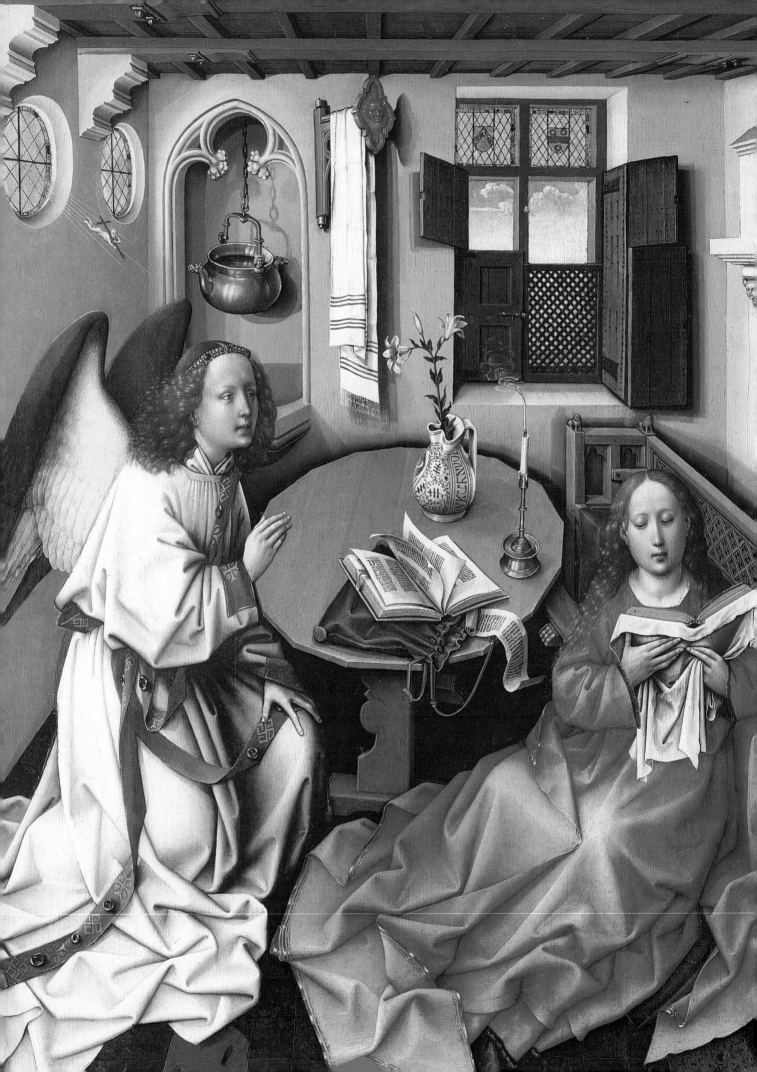

# Chapter 2

# Constructing space in Renaissance painting

*Carol M. Richardson*

Although we don't think of it every time we write about naturalism in visual art, perspective is there at the foundations of our concept. It is the firmest link between paintings and the measurable world known to physics, and therefore, even if that link is not usually evoked in any grand detail, perspective plays a central role in art historical writing that involves versions of naturalism.[1]

Single-point perspective has acquired almost mythic status for historians as a yardstick for the sophistication of art produced in the first half of the fifteenth century. It was a particularly effective tool for constructing convincing spatial settings and relationships between figures and objects in art works, creating often striking effects. However, in what follows I will suggest that it has been overprivileged by historians dealing with Renaissance art and that artists from other artistic traditions had different priorities and preoccupations.

Until recently, as James Elkins put it, finding single-point perspective in paintings was the closest art historians could get to 'solving' pictures; by 'making a map or blueprint' of a picture, it could be defined at least according to the rules of geometry, even if its meaning or cultural significance seemed more illusive.[2] As a measure of the success of painting in the fifteenth century, single-point perspective prompted Erwin Panofsky and Millard Meiss to go to considerable lengths to demonstrate links between artists working north of the Alps and Italian artists who invented the technique, because otherwise the northern artists would seem backwards in comparison to their Italian counterparts.[3] These links now distract from the particular merits of Netherlandish painting.

In his essay published in 1927, 'Perspective as symbolic form', Panofsky raised the stakes still further, declaring that 'the history of perspective may be understood with equal right as a triumph of the feeling for reality, making for distance and objectivity, and as a triumph of the human struggle for power, denying distance'.[4] He went on to construct grandiloquent ideas of space as an abstract concept which could express 'cultural ideas' and, as a result, gave it a position of importance above what seems to have been its actual significance in the fifteenth century.[5] But, fortunately, Panofsky's 'symbolic form' represents the summit of perspective's complexity. Ernst Gombrich helped reclaim perspective from grand narratives of cultural progress by defining it as 'precisely what it claims to be, a method of representing a building or any scene as it would be seen from a particular vantage point'.[6] No more and no less.

But single-point perspective was an important development for artists in the fifteenth century because it presented the possibility of capturing an illusion of reality through measurement to make their pictures more effective. The thirteenth-century Franciscan philosopher and mathematician Roger Bacon, who was an influential figure in the fifteenth century, put it thus: artists should know geometry so that they might 'make literal the spiritual sense'. Instead of shaky and unconvincing spaces that looked like 'the unstable tabernacle

Plate 2.1   (Facing page) Circle of Robert Campin/Master of Flémalle and assistants, Mérode altarpiece, central panel (detail from Plate 2.26).

swaying to and fro … we should enter the firm temple built by the wisdom of Solomon', instructed Bacon.[7]

The problem is now one of establishing boundaries – where to start and when to stop looking for geometrical solutions to paintings. Recent studies, with their more cultural and historical slant, have moved on to consider the circumstances of the discovery and development of the technique. But the controversy continues. Art historians such as Samuel Edgerton and Martin Kemp have attempted to establish once and for all how single-point perspective was discovered and developed by combining the study of science and art.[8] Since the 1990s, in part due to the studies of James Elkins, single-point perspective has taken a more reasonable place as one technical and intellectual innovation available to fifteenth-century artists.

In this chapter I want to ask just how significant single-point perspective was in the fifteenth century by first looking at its 'invention' and then considering how artists actually used it. But before I move on, it is worth pausing to consider how artists could construct a convincing sense of spatial relationships in their paintings *without* single-point perspective.

## 1 Depicting spatial relationships without single-point perspective

Depicting the convincing three-dimensional relationship of one object or figure to another in space on a two-dimensional surface is arguably the single most important element in paintings and relief sculptures in the fifteenth century. Artists before the fifteenth century knew very well how to represent buildings or objects in pictures in ways that made them look lifelike and to create convincing spatial settings for their figures. Their observations were based not on treatises or abstract theories but on the empirical observation that lines in a picture which are horizontal or vertical in relation to the viewer are always just that – horizontal or vertical. However, lines parallel with one another that recede from the viewer into the distance (orthogonals) look as though they might converge on a single point, like train tracks running towards the horizon – or, as Leonardo da Vinci put it, like two horses 'running towards their goal along parallel tracks'.[9] Cennino Cennini, in his *Il libro dell'arte* or *The Craftsman's Handbook* (c.1390),

told artists that when they painted buildings they should use 'this uniform system', so that

> the mouldings which you make at the top of the building should slant downward from the edge next to the roof; the moulding in the middle of the buildings, halfway up the face, must be quite level and even; the moulding at the base of the building underneath must slant upward, in the opposite sense to the upper moulding, which slants downward.[10]

Artists such as Pietro and Ambrogio Lorenzetti (active 1306–45 and 1317–48) and Giotto (c.1270–1337) certainly knew this trick and used it to help create convincing architectural settings for their narratives. However, it is important to stress that artists were not trying to recreate an abstract sense of space so much as buildings, objects and figures in realistic-looking relationships with one another.

By the fifteenth century there were various ways of representing realistic relationships between objects and figures in space in a picture or, to put it another way, of representing three-dimensional objects on the two-dimensional surface of a picture. Landscapes pose particular problems because of the lack of orthogonals. Consider, for example, Andrea Mantegna's *The Agony in the Garden* (c.1460, Plate 2.2). Behind the three sleeping Apostles in the foreground, Christ, raised on a mound, kneels before a group of five angels who bring him the instruments of his impending Passion. On the right-hand side in the middle distance, Judas leads a band of soldiers to arrest Christ and begin the series of events that will lead to his crucifixion. Mantegna (c.1431–1506) used several different devices to create an outdoor setting for his narrative apart from single-point perspective, even though he was working some 50 years after its 'discovery' in Florence.

Mantegna depicts his scene in a landscape where there are no straight lines receding into the depth of the picture plane – a sure sign that the composition does not rely on single-point perspective. Instead the pictorial space is divided into the three planes: foreground (occupied by Christ and the Apostles), middle ground in which Judas leads the soldiers from the city, and a background of blue hills in the distance. A consistent light source, from the top left, models the landscape in light and shade (lighter and darker paint) and models the figures in a consistent and logical and therefore convincing fashion. The road that winds from the left foreground, behind Christ's

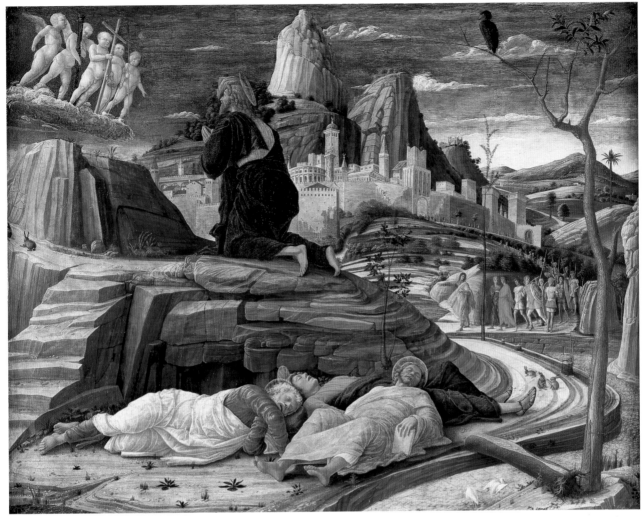

Plate 2.2   Andrea Mantegna, *The Agony in the Garden*, c.1460, egg tempera (with oil?) on panel, 63 × 80 cm, National Gallery, London. Photo: © The National Gallery, London.

mound, connects the three planes with one another. Although the three planes are not linked and the road does not actually join up in the picture, we assume it must be the same road because it looks like it is part of the same landscape.

Recession is also constructed by depicting figures and objects in relation to, or proportional with, one another in terms of scale. Thus the figures which are meant to look closest to us – Christ and the Apostles and the tree on the right-hand side – are much bigger than the figures and the trees further back in the landscape. The figures in the middle distance who are meant to look further away are painted smaller than those in the foreground. So, although the figure of Judas is as tall as the city walls in the painting, we make the logical leap and assume not that this is an unusually small town but that he must be in front of and below the walls. Clearly, then, single-point perspective was not the only way that artists could create an illusion of space in their works.

I want now to explain what single-point perspective was and describe its development in Italian sculpture and painting in the first half of the fifteenth century – the possibilities it afforded as well as the limitations of the system – before going on to consider its significance north of the Alps and specifically its adoption by artists in the Netherlands.

## 2   Brunelleschi's experiment and its impact

According to a letter of 1413, 'an ingenious man called Filippo Brunelleschi' was already well known in Florence as a surveyor and skilled in the science of optics.[11] Brunelleschi's biographer, Antonio Manetti (1423–97), declared that he 'propounded and realized what painters today call perspective [and] originated the rule that is essential to whatever has been accomplished since his time in

that area'.[12] That it was Brunelleschi (1377–1446) who 'propounded and realized' perspective is not surprising because, as the son of a successful Florentine notary, he had received a higher level of education than artists would normally expect. He then trained as a goldsmith, entered the Florentine guild that included metalworkers, the Arte della Seta, in 1404, visited Rome to study and survey the ancient ruins, and went on to a successful career as an architect. By the time Manetti wrote his biography in the 1480s, a theoretical understanding of single-point perspective had become an important part of artistic practice. The concept also attracted contributions from some of

the period's most important theorists, including Lorenzo Ghiberti, Piero della Francesca and Leonardo da Vinci.

Manetti describes Brunelleschi's experiments which produced two accurate perspectival paintings, one of the baptistery and one of the Piazza della Signoria, both important Florentine landmarks.[13] For his first demonstration Manetti tells us that Brunelleschi, standing about three braccia (180 cm) inside the main door of the cathedral, painted the view of the baptistery before him on a panel about half a braccio square (29 cm) (Plate 2.3). He did not fill in the sky, instead coating

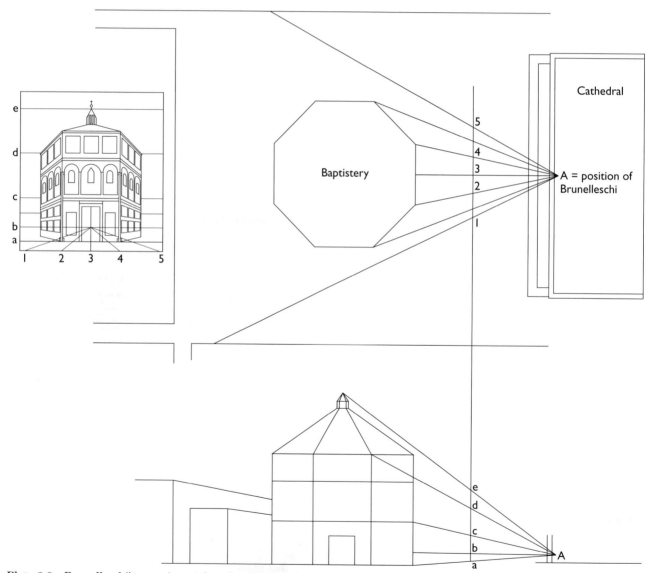

Plate 2.3   Brunelleschi's experiment (based on Krautheimer, 1970, vol.1, Diagram 4). The diagram shows the position (A) from where Brunelleschi took his measurements based on surveying techniques (represented by a–e and 1–5) before using them to make a measured representation of the baptistery on the panel (top left). Eye level equates to 'b', which establishes the horizon line. The point at the intersection of '3' and 'b' is the point of convergence of the lines extended from Brunelleschi's measurements (later the 'centric' or 'vanishing' point) and the position of the small hole through which the viewer looked at Brunelleschi's painting in a mirror.

the area with polished silver to reflect the actual sky. A small hole was drilled in the middle of the panel at a point coinciding with the horizon. To view the painting, one had to look through the hole from the back of the panel at the baptistery. A mirror was then raised and lowered so that the accuracy of the scene Brunelleschi had painted could be tested, and 'so that the spectator felt that he saw the actual scene when he looked at the painting'.[14]

The effectiveness of Brunelleschi's experiment depended on manipulating the viewer, who had to stand on a particular spot just inside the main door of the cathedral and look, with one eye closed, through a small hole. What this did was reduce the viewer's gaze to monocular rather than binocular vision, which made the two-dimensional panel seem all the more convincing. A similar experiment was repeated of a view of the town hall of Florence and its square, the Piazza della Signoria, from the Via dei Calzaiuoli.[15] No hole was drilled in this panel, however, because the view of the square was so much wider and therefore impossible to take in in one glance with one eye.[16] A drawing of 1619 by Jacques Callot gives some idea of Brunelleschi's view (Plate 2.4).

Plate 2.4   Jacques Callot, *Piazza della Signoria, c.*1619, Hessisches Landesmuseum, Darmstadt.

What was Brunelleschi trying to demonstrate? The important point to make here is that he was working as an architect, not a painter. Brunelleschi did not make his painting of the baptistery by standing outside and painting what he saw in front of the cathedral: artists in the fifteenth century never painted out of doors. Instead, he would have made accurate measurements of the buildings and the square in which the baptistery stands and then plotted them on a scaled grid, using mathematics

and surveying techniques well known in Tuscany since the thirteenth century, taken them back to his workshop and produced his painting.[17] From this he would have worked out an elevation (vertical cross-section) plotted on the measured grid or plan. The accuracy of the image produced on the panel from the ground plan and section could then be checked through the intersection of all the lines on a single point – something not altogether clear from the experiment because the visible walls of the octagonal baptistery are not perpendicular to the picture plane, unlike those of the buildings to its side. The point of convergence, later called the 'centric point' or 'vanishing point', coincided with the eyehole made in the panel – and for good reason, because the vanishing point also corresponds with the eye level and focal point of the viewer. This sounds complicated but it is not. The problem comes when the experiment, which records visual phenomena, is put into words; like anything to do with single-point perspective, it is much better explained by diagrammatic means. Indeed, some later printed treatises on the subject consisted only of diagrams.[18]

But how could Brunelleschi's experiment help practising artists who were concerned less with portraying recognisable urban scenery, as Brunelleschi had done, than with the construction of an illusion of three-dimensional space on a two-dimensional panel? We do not know for sure when Brunelleschi painted his panels, though a date around 1425 holds common currency, but his ideas seem to have been quite slow to catch on. It was not until the late 1430s that it was a regular feature of Florentine painting, after Alberti had written about it, as we shall see in the next section. Brunelleschi himself did not write about or broadcast his discoveries because, as one contemporary source suggests, he thought that new discoveries should be kept quiet and is reported to have said: 'Do not share your inventions with many. Share them only with the few who understand and love the sciences. To describe too much of one's inventions and achievements is one and the same thing as to debase your talent.'[19]

Two of the first artists to 'understand and love' Brunelleschi's ideas were the sculptor Donatello (*c.*1386–1466) and the painter Masaccio (1401–*c.*1428). As early as *c.*1415–17 Donatello included a hint of concurrent innovation in the marble relief he made for the niche of the Arte dei

Plate 2.5   Donatello, *Saint George and the Dragon*, c.1415–17, marble, 39 × 120 cm, Orsanmichele, Florence. Used with the permission of the Ministero Beni e Attività Culturali. Photo: © 1990 Scala, Florence.

Corazzi e Spadai (armourers and sword-makers) at Orsanmichele, the guildhall of Florence, to accompany his statue of Saint George (Plate 2.5; see also Plate 3.9).[20] It depicts, in the shallowest possible carving, or *relievo schiacciato* (squashed relief), a knight impaling a dragon watched by a maiden. The scene takes place in a landscape, with a cave on one side and an arcade on the other. Logically, the arcade seems out of place for a dragon-slaying episode but it is an important addition: the orthogonal lines at the top and bottom of the arcade converge on a single point behind Saint George. No element from a landscape setting would have allowed Donatello to communicate the depth of an expansive landscape in such shallow relief as the perspectively foreshortened arcade has done. Compositionally, the perspective also highlights the main action, the diagonals of the arcade acting like an arrow to point at the key protagonists.

Although Donatello uses single-point perspective to add an unprecedented sense of space to his relief, Masaccio in his fresco of the *Trinity* in Santa Maria Novella, Florence, probably painted around 1426–7, takes it much further and is therefore considered the first expression of the full potential of Brunelleschi's scheme (Plate 2.6). Although Vasari refers to the *Trinity* in his life of Masaccio as 'over the altar of S. Ignazio', it most likely started its life as a funerary monument to Berto di Bartolomeo di Berto and his family, the Berti.[21] In the 1560s Vasari was responsible for the modernisation of Santa Maria Novella and for having the fresco detached from the wall and moved near the door of the church, where it was not rediscovered until the nineteenth century. In 1950–1 the remains of the skeleton, inscription and painted altar were found below the original location of the fresco and

its parts brought back together. The inscription above the skeleton sends a direct message about the fresco's original purpose: 'I once was what you are now, and what I am, you too will be.'[22]

The subject of the *Trinity* is a fairly standard one in western iconography – the 'Throne of Mercy' or 'Mercy Seat' in which God the Father displays his Son on the Cross to inspire the faithful to seek forgiveness.[23] Mary and Saint John the Evangelist add power to the vision by pointing to and meditating on its significance. The two donor figures, Berto di Bartolomeo and his wife Sandra, kneel on a step that separates them from the heavenly apparition at the base of the Corinthian pilasters that define its edge. We know that Berto di Bartolomeo, a mason or builder, was not particularly wealthy by Florentine standards; although no documents survive, a fresco painting like the *Trinity* would not have been a terribly expensive commission. It certainly would not have cost as much as an altarpiece on panel with a wooden or a marble frame. The fresco painting itself took Masaccio only 27 or 28 days (a fact we can work out from the sections into which the surface is divided, each representing a day's work, called *giornate*), although such material concerns should not distract from the significant artistic achievement Masaccio's *Trinity* represents.

Berto di Bartolomeo may well have known Brunelleschi as both were attached to the building trade.[24] Indeed, the architecture depicted in the fresco has been compared to Brunelleschi's own designs of the time, although it uses pink stone where he would have used the grey Florentine *pietra serena*. In fact, the *Trinity* seems to defer to Brunelleschi's achievements. Not only does Masaccio's *Trinity* rely on Brunelleschi's

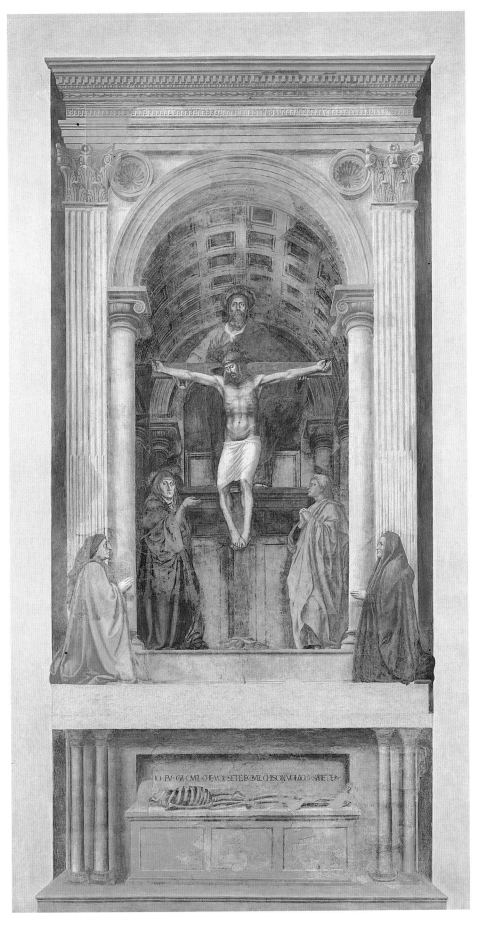

Plate 2.6   Masaccio, *Trinity*,
*c.*1426, fresco, 667 × 317 cm,
Santa Maria Novella, Florence.
Photo: © 2002 Scala, Florence.

experiments in depicting three-dimensional space in two dimensions, but it even seems to refer to one of his sculptures, the *Christ Crucified* in the same church, dated around 1413 (Plate 2.7). Both, in turn, rely on Vitruvius' proportions of the ideal man, later made famous by Leonardo's drawing of a man, arms outstretched, inside a square and a circle.[25] The height of the man is the diameter of a circle, while his arms outstretched establish the side of a square which fits inside the same circle (see Plates 4.2 and 4.3). This was an important fifteenth-century paradigm: Alberti, for example, writes in his treatise, *On Painting* (1435), and elsewhere that 'man is the scale and measure of all things'.[26]

But it is the barrel vault of Masaccio's *Trinity* that has attracted most attention from scholars for the sophisticated reconstruction of the illusionistic space. The orthogonals of the barrel vault provide plenty of lines perpendicular to the picture plane to find the centric (vanishing) point: low down in the picture, at the foot of the Cross in the middle of the step on which the donors kneel (Plate 2.8). This centric point also marks the eye level of the viewer (just like the hole in Brunelleschi's painting of the baptistery). But it would be wrong to assume that Masaccio painted a picture that was controlled exclusively by the geometrical system he used: single-point perspective served his requirements as an artist, not the other way round. To establish the perspectival grid, a nail would have been hammered into the wall at the point where all the orthogonals were to converge (V on Plate 2.8), and a string tied to it that was long enough to reach the top of the area to be painted. Masaccio seems to have tied a large knot in his string when he attached it to the nail so the 'point' of convergence of the lines is as large as this original knot. The string would have been stretched out from the nail and 'snapped' into the wet plaster to make incised lines to establish the orthogonals for the architectural elements like the vault.[27] But despite the presence of carefully incised lines on the surface of the fresco, the dimensions of the coffers lower down in the vault have in fact been exaggerated to make them *look* right. As a result, the ribs of the vault deliberately point down to Christ's hands and link them to the capitals of the Ionic columns, thus holding the composition of the image firmly together.

There have been several attempts to reconstruct the space of the *Trinity* as a ground plan, assuming

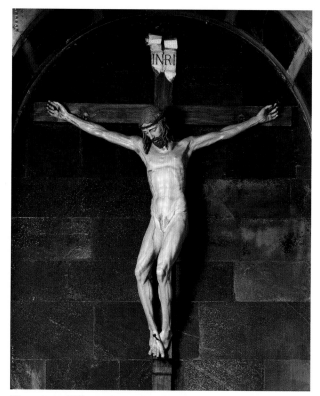

Plate 2.7    Filippo Brunelleschi, *Christ Crucified*, 1412–13, polychrome wood, Santa Maria Novella, Florence. Photo: © 1990 Scala, Florence.

that Masaccio used Brunelleschi's method and would have started with a plan.[28] This has proved an interesting exercise but one which usually has to smooth over the 'inconsistencies' in Masaccio's method. Assuming the space behind the figures is based on a square ground plan, Masaccio probably then raised his architectural elevation from this, very like a demonstration drawing of a vault made by Piero della Francesca (*c.*1415–92) for his treatise, *De prospectiva pingendi* or *On Perspective for Painting* (*c.*1474, Plate 2.9). In the lower part of the drawing, the square floor plan is projected perspectively so that the orthogonals are extended to meet on a single point. Then the architectural elevation is measured up from this plan. The centric point can be used as a check for the accuracy of the elevation (and in the drawing some of the orthogonal lines in the upper part of the drawing are extended towards the point).

However Masaccio actually did it, the depiction of a convincing three-dimensional space is not just a geometrical exercise but is also an important part of the meaning of the *Trinity*. The apparition in the western aisle would have been the first thing

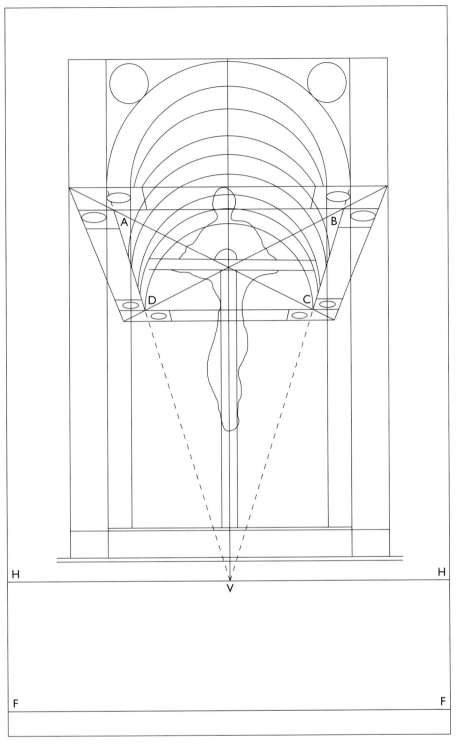

Key:

ABCD: square ground plan of the vault raised to the level of the tops of abacuses (top of the capital)

V: point of convergence of the orthogonals ('vanishing' point)

H: horizon or eye level

F: floor level

Note: the eight ellipses beside the corners of ABCD mark the positions of the columns, but are not drawn to scale

Plate 2.8    Perspective diagram of Masaccio's *Trinity* (based on Kemp, 1990, Figure 19).

Plate 2.9    Piero della Francesca, perspectival construction of a vaulted bay from *De prospectiva pingendi*, *c.*1474, Figure 43, Biblioteca Palatina, Parma. Used with the permission of the Ministero Beni e Attività Culturali.

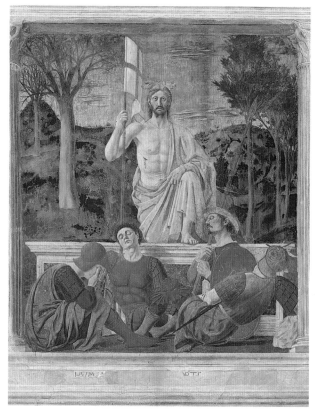

Plate 2.10    Piero della Francesca, *Resurrection of Christ*, *c.*1465, fresco, 225 × 200 cm, Pinacoteca Comunale, Sansepolcro. Used with the permission of the Ministero Beni e Attività Culturali. Photo: © 1990 Scala, Florence.

that visitors to Santa Maria Novella saw as they entered through the eastern side door from the old cemetery that adjoined the flank of the church – a reminder to them of the life after death made possible through Christ's sacrifice.[29] Masaccio uses the perspectival construction to reinforce the conventions of the religious image. In earlier and indeed some later paintings, donors might be depicted smaller than saints to maintain the hierarchy of the divine over humanity. But in the *Trinity* all the figures share the same space so that those further away – even if they are God or Christ – should appear smaller, and those closer to the viewer larger. Instead of a hierarchy of scale, Masaccio introduces a hierarchy of levels which ascend from earthly beings – the skeleton and donors – to the saints and up to the Trinity itself. This is reflected in the architecture, which is more richly ornamented the higher up you look.

But while all of the figures are modelled in space – the viewer looks up at the figures so that the underside of Mary's hand is more visible, we look up at John's chin and up at the face of Christ – God evades the pictorial space and is presented fully frontal and parallel with the picture plane. This is no earthly being, unlike the other figures in the fresco, and so he cannot inhabit the same space. Only by having such a controlled space can God be depicted as transcending that space. A similar effect – of both divine and human reality – is achieved in Piero della Francesca's *Resurrection of Christ* of *c.*1465 (Plate 2.10). Whereas the unconscious soldiers are depicted with their heads foreshortened in 'real' space, the resurrected Christ is represented without any foreshortening and, like the sarcophagus[30] from which he rises, fully frontal. As a result of the use of single-point perspective, the messages of the *Trinity* and the *Resurrection* are communicated with a directness unimaginable before Brunelleschi's experiments because they are constructed by taking into consideration the relationship of the viewer with them.

# 3   Alberti teaches perspective

Leon Battista Alberti (1404–72) was the first to write down instructions for artists on how to use single-point perspective. A member of a wealthy – but exiled – Florentine banking family, he attended the University of Bologna to study canon law from 1421 to 1428, where he also seems to have developed an interest in ancient Greek and Roman texts. In 1434 Alberti returned to Florence as a member of the papal court which was based there under Eugenius IV. In Florence he wrote *On Painting*, first of all in Latin in 1435 (*De pictura*), and a year later in an Italian version, *Della pittura*, which he dedicated to Brunelleschi. Although it was not published in printed form until 1540, the pictorial evidence suggests that by the late 1420s painters were already reflecting some of the ideas in the treatise, and it prompted further attention.

Alberti's treatise, and in particular the basis it establishes of single-point perspective in the first of three books, depend on an understanding of the actions of the eye, something that must also have informed Brunelleschi's experiments. Starting with a brief outline of the geometric basics of points, lines and surfaces, Alberti quickly moves on to an extended discussion on 'matters related to the power of vision' and then proportion or measure. For Alberti perspective was a 'mixed science' that combined optics and the action of light with geometry and mathematics.[31] He describes the act of seeing as 'rays stretching between the eye and the surface seen'.[32] What does he mean by this?

Seeing was understood as active, not passive. The eye was not merely a physical channel through which information is collected for the brain to process, as Descartes, who provided the foundations for the modern science of optics, later had it.[33] On the contrary, seeing involved a direct relationship between the viewer and the thing viewed: Michael Psellos (1018–81), the Byzantine philosopher, wrote that 'Man experiences and produces many effects through his eyes.'[34] Alberti's 'rays stretching between the eye and the surface seen' derive from the science of optics rooted in the ancient Greek works of Aristotle, Euclid and Ptolemy, which were transmitted to fourteenth- and early fifteenth-century Italy via Arabic translations, in particular the investigations of Alhazen (Ibn al-Haytham, *c.*965–1040). In two common theories, 'extramission' and 'intromission',

visual rays physically connected the viewer and the thing seen. In extramission seeing happens when light is sent out from the eye to 'capture' objects by means of visual rays. Theophrastus (*c.*371–287 BCE), a pupil of Aristotle (384–322 BCE), questioned this idea so intromission gained more favour. Taking only the idea of the visual cone or pyramid from extramission, Alhazen demonstrated the intromission theory of vision in which objects were understood to send an image of themselves to the eye: as Leonardo put it, 'all things send their semblances to the eye by means of pyramids' or visual rays.[35] The more visual rays sent to the eye by the object, the more precisely it could be seen by the eye, or, as Alberti put it, 'the more rays are employed in seeing, the greater the quantity seen will appear, and the fewer rays, the smaller the quantity'.[36] The further away an object was, the weaker the rays it emitted and so the more dimly it could be seen.

The relationship between the visual pyramid and the perspectival reconstruction of space is the key to Alberti's account. Alberti's achievement was to take these ideas about optics and make them available to artists. Visual rays physically linked the eye of the beholder and things seen, hence the standard means of depicting single-point perspective which has lines sent out from a single point outside the picture – the eye – to the object seen through the window of the picture plane. Alberti conceived the picture plane as a window through which the viewer sees the pictorial space (see Plate 2.11). This is quite different from, for example, Byzantine art. Byzantine icons offer not a window but a door between the viewer and the picture, which can be opened and passed through.[37] The worshipper enters the spiritual space of the saints via the icon, and likewise Christ, Mary, angels and saints share in the act of worship with the living. Thus the church or chapel in which an icon is housed itself becomes 'an earthly heaven, in which the heavenly God dwells and moves'.[38]

Alberti's window serves as a boundary between the viewer and the thing viewed. He goes on to describe how to depict objects by working out where the picture plane cuts the visual pyramid (Plate 2.11). At the start of the second book he provides a shorthand way to do this in the context of composition, which includes the scaling of objects in space. In it he describes another perspectival method that works by artificially inserting a

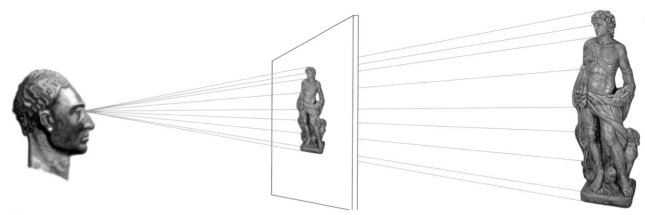

Plate 2.11   Alberti's visual pyramid cut by the picture plane.

picture plane in the visual pyramid: 'A veil loosely woven of fine thread … divided by thicker threads into as many parallel squares as you like, and stretched on a frame' was positioned 'between the eye and the object to be represented, so that the visual pyramid passes through the loose weave of the veil.'[39] Dürer described this technique in a later (1525) engraving in which the artist views his model through a veil (Plate 2.12).

The idea of the picture plane as an intersection in the visual pyramid was an important one, and the vanishing point was not considered the main feature of perspective until the seventeenth century. The closest Alberti gets to the vanishing point per se is what he calls the centric (central) ray, 'the leader and prince of rays' which emerges from the eye and goes straight to the object seen.[40] Together with the extrinsic (outer) rays (which 'hold on like teeth to the whole of the outline')

and median (middle) rays, the visual pyramid is created, with the field of vision (or object seen) as its base and the eye as the point where the diagonals converge in a point.[41] Objects can be depicted in proportion to one another and in relation to the viewer as though the picture plane were inserted into the visual pyramid, cutting it so that 'viewers of a painted surface appear to be looking at a particular intersection of the pyramid'. The painter can work out where the visual rays intersect with that plane and 'by drawing and colouring can express whatever outlines and colours that intersection presents'.[42]

Having described the 'visual pyramid', Alberti goes on to the proportional relationship of objects, providing an 'excellent method' for reconstructing a tiled floor in depth. With orthogonal lines meeting on the centric point (i.e. parallel lines running into the distance meeting on a vanishing point on

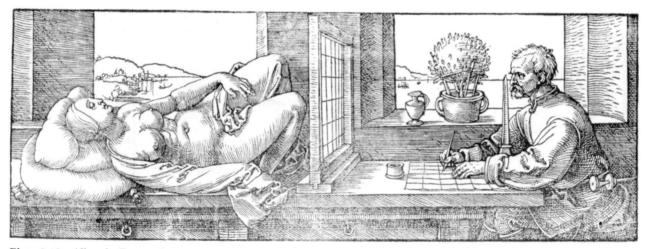

Plate 2.12   Albrecht Dürer, the artist views his model through a veil, from *Underweyssung der Messung, mit dem Zirckel und Richtscheyt, in Linien, ebenen unnd gantzen Corporen* or *Course in the Art of Measurements, with Compasses and Rule, in Lines, Areas and Solids*, Nuremberg), 1525, woodcut, Beinecke Rare Book and Manuscript Library, Yale University, New Haven.

the horizon), the next stage was to work out the 'transverse quantities', or the correct proportions of the tiled floor in recession so that the tiles get smaller the further away from the picture plane they are. He did this by working out in elevation where the visual rays would be cut by the picture plane as they attached themselves to each tile in turn. That the correct divisions were made could then be checked by drawing a diagonal line through the corners of the tiles of the floor; these should, if correct, line up and meet on two points on the horizon, one to each side, which Alberti calls 'distance points'.

Again this is much easier to understand by means of a diagram (Plate 2.13). The explanation of Alberti's method in action is based on Paolo Uccello's predella panel for an altarpiece for the church of Corpus Domini in Urbino, *Miracle of the Desecrated Host (The Selling of the Host)* (c.1465–9). In the painting the original perspectival grid can be reconstructed first by extending the orthogonal lines of the tiled floor into the depth of the picture to meet on a point on the imaginary horizon. Then diagonal lines can be drawn through the corners of the tiles and on to a point, in this case on the right-hand side, to reconstruct the distance point. The same exercise can be carried out for the left-hand side. Once those transverse divisions were established in the correct ratios, objects and figures could be raised from this ground plan in the correct proportion to one another. It is important to stress once more that the aim was not to create an abstract sense of space but accurate proportional relationships between objects. Alberti follows the Aristotelian definition of space as the relationship between objects, because 'no objects in a painting can appear like real objects, unless they stand [next] to each other in a determined relationship'.[43] The fact that, for Alberti, space does not exist without there being objects in it, makes the idea of creating abstract space with orthogonal lines and vanishing point alone less important.

Although *The Selling of the Host* (Plate 2.14) comes from his last known commission, many of Uccello's paintings exhibit a similar interest in single-point perspective – so much so that Vasari described him later, somewhat unfairly, as an artist who 'knew no other delight than to investigate certain difficult, nay, impossible problems of perspective, which, although they were fanciful and beautiful, yet hindered him so greatly in the painting of

figures, that the older he grew the worse he did them'.[44] It is tempting to follow Vasari's judgement because Uccello (c.1397–1475) even managed to include Alberti's pavement in an outdoor scene for his small panel of *Saint George and the Dragon* (c.1470, Plate 2.15). The chequered floor is barely disguised by vegetation in a relatively random but decisively squared arrangement which nevertheless allows just enough information for the centric point to be determined. In this way Uccello got over the problem of using single-point perspective in landscape where there are not normally straight lines, as we saw in the case of Donatello's *Saint George and the Dragon* (Plate 2.5). Perhaps Uccello used the same subject to show Donatello how it might be done, avoiding the addition of architecture which was not part of the story.

But while some artists seem to have followed Alberti's instructions to the letter, others took his rules and deliberately broke them. Domenico Veneziano's *Saint Lucy* altarpiece (c.1444), for the church of Santa Lucia de' Magnoli in Florence, was painted soon after Alberti's treatise was written (Plate 2.16).[45] Domenico Veneziano (active 1438–61) follows Alberti's instructions to create a convincingly foreshortened tiled floor, but – obviously keen to show off – goes one stage further by using hexagonal tiles instead of square ones.[46] At the rear of the tiled floor on which the four saints (Francis, John the Baptist, Zenobius and Lucy) stand, the Virgin sits raised on a platform above two steps, underneath a three-bay loggia. Behind that it looks as though there is a space backed by a niched wall consisting of five sides of an octagon. The architectural space is constructed so that the orthogonal lines converge on a point between the Virgin's knees. But – and this is the important point – although the space appears convincing, the perspectival construction is hidden, perhaps deliberately, by Domenico's use of curves and avoidance of obvious orthogonal lines. Reconstructed in plan, the space seems unlikely because on a plan the gap between the Virgin and the architecture would have to be very wide for the niches to frame the different figures as they do. But Domenico's intention seems to have been to create an image reminiscent of a more conventional polyptych in which all of the saints would have had their own separate panel (see Plate 5.30). In the *Saint Lucy* altarpiece the tops of the front arches touch the edge of the picture

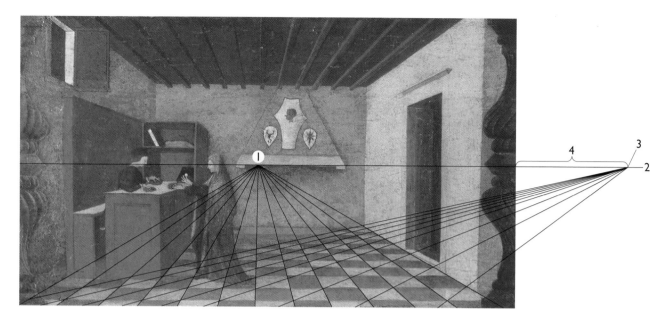

Key:

1: vanishing or centric point

2: horizon or centric line (eye level)

3: distance point

4: distance of viewer from the picture plane

Plate 2.13    Alberti's tiled floor: the centric point (1), centric line (2) and the distance point (3) as used in Paolo Uccello, *Miracle of the Desecrated Host (The Selling of the Host)*. The theoretical distance of the viewer from the picture plane (4) is established by the gap between the distance point (3) and the edge of the picture plane.

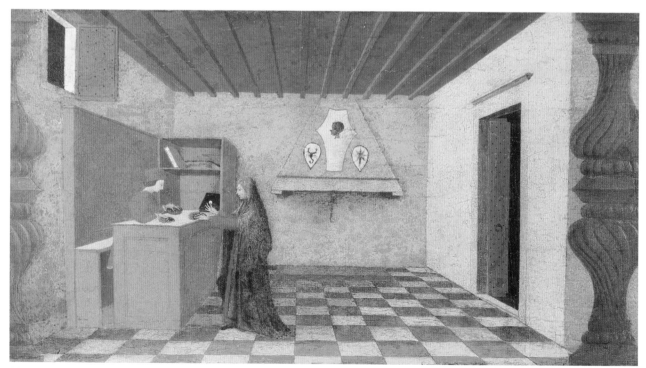

Plate 2.14    Paolo Uccello, *Miracle of the Desecrated Host (The Selling of the Host)*, c.1465–9, tempera on panel, 43 × 58 cm, Palazzo Ducale, Urbino. Used with the permission of the Ministero Beni e Attività Culturali. Photo: © 1990 Scala, Florence.

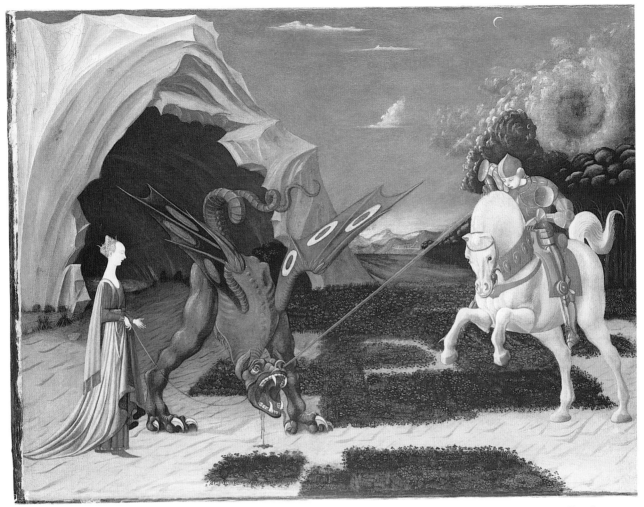

Plate 2.15   Paolo Uccello, *Saint George and the Dragon*, *c.*1470, oil on canvas, 57 × 74 cm, National Gallery, London. Photo: © The National Gallery, London.

as though they are meant to be read as part of the frame, although the bases of the columns occupy the pictorial space behind the saints.[47] The central shell niche is positioned not so much to form a convincing interior but to frame the Virgin and Child. As a result Domenico Veneziano has created an altarpiece that extends the conventional *sacra conversazione* with figures depicted in clear spatial relationships with one another and lit by a consistent light source. It is a virtuoso display that combines both traditional altarpiece design and the intellectual challenge and artistic innovation that single-point perspective made possible.[48]

Piero della Francesca's *Flagellation* (1450–60) is rare for the degree to which it conforms to the formal construction of single-point perspective, something that, as we have seen, was unusual in the fifteenth century where other artistic concerns often compromised the geometry to some extent

(Plate 2.17). His treatise, *De prospectiva pingendi* (*c.*1474), one of at least three mathematical works by him, ensured that for a long time he was better known as a mathematician than as an artist, and he seems to have turned completely to mathematics in the last 15 years of his life.[49] The fact that the structure of the *Flagellation* is so clear makes it all the more surprising that the subject of the painting is so elusive. It is as though Piero used the geometrical certainty made possible by single-point perspective to emphasise the fact that few things in life are knowable or explicable. Although much has been written about the geometry and 'intellectual structure' of the *Flagellation* in recent years, its subject remains controversial.[50]

The painting is divided in two halves by a glowing white Corinthian column and colonnade – an interior praetorium and an exterior courtyard. On the left-hand side, pushed far back into

Plate 2.16   Domenico Veneziano, *Saint Lucy* altarpiece, *c.*1444, tempera on panel, 208 × 213 cm, Uffizi Gallery, Florence. Used with the permission of the Ministero Beni e Attività Culturali. Photo: © 1990 Scala, Florence.

the pictorial space, Christ, tied to a column surmounted by a gold statue of Apollo (*sol invictus* or 'invincible sun' and classical precursor of Christ), is flogged while Pontius Pilate looks on from his throne to the left. The surprising thing is that the main scene which gives the picture its name – the Flagellation – is pushed back in space, while three mute bystanders occupy the foreground. Piero's cold clear light casts shadows consistently from the upper left, with the exception of the inside of the praetorium, where Christ's face and body

are illuminated by a source low down and hidden between the columns so that the ceiling above his head is brightly lit. Only Christ seems aware of this supernatural light as he turns his head to it. On the right, the space has been constructed so that the three silent men stand in front of three different backgrounds in a way not unlike Domenico Veneziano's *Saint Lucy* altarpiece. The bearded man with dark hair wearing a hat stands in front of a palace articulated by Corinthian capitals, a blond-haired man with bare feet stands

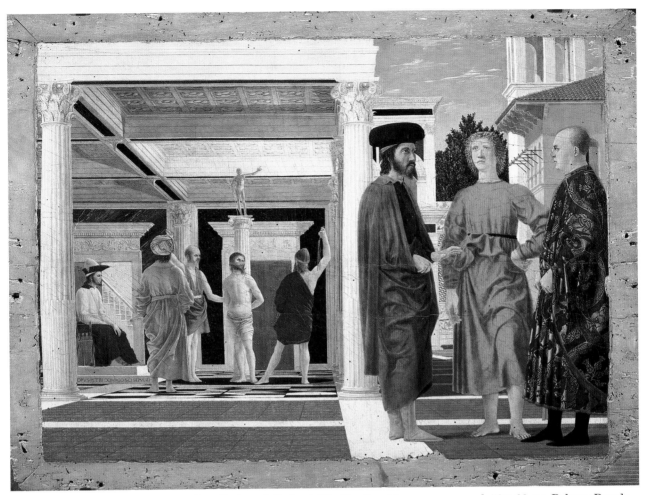

Plate 2.17   Piero della Francesca, *Flagellation of Christ*, 1450–60, oil and tempera on panel, 58 × 82 cm, Palazzo Ducale, Urbino. Used with the permission of the Ministero Beni e Attività Culturali. Photo: © 1991 Scala, Florence. (The small black dots on the painted surface are woodworm.)

silhouetted against a tree and a richly ornamented wall, and a balding man wearing a rich brocaded garment appears before a town house. Not only are the three-dimensional spatial relationships worked out with considerable care, as Kemp has demonstrated, so too are the two-dimensional ratios across the picture plane.[51] The height of the panel is about one braccio (58.4 cm). A width of one braccio establishes the edge of the Corinthian palace and the white band that separates the two parts. The top of Christ's head is the centre point of this braccio square. The overall width of the panel is set by the diagonal of a square established by its height, and so on. Even the black and white tile pattern in the praetorium is a geometrical exercise based on Pythagoras' theorem.[52]

What does such precise geometrical control represent in the *Flagellation*? Was it simply an exercise in geometric virtuosity? I would suggest an interpretation that relies on the timelessness of the image, not the particulars of the narrative. Originally the frame of the picture bore an inscription, 'convenerunt in unum' or 'they conspired together', a biblical quotation from Psalms 2:2.[53] The three figures closest to the edge of the picture plane, and thus the viewer, could stand for all of humanity, including the viewer. Together they represent three very different races, professions (a scholar or lawyer, a craftsman and a merchant?) and ages. Could they, through their ignorance of the divine light, be responsible for Christ's continued suffering? Only through such a carefully constructed image could Piero have made a painting of such enduring richness and complexity.

## 4  Fresco painting and the problem of multiple viewpoints

The relationship between the viewer and the art work is a fundamental element of single-point perspective. Sculptors were already accustomed to taking into consideration the relative position of the spectator. Thus at Orsanmichele the sculptors made physical changes to their works to take account of the position of the niches, which are well above the head height of the viewer (see Chapter 3). Donatello's *Saint George* appears pensive viewed from the front but, from below, the furrowed brow, long nose and elongated torso produce the powerful effect of a knight poised for action (see Plate 3.9). However, while painters working in two dimensions did not make such dramatic adjustments to their figures to compensate for a low viewpoint until the end of the fifteenth century, they could use single-point perspective to bring the disparate scenes of a fresco cycle together.

The decoration of large wall surfaces using fresco painting was particularly popular in Italy, made possible because of the relatively dry climate there. More often than not in the fifteenth century, the decoration consisted of a series of individual narrative scenes divided by painted frames and arranged in tiers around the walls of a chapel. This presented a particular problem for artists because all of the individual narratives had to make sense both on their own and as part of the complete cycle. Alberti advocated the use of a consistent perspective and light source throughout the narratives in a fresco cycle. What painters did was use the fact that the vanishing point establishes the horizon and the horizon is the eye level of the viewer, so that the viewer could see how to relate to the space of the scene even if they could not actually adopt the correct position in relation to the picture. Thus anything above the horizon will be painted as though it is above the viewer, and anything below the horizon will be painted to look as though it is below the viewer, even if the painting had to be positioned above eye level, as was often the case in the multiple scenes of a fresco cycle.

In *On Painting* Alberti describes the importance of the horizon, which he calls the 'centric line' because 'it passes through the centric point'. He gives a specific example of how artists can use it to organise the composition of a painting when he considers how figures standing closer to or further away from the viewer in an uninterrupted space like a church interior might look as they relate to the horizon:

> This line [the horizon] is for me a limit or boundary, which no quantity exceeds that is not higher than the eye of the spectator ... This is why men depicted standing in the parallel [of the perspectival grid or ground plan] furthest away are a great deal smaller that those in the nearer ones – a phenomenon which is clearly demonstrated by nature herself, for in churches we see the heads of men walking about, moving at more or less the same height, while the feet of those furthest away may correspond to the knee level of those in front.[54]

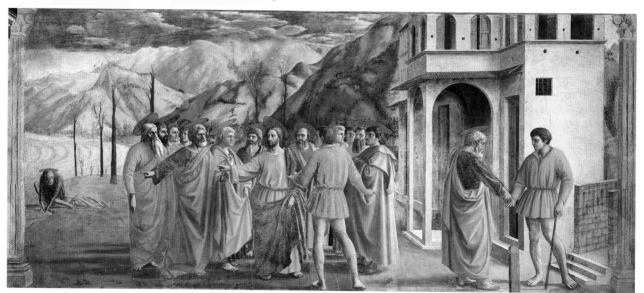

Plate 2.18  Masaccio, *Tribute Money*, *c.*1425, fresco, 255 × 598 cm, Brancacci Chapel, Santa Maria del Carmine, Florence. Photo: © 1990 Scala, Florence.

Thus the 'centric point' (and therefore the horizon) must be no 'higher or lower than the height of a man in the picture' because 'no objects in a painting can appear like real objects, unless they stand to each other in a determined relationship'.[55]

An example will make this clearer because Masaccio and Masolino (1383–c.1435) used this observation in their paintings for the Brancacci Chapel (c.1425) in Santa Maria del Carmine in Florence to link the figures together and unify the composition. The Brancacci Chapel itself is typical of the church spaces that were being decorated in Italy in the fifteenth century. The Brancacci family were wealthy cloth merchants who had lived in the area of the church since the thirteenth century and owned the rights to the chapel.[56] Piero di Piuvichese, an eminent member of the Brancacci clan whose testament of 1367 left five florins a year for 40 years to endow the chapel, gave it its focus on scenes from the life of Saint Peter.

In both the *Tribute Money* and *The Raising of Tabitha and Healing of the Cripple* (scenes directly opposite one another in the chapel), the heads of all the standing figures are at the same height while their feet vary in distance from the bottom edge of the picture (Plates 2.18 and 2.19). The vanishing point can be found by extending the orthogonals back into the pictorial space, where they meet on a point: in the *Tribute Money* on Christ's head, and in *The Raising of Tabitha and Healing of the Cripple* between the two fashionably dressed young men in the middle. The vanishing point dictates

where the horizon is, even though the mountains in one and the buildings in the other scene obscure the full extent of vision, cutting off the view. The horizon line therefore coincides with the heads of the standing figures in the picture, a structure called 'horizon line isocephaly'.[57] (Isocephaly means literally 'equal heads'.) The figures who are sitting on the ground or crouching, such as Peter removing coins from the mouth of a fish on the left-hand side of the *Tribute Money* (attributed to Masaccio) and the beggar on the left or Tabitha and her attendants on the right of *The Raising of Tabitha and Healing of the Cripple* (usually attributed primarily to Masolino), are below the horizon and therefore below the viewer. Now, because the heads of the standing figures coincide with the horizon line, it is possible to say that the viewpoint is about head-height: that is, neither lower nor higher than the viewer. This is slightly confusing because the two scenes are actually above the head-height of the viewer in the chapel (see Plate 2.20). But the artists did this to include their viewers by painting in such a way that they make the imaginary leap dictated by the height of the horizon. Of course, it is much easier to do this when looking at the images in a book, and not in their original physical environment.

Both the *Tribute Money* and *The Raising of Tabitha and Healing of the Cripple* rely on architectural elements to make up the pictorial space. But while the vanishing point is used to focus attention on Christ in the *Tribute Money*, *The Raising of*

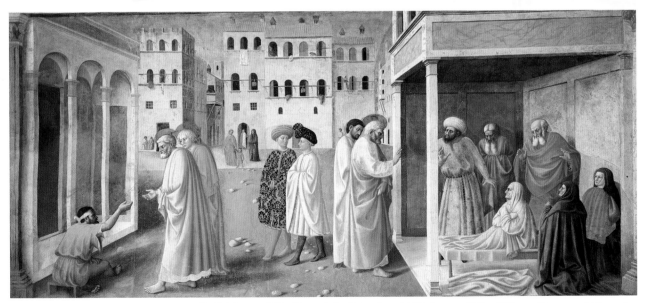

Plate 2.19   Masolino, *The Raising of Tabitha and Healing of the Cripple*, c.1425, fresco, 255 × 598 cm, Brancacci Chapel, Santa Maria del Carmine, Florence. Photo: © 1990 Scala, Florence.

*Tabitha and Healing of the Cripple* lacks the same focus, with the vanishing point coming between two figures who are superfluous to the narrative. The biblical scene Masaccio depicted in a decidedly Tuscan landscape comes from Matthew's Gospel. Arriving at Capernaum, Christ and the Apostles were approached by a tax collector. Christ instructed Peter to go to the sea and look for a shekel in the mouth of the first fish he caught: 'take that and give it to them for me and for yourself'.[58] All three parts of the story are included in the same picture, the spatial setting separating them into distinct zones. The architecture on the right-hand side frames the central group of the Apostles while also explaining the pictorial space of the scene as a whole. Masaccio even tilted the halos of the Apostles to emphasise the spatial 'reality' of the scene – a remarkable innovation at the time.

The spatial unity achieved by Masaccio and Masolino is all the more remarkable if we take into consideration the limitations of the technique of fresco painting in which they were working. Once the design was established on the wall – either drawn direct in the form of a *sinopia* or, later, from a cartoon which was punched or traced – it was gradually covered up by white plaster applied only in sections that could be painted in a single day (*giornate*) before the plaster dried. The colours were mixed with water and applied without a binder direct to the wet plaster and always dried paler as a result. It was a difficult balance to achieve, not least because a unified design had to be worked up from a number of sections in colours that looked very different when they were wet and dry. The perspective also had to be established across the entire scene for it to work as a whole. A simple method was employed by Masaccio and his assistants to build the perspectival model on the wall. As he did for the *Trinity*, a nail was fixed to the wall where the orthogonals were to converge. A long string was stretched from the nail to check the orthogonals that made up the architecture. The line was 'snapped' into the wet plaster and the dents it made are still visible today. In the *Tribute Money* the lines converge – or the nail would have been – on the bridge of Christ's nose. It is not a precise science, however, and as new *giornate* were added the nail had to be removed and then replaced, resulting in a second nail hole or vanishing point above the first on Christ's forehead.

The scenes on the same level but on either side of the altar, *Saint Peter Healing with his Shadow* and

*Distribution of the Goods of the Church*, probably both the work of Masaccio, further overcome the problems of bringing so many pieces together in the fresco jigsaw and across the different narratives: these two scenes share the same perspective so that their orthogonal lines converge on a vanishing point behind the altar (Plate 2.20). Like the *Tribute Money* and *The Raising of Tabitha* on either side, all the heads of the standing figures in *Saint Peter Healing with his Shadow* and *Distribution of the Goods of the Church* are lined up along the horizon set by the vanishing point. All the scenes in the chapel are further unified by a consistent light source which coincides with the existing window. Not only does this add solidity to the figures and consistency across the scenes, but it also enables Masaccio to develop the symbolism of *Saint Peter Healing with his Shadow* in the most subtle of ways. As Peter passes the cripple crouched by the side of the road, his shadow, which appears to be cast by the light from the window of the chapel, heals those that it touches, creating a scene of remarkable subtlety and immediacy.

Masaccio and Masolino seem to have stopped working on the Brancacci Chapel for the winter of 1425 when it would have been too cold to work in fresco because the plaster would not dry properly, but for some unknown reason they did not resume their work the next spring. The fresco cycle was not completed until Filippino Lippi worked on it in around 1485, but he did not do anything that would disturb the consistent and coherent spaces established some 60 years earlier.

Because of the complexities involved in both the technique and spatial settings of fresco painting, Leonardo later advised artists to keep their perspective foreshortenings in frescoes as simple as possible, not least because 'the wall on which you are painting is to be viewed by several people'.[59] Piero della Francesca was as proficient a mathematician as he was an artist, as can be seen in a geometrical drawing from *De prospectiva pingendi* (Plate 2.21). But in the fresco cycle he painted in the 1450s for the chapel of the Holy Cross in the church of San Francesco, Arezzo, he keeps his complex spatial constructions as unobtrusive as possible; it is the narrative of the fresco cycle and not his artistic or mathematical prowess that stands out.

The Bacci family, one of the wealthiest in Arezzo, commissioned Bicci di Lorenzo, a Florentine artist, to decorate the chancel of the church over the high

Plate 2.20   View of frescoes at the Brancacci Chapel, Santa Maria del Carmine, Florence. Photo: Raffaello Bencini/Alinari Archives, Florence. (The chapel is much altered: it was originally lit by a tall biforate Gothic window, replaced in the seventeenth century. The fresco of the Crucifixion below the window was destroyed c.1458 and replaced sometime later by a *Virgin and Child* attributed to Coppo di Marcovaldo. The cross-vault with frescoes of the Evangelists by Masolino was replaced 1746–8.)

Plate 2.21    Piero della Francesca, measured heads, from *De prospectiva pingendi*, *c.*1474, Biblioteca Palatina, Parma. Used with the permission of the Ministero Beni e Attività Culturali.

Note the vertical lines connecting the view of the head in profile (top left) to the view from above (middle left) and from below (bottom left), and the horizontal lines drawn from the head in profile across to the head viewed from the front. These lines demonstrate the accuracy of the proportions of the head in a variety of views and, conversely, how these measurements can then be used to depict the human head in a range of positions.

altar in 1447. When Bicci died in 1452 Piero took over the commission, but it was not finished until 1465. The space of the chapel is very similar to the original Brancacci Chapel before it was later reduced in size and modernised – large with a tall Gothic cross-vault and windows, typical of the open-plan spaces of Franciscan churches. The subject of the narrative is of particular relevance for the Franciscans, because since 1342 they had been custodians of the holy sites of Jerusalem and even before then the order had a special devotion to relics of the Cross.[60] Each of the three walls of the chapel was decorated with two levels of rectangular scenes surmounted by a third of lunettes adjoining the vault, telling the story of the Cross on which Christ was crucified, its origins as a tree over Adam's grave, and then its rediscovery by Helena, mother of the first Christian emperor, Constantine (Plates 2.22 and 2.23).[61]

Piero makes some changes in the narrative order so that the chapel is about more than just telling a story. The first scene of the origins of the tree as the marker for Adam's grave is set across from the last, the veneration of the Cross in Jerusalem in the lunettes. As a result the side walls are dominated by the tall silhouettes of the tree on one side and the Cross on the other. The middle registers, both framed by architecture, show scenes opposite one another of the recognition of the tree by the Queen of Sheba and the discovery of the Cross by Helena. The lower scenes are both battles, dominated by horses and soldiers. Thus the symmetry is not limited to geometry but extended to the settings and subjects in ways that invite thematic rather than just chronological connections to be drawn out by the viewer. However, it is in the individual scenes that the clear geometrical composition which underlines the complex narrative is most obvious.

Just as Masaccio did at the Brancacci Chapel, Piero uses the actual light source of the chapel, the large Gothic window, to model the figures on either side. Those on the window wall, including two prophets in the uppermost register, are lit sharply from the side, almost in silhouette. This use of light brings all the different parts of the cycle together. In addition, each of the scenes is treated like a relief, with all of the action arranged across the foreground, a 'pattern of actions which are knotted together, one evolving from the other'.[62]

Take, for example, the scene of the *Victory of Herakleios over the Persian King Chosroes* at the bottom of the left wall. The story comes at the end of the narrative. The Cross was taken from Jerusalem by Chosroes, a Persian king, who set it up on one side of his throne to represent Christ, with a cockerel on the other to represent the Holy Spirit, and declared himself God in the middle of this trinity. Herakleios, Byzantine emperor (ruled 610–41), defeated the vainglorious king in a violent battle. In the fresco Chosroes' son is stabbed in the throat while Chosroes himself awaits execution under the shadow of the Cross on the right-hand side. The uppermost scene on the same wall shows Herakleios returning the Cross to Jerusalem and giving it its due veneration. Unlike the parallel scene of the *Victory of Constantine over Maxentius*, with its focus on the Cross held by the emperor emphasised by the division between the two armies as Maxentius turns and flees, the culmination of the *Victory of Herakleios over the Persian King Chosroes* – the execution of the king – is almost obscured by the energetic battle at the right-hand side of the scene. Although Piero does use single-point perspective to construct the throne canopy, the vanishing point is obscured behind the battle.

The edges of the scene are not demarcated, as Piero allows figures and horses to be cut off by the end of the scene. This is something he must have seen in antique friezes in Rome (such as those on the arch of Constantine, ancient Roman sarcophagi and triumphal columns such as those of Trajan or Marcus Aurelius), perhaps when he worked there in the late 1450s. But the figures were not applied freehand to this relatively loose structure. Pouncing and incised lines still detectable on the walls betray the extreme efforts which the artist and his workshop went to, working out figures and objects geometrically, and then assembling all the parts in larger cartoons. Surviving geometrical studies, such as Piero's study of the human head, suggest the efforts he made to depict every single object accurately in space, working out their correct proportions and foreshortening from a plan (Plate 2.21). Arranged like a frieze, the stories unfold across the front of the picture plane. He restricts obvious perspectival constructions to interior spaces, using them only where absolutely necessary. Single-point perspective was one of several tools Piero used to achieve a narrative that both enables an intricate web of connections to be made across the actual and pictorial space of the chapel, and is as clearly readable as possible. Or, as Kenneth Clark put it, it is 'both bafflingly complex and astonishingly simple'.[63]

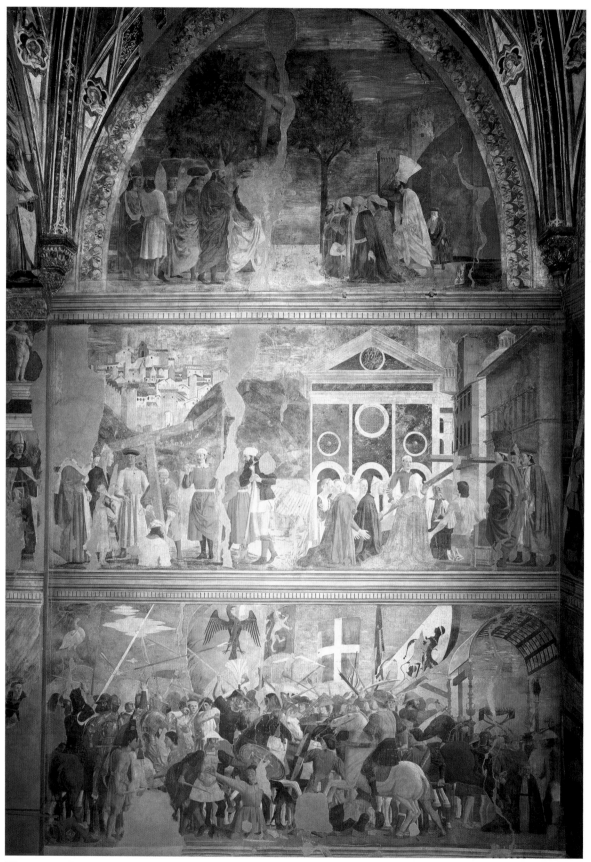

Plate 2.22   Piero della Francesca, *Herakleios Restoring the True Cross to Jerusalem, the Discovery and Proof of the True Cross, and the Victory of Herakleios over the Persian King Chosroes,* 1450s, fresco, left wall of the chapel of the Holy Cross, San Francesco, Arezzo. Photo: Alinari Archives, Florence.

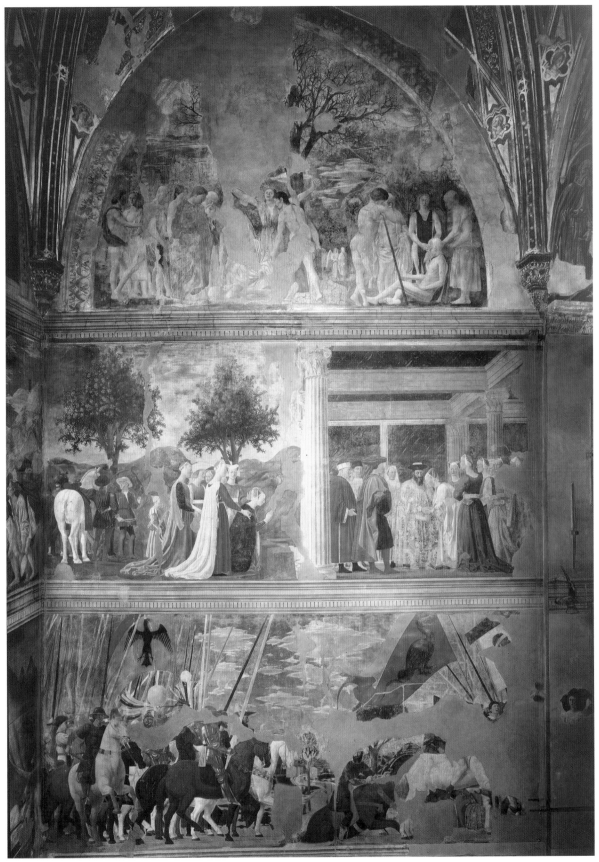

Plate 2.23   Piero della Francesca, *Death and Burial of Adam, the Queen of Sheba Adoring the Bridge and the Meeting of the Queen of Sheba and Solomon, and the Victory of Constantine over Maxentius*, 1450s, fresco, right wall of the chapel of the Holy Cross, San Francesco, Arezzo. Photo: Alinari Archives, Florence.

# 5  Perspective north of the Alps

Single-point perspective was a distinctly Italian phenomenon before the 1450s. During this decade the first signs of its adoption north of the Alps appeared. The reason was certainly not that artists working in the Netherlands were slower than the Italians but, more likely, that they had very different priorities: single-point perspective does not seem to have been as relevant or useful to them until later in the fifteenth century. By the second half of the century, artists from the north who ventured south of the Alps, perhaps on pilgrimage to Rome or to work for an Italian patron, were beginning to encounter Italian ideas about single-point perspective. Paintings by Petrus Christus, for example, suggest that he may have visited Italy in the 1450s, as thereafter some of his paintings employ the technique. Certainly by the early sixteenth century a trip to Italy to learn the secrets of single-point perspective, among other things, could be part of an artist's training. That does not mean, however, that art north of the Alps in the fifteenth century should be understood as the gradual adoption of Italian values. Just as not all artists working in Italy used perspective systems even when they were widely available, so artists north of Alps used other options available to them.

At the same time that artists in Italy were developing their ways of depicting the built environment, artists in the north were more concerned with the depiction of light and of landscapes where a lack of buildings and straight lines made single-point perspective redundant. In the north the more customary use of oil paint, which was applied in thin translucent glazes that did not dull the bright colours of the pigments, enabled artists to depict naturalistic landscapes and outdoor scenes more effectively than their southern counterparts. The relatively slow drying time of oil paint allowed the colours to be blended to make subtle gradations of colour that were used to create aerial perspective – literally, perspective of the air. It was the Italians who wrote about aerial perspective, however.

At the end of the fourteenth century Cennino Cennini told artists painting landscapes that 'the farther away you have to make the mountains look, the darker you make your colours; and the nearer you are making them seem, the lighter you make the colours'.[64] But a century later Leonardo counselled just the opposite: 'there is another perspective which we call aerial … in such air the furthest things seen in it – as in the case of mountains, when great quantities of air are found between your eye and the mountains – appear blue, almost the colour of the air when the sun is in the east'.[65] Aerial perspective was a common feature of the stunning landscapes glimpsed through windows in northern paintings – for example, Jan van Eyck's *Virgin and Child with Chancellor Rolin* of *c.*1436 (Plate 1.5) – in which the distant landscape with its paler and bluer mountains opens up the picture, creating a relief from the claustrophobic space of the foreground.

Leonardo went on to explain why mountains appear lighter at their bases and why those which are highest and wooded appear 'the most beautiful blue that is in itself the darkest'. Similarly, the sky should appear whiter nearer the horizon and bluer or darker the further above the horizon it is, because colours appear changed as they recede into space as moisture in the atmosphere dilutes their intensity. In addition, colours at the top appear different from those closest to the horizon. In the uppermost part of the sky – or 'the blackness of the void' as Leonardo put it – colours appear darker or stronger, whereas nearer the horizon, where the air is densest and the rays of the sun are therefore absorbed more intensely by this thicker air, colours will appear lighter. Later paintings such as Leonardo's *Mona Lisa* (*c.*1503–6) incorporate both effects of aerial perspective: the recession of colour into the distance and its subtle gradation from top to bottom, made possible because it was painted in oils. The tempera technique, whereby pigments were bound in opaque egg yolk which, because it dried so quickly, had to be applied in tiny brushstrokes, simply did not allow the same subtle effects.

Dieric Bouts's cloth *Entombment* (*c.*1450–60, Plate 2.24) is unparalleled in Italian art until much later in the fifteenth century. Even though it is painted in colours mixed with glue tempera on cloth (because it was intended for use as a church hanging) and not in oils, by using aerial perspective the figures are set in a landscape in a much more plausible way than in, for example, Mantegna's *Agony in the Garden* (Plate 2.2). Changes in the colour because of the technique and wear mean that the landscape, particularly in the distance, is now no longer as blue as it once would have

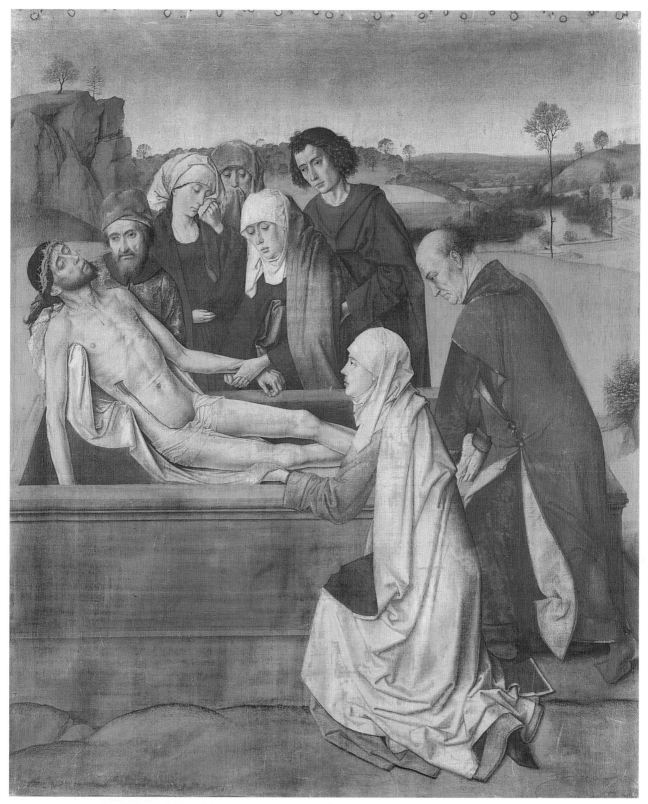

Plate 2.24   Dieric Bouts, *The Entombment*, c.1450–60, glue tempera on linen, 90 × 74 cm, National Gallery, London.
Photo: © The National Gallery, London.

Plate 2.25   Dieric Bouts, *The Virgin and Child, c.*1465, oil with egg tempera on oak, 37 × 28 cm, National Gallery, London. Photo: © The National Gallery, London.

been, although the delicacy of the treatment is in no way diminished.[66] Bouts's *Virgin and Child* of *c.*1465 includes a distant landscape strikingly blue in colour (Plate 2.25). In this case it is part of a sophisticated composition in which Bouts (*c.*1415–75) deliberately draws attention to the ambiguities of depicting a three-dimensional scene on the two-dimensional picture surface by inserting a window between the Virgin and Child and the viewer. The cushion on which the Child is propped juts forward into the viewer's space, and the white cloth was probably originally continued onto the frame. The figures are lit not by the window behind but by a frontal light source set slightly to the left-hand side, as though it comes from outside the picture. The Virgin and Child appear at a window in a room which includes another window through which an airy landscape is visible. The space of the room is not easily understood because the red brocade hanging – the Virgin's cloth of honour

– intrudes, cutting the picture in half vertically. Both space and light are here used as attributes of the Virgin. The foreground window refers to Mary's title as *fenestra coeli* or window of heaven, as through her the true light of God falls on the earth.[67] The landscape behind represents the light of God falling on the earth, and the blueness of the aerial perspective is exaggerated to make this more prominent.[68] Such subtle symbolism of light and space was achieved without the use of single-point perspective.[69] Nevertheless Bouts was also one of the first artists in the north to absorb the techniques of single-point perspective. The very first, however, was Petrus Christus.

Before we move on to paintings by Petrus Christus and Dieric Bouts in which they assimilated

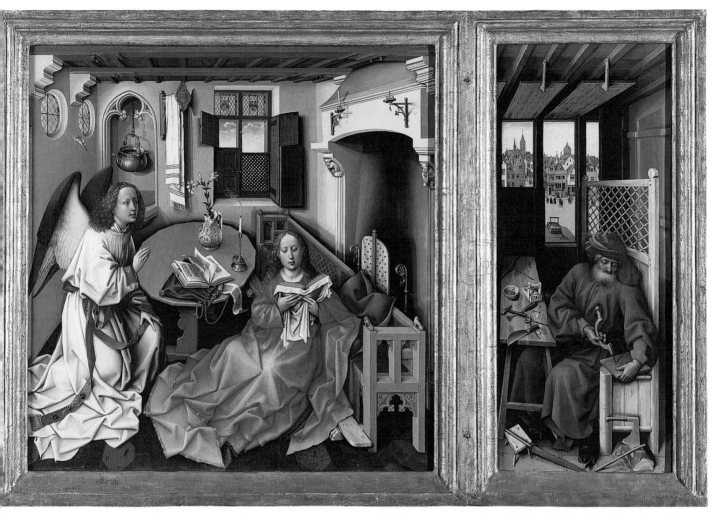

Plate 2.26   Circle of Robert Campin/Master of Flémalle and assistants, *The Annunciation* triptych (Mérode altarpiece), *c.*1425, oil on panel, 65 x 118 cm overall (open), 64 x 63 cm (central panel), 65 × 27 cm (each wing), Metropolitan Museum of Art, New York, The Cloisters Collection, 1956 (56.70). Photo: © 1996 The Metropolitan Museum of Art.

single-point perspective into their work, it is worth considering the very different approach to depicting spatial relationships that characterises Netherlandish painting. In general, spatial relationships between objects were of secondary concern to capturing their material qualities – texture, colour, translucence – all helped by the development of oil paint. In the central panel of the Mérode altarpiece (*c.*1425), a relatively small altarpiece probably intended for private devotion, *The Annunciation* is set in a convincing – if not perspectively accurate – interior space (Plates 2.1 and 2.26). Orthogonal lines have been adjusted so that if extended they would meet in roughly the same area (between the hanging towel and the window), suggesting that the perspective

was formed by the artist's eye rather than by abstract principle, not unlike Cennino Cennini's instructions. The main goal is visibility, with objects and furniture manipulated within the space to make them more obvious: the far end of the bench on which the Virgin is perched is deliberately raised so that it can be seen, while the table top is tipped forward so that all of the objects – symbols of the Virgin's purity – are more easily read.

It is this 'worshipful respect for the particular' and attention to detail that Panofsky highlighted in the work of Jan van Eyck.[70] One of his largest paintings, the *Madonna of Canon van der Paele* (Plate 2.27), is astonishing for both detail and clarity of space. The painting celebrates the establishment of a chaplaincy by Canon Joris

Plate 2.27   Jan van Eyck, *Madonna of Canon van der Paele with Saints Donation and George*, 1436, oil on panel, 122 × 157 cm, Stedelijke Musea, Groeningenmuseum, Bruges (inv. OGRO161.I).

van der Paele at the church of Saint Donation in Bruges in 1434, recorded in an inscription on the frame.[71] But despite the incredible illusion of space, the artist did not rely on perspective techniques to create the wide-angle view. The space is divided into several distinct zones, each of which includes areas where orthogonal lines converge. The attention to the detail, texture and lighting hides any inconsistencies in the space, creating instead a system of intricate relationships between objects.

The closer one looks, the more one is drawn into the painting. Tiny sculptural details – such as Adam and Eve, Cain killing Abel and Samson slaying the lion – decorate the Virgin's throne. Saint George, the canon's patron saint, presents him to the Virgin and Child, while Saint Donation, the patron of his

church, draped in a voluminous cope and holding his symbol of a wheel with five candles round its rim, stands on the left-hand side. Saint George's foot rests on the canon's alb – an audacious detail that keeps him on his knees – and serves to explain the spatial relationship by establishing direct physical contact between the figures. Just as Alberti defined it (based on Aristotle), space was understood not as an abstract quality but as a series of relationships between figures and objects. The carpet extends towards the viewer and is shown incomplete at the edge as though the rest of it is to be found in our space. All the details produce an effect of sparkling clarity and bejewelled naturalism, but they also add meaning. The light, for example, uncovers even more details:

van Eyck famously included himself in the mirror on the rear wall of the *Arnolfini Portrait*, and in the van der Paele altarpiece the artist and the Virgin are reflected in the shining surfaces of Saint George's armour. But these reflections are not only artistic devices: another inscription on the frame – 'speculum sine macula' – refers to the Virgin as the flawless mirror.[72]

Much scholarly effort has been devoted to proving that Jan van Eyck did – or did not – have knowledge of the same developments in single-point perspective that Masaccio was using concurrently in Florence. There have been six different theories about the *Arnolfini Portrait* alone, which propose anything from one to seven vanishing points.[73] But as Elkins has demonstrated, in the *Arnolfini Portrait* – like the van de Paele altarpiece – the space is treated in a uniquely Netherlandish way, in distinct sections which were conceived separately and then assembled. The dog in the bottom centre of the picture helps disguise the central vertical line which divides the painting into two separate zones. Where there are orthogonals, they meet in general vanishing areas rather than precise points. Combined, they draw the eye to the main features of the picture and especially the hands of the two figures (Plate 2.28). As a result, no single element is subordinated to any other: incidental details such as the mirror on the rear wall or the window to the left are works of art in themselves.

Rogier van der Weyden, who was a pupil of the Master of Flémalle, produced with his workshop a large number of works, many of which deliberately test the boundaries of the picture plane in a variety of ways. Although he may have visited Italy in the 1450s, even his later paintings do not acknowledge developments in single-point perspective. In the *Descent from the Cross* (1435–8, Plate 2.29), all the figures are arranged parallel to the picture plane in a box-like space, like a painted version of a carved altarpiece (see Plate 3.15). The shallow space serves to emphasise the intense emotion of the scene, while Rogier's 'graceful linear abstractions' produce a painting which does not purport to depict reality. Instead it is a sophisticated two-dimensional painting pretending to be a three-dimensional carved altarpiece.[74] This tension between the picture surface and the illusionistic space so evident in Rogier's painting was something that Panofsky used to characterise the evolution of painting in the Netherlands in

the first half of the fifteenth century, suggesting that artists were thinking along the same lines as the Italians about the limitations of the picture plane.[75] It is an important point, but it obscures the unique developments in Netherlandish painting by allowing them to be overshadowed by comparison with the Italians.

Single-point perspective as developed in Italy finally reached the Netherlands via the work of Petrus Christus (c.1410–75/6). Little more is known about him than that he was the 'son of Pieter, born in Baerle, purchased his citizenship [of Bruges] on the sixth day of July; sponsored by Joos van der Donc, in order to be a painter'.[76] It is not known for certain what Christus's background as a painter was, and, more intriguingly, it is not known where he was in the years 1454–62. Certainly, of his surviving 25 works, eight can be linked to Italy or Spain, suggesting he had some kind of contact there.[77] Whether he actually visited Italy or came into contact with Italian developments in single-point perspective through members of the foreign communities in Bruges is unknown, but the change in his paintings in the 1450s as a result of single-point perspective is dramatic.

Up to 1457 Petrus Christus used the general principles of empirical perspective as Cennino Cennini described. But in *The Virgin and Child Enthroned between Saints Francis and Jerome*, signed and dated 1457 (Plate 2.30), the visible orthogonals of the floor and doorway converge on a point under the chin of the Virgin, although the transversals of the tiled floor do not correspond to Alberti's check.[78] The inclusion of Saints Francis and Jerome in the altarpiece may suggest an Italian patron and help account for the artist's adoption of single-point perspective. Close examination of the painting has revealed lines converging on a point incised into the ground layer of the panel.[79] The four figures appear slightly off centre, but the panel has been cut at the left edge. The vanishing point coincides with the horizon line visible through the open door.

By the 1460s Petrus Christus was showing some confidence in his use of single-point perspective. In his *Virgin and Child Enthroned on a Porch* (1460–5, Plate 2.31), he employed a tiled floor to careful effect as the lines converge on a point that meets the corner of the Virgin's left eye, no doubt to direct the gaze of the viewer to her. Even so, the

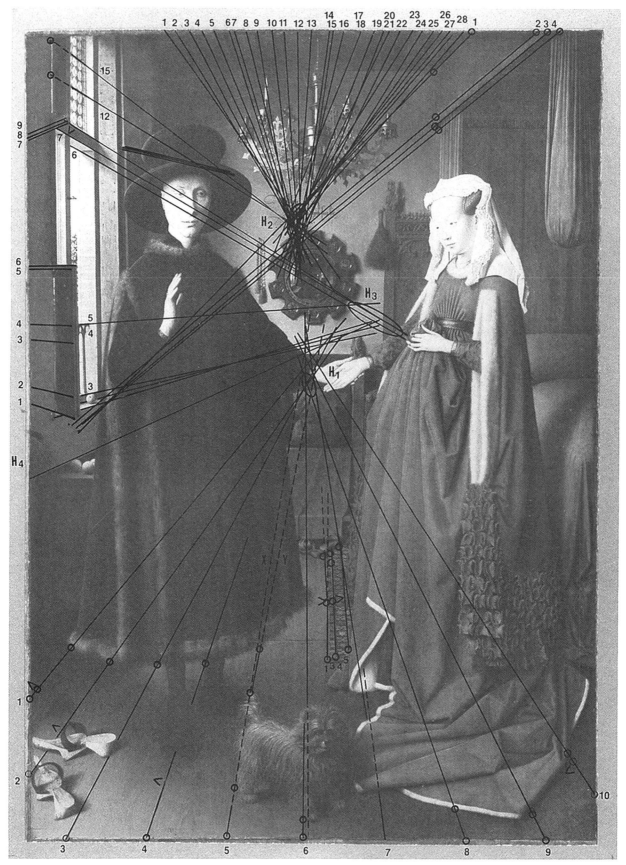

Plate 2.28  Jan van Eyck, *Arnolfini Portrait*, 1434, oil on oak, 82 × 60 cm, National Gallery, London. Perspectival reconstruction by Dr James Elkins, *The Art Bulletin*, March 1991. Photo: © The National Gallery, London, and Dr James Elkins.

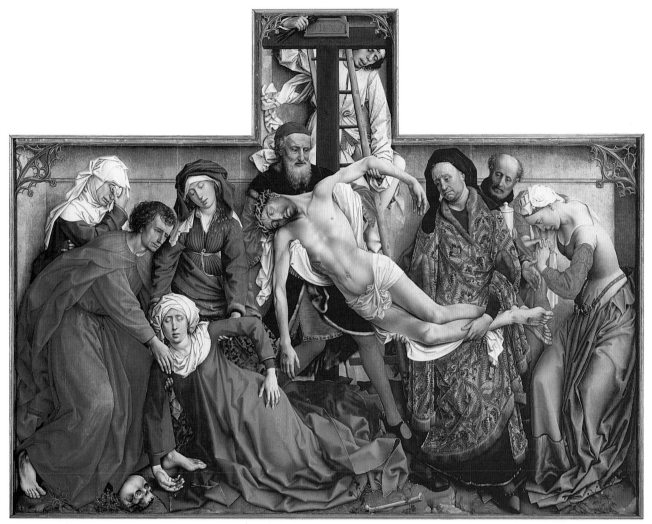

Plate 2.29   Rogier van der Weyden, *Descent from the Cross*, 1435–8, oil on panel, 220 × 262 cm, Museo del Prado, Madrid. Photo:

vanishing point is below the horizon, which was perhaps raised to make the landscape setting more clearly visible through the window and doorways. Again the regression of the transversals was not checked by drawing a diagonal line through them to meet the horizon at a lateral point, as Alberti recommended. Nor do the orthogonals of the arched porch match the perspectival construction of the floor. Despite these inconsistencies, detailed analysis of this picture, including x-ray, has revealed a round white dot below the surface at exactly the vanishing point and perspectival lines incised into the ground layer below the paint.[80]

In one of Christus's later paintings, the *Holy Family in a Domestic Interior* of *c.*1460–7 (Plate 2.32), the Virgin and Child are set in the traditional Netherlandish interior employed so frequently by his predecessors such as Jan van Eyck. In this case the convincing perspectival construction allows a

continuous view from the foreground through to rooms further back, into which Joseph enters. The *hortus conclusus* (walled garden) just visible to the left, which symbolises Mary's virginity, seems a natural part of the setting. Aerial perspective is used to add to the spatial effect, progressing from warmer, richer colours in the foreground to cooler, lighter ones in the background. The point of convergence of the orthogonals is used to point to the bed and to Joseph, which emphasises his importance as part of the holy family, a relatively recent theological development which promoted him from being merely a comical old man.[81]

Dieric Bouts employed single-point perspective more consistently but with more artificial results. Just before he became official painter of Leuven in 1468, Bouts painted his *Last Supper* altarpiece for the church of Saint Peter there. In the central panel single-point perspective is used to push the

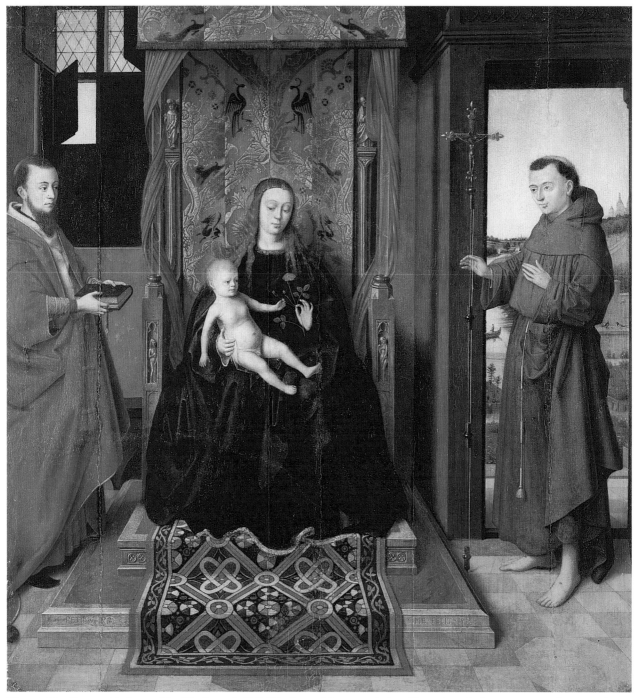

Plate 2.30　Petrus Christus, *The Virgin and Child Enthroned between Saints Francis and Jerome*, 1457, oil on panel, 47 × 45 cm, Städelsches Kunstinstitut und Städelsche Galerie, Frankfurt. Photo: Ursula Edelmann, Artothek.

Plate 2.31   Petrus Christus, *Virgin and Child Enthroned on a Porch*, 1460–5, oil on panel, 49 × 34 cm, Museo del Prado, Madrid.

Plate 2.32   Petrus Christus, *Holy Family in a Domestic Interior*, *c*.1460–7, oil on panel, 70 × 51 cm, Nelson-Atkins Museum of Art, Kansas City (purchase: Nelson Trust, 56-51). Photo: Mel McLean.

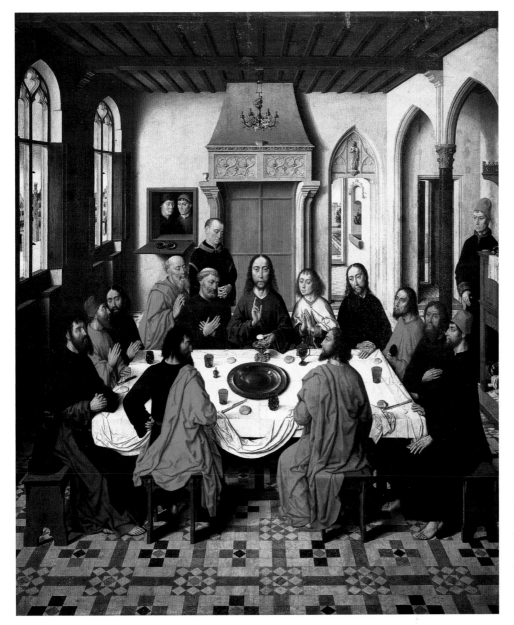

Plate 2.33   Dieric Bouts, *The Last Supper* from the altarpiece of the *Holy Sacrament*, 1464–7, oil on panel, 180 × 150 cm, church of Saint Peter, Leuven. Photo: © 1998 Scala, Florence.

narrative back into space so that the Apostles are all visible as they sit round the table (Plate 2.33). The horizon and vanishing point are high so that the viewer looks down on the scene – the orthogonals converge directly above Christ's head, where the wooden shutters and mantelpiece meet. Unlike Petrus Christus's floors, the foreshortening of the transversals are correct in accordance with Alberti's check. Compromises have been made to serve the overall composition, however. The horizon visible through the doors and windows has been lowered slightly to permit a glimpse of the sky as well as landscape – pictorial considerations still dominate this otherwise geometrically accurate scene. Nevertheless, the figures and domestic

details seem to compete with the geometrical structure of the picture, so that it looks odd even if the space is perspectively correct. It was Albrecht Bouts, Dieric's son, who in the sixteenth century went on to develop single-point perspective much closer to Italian consistency in concert with Netherlandish attention to detail. But close observation of detail, texture and light, combined with the technique of oil painting, created a verisimilitude that forced single-point perspective to play a lesser role in the north. Just like the Italians, it did not always suit the overall purpose of artists in the Low Countries.

# 6   Conclusion

To return to my original question – how significant was single-point perspective for fifteenth-century artists – it is possible to answer that it all depended on the artist's intentions. Single-point perspective served and only occasionally led their objectives. Only very rarely did artists adhere to it in the obsessive ways that modern geometrical analyses would like to suggest for them.[82] Although art historians have made much of it as a 'scientific' development and proof of Renaissance progress, the evidence suggests that artists were well aware of its limits. If it suited their purposes they used it, but often they had to make adjustments to stop their works of art seeming too artificial and measured and to reinforce the overall impression they wished to achieve. A painting such as Piero della Francesca's *Flagellation* is a rare example of a work in which the subject seems deliberately subservient to the geometry; I would argue that the geometry and the meaning are inseparable. In Italy as well as in the Low Countries, artists used several complementary ways of reproducing convincing spatial relationships in their images. The very fact that such an important treatise as Alberti's *On Painting* was not published until the sixteenth century suggests that artists relied more on the practice of perspective than on the theory.

# Chapter 3 introduction

In his ground-breaking book *The Limewood Sculptors*, published in 1980, Michael Baxandall explored, among other themes, how the peculiar properties of limewood affected the sort of sculpture a wood-carver working in lime might produce. In his essay on technique that Vasari wrote as an introduction for the 1550 version of the *Lives*, he singled out limewood for the scant praise he was prepared to concede to wood sculpture. So far as he was concerned, it was a material ideally suited to the production of virtuoso effects, and indeed the spectacular statue of Saint Roche by Veit Stoss in S. Annunciata, Florence, with which Vasari was familiar, must have seemed proof enough of its potential, but Vasari showed no awareness of its particular pitfalls. A fifteenth-century sculptor using limewood could not afford such ignorance and neither, since Baxandall's book, can the student of art history.

This chapter has a dual focus. It aims to provide a basic grasp of the very wide range of materials and techniques essential for an understanding of the making of Renaissance sculpture, but it also sets out to explore the ideal of faithfulness to nature identified by Vasari as one of the key characteristics of fifteenth-century Renaissance art. Speaking of his famous *Gates of Paradise*, the second set of bronze doors made for the east face of Florence Baptistery between 1428 and 1452 (Plate 3.14), Lorenzo Ghiberti commented, 'These stories, filled with figures, were stories of the Old Testament in which I tried in every way to be faithful in seeking to imitate nature.'[1] Here the emphasis is on convincing, lifelike narrative. It shows that this concern, famously explored by Alberti in his 1435 treatise *On Painting*, applied no less to sculpture, and it is demonstrated not only in Ghiberti's reliefs but also, for example, in Netherlandish carved altarpieces. Gauricus, in a treatise published in 1504, judged sculpture by a slightly more precise criterion: its capacity to capture a moment.[2] Clearly he was articulating an ideal long maintained, of which Donatello was surely one of the most skilled masters (see Plates 3.9 and 3.29). While sculptors north of the Alps did not write about their activities at this date, Bernt Notke's use of real objects such as antlers in his sculpture of Saint George and the Dragon (Plate 3.30) was clearly designed to enhance both immediacy and lifelike qualities. It might be fair to suggest that many Renaissance sculptors pushed their materials to their limits during the fifteenth century, and that they did so not just from the desire to display their skill – though technical skill was clearly highly prized – but in pursuit of the ideal of the illusion of life, which sculptors both north and south of the Alps appear to have embraced no less than painters and conceivably sometimes even in competition with them.

*Kim W. Woods*

# Chapter 3

# The illusion of life in fifteenth-century sculpture

*Kim W. Woods*

to speak first of the sculptors … They had a manner of their own, so much more graceful and more natural, and so much richer in order, in design, and in proportion, that their statues began to appear almost like living people, and no longer figures of stone …[1]

While discussing architecture, painting and sculpture, it is sculpture that Vasari praises most highly in the preface to Part II of his *Lives*, the section that deals with artists of the fifteenth century. Sculpture, he claims, came so close to the 'exact imitation of the truth of nature' that little remained to be accomplished in the sixteenth century to bring it to perfection.[2] Vasari singles out for particular praise Lorenzo Ghiberti, who made the famous bronze doors for Florence Baptistery, 'wherein he showed such invention, order, manner, and design, that his figures appear to move and to have souls'. Most remarkable of all, however, was a second Florentine, Donatello, 'for he brought his figures to actual motion, giving them such vivacity and liveliness that they can stand beside the works of to-day, and, as I have said, beside the ancient as well'.[3]

In comparing the work of Donatello to ancient works of sculpture, Vasari meant the antique sculpture of Rome which, unlike Roman painting, survived in significant quantities in Italy and was readily accessible to artists. For some fifteenth-century Italian sculptors, Roman art was as much the inspiration for convincingly lifelike work as the study of nature itself, and as we shall see, Nanni di Banco (d.1421) is one of the first sculptors in whose work this trait can be observed. It was Roman sculpture's capacity for the illusion of life that also impressed the Florentine scholar Poggio Bracciolini (1380–1459): 'I am greatly delighted by sculptures and bronzes made in memory of the excellent men of old. I am forced to admire their genius and art since they render a mute and lifeless thing as if it breathed and spoke; often indeed they represent even the emotions of the soul so that a thing which can feel neither pain nor joy looks to you as if it laughed or mourned.'[4] Ancient sculpture also provided a crucial source for the 'correct' way to represent the human body, for the 'nature' represented in much antique art was nature perfected: the ideal human body perfect alike in proportions, anatomy and musculature. Fifteenth-century northern sculptors, conversely, were largely unacquainted with antique art; nor is there strong evidence that they learned directly from their Italian counterparts before the early sixteenth century. Yet in northern Europe – and specifically in the Netherlands – an illusion of reality was also attained drawing on markedly different traditions and sometimes using different techniques and materials.

Fifteenth-century sculpture was valued not just for its truth to nature but for its technical expertise, though technical virtuosity and a realistic style

Plate 3.1    (Facing page) Niccolò dell'Arca, detail from *Lamentation over the Dead Christ* (Plate 3.22).

often went hand in hand. For example, Donatello effected a technical transformation of the art of relief carving, and in so doing attained pioneering illusions of convincing spatial recession. All sculptors were bound to a lesser or greater extent by the properties, possibilities and limitations of the medium in which they worked, whether stone, wood, bronze or terracotta. This chapter explores the making of Renaissance sculpture in terms of the varying ways in which sculptors north and south of the Alps attained the illusion of 'truth to nature', taking into account the differing sculptural materials and techniques at their disposal.

# 1   The Florence Baptistery doors

In 1401 a memorable competition took place in Florence. The Arte di Calimala, the wealthy guild of cloth merchants that took responsibility for the upkeep of the baptistery, launched a competition in order to choose a craftsman to make a new set of bronze doors for the eastern entrance. The existing south doors had been made much earlier by Andrea Pisano in 1330–6. Each of the seven competitors was required to make a relief of the Sacrifice of

Isaac, the incident from the Old Testament book of Genesis in which Abraham, the father of the Israelite nation, was saved at the last minute from sacrificing his son to God (Genesis 22:1–14). According to Ghiberti's own, probably rather biased account of the competition, written decades after the event in his *Commentaries*, the 34 judges and his fellow competitors came to a unanimous decision in his favour. If true, this is remarkable for he was the youngest of the competitors and, until this moment, on his own admission had been working as a painter, though he trained as a goldsmith.[5]

Two of the competition reliefs survive: Ghiberti's winning entry (Plate 3.2) and that of his fellow Florentine, Filippo Brunelleschi (Plate 3.3), now much better known as an architect (of Florence Cathedral's dome and several churches and chapels) than as a sculptor. Both included the same figures: Abraham, Isaac, an angel, the ram that arrived at the last minute to replace Isaac as sacrificial victim, and two servants waiting with an ass. These were presumably stipulated in the competition rubric. Why, then, was Ghiberti's judged the best?

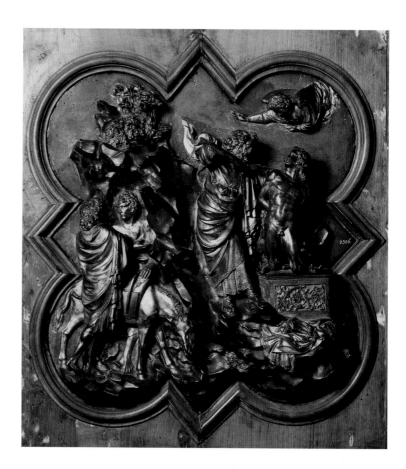

Plate 3.2   Lorenzo Ghiberti, *Sacrifice of Isaac*, 1401, bronze, 53 × 45 cm, Bargello, Florence. Used with the permission of the Ministero Beni e Attività Culturali. Photo: © 1990 Scala, Florence.

The prowess of both Ghiberti and Brunelleschi at accurate anatomy, whether of human or beast, at convincing storytelling and at the illusion of three-dimensional space is not in question; nor are their classical credentials. The pose of Brunelleschi's servant on the lower left examining the sole of his foot is taken from a famous antique sculpture of a boy removing a thorn from his foot called the *Spinario*, while the physical perfection of Ghiberti's Isaac is equally classically inspired.[6] What is striking is the markedly different style in which the two sculptors pursue an illusion of life. Ghiberti's relief is the more elegant and coherent of the two, based as it is around the strong diagonal running from the ram through Abraham's arm to the collar bones of Isaac, and echoed by a weaker, fluid movement from the heads of the servants down through the landscape edge to the lower right. All figures are gracefully posed at an angle to the picture plane, showing off Ghiberti's prowess at creating an illusion of space and, in the figure of the angel above, foreshortening. Even Isaac's cloak, tossed before the altar, has a careless elegance. By contrast, Brunelleschi's relief demonstrates an unsettling contrast of brutality and indifference. Isaac crouches awkwardly, his father's hand at

his throat, and Abraham lunges so violently that his fluttering cloak catches around a nearby tree trunk. The inelegant and preoccupied attitudes of both servants strain the confines of the picture space at the lower corners, while Ghiberti's scene is fitted cleverly into the Gothic quatrefoil frame, defying the artificiality of such a peculiar picture space.

Ghiberti's relief may be easier on the eye, but part of the rationale of the competition was probably a test not just of style but of expertise. Bronze was expensive and required considerable technical skill to cast successfully. Andrea Pisano had resorted to Venetian bronze founders because of the dearth of expertise in Florence. The winner needed to prove himself adequate to the considerable technical challenge involved. This Ghiberti did. While Brunelleschi's relief is cast in several pieces which are then soldered and bolted onto the bronze base, Ghiberti's is cast in one hollow piece, with only the figure of Isaac and his surroundings cast separately and joined on. Although a more risky technique since potentially the whole cast could go wrong at once, it represents an impressive technical achievement as well as a significant

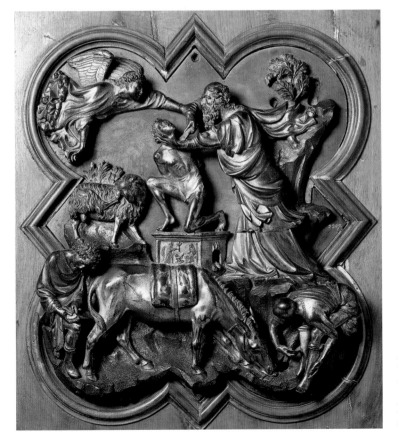

Plate 3.3   Filippo Brunelleschi, *Sacrifice of Isaac*, 1401, bronze, 55 × 45 cm, Bargello, Florence. Used with the permission of the Ministero Beni e Attività Culturali. Photo: © 1990 Scala, Florence.

financial saving because less bronze was used. As Richard Krautheimer pointed out, the hollow format also made flaws easier to repair.[7] Even a perfectly cast bronze required extensive 'chasing' – that is, smoothing and polishing with chisels, files and pumice – and Ghiberti seems to have excelled in this as well. He includes decorative detail, for example in the borders of the robes and the front of the altar; convincing texture such as the wool of the ram and the rough rocky setting; and flawlessly polished, rippling flesh. This detail is enhanced by partial gilding. Despite his youth, Ghiberti had proved his expertise.

Bronze casting was the technology of bell founders and the makers of cannons, and not all sculptors did their own casting. Donatello's tax returns revealed that in 1427 he owed a sum of money to a bronze caster for casting a reliquary bust of San Rossore (Museo Nazionale di San Matteo, Pisa).[8] Ghiberti, charged with the baptistery doors in November 1403 and a second set for the same building in 1425, had a foundry supplied by the Arte di Calimala, and he certainly did his casting himself.[9]

Ghiberti used the so-called direct lost wax method. A full-scale model of the sculpture was made either in solid wax or else in wax on a thoroughly baked core of clay, horse dung and hair or cloth clippings. The wax image was then coated with the same mixture used for the core. When this outer coating was hard, the wax was melted out through vents, leaving a cavity between core and the outer clay coating that corresponded to the full-scale clay model with which the sculptor began. The structure was then buried in a casting pit and the cavity filled with molten bronze, using the amount of wax melted off to calculate the bronze needed. Fifteenth-century Florentine bronzes were typically 90 per cent copper, up to 2 per cent lead and the remainder tin.[10] The cost and weight of the bronze cast depend partly on whether the sculptor used a core or not. Solid bronze is heavy and expensive, but it also tends to be marred by gas bubbles produced in the casting process.[11] For the lost wax method, it was better to use a core, which in the case of a relief could easily be removed after casting.

The problem with the lost wax method was that one cast only could be made; if it failed, the sculptor had to begin again. Vasari, nearly 150 years later, outlined a new casting method which enabled recasting in case of disaster and the production of multiple versions of the same sculpture. In the so-called indirect casting method, a plaster mould was taken in several different sections from a full-scale clay model. Each section of this mould was then lined with a thin layer of wax. The moulds were removed, and the remaining wax sections were reassembled over a core, so creating a wax version of the original clay model. The casting method from this point on was the same as the direct lost wax method. The plaster moulds could be reused to make new wax models and hence the same figure could be cast again and again.[12]

Ghiberti spent the next 21 years working on the casting and chasing of the 28 panels, 74 border panels, 48 heads and three large outer borders that constituted the doors. This first set of doors was modelled on those of Andrea Pisano, and each scene was set within a quatrefoil. The *Sacrifice of Isaac* was never used, though, for the programme was changed from Old Testament scenes to the New Testament.

The *Flagellation* relief (Plate 3.4) provides an insight into Ghiberti's working methods. The aggression of the assailant to the left is hampered by the fact that his right arm is wrapped around a column. Krautheimer suggested that the model for the cast was done in phases, beginning with the figures, and that it was in the final addition of the architecture that the mistake was made.[13] A sheet of drawings formerly owned by Vasari survives showing five studies of men brandishing whips, one of whom is virtually identical to the assailant with the trapped arm (Albertina, Vienna). Hurriedly scribbled in pen and ink, these sketches are not at all what one would expect of an artist carefully copying the work of another artist for the purpose of training or borrowing motifs, so it seems possible that the drawing is by Ghiberti himself. If so, drawing may have played an important part in working out convincing and lifelike poses for the reliefs.

Plate 3.4   Lorenzo Ghiberti, *Flagellation*, *c.*1416–19, gilded bronze, 51 × 43 cm, north doors (right door, inner panel, second from the top), Baptistery, Florence. Photo: © 1990 Scala, Florence.

## 2   The Goldene Rössl

It is often claimed that the roots of Ghiberti's lyrical verisimilitude lay not in Italy but in northern Europe, and there is a little evidence to show that he did admire northern metalwork. One of the artists for whom he expressed admiration in the *Commentaries* was a goldsmith from the Cologne area called Master Gusmin, whom he described as 'perfect in his works' and 'equal to the ancient Greek sculptors'.[14] Most metalwork from the turn of the fifteenth century was melted down centuries ago, and no work can now be identified by Master Gusmin. Indeed, according to Ghiberti, he ended his days in a hermitage in distress at witnessing the destruction of his work. An extraordinary work of art does survive from this period, however, which gives an impression of the technical skill and naturalism of northern goldsmiths. The *Goldene Rössl* (Plate 3.5) was made in 1404 as a present for New Year 1405 to the French King Charles VI (ruled 1380–1422) from his wife Isabel of Bavaria. The upper portions are of gold, studded with rubies, sapphires and pearls, and enamelled.

Plate 3.5  Unknown artist, *Goldene Rössl*, 1404, gold and enamel, 62 × 45 × 27 cm, Kapellstiftung, Schatzkamer der Heiligen Kapelle, Altötting (Bavaria). Photo: Bayerisches Nationalmuseum, Munich.

The architecture of the base and the armour of Charles VI, kneeling in prayer to the left, and of his knight, presenting Charles's helmet to the Virgin to the right, are of gilded silver. Concealing gold with coloured enamel represented the ultimate in opulence, but it used up-to-date technology peculiar to the court of France. Enamelling – a pigmented glass-based glaze fused onto a metal surface at high temperatures – had hitherto been employed chiefly for flat objects rather than three-dimensional ones.

The proportions and poses of all figures are convincing, from the Virgin reaching out to turn the pages of her prayer book to the two kneeling children below, identifiable as Saint John the Evangelist and Saint John the Baptist by their attributes, the chalice and the appealingly convincing lamb. The frizzy hairstyle of the equally childlike Saint Catherine, seated on a cushion behind Charles, is minutely detailed. The features of Charles VI appear to be based on life, and it is possible that the moustached knight, the horse and the barking dog behind Charles with its curiously cut fur may all be portraits of court favourites.[15] It is the horse and groom waiting below for their master which impress most of all, however, and from which the sculpture takes its name, for *Rössl* means a steed. The very complex contrapposto pose of the liveried groom and the impeccable anatomy of the neighing horse demonstrate the naturalistic skills of the craftsmen while remaining within the confines of elegance essential for such a costly and courtly object. Ghiberti cannot have seen the *Goldene Rössl*, which in 1405 was pawned to Isabel's brother and by 1413 was in the church of Our Lady in Ingolstadt in Bavaria, but it is tempting to think that the work of Master Gusmin, which he did know, might have been of similar naturalism.

The unknown goldsmiths responsible for the *Rössl* were faced with technical problems comparable to those facing the baptistery competitors of 1401. Gold was more precious still than bronze, and although it could be cast like bronze, it was fabulously expensive to do so. Only tiny portions like the foliage on the capitals were cast. A few components, such as the hands and Saint John's cup, are of solid gold, but even then the bottom of the chalice is hollow.[16] The edge of Saint Catherine's cushion that could not be seen was cut away, apparently as an economy measure. Most of the components are hollow, worked from sheets of the malleable gold, and, in the case of the parts to receive the enamel, are wafer thin. This working method, together with the fact that some but not all parts were to receive enamel, necessitated constructing forms from several different pieces. The famous horse is made out of some nine pieces soldered together, and the saddle was attached only after the rest had been enamelled. This saddle is decorated with punches rather like the punched gold background of medieval panel paintings. Both the lower and upper floors are punched with a simulated tile pattern. The fleurs-de-lis decorating the cloak of Charles VI were soldered on before enamelling and the blue enamel then poured into the gaps between them, like the *cloisonné* enamelling technique.

The effect of the enamel is to enhance the air of reality with which this ultimate in courtly sculpture is infused. The green simulates a lawn speckled with white daisies. Opaque white is used for the flesh tones of all the figures. The horse is also enamelled white, but remarkably its hooves are naturalistically coloured buff. Blue is used to simulate rich textiles, while the Christ Child and Saint Catherine wear red, symbolising sacrifice and martyrdom respectively. Precious stones within the trellis of the arbour evoke flowers, intermixed with white-enamelled gold flowers provisionally identified as hawthorn. The fillet around the head of Charles VI is studded with pearls. Goldsmiths' work was later relegated to the decorative arts, but around 1400 the *Rössl* represented the height of both craftsmanship and artistic innovation.

## 3   Champmol

According to Ghiberti, Master Gusmin worked for the French Duke of Anjou, and he was one of many expatriate artists from the area now defined by Belgium, the Netherlands and the German border who migrated to France in the late fourteenth century. The Parisian technique of enamelling figures in the round may even have been Netherlandish in origin. Around 1400, Paris was the foremost magnet for artists from north-west Europe, but that was all set to change when Charles VI's uncle, Philip the Bold (d.1404), married the heiress of Flanders, Margaret, in 1369. On the death of her father in 1384, he inherited not only territory but a tradition of outstanding artistic expertise that his patronage served to foster and

develop. While Margaret of Flanders sampled Parisian art – she gave her husband an enamelled Crucifix of precious metals as a New Year gift in 1403 (Museum of Christian Art, Estergom) – her French husband was employing Netherlandish craftsmen at the Carthusian monastery of Champmol near Dijon in Burgundy, which he refounded as his personal mausoleum. The most famous northerner whom he employed was the sculptor Claus Sluter (d.1406).

According to the lists of the Brussels stoneworkers' guild, which Sluter joined sometime prior to his arrival in Dijon, he was from Haarlem in the northern Netherlands. Sluter arrived at Champmol in March 1385 and took over as master sculptor in 1389, after the death of his predecessor Jean de Marville. Like Ghiberti, he had a large team of assistants that included junior craftsmen as well as accomplished sculptors like his nephew Claus de Werve and Hennequin Prindale from Brussels, later employed by Duke Amadeus of Savoy at Chambéry. Surviving works by Sluter should be regarded as team products, not those of a single man.

Jean de Marville began work on the tomb of Philip the Bold as early as 1384, but progress was slow. When a new contract was drawn up shortly after Philip's death in 1404 between Sluter and the new duke, John the Fearless, only two of the 41 mourners surrounding the tomb had been completed. By this time Sluter, like Master Gusmin, had retired to a monastery, and although he continued to work until his death in 1406, the tomb was finished only in 1410. Parts of the tomb itself are made of black marble from Dinant, but the figures are alabaster from Grenoble, roughed out with a sharp tool and then progressively modelled and smoothed with a variety of chisels, rasps and files. Alabaster takes a polish like marble, and at Champmol this final task of polishing was entrusted to two women: Jacqueline d'Orléans and Guillemine Leclerc.[17] Malouel, the court painter, applied finishing touches in azure blue and gold.

The revolutionary feature of the tomb was that the stylised relief figures of mourners that traditionally decorated high-status tomb chests were transformed into the illusion of a real funeral cortège comprising free-standing statues of clergy, laymen and Carthusian monks, set beneath a three-dimensional architectural arcade extending round all four sides of the tomb (Plate 3.6). Although the concept of a three-dimensional arcade is sometimes attributed to Jean de Marville rather than Sluter himself, it is also possible that Sluter effected this change to Marville's original design when he took over the project.[18] Sluter must surely have designed most of the mourners, even if he did not live to execute very many of them himself. Mourners appear to walk from one arcade to the next, carry heavy books, hold rosaries, read and gesticulate. They are captured in a variety of emotions from preoccupation to overt pain, some faces shrouded expressively in heavy hoods, others revealed lined with grief, hands raised as if to wipe weeping eyes. Nothing like this had been done before. The prestige of this monument is demonstrated by the fact that it served as a model for other high-status tombs.[19]

Equally celebrated for its lifelike qualities was Sluter's *Puits de Moïse* (*Well of Moses*), a gigantic stone cemetery Cross some ten metres in height and placed over a well in the great cloister at the monastery of Champmol.[20] Surrounded by the 24 cells of the monks, the cloister also served as a cemetery. Work began in 1396 and was finished by the end of 1405. The Cross, the figure of Christ and the figure of Mary Magdalene originally clasping the foot of the Cross have largely perished, though a few fragments were recovered from the site.[21] The hexagonal base, with its six prophet figures and six mourning angels, remains *in situ* at Champmol. The strongly characterised prophets with their heavily lined faces, the fall of their heavy drapery, and their lifelike poses – such as Jeremiah turning on his pedestal to one side – all contribute to the strikingly lifelike appearance of the work (Plate 3.7). Realistic details are also included: Jeremiah's book is carved as if the pages had just fallen open, the prophet's hand marking his place. Above, mourning angels clasp their hands and wipe their weeping eyes, adding an air of intense emotion to complement the moving image of the dead Christ above. Papal indulgences were granted to those praying at the Cross in 1418, 1432 and 1445.[22]

Plate 3.6   Claus Sluter, tomb of Philip the Bold, 1384–1410, alabaster and black marble, 360 × 254 × 243 cm, Musée des Beaux-Arts, Dijon. Photo: © 1990 Scala, Florence.

At least one copy was made of the structure in 1508 for the hospital at Dijon, and as late as 1601 the prior of a Carthusian monastery in Portugal requested drawings of it so that he could have a copy made.[23]

Such a monumental work needed engineering as well as artistic skills. An iron bar was supplied in 1396 to reinforce the Cross and pedestal, and this seems to have been secured down the central core of the structure with lead.[24] In 1398, before work on any of the figures was complete, Sluter took the precaution of making what may have been a large-scale plaster model.

The final structure was made of at least three different sorts of stone, including Tonnerre limestone for the Cross and limestone from Asnière for the figures. Despite its outdoor location, the Cross was both painted and gilded by Jean Malouel and another painter called Herman of Cologne, and this would have heightened its lifelike quality.[25] The artists used oil paints over a limewash, and fragments of colour survive, including the suggestion of horizontal stripes and gold stars on David's blue robe. Despite the adverse effect weathered copper would have on stone, a copper coronet was ordered for Mary Magdalene and a real pair of metal spectacles for Jeremiah, who is shown reading. David holds a harp low in his right hand; this had copper or perhaps bone strings (the borders of his mantle are also decorated with harps carved in relief). The wings of the angels were gilded, together with details such as David's harp and shoes. All these techniques helped to set new standards for the illusion of life at Champmol, but as with the *Goldene Rössl* it was an opulent naturalism appropriate for such a high-status patron.

Plate 3.7 Claus Sluter, *Well of Moses* (showing Moses, David and Jeremiah), 1396–1405, stone, Charterhouse of Champmol, Dijon. Photo: © 1995 Scala, Florence.

# 4  Orsanmichele

In Florence the main project around the turn of
the fifteenth century involving statuary was civic
rather than royal. Orsanmichele had originally
been a grain market that was transformed into
a church on account of a miracle-working image
of the Virgin. As early as 1339 a ruling had been
made that the Florentine guilds should each
decorate a pier of the church with a statue of
their patron saints, but very few complied; the
Signoria, the city's ruling body, reiterated the edict
in 1406, with a time limit of ten years. This haste
created a unique atmosphere of artistic creativity
and competition on the part of guilds and artists.
Ghiberti was the technical innovator in making
two statues not of the conventional marble but
cast from bronze. In fact, so innovative was it to
use bronze for a large-scale figure that in 1413–16
Ghiberti was obliged to cast the Saint John the
Baptist for the cloth merchants' guild at his own
risk. His second statue was a Saint Matthew made
for the bankers' guild in 1419–23, for which he
designed the tabernacle as well.

Bronze was a costly, risky and hence impressive
material to choose, and most of the other statues
commissioned for Orsanmichele were of marble.
Marble was the conventional material for Tuscany,
indeed for much of Italy, and also for ancient
Roman sculpture. The pure white marble quarried
in the region of Carrara was particularly favoured
in fifteenth-century Tuscany. The quarried stone
was transported to Pisa, which from 1406 was
ruled by Florence, and then taken along the River
Arno to Florence. The brittle nature of marble
served as a limitation to what might be attempted;
protruding or vulnerable sections were easily
broken, leaving the statue beyond saving. On the
other hand, marble could be highly polished, and
varying the degree of this polish could suggest or
accentuate a variety of surface textures while also
controlling the reflection of light.

Two of the marble ensembles at Orsanmichele
were really innovative in terms of the illusion
of life, one by Nanni di Banco, one by Donatello.
Neither is securely documented but both were
probably completed around the same time, c.1417.[26]
Donatello's *Saint George* was commissioned by the
guild of armourers and sword-makers, Nanni di
Banco's *Four Crowned Saints* for his own guild, the
stone and woodworkers.

Donatello had been employed by Ghiberti c.1404–7
as an assistant working on the first bronze doors of
the baptistery. In 1412 he entered the Florentine
artists' Confraternity of Saint Luke as a stone-
carver and goldsmith, but also worked in wood,
terracotta, bronze and stucco. Nanni di Banco, then
the older and more eminent of the two, was the son
of the master of works of Florence Cathedral, and
by the time the Orsanmichele statue was made he
had held office in the guild of sculptors and also in
the government of Florence.

In contrast to Sluter's *Well of Moses*, Nanni di
Banco's *Four Crowned Saints* derive their realism
partially, though not entirely, from classical art
(Plate 3.8). The four patron saints were sculptors
who had been martyred under the Roman ruler
Diocletian for refusing to make a pagan cult
statue for worship, so in a sense Nanni di Banco's
classicising style suits the subject. The four
figures are arranged in the niche like four Roman
senators with their close-cropped hair and toga-like
garments. The figure to the right gesticulates with
his mouth open as if speaking, very much like a
classical orator. The youngest figure on the inner
left resembles some sculptural portraits of Junius
Brutus – in fact all four heads resemble Roman
portrait busts, which were readily accessible in
fifteenth-century Italy – and the concept of the
fictive curtain found behind the figures might
have been taken from Roman funerary reliefs
and sarcophagi.[27] The two saints to the right are
carved from the same block. As Mary Bergstein
pointed out, Pliny the Elder praised Lysias,
Apollonius, Tauriskos and Arkesilaos for carving
more than one figure from a single block, so this
may have been viewed as something of a technical
feat.[28] Surviving Roman statues were invariably
unpainted (although some might have been
coloured originally); the *Four Crowned Saints* were
not polychromed either, though coloured stones
create a rich pattern in the tabernacle behind.
For the four consuls of the sculptors' guild and its
members gathering at the tabernacle on the feast
day of their patron saints, these four gesticulating

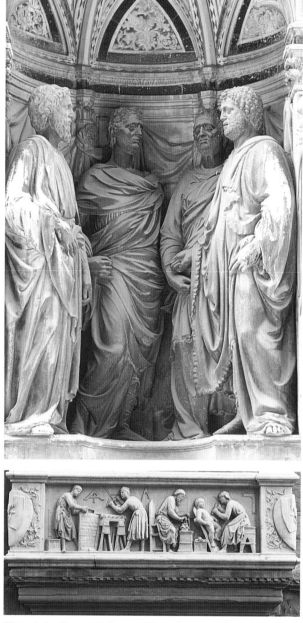

Plate 3.8    Nanni di Banco, *Four Crowned Saints (Quatro Coronati)*, c.1415–17, marble, height c.183 cm, Orsanmichele, Florence. Photo: Bridgeman Art Library, London.

and interacting statues must have had an extraordinary resonance.

Like Nanni di Banco's *Four Crowned Saints*, Donatello's *Saint George* also recalls ancient Roman sculpture, not least because he wears superficially Roman-style armour and sports a

Roman hairstyle (Plate 3.9). These details are far less significant than the intensity and immediacy of the pose and expression of this soldier saint. His stance is poised, relaxed but alert, twisting a little from the waist, head slightly turned and gaze fixed on some undefined object, the eyebrows faintly raised, the brow furrowed. His weight is unequally distributed, more on the left leg than the right as if stepping slightly, a subtle adaptation of the rather more elegant contrapposto stance characteristic of ancient Roman statues. Just as David and Jeremiah in the *Well of Moses* were given real items to heighten verisimilitude, so Saint George may originally have worn a metal helmet, for traces of metal have been detected in drill holes in the head. He also probably held a metal sword in his right hand, which would have had significance for the guild that commissioned the work. Vasari paid tribute to its lifelike qualities: 'there is a marvellous suggestion of life bursting out of the stone'.[29]

It is almost inconceivable that Donatello could have produced this complex statue working directly into the block of stone without having made some sort of prior design, but his preparatory methods remain uncertain. He might have produced drawings; according to Gauricus's 1504 treatise on sculpture, Donatello is supposed to have told his pupils 'that the art of sculpture could be taught with one word: draw!'[30] No surviving drawings can be attributed to Donatello with any certainty, but Vasari mentions one at the end of his life of Donatello. The mid-sixteenth-century goldsmith, sculptor and treatise-writer Benvenuto Cellini claimed that Donatello made small-scale preparatory models, and around the same time Vasari described how such models might be made out of clay or wax (which could be warmed and reworked if necessary).[31] A method for scaling up a smaller model to make a statue was outlined by Alberti in his treatise *De statua* or *On Sculpture*, dating from the 1460s or perhaps earlier.[32] There is no clear evidence that Donatello used such methods, however. No preparatory models survive or are documented with the exception of the model for the pulpit Donatello and his partner Michelozzo were contracted to make for Prato Cathedral in 1428, and this was clearly done for the benefit of the patrons rather than the artist.

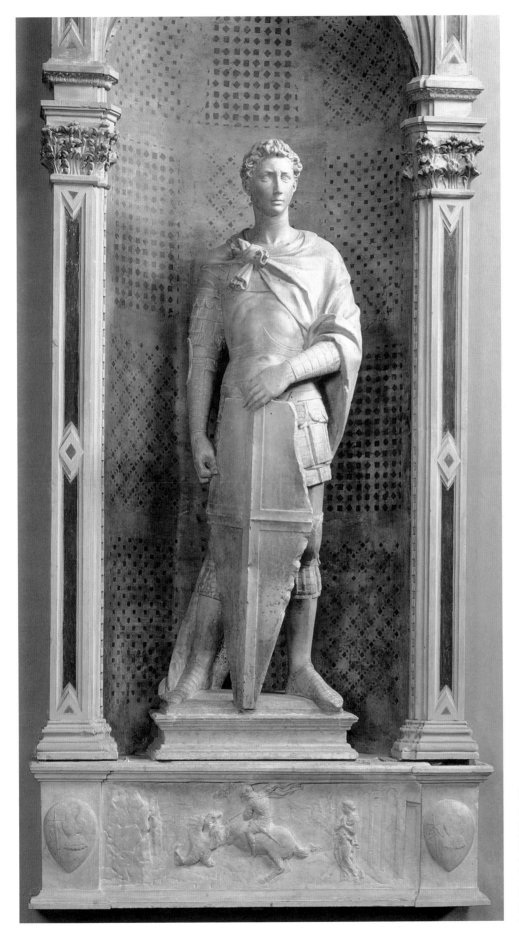

Plate 3.9   Donatello,
*Saint George*, *c.*1415–17,
marble, height 209 cm,
Museo Nazionale del
Bargello (originally
Orsanmichele),
Florence. Photo:
Bridgeman Art Library,
London.

# 5   Relief sculpture in Florence

Beneath the *Four Crowned Saints* were set relief carvings that have become almost as famous as the statues themselves. They represent the activities of the saints above (and also of the stoneworkers of the commissioning guild): a mason building a wall, a sculptor making a twisted column, a second measuring a capital with a set square, and a third roughing out a statue of a putto (naked boy).[33] However original the subject matter might be, the high-relief technique Nanni di Banco used is not: figures are carved almost but not quite in the round from a flat background, the sense of depth dependent on the nearly three-dimensional nature of the carving rather than illusionistic effects. This is a standard relief technique often used by fourteenth-century Italian sculptors.

Donatello's relief scene of *Saint George and the Dragon* set below his statue (Chapter 2, Plate 2.5) forms a total contrast. Donatello carved parts of Saint George, the dragon and the princess in higher relief, setting up dark shadows with the undercutting and hence sharpening the visibility of these key figures, rather as a painter might use strong tonal contrast to emphasise foreground figures. None of the scene could be classified as high relief, and parts of it are extremely shallowly carved. This was probably Donatello's first venture in what has come to be known as *rilievo schiacciato* (squashed relief), in which he relied not so much on a contrast between high and low relief to create the illusion of spatial recession but on a far more complicated use of undercutting, textures, incised lines and limited variations in depth of carving

in what was essentially an extremely low relief. The principal figures appear flattened rather than conventionally modelled. It gives an unprecedented impression of spatial depth, turning a relief into a sort of carved picture. This form of relief carving is probably Donatello's most celebrated technical innovation.

Donatello's *Christ Giving the Keys to Saint Peter* is perhaps the archetypal example of fully fledged *rilievo schiacciato* (Plate 3.10). The subject is slightly unusual, combining as it does the giving of the keys of the kingdom of heaven (Matthew 16:18) with the ascension of Christ (Luke 24:50–3 and Acts 1:6–11).[34] This relief is carved to a depth of only a few millimetres, so although figures in the foreground are in slightly higher relief than the background, the differences are very subtle, and figures are accented more by the use of shadow created by undercutting. The profile of Christ's face, his right arm and the drapery around his knees are all undercut for emphasis. The background trees and clouds, by contrast, are barely scratched into the surface of the marble and at a distance are scarcely visible. *Rilievo schiacciato* excels in conveying such convincing atmospheric effects but really requires close scrutiny. The emphasis is on expressive poses rather than the impeccable anatomy and acutely captured pose of Donatello's *Saint George*. The low viewpoint emphasises the upward movement of Christ but impedes somewhat the sense of spatial recession so marked in the *Saint George* relief, and makes the figures here appear squat and oddly proportioned. For this relief Donatello chose not white but grey-veined marble; he left the surface relatively unpolished,

Plate 3.10   Donatello, *Christ Giving the Keys to Saint Peter*, c.1430, marble, 41 × 115 cm, Victoria and Albert Museum, London (original location uncertain but possibly Santa Maria del Carmine, Florence). Photo: © V&A Images/Victoria and Albert Museum.

the texture a little like fine sugar, so that rather than reflect the light the luminosity of the marble is exploited to the full.

Instead of the usual marble, Donatello's *Cavalcanti Annunciation* relief in Santa Croce is carved of local sandstone (Plate 3.11). *Macigno* is a soft stone suitable only for interior use but easy to carve, which may account for the unusually rich carved and gilded decoration in the background and, for example, in the collar of the Virgin's dress. This stone does not take a polish, however, and was never designed to be polychromed, so the finish is slightly rough. Made for the Cavalcanti family chapel and usually assigned to the 1430s, this is a very different kind of relief in which Donatello utilised the greater real depth of the architectural tabernacle in order to create the illusion of an interior setting with intarsia (or inlaid) panelling, even suggesting that the join between the two blocks of stone of which the background is made is a closed door.[35] The terracotta putti on top of the tabernacle add a touch of realism: Vasari suggested that they were clinging to each other as if scared of the height at which they found themselves![36] This mix of stone and terracotta is unusual and some claim that the putti were added as an afterthought, but they would originally have been painted to harmonise with the work as a whole.

Where Donatello's *Saint George* evokes a timeless naturalism and dynamism of pose, the *Cavalcanti Annunciation* evokes primarily the antique in the architectural and decorative forms used and in the profile of the Virgin, which is sometimes said to resemble Greek more than Roman models. In fact, Renaissance sculptors had virtually no first-hand experience of ancient Greek sculpture, though in 1429 Poggio Bracciolini at least was trying – largely unsuccessfully – to collect genuine Greek sculpture from agents at Rhodes and Chios. Donatello had been consulted on ancient statuary that Bracciolini acquired in Rome, and it has been suggested that he might even have been invited to view the few Greek items that finally reached Bracciolini's and Cosimo de' Medici's collections.[37] Be that as it may, ancient Roman sculpture was the crucial model for Renaissance artists.

In contrast to the detail and decoration of the *Cavalcanti Annunciation*, Donatello's relief carvings decorating an organ loft[38] in Florence Cathedral were criticised by at least one early sixteenth-century commentator as sketchy and

unfinished.[39] Two organ lofts, or *Cantoria* (*Singing Galleries*) (Plates 3.12–3.13), were commissioned for either side of the crossing of Florence Cathedral in the 1430s, one from Donatello and one from his near contemporary, Luca della Robbia (c.1399/1400–1482), who attained fame primarily for his terracotta reliefs but who also worked in stone. Both *Cantoria* were dismantled in the seventeenth century and have been provisionally reconstructed from the remaining architectural fragments.

Luca della Robbia's *Cantoria* includes ten panels of music makers and dancers of superbly naturalistic anatomy and pose, many of which were culled from antique sources such as carved sarcophagi. These graceful scenes were carved in high relief against a plain background, the base sometimes overhanging the edge of the structure, giving the illusion that the figures are standing on solid ground. The level of detail in hair and drapery, for example, and the polished finish of the marble are superb. Donatello's *Cantoria* is also carved in high relief and his dancing angels again appear to stand on an illusionistic ground, but there the similarity ends. A continuous frieze of riotously dancing putti is glimpsed behind double columns decorated with tesserae (the small blocks with which mosaics are made). The winged children are lumpy in anatomy and occasionally awkward in pose, their drapery and faces somewhat rudimentarily carved, and the whole work lacks the lustrous surface of Luca della Robbia's, though the gold tesserae with which the background is also studded add a lustre of their own.

While Luca's *Cantoria* may have been generally preferred at the time, Vasari defended his hero Donatello's work.[40] His argument was effectively that the high polish used by Luca flattens forms and reduces visibility (rather like flash photography), while Donatello's rough surfaces become a virtue *in situ* because they increase visibility. It is not possible to be sure to what extent this was premeditated or whether Donatello was essentially not particularly interested in detail and applied himself to surface finish only where essential. It is significant, however, that by the sixteenth century technique was being debated not in terms of meticulous craftsmanship but in terms of effect.

So far as meticulous craftsmanship goes, it was Ghiberti rather than Donatello who dominated

Plate 3.11   Donatello, *Cavalcanti Annunciation*, *c.*1430s, sandstone, height 420 cm, Santa Croce, Florence. Photo: Bridgeman Art Library, London.

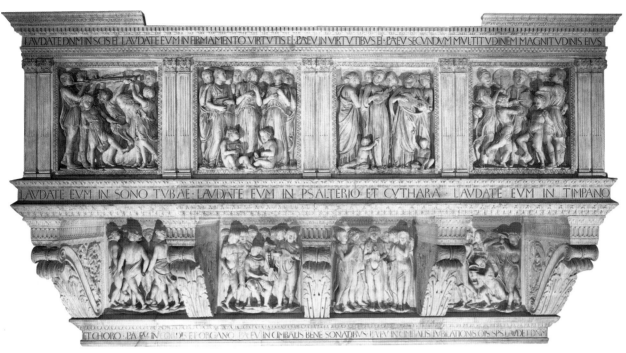

Plate 3.12   Luca della Robbia, *Cantoria*, 1431–8, marble, 328 × 560 cm, Museo dell'Opera del Duomo, Florence. Photo: © 1990 Scala, Florence.

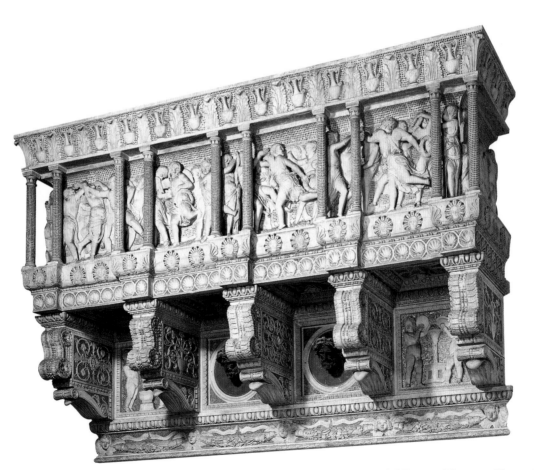

Plate 3.13   Donatello, *Cantoria*, 1433–9, marble, length *c.*570 cm, Museo dell'Opera del Duomo, Florence. Photo: © 1991 Scala, Florence.

119

the art of relief sculpture in the first half of the fifteenth century. Ghiberti's first set of baptistery doors were so admired that he was engaged to produce a second set for the north entrance, though in the final event the first set were moved to the north, leaving the new set for the principal east entrance. The second doors were begun after 1428/9 and cast by 1437, though the chasing was still not complete in 1444 and the doors were finished only in 1452. Instead of the rather artificial pierced quatrefoil format and limited illusion of space

of the reliefs in the first doors (Plate 3.4), the second doors comprise ten roughly square reliefs which offer greater potential for the illusion of a 'real' scene. In the *Joseph* panel, for example, Ghiberti creates depth by using higher relief in the foreground, contrasting with low relief in the background; but it is the impeccable perspective of the receding architecture, and the three narrative moments set in diminishing scale at spatial intervals, that create convincing recession (Plate 3.14). In the left foreground the 'stolen' cup is

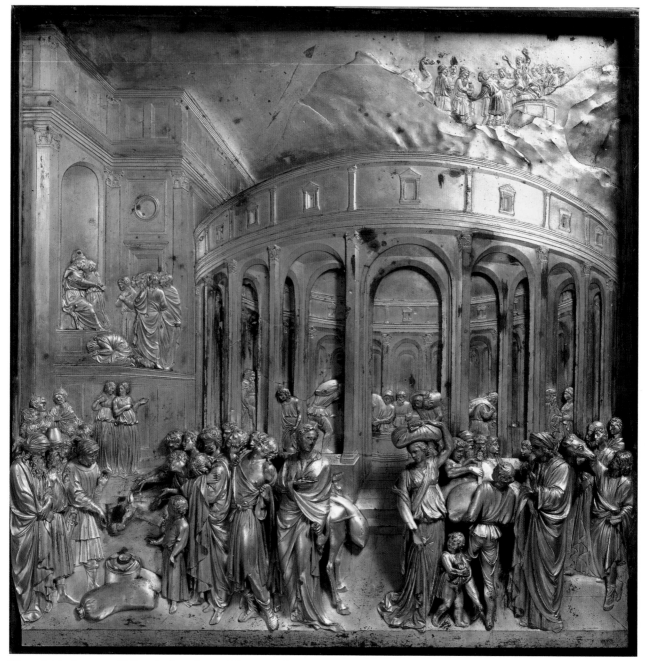

Plate 3.14  Lorenzo Ghiberti, *Joseph* panel from the *Gates of Paradise* (right door, centre panel), *c.*1435, fire-gilded bronze, 80 × 80 cm, Baptistery, Florence. Photo: © 2000 Scala, Florence.

discovered in the sack of the framed Benjamin, and his older brothers dramatically tear their robes in distress. Above, in lower relief, the brothers plead with Joseph. Above the circular building is the tiny, earlier narrative moment of Joseph sold by his brothers to the Ishmaelites.[41] Ghiberti's penchant for realistic anecdote is revealed in the individuals manhandling sacks of grain in the right foreground and the little boy who carries his tiny load wrapped up in the skirt of his tunic. Through his convincing poses and ambitious setting of figures in space, Ghiberti captures the bustling atmosphere of a busy marketplace. The elegance of pose is as marked as ever, but the looping drapery folds of the first doors are replaced by antique-style dress epitomised in the woman carrying a sack of grain on her head in the right foreground.

Ghiberti cast some figures separately using more fluid bronze and joined them onto the main panel. All of the reliefs were then fire gilded: the bronze surface was covered with a paste of ground gold mixed with mercury and fired at a low temperature so that the mercury burned off, leaving the gold melted and fused with the bronze surface without melting the sculpture. According to Vasari, it was no less a figure than Michelangelo who dubbed these doors the 'gates of Paradise'.[42]

# 6   Materials and techniques in the Netherlands

Fifteenth-century sculptural traditions in northern Europe were very different from Italy. Here bronze was primarily employed for high-status tombs rather than complex reliefs. Marble was not available, though alabaster served as an acceptable substitute, as in Sluter's tomb of Philip the Bold (Plate 3.6). In the Netherlands, wood was one of the most common materials used in sculpture, and the most sought-after wood was the high-quality oak imported by sea from Baltic ports such as Danzig (now Gdańsk in present-day Poland).

Baltic oak was felled initially from primary forests in the hinterlands of Danzig and, as the fifteenth century progressed and forests became exhausted, from further east into Lithuania. Baltic oak was infinitely superior to the local oak of north-west Europe because its slow, steady growth produced a wood with few knots and narrow growth rings, which meant that the damaging atmospheric expansion and contraction to which wood is so prone was reduced to a minimum. This is the material out of which much fifteenth-century northern sculpture was produced, and Netherlandish guilds exerted stringent quality controls about its use. The Brussels sculptors' guild and the Antwerp guild of Saint Luke passed regulations in 1454 and 1470 respectively stipulating that carvers could work only in oak or walnut – not, for example, the limewood so favoured in Germany which, though easier to work, is very prone to insect infestation and cracking. The use of unseasoned wood or sapwood (also prone to infestation) was strictly forbidden. The regulations required completed wood sculpture to be inspected by the guild and hallmarked before it could be delivered to the customer. Polychromy was the province of the separate painters' guild in Brussels, but in Antwerp both sculptors and painters belonged to the same guild, so collaboration in the production of painted sculpture was somewhat more straightforward.

The Burgundian Netherlands (that is, roughly present-day Belgium and the Netherlands) was particularly famed for carved wooden altarpieces. Indeed, Philip the Bold commissioned two such works for the Charterhouse of Champmol in 1390, and both survive in Dijon's museum (Plate 3.15). These altarpieces had rudimentary narrative scenes and standing saints, but in neither style nor structure were they realistic. Only a couple of decades or so later, however, an unknown Netherlandish sculptor known as the Master of Hakendover carved an altarpiece of walnut for the Reinoldikirche, Dortmund that was truly innovative in terms of the illusion of life (Plate 3.16). Here the twelve apostles stand to either side swathed in elaborate, looping Gothic-style drapery. Nevertheless, the poses of these apostles are lifelike, and they gesture and communicate beneath their tracery rather as Sluter's mourners did under the arcade of Philip the Bold's tomb (Plate 3.6). The naturalism of the figures of the central *Crucifixion* infinitely exceeds that of the puppet-like figures of the Champmol altarpieces. The emotional expression is so powerful that it has wrongly been assumed that the carver must have derived his style from the painter Rogier van der Weyden: the altarpiece probably dates from before 1420, whereas Rogier only began his apprenticeship in 1427.[43] The piled-up figures

Plate 3.15   Jacob de Baerze, *Crucifixion* altarpiece, 1390–9, gilded, polychromed oak, 167 × 252 cm, Musée des Beaux-Arts, Dijon. Photo: © RMN.

of the *Crucifixion* evoke a real spatial setting no more than did Ghiberti's contemporaneous first set of doors. However, the carver cut new ground in spatial illusionism by simulating an ecclesiastical interior through the tracery decorating the back of the case and the three-dimensional canopies above.

Subsequent Netherlandish carved altarpiece producers refined this spatial illusionism, and produced narrative scenes of an extraordinary intricacy and lifelike quality, heightened by sumptuous polychromy. The de Villa altarpiece, made by a Brussels carver, is particularly interesting because it shows the allure that these exquisitely detailed works of art had for other Europeans. It was commissioned by a member of the expatriate Italian de Villa family, representatives of which lived in Bruges and Brussels, and was exported to Chieri in Italy to be placed in the family chapel of the Dominican church (Plate 3.17).[44] In Netherlandish carved altarpieces it was not normal practice to include donor figures within the carved scenes, although they were sometimes depicted on the painted shutters. Here, however, the carved figures of

the donor and donatrix are represented with their patron saints to either side of the central Crucifixion. The narrative scenes are carved with virtuoso skill principally out of a single block of wood (two in the case of the Crucifixion), suggesting space through the sloping ground of each scene and recession through the vertical stacking of figures. The resistant oak was apparently no impediment to fine detail, such as the excavated area below the table in the first scene, where the kneeling Mary Magdalene pushes her head beneath the tablecloth to anoint Christ's feet. Individual figures measure less than 40 cm in height, so these scenes are three-dimensional, lifelike narratives in miniature; they represent the ultimate, perhaps, in terms of art visualising sacred stories in ways accessible to the viewer.

The polychromy of this altarpiece is of a beauty to rival the carving, and enhances its lifelike qualities while also evoking the heavenly through its richness.[45] To prevent the paint soaking into the wood, the carvings were prepared in very much the same way as wooden panels to be painted: they were covered with fine layers of chalk mixed with

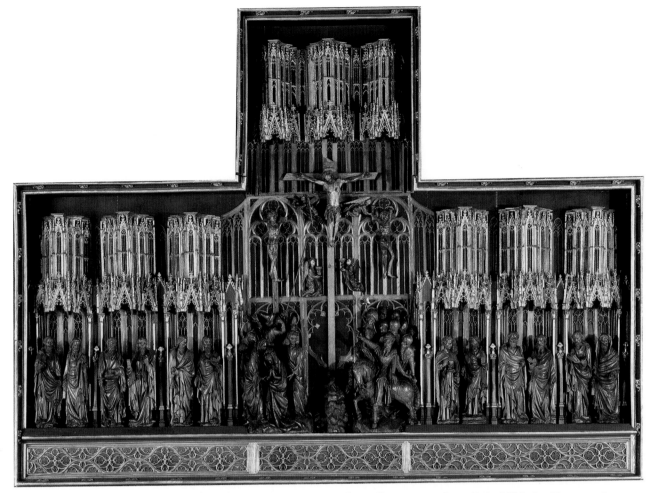

Plate 3.16  Master of Hakendover, *Crucifixion* altarpiece (central panel), *c*.1415, walnut, Reinoldikirche, Dortmund. Photo: Glahs and Wulfert, Muelheim.

glue. Areas to receive gold leaf were painted with a red substance called bole, which shone through the gold leaf and increased its brilliance. Gold was applied in tissue-thin leaves, which were burnished to reflect the light, rather like polishing marble. The gold might then be decorated with punchmarks as in the *Goldene Rössl*. Simulated brocade fabrics were created through the application to the figures of thin, moulded appliqué sheets of wax or chalk mixed with glue, which were gilded and painted. More typical of Antwerp polychromy was the *sgraffito* technique, where colour was applied over the gold leaf and then scratched away so the gold showed through to make a pattern, again simulating rich fabrics. Polychromy was no inferior art but of a quality to rival painted panels, and even famous painters such as Jan van Eyck and Rogier van der Weyden were occasionally commissioned to polychrome sculpture.[46]

Brussels and Antwerp sculptors developed highly commercial strategies for commissioning and marketing carved altarpieces, and indeed other wooden sculpture.[47] However, a carved altarpiece commissioned by the Confraternity of Our Lady, s'Hertogenbosch in 1475 from the Utrecht carver Adriaen van Wesel (active 1447 – d.1489) gives an idea of how a more typical commissioning process would be conducted.[48] Initially, representatives of the Confraternity of Our Lady – including the painter Hieronymus Bosch (d.1516), his brother and father – discussed the commission with van Wesel, who came to s'Hertogenbosch for the occasion. Designs were debated at this meeting and detailed designs were subsequently made, though it is not absolutely clear by whom. Members then rode to Utrecht formally to commission the work, which was to be completed within two years. Brotherhood representatives visited Utrecht the

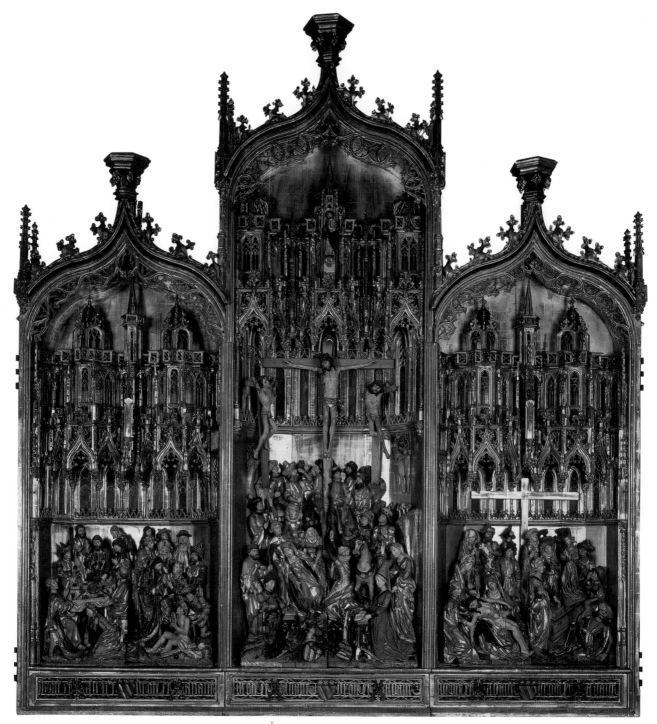

Plate 3.17   Unknown Brussels carver, de Villa altarpiece, 1460s, gilded, polychromed oak, 265 × 252 cm, Musées Royaux d'Art et d'Histoire, Brussels.

following year to check on the quality of the work. In 1477 the carver sent one of his assistants to announce that the altarpiece was ready. In order to carve such a large and complex work in two years, van Wesel must have employed several such assistants. The confraternity then shipped the altarpiece to s'Hertogenbosch along the river system. Often carvers supervised the installation of their altarpieces themselves or sent assistants to do so, but in this instance van Wesel was summoned only after the work had been installed in the church. He successfully appealed to be paid 10 per cent more than the sum originally agreed, claiming the altarpiece was better than stipulated in the contract. Both polychromy and the supply of painted wings were under the control of the patron

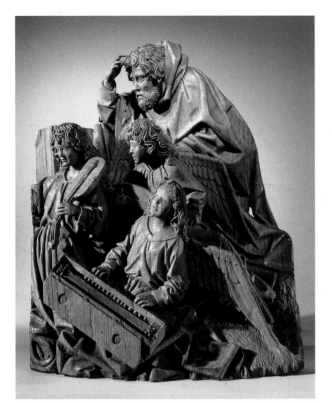

Plate 3.18   Adriaen van Wesel, *Angel Musicians* (fragment of s'Hertogenbosch altarpiece), 1475–7, oak, 45 × 38 cm, Rijksmuseum, Amsterdam. Photo: © Rijksmuseum, Amsterdam.

rather than van Wesel, and were done in the early sixteenth century. This was a celebrated work of art, which the confraternity guarded for six days and nights from image breakers in the religious troubles of 1566.

This altarpiece, dedicated to the life of the Virgin, was largely destroyed, but the sections that survive give an idea of the stunning quality of the original work. Unlike most Brussels altarpieces of the same era, the scenes were constructed not out of a single block but out of several fitted together like a jigsaw puzzle. Here the sheer scale of the altarpiece might have necessitated such a strategy, but the 'jigsaw' technique was also routinely used by Antwerp altarpiece makers. Joseph and the angel musicians must have belonged to a Nativity (Plate 3.18). This is a touchingly homely scene, amiable angels playing recognisable musical instruments, skilfully arranged behind one another on the sloping ground to create an illusion of space. In its original state, the illusionistic scenes, the naturalistic figures and the realistic polychromy must have evoked a powerful impression of life despite the humble medium of wood.

# 7   Materials and techniques in Italy

Although extensively used for crucifixes and devotional statues, wood-carving was far less esteemed than marble in Italy. There was a long tradition of wood statuary in Siena, however, where marble was harder to obtain. Here sculptor Jacopo della Quercia (?1374–1438), one of the 1401 contestants for the Florence Baptistery doors, lived and worked. According to Vasari, Jacopo 'began to show that it was possible to make an approach to nature, and [was] the first who encouraged the others to hope to be able in a certain measure to equal her'.[49] Jacopo's father had been a wood-carver as well as a goldsmith, and although primarily a stone-carver, Jacopo also produced wood sculpture on occasions. *The Annunciation* (Plate 3.19) was carved of chestnut, and both figures were hollowed out to minimise cracking. The polychromy, which survives, was done by a friend of Jacopo's and is relatively naturalistic, with gold used only with restraint, unlike the elaborately decorated and heavily gilded polychromed altarpieces of the Netherlands. Gabriel, whose wings are now missing, is somewhat unusually represented erect, less like a heavenly messenger than a Roman senator with the fillet around his brow, and the illusion of life lies less in the figures than in the dynamic between them. The essence of *The Annunciation* is the communication between the two protagonists, and the two separate figures appear designed to be placed at a distance from one another, such as across a portal or even a chancel arch.[50] By means of the divided location of the two figures and their convincing poses, a dramatic encounter is re-enacted in sculpture, enlivened by the naturalistic polychromy.

It was the versatile Donatello who, albeit on rare occasions, exploited wood to more expressively dramatic effect. His best-known wooden sculptures are a John the Baptist dated 1438, carved for the Frari church in Venice, where Florentine expatriates had a chapel, and a Mary Magdalene (Plate 3.20), documented in Florence Baptistery by 1500, who is represented not as a fashionable courtesan but as the penitent she is claimed to have become in later life.[51] This figure is undated but probably was made around the same time as the Saint John. In contrast to the block-like forms conventionally used to mask the hollowed-out core of the figure, Donatello chose to overcome the dangers of cracking by

Plate 3.19   Jacopo della Quercia, *The Annunciation*, 1421–6, polychromed chestnut, angel (left) 173 cm, Virgin (right) 174 cm, Collegiata, San Gimignano. Commissioned for the church in 1421; the base of the Virgin bears the date 1426 and the signature of the polychromer Martino di Bartolommeo, and Jacopo signed the base of the angel. Photo: © 1990 Scala, Florence.

making the statue very shallow and excavating between the legs, effectively hollowing the figure in a naturalistic way.[52] The polychromy too was naturalistic, eschewing the bright colours of Jacopo's *Annunciation* in favour of a tanned skin, bright blue eyes and light brown hair with liquid gold highlights instead of solid gilding. The gesso (calcium sulphate), applied to provide a smooth, non-absorbent surface for the polychromy, was itself carved to simulate the hair falling over the arms. Not surprisingly, the gesso details have disintegrated over time, but they illustrate the virtuosity with which Donatello approached the medium. Vasari commended Donatello for his rendering of Mary Magdalene's frightening emaciation.[53]

Italy could boast one material commonly used for large-scale sculpture that was only seen in low-cost, small-scale sculpture in the north: terracotta. Donatello may have pioneered its use on a large scale, for in 1410–12 he made a giant figure of Joshua, now lost, for one of the buttresses of Florence Cathedral, imitating the antique both in the size of the statue (colossi were a classical concept) and in the medium (the Roman treatise writer Vitruvius associated terracotta with the Etruscans, forebears of the Tuscans).

Luca della Robbia was the foremost sculptor in terracotta in Florence. He pioneered a technique for glazing three-dimensional terracotta figures and reliefs by adapting the glazes used for flat maiolica ceramics. The della Robbia recipe remained a closely guarded family secret. The clay was fired and then painted with pigment mixed with about three times the level of tin opacifier (tin oxide) that would normally be used for maiolica.[54] The result was an extremely durable and attractive alternative to polychromy that made the della Robbia kiln very popular in the fifteenth century. Between 1442 and 1445, Luca produced a large-scale lunette-shaped *Resurrection* relief (Plate 3.21) to be placed over the north sacristy door in the

cathedral. The contract mentions a preparatory drawing, but this might have been supplied by the patrons rather than the artist.[55] Like Brunelleschi's competition relief, it was fired in several pieces that were then joined together: Christ, for example, was joined at the waist.[56] These glazed terracottas represented more of a technical advance than an advance in naturalism, for the medium failed to attain effects of spatial recession just as the small colour range and gilded details could not serve to heighten the illusion of life. Here the most convincing figure, the soldier lying on his back, is probably derived from the antique, Luca's continuing source for realistic figures.

Unglazed terracotta was used to very different effect by the northern Italian sculptor Niccolò dell'Arca (d.1494), who, perhaps inspired by the intense emotional expression of some of Donatello's work, modelled a large-scale *Lamentation* group of astonishing emotional realism for the hospital church of Santa Maria della Vita in Bologna in 1463 (Plate 3.22). Like Sluter's *Well of Moses*, it quickly attracted a papal indulgence in 1464.[57] So convincing is the drama of the piece that it has been considered repulsive as well as remarkable. Its original layout is unclear, for all six of the bystanders surrounding the impassive figure of the dead Christ are movable. According to the most plausible reconstruction, the composition is one that explodes from the right and comes to rest on the left with the impassive kneeling figure of Joseph of Arimathea, who engages the viewer.

Mary Magdalene and one of the other women are represented as if rushing to the scene and caught mid-movement and off balance, their headdresses and robes fluttering behind them and blown close to the body in front. It has been suggested that the model for the dramatic pose of Mary Magdalene might have been an antique figure of Victory.[58] Her flying drapery is a tour de force of modelling in clay; it would have been quite impossible to carve in the brittle, traditional medium of marble. The mouths of all four women are open as if they were howling in grief, while the face of John the Evangelist is crumpled as if he were bursting into tears. His wildly curling hair is arranged in loops through which daylight can frequently be seen, and again was possible only because it was modelled rather than carved in stone. Instead of using della Robbia-type glazes, the *Lamentation* was polychromed, for the most part using pigments mixed with oil laid

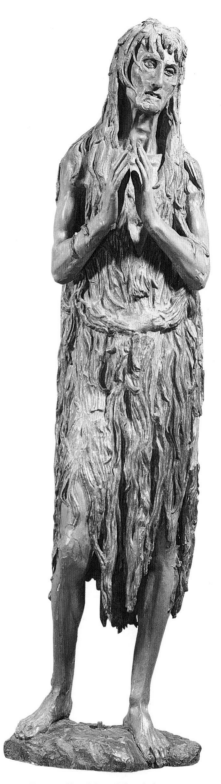

Plate 3.20  Donatello, *Mary Magdalene*, c.1440s, polychromed wood, height 188 cm, originally in Baptistery, now in Museo dell'Opera del Duomo, Florence. Photo: © 1990 Scala, Florence.

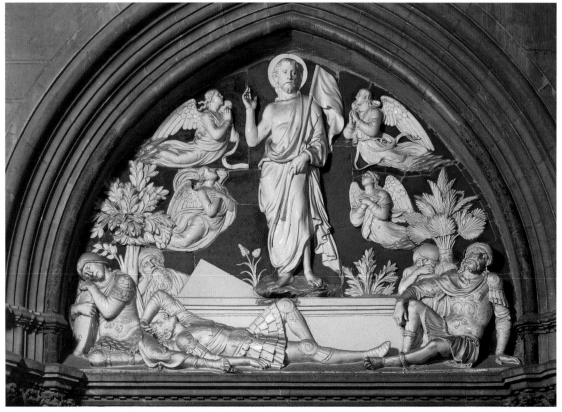

Plate 3.21   Luca della Robbia, *The Resurrection*, 1442–5, glazed terracotta, 200 × 265 cm, Florence Cathedral. Photo: © 1990 Scala, Florence.

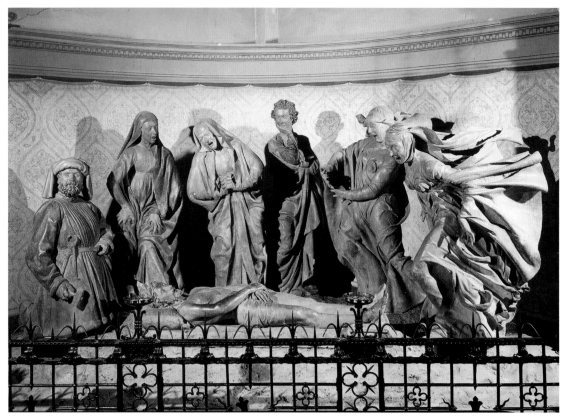

Plate 3.22   Niccolò dell'Arca, *Lamentation over the Dead Christ*, 1463, polychromed terracotta, Santa Maria della Vita, Bologna. Signed 'Opus Nicolai de Apulia' on Christ's pillow. The dead Christ is mourned by Joseph of Arimathea, Saint John and the Virgin with Mary Magdalene, Mary Salome and Mary Cleopas. Photo: © 1990 Scala, Florence.

over a yellowish base colour designed to prevent the paint soaking into the terracotta.[59] The original paintwork would no doubt have heightened the lifelike quality still further, but, like Donatello's *Mary Magdalene*, this was not so much the illusion of nature as the illusion of emotional expression.

# 8 Sculpture produced in multiple versions

Terracotta was used not only for one-off works of art like Luca della Robbia's *Resurrection* and Niccolò dell'Arca's *Lamentation*, but also for works of art produced in multiple versions. So long as there was no undercutting, moulds could be taken from a shallow master relief and used to make duplicate terracotta reliefs, which were then polychromed and gilded to be sold as devotional works of art, often for a domestic setting within a house or decorating its exterior.[60] Luca della Robbia's *Bliss Madonna* (Plate 3.23) is an affecting image made using a mould, then gilded as well

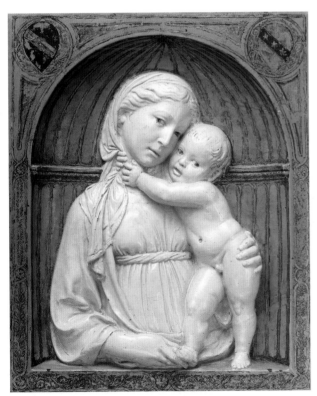

Plate 3.23   Luca della Robbia, *Bliss Madonna (Virgin and Child in a Niche)*, c.1460, glazed terracotta with gilt and painted details, 48 × 39 cm (without frame), Metropolitan Museum of Art, New York. Photo: © 2004 The Metropolitan Museum of Art, New York. Bequest of Susan Dwight Bliss, 1966, 67.55.98.

as glazed and personalised by means of heraldic shields. The same moulds were clearly used to make a nearly identical relief now in Boston, Massachusetts. The *Bliss Madonna* may date from around 1460, though he was probably producing reliefs in multiple versions using moulds from the 1450s. He was not the first to do so, however.

A terracotta *Madonna and Child* (Plate 3.24) surviving in more than 40 versions and known to date from before 1427 has been attributed to Ghiberti.[61] The Cleveland version of this design has on the base a reclining Eve taken from Ghiberti's *Gates of Paradise*, installed only in 1452, which shows that the same design might be used over several decades, albeit updated. Like the *Bliss Madonna*, this is an affecting, simple and homely image, and the sturdy base suggests that it was intended to stand independently, probably on furniture in the home.

Examples of this *Madonna and Child* relief exist in stucco as well as terracotta. Stucco is ground marble (one-third) mixed with lime (two-thirds). A design can be impressed into wet stucco using a mould, or reliefs can be modelled individually in layers over an armature of brick, stones or nails. Once dry it is very durable and suitable for outside use, and many stucco Madonna reliefs may have been designed to hang on the exterior of houses. From c.1460 stucco became the favoured medium for reliefs produced in multiple versions, and the painter Neri di Bicci (1418–92) recorded painting many such reliefs in the 1460s.[62]

According to his *Commentaries*, Ghiberti 'helped many painters, sculptors and masons by making for them numerous models in wax and clay'.[63] It is possible, therefore, that the original design for the Cleveland *Madonna and Child* and others like it was a purpose-made model, specifically designed for plaster moulds to be taken from it. Conversely, Donatello's *Pazzi Madonna*, probably carved in the 1420s, exists in around 12 stucco versions, which shows that multiple versions could also be made of one-off, high-status works of art, and may even be the earliest example of such reproductive practices.[64]

Donatello also seems to have flirted with multiple production. The bronze *Chellini Madonna* (Plate 3.25) was given in gratitude by Donatello in 1456 to his doctor Chellini, who recorded that the back was 'hollowed out so that melted glass could be

Plate 3.24   Lorenzo Ghiberti, *Madonna and Child, c.*1450, polychromed terracotta, 81 × 59 × 22 cm, Cleveland Museum of Art. Photo: © 2004 The Cleveland Museum of Art. Gift of Leonard C. Hanna, Jr, for the Coralie Walker Hanna Memorial Collection, 1939.161.

Plate 3.25   Donatello, *Chellini Madonna*, before 1456, bronze, diameter 29 cm, Victoria and Albert Museum, London. Photo: © V&A Images/Victoria and Albert Museum.

cast onto it and it would make the same figures as those on the other side'.[65] The back of the relief is, indeed, a perfect mould for the obverse, and there may be precedents for the use of bronze moulds for Madonna reliefs: a round stucco relief of the Virgin and Child with angels by Luca della Robbia dated 1428 was formerly covered with bronze-coloured paint, and it has been suggested that it was originally cast from a bronze relief.[66] Two stucco casts survive of the Chellini relief but none of glass. The Victoria and Albert Museum supervised the making of a successful glass cast, however, showing

that this novel technology for reproducing a relief did actually work.[67]

Moulds were also used in the north to produce devotional clay reliefs. Even though it was distant from the sources of suitable clay, Utrecht became one of the most important centres for 'pipe-clay' figures, though Cologne and Liège, where the clay came from, were also centres of production, and probably many other towns in the northern Netherlands. Most of the surviving moulds and casts are small scale, often with the childlike charm of Adriaen van Wesel's carving, but figures

Plate 3.26  Unknown Utrecht craftsman, relief of the Virgin and Child, pipe clay, 42 × 22 cm, Bischöffliches Museum, Haarlem. © Museum Catharijneconvent, Utrecht. Photo: Ruben de Heer.

as large as *c*.70 centimetres were also produced. The most ambitious surviving casts are a series of rectangular reliefs over 30 centimetres high of the Virgin and Child (and one of Saint Barbara) in an interior, one of which has a devotional inscription in Dutch around the edge (Plate 3.26).[68] Through receding orthogonals and a heavily shadowed protruding pedestal, the relief simulates a shallow interior space with leaded windows to either side. Like the Italian multiple reliefs, the casts vary a little but clearly refer back to the same original mould. Similar interior settings are found in

contemporary paintings, as in van Eyck's famous *Arnolfini Portrait* (National Gallery, London) and his *Lucca Madonna* (Städelsches Kunstinstitut, Frankfurt). Although hardly equivalent to Donatello's *rilievo schiacciato*, these reliefs are also a kind of sculpted picture.

## 9  Tombs and portraits

So realistic were Donatello's marble beardless prophet (1420–2), his Jeremiah (1425), and Nanni di Banco's Isaiah (1408) – all carved for Florence Cathedral – that they were erroneously identified as portraits at some stage in their history.[69] Drawing a line between convincing figures and actual portraits is not easy. Although in theory the ultimate in the illusion of life may appear to be accurate portraiture, the demands governing portraiture meant that in practice it was very different.

For all that death masks were sometimes taken from European rulers of note and even used to make accurate coloured portraits in wax to be carried in funerary processions, it could by no means be taken for granted in the fifteenth century that the carver of a permanent tomb effigy would even attempt to record the features of the person commemorated.[70] A tomb was first and foremost an honorific or dynastic monument rather than a likeness. There were exceptions, though. Jean, Duc de Berry (d.1416) commissioned for himself an alabaster tomb with mourners modelled on Sluter's famous tomb of Philip the Bold, the duke's brother, to be placed in the Sainte-Chapelle, Bourges. The tomb is now dismantled and partially destroyed, but the effigy carved by Jean de Cambrai (active 1375–1438), sculptor to the duke from 1402, survives in the crypt of Bourges Cathedral (Plate 3.27).[71] This effigy is entirely unlike conventional idealised French tombs of around 1400. Instead, the bulbous, pugnacious features of the duke are described in detail, down to his fat cheeks and the crow's feet around his eyes. The duke's robe shows traces of polychromy, and this would have heightened the realism of the effigy. The extent to which this portrait approach was Jean de Cambrai's own contribution to Sluter's radical tomb design is uncertain, because Sluter's tomb effigy of Philip the Bold was destroyed and replaced by a nineteenth-century version. Sluter did produce a plausible likeness of Philip the Bold in the

kneeling donor statue carved for the portal of the Charterhouse of Champmol before 1391.

Plate 3.27 Jean de Cambrai, tomb of Jean, Duc de Berry, begun before 1416 and completed 1450s (by Etienne Bobillet and Paul Mosselman), alabaster, Bourges Cathedral. © CMN Paris. Photo: Lefevre-Pontalis, coll.SFA, Arch.Phot.

Jean de Cambrai was probably also responsible for the kneeling portraits of the duke and his wife originally placed to either side of an altar in the Sainte-Chapelle, Bourges, now heavily restored and in the cathedral but known in their original condition through a drawing by the sixteenth-century painter Hans Holbein. The fact that Holbein, himself a portraitist, made such a detailed drawing of the faces suggests that it was Jean de Cambrai's physiognomical realism that fascinated him. Since the figures were originally polychromed, they must have appeared remarkably lifelike. The tomb effigy of Louis II of Bourbon (d.1410) at Souvigny has also plausibly been attributed to Jean de Cambrai on the basis of the highly convincing representation of the ravages of old age, albeit again with the dignity demanded by decorum.[72]

Issues of decorum governed portraits of women much more tightly than men, and an individualised representation of old age was not a possibility in sculpture. In the case of Ilaria del Caretto (d.1405), wife of the ruler of Lucca, old age was not an issue for she died in childbirth. Jacopo della Quercia's Carrara marble tomb (c.1406–7, Plate 3.28) is justly celebrated for its innovative frieze of antique-

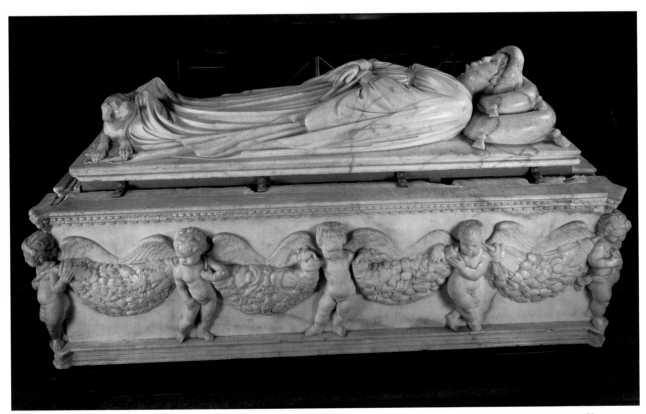

Plate 3.28 Jacopo della Quercia, tomb of Ilaria del Caretto, c.1406–7, marble, sarcophagus 244 × 88 × 67 cm, effigy 204 × 69 cm, Lucca Cathedral. Photo: © 2002 Scala, Florence.

style putti holding swags around all four sides of the tomb, but the effigy itself has sometimes been seen as a throwback to idealised Gothic styles.[73] One reason why the effigy looks so very Gothic, however, is because the dead woman is represented dressed in a highly fashionable and sought-after northern European dress, which James Beck suggested may have been especially imported for her from France or Flanders.[74] This detail alone is suggestive of portraiture, though it is impossible to know whether this extended beyond the dress to the face. The figure is not without naturalistic details, for the breasts flop slightly to either side under the force of gravity.[75]

Donatello's *Gattamelata* represents a new sort of funerary monument: the first bronze equestrian statue since antiquity and one commemorating a condottiere or mercenary soldier, Erasmo da Narni, known as Gattamelata (1370–1443), who fought for the city of Padua. The monument dates from between 1447 and 1453 (Plate 3.29). Although the realistic folds of skin under the horse's arched neck, its open mouth and pricked ears seem the

ultimate in verisimilitude, Donatello's source may in fact have been not a real horse but antique bronzes: a late Hellenistic bronze horse's head that used to form part of a fountain in the palace of Donatello's patrons, the Medici family, and the famous bronze horses from Constantinople placed outside the basilica of San Marco, Venice (which would have been adjacent had the monument been erected in the Piazza San Marco as Gattamelata had wished).[76] Although one very potent antique precedent existed for this equestrian monument in the famous bronze Marcus Aurelius on view in Rome, Donatello added armour of a hybrid Roman and contemporary style and a realistic fifteenth-century saddle. Whether the face was a real portrait of Erasmo da Narni is unknown – it is tolerably like the effigy of his tomb.[77] Donatello did include a representation of Gattamelata's silver-gilt baton, an honorific gift from the Venetian authorities in 1438.[78]

Just as Donatello's *Cantoria* had been criticised for its rough finish, so Ascanio Condivi, the sixteenth-century biographer of Michelangelo, declared that

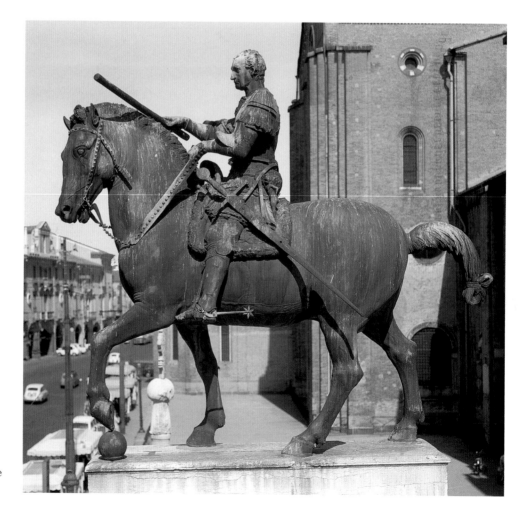

Plate 3.29   Donatello, *Gattamelata*, 1447–53, bronze, 340 cm, Piazza di Sant'Antonio, Padua. Photo: © 1990 Scala, Florence. In his will, Erasmo da Narni left a sum of money to the Venetian Republic on condition that an equestrian monument be erected to him.

the finish of Donatello's bronzes was poor. His *Gattamelata* is a mixture of extraordinary skill and puzzling flaws. The horse's tack is so realistic that it has been suggested certain details might have been cast from life.[79] Donatello had certainly used this device before in his monumental bronze *Judith and Holofernes*, where Judith's drapery was cast from a model draped in real cloth covered with wax and where Holofernes's legs were probably cast from life (Vasari described how even flowers and herbs might be cast from life).[80] Conversely, *Gattamelata* has two patches on the face. Flaws in casting were inevitable and Vasari later outlined the accepted procedure for repairing them, but Donatello seems to have made little effort to do so.[81]

No tradition of bronze equestrian monuments existed in the north. In Stockholm Cathedral, however, an exceptionally lifelike monumental wooden statue of Saint George and the Dragon was erected by Lübeck carver Bernt Notke (active 1467–1509) in honour of Sten Sture, ruler of Sweden. Since the base was originally intended to contain Sture's tomb, it is a funerary monument of sorts (Plate 3.30). Saint George is not a disguised portrait of Sture, though Notke was well capable of such a feat: he had already produced a carved donor portrait of King Karl Knutsson Bonde (Schloss Gripsholm) which is sufficiently idiosyncratic to suggest an attempted likeness. Donors did not need portraits to identify themselves, however; Sture's coat of arms appears in many places, and the horse is branded with a waterlily mark, as were Sture's actual horses.[82] Like Gattamelata's horse, the anatomy of Saint George's horse is immaculate, but Roman prototypes can have played no role in this northern location remote from sources of antique art. Presumably the model was nature itself – a real animal.

Bernt Notke used many other virtuoso devices to enhance verisimilitude in what is essentially a courtly, chivalric legend involving a princess and a Christian knight. Unlike Gattamelata, Saint George wears accurate fifteenth-century armour. Just as Donatello modelled gesso to supplement the hair in his wooden Mary Magdalene, so Notke used string to simulate the raised veins of the excited horse, and real linen and bristles for the mane and tail; apparently, some of the horse's hide is real, and the carver included metal reins and bit and leather stirrups.[83] Around the base on which the figures stand are gruesome body parts, the remnants of the dragon's previous meals. Severed hands are encased in realistic sleeves formed not of wood but of parchment. Skulls are carved to simulate the flesh partially rotted away. A severed head seems likely to have been based on a study of a real body cut down from a scaffold, just as Pisanello made studies of hanged men for his Verona fresco of the same subject (see Chapter 1, Plate 1.10). Notke used real elk antlers to form the frightening spines along the back of the dragon. This monument shows that the northern art of wood-carving might be every bit as inventive as Italian bronze casting, and the originally polychromy, including the simulated brocade dress that the princess wears, would have enhanced further this curious mixture of stark realism and courtly opulence. The wood-carver's mallet found within the hollow belly of Saint George's horse is an apt memorial to the skilled craftsmen who made it.

It is the emergence of the Renaissance portrait bust that most aptly epitomises this quest for the lifelike in sculpture, however. Although the concept of a portrait bust was derived in part from antique votive terracotta busts, funerary *stellae* or tomb monuments, Irving Lavin showed how Renaissance carvers adapted the format to one visible from all sides and one designed to be a true likeness rather than a generic type.[84] The earliest datable carved portrait bust is of Piero de' Medici, done in 1453 by Florentine carver Mino da Fiesole (1429–84) (Plate 3.31). It shows the sitter bare headed, dressed in a simulated brocade robe, which is carefully carved in shallow relief. The cropped hair, pursed lips and intense gaze with furrowed brow are reminiscent of Donatello's *Saint George*, and it seems possible that the carver learned something about specificity of pose from this famous prototype. It was certainly intended to be a likeness, for underneath an inscription names the sitter, his age and the artist, but just as van Eyck modified his initial drawing of Cardinal Albergati in the painted version (Chapter 1, Plates 1.2–1.3), so Piero's features seem to have been cast in an idealised, classicising form appropriate to his high status. It is known that this portrait, together with those of Piero's wife and brother, were placed in lunettes above the doorways in the Palazzo Medici, a dynastic statement if ever there was one.[85] Here the division between art and life is deliberately blurred.

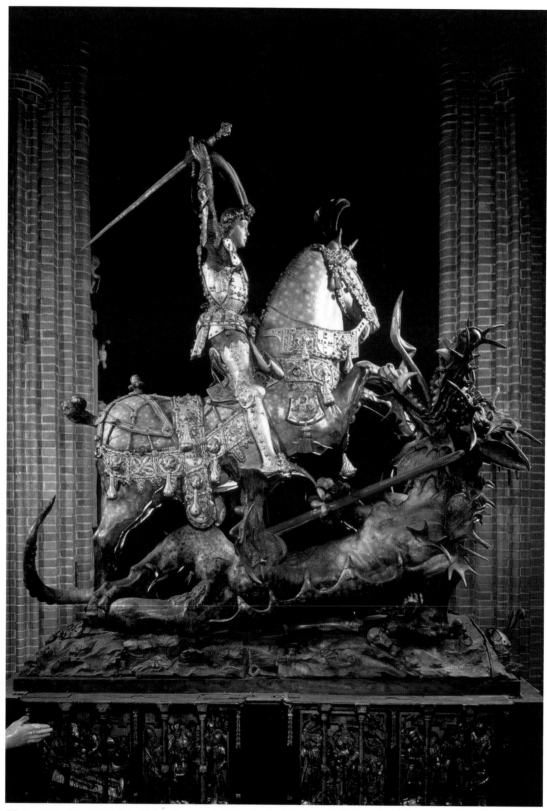

Plate 3.30   Bernt Notke, *Saint George*, 1489, polychromed wood, height 374 cm, Stockholm Cathedral. Photo: © Anders Qwarnström.

This monument was commissioned by Sten Sture, imperial administrator of Sweden, as a thanks offering for a military victory over the Danes in 1471. It was placed at the east end of the nave of the cathedral on a large wooden pedestal with relief scenes that served as a chantry chapel of Saint George and was originally intended to contain Sture's tomb. A surviving figure of the princess also belonged to the group, which was installed on New Year's Eve 1489.

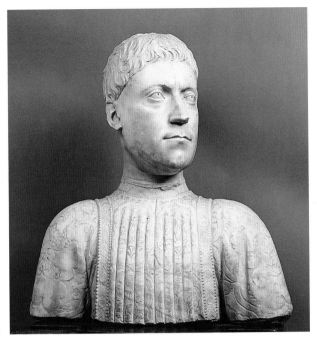

Plate 3.31   Mino da Fiesole, portrait bust of *Piero de Medici, Lord of Florence*, 1453, marble, 50 cm, Bargello, Florence. Used with the permission of the Ministero Beni e Attività Culturali. Photo: © 1990 Scala, Florence.

# 10   Conclusion

Vasari viewed truth to nature as part of a linear progress in art, the necessary prelude to the inspired art of his own day, which he considered to venture beyond what he saw as the limitations of fifteenth-century verisimilitude. The illusion of life was clearly a key priority in the making of fifteenth-century sculpture, and as we have seen, the virtuoso manipulation of materials often served to enhance this illusion. Real accoutrements or materials were used in the making of Donatello's *Saint George*, Sluter's *Well of Moses* and Bernt Notke's *Saint George*, for example. This task of appearing to bring the essentially inert medium of sculpture to life demanded skills beyond those of mechanically reproducing nature, however. Arguably, an impression of the lifelike in a statue depends above all on a sense of moment, movement, pose and gesture, while in the relief of *Christ Giving the Keys to Saint Peter*, Donatello pushed back the boundaries of illusionism with the atmospheric effects and spatial possibilities of his *relievo schiacciato*.

For the fifteenth-century sculptor and patron, any illusion of life was inextricably harnessed to the function of the work, be it the affective power of a devotional statue like Donatello's *Mary Magdalene* or the dramatic re-enactment of key religious events such as Niccolò dell'Arca's *Lamentation* and the narrative scenes in miniature of the de Villa altarpiece. A degree of artistic discretion was necessarily brought to bear in this illusion. A 'warts and all' realism was the last thing required by Italian sculptors schooled in the ideal proportions and anatomy of antique sculpture, still less by courtly and sophisticated northern European patrons. Hence the *Goldene Rössl* is in some respects intensely lifelike, and yet it remains essentially a fabulous, courtly object that is not fundamentally realistic at all. Even in that most mimetic of artistic tasks, portraiture, the illusion of life did not constitute the accurately real. Fifteenth-century sculptors were masters of illusion and formidably accomplished technicians, not copyists.

# Chapter 4
# introduction

According to both Vasari and Brunelleschi's biographer Antonio Manetti, Brunelleschi, in company with Donatello, spent some time in Rome measuring and studying ancient buildings, learning the ancient orders of Doric, Ionic and Corinthian columns, and trying to deduce from studying antique building practices how to apply these features consistently in modern buildings. Brunelleschi did indeed design buildings using antique forms such as columns or pilasters with capitals, bases and entablatures and replacing Gothic pointed arches with round ones. Persuasive as his debt to the antique appears to be on the surface, it has come under increasing challenge by architectural historians. Howard Burns revealed that few if any of the classical features of his buildings could not have been copied from Tuscan Romanesque buildings close at hand, such as Florence Baptistery.[1] Howard Saalman showed that the forms of Brunelleschi's capitals, while classical in spirit, were unlike any antique prototypes.[2] Similarly, it is hard to find a single detail in his buildings which would have required a reading of Vitruvius' treatise on architecture or a trip to Rome.

In this chapter, Tim Benton takes up the baton from Saalman and Burns to challenge the very concept of Renaissance architecture presenting a decisive break with the Gothic past. By studying the late Gothic Milan Cathedral, he shows that the various solutions proposed through the fourteenth and fifteenth centuries were all in fact based on medieval building practices emphasising geometry. Certain habits of thought and assumptions about the desirable relationship between ground plan and elevation were built into the training of masons in the north until the end of the fifteenth century. The Lombard masons responsible for the cathedral refused to accept the formal and theoretical precepts advocated by their French and German colleagues, insisting on a very Italian taste for lower, squatter proportions, but they too used arguments based on geometry to defend their proposals. The preoccupation with medieval approaches to geometry continued, Tim Benton argues, throughout the early Renaissance period: Brunelleschi thought about geometry in very similar ways to the masons responsible for Milan Cathedral. However different Gothic and Renaissance buildings might appear, the principles on which they are constructed have more common factors than differences. Brunelleschi's great innovation was to invent a discipline of architectural design which, in its rigour and formal clarity, evoked the antique past while adapting to modern conditions.

*Kim W. Woods*

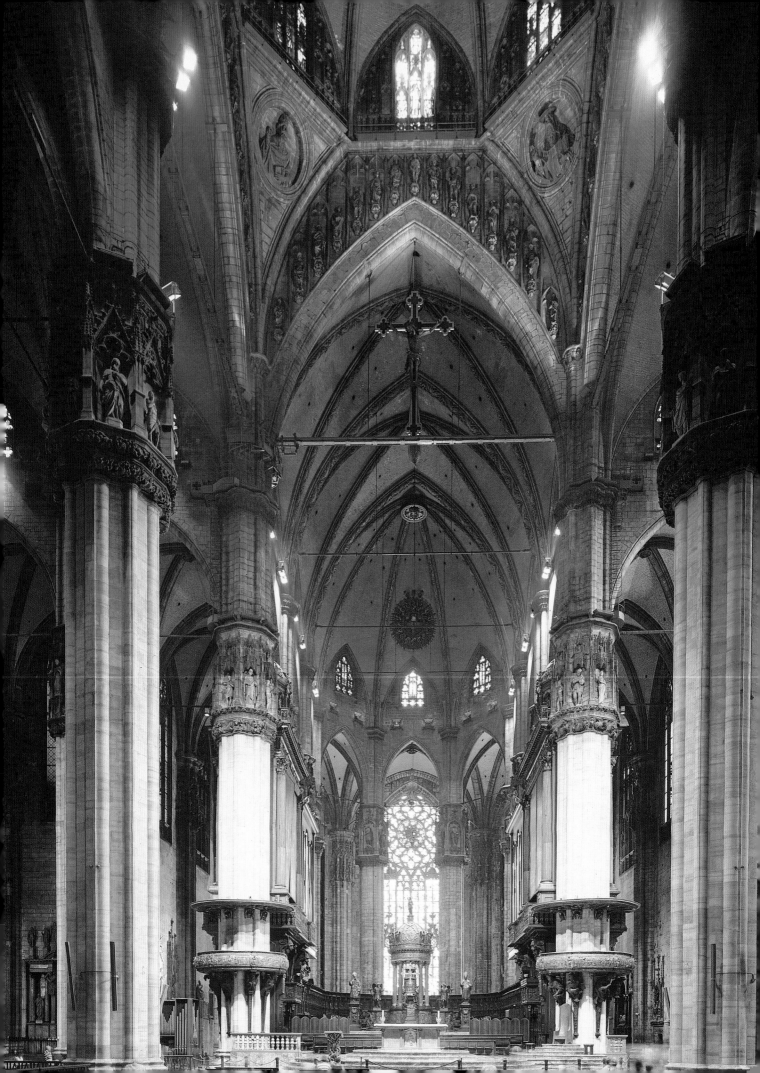

# Chapter 4

# Architecture: theory and practice

*Tim Benton*

The term 'Renaissance' – or rebirth – seems to be applied more naturally to architecture than to the other arts. To judge from some of the literature, it seems that what Renaissance architects in Italy achieved in the early years of the fifteenth century was not simply the assimilation of antique motifs found in ruined form all over Italy (something similar could be said of sculpture), but rather a change of theory and practice which was all the more precise because it was based on an antique architectural treatise: Vitruvius' *De architectura libri decem* or *Ten Books on Architecture*.[1] And this change extended from the social structure of the building trades to techniques of design and execution, the materials used, the representation of built and projected works of architecture, the associations and myths giving meaning to architectural forms, and the view of the world which underpinned these changes. The Renaissance happened in Italy because this is where the antique sources of the style were in greatest abundance, because the Gothic style was resisted in most Italian states and cities during the medieval period, because forms of government and the organisation of labour were propitious for change, and because the structure of Renaissance courts (and other patronage centres) placed architects close to other artists, to humanist scholars and, most important of all, to copies of antique texts. That this groundbreaking set of changes did not take place north of the Alps until

nearly a century later makes it all the easier to adopt a simple and universal explanation.

It is the purpose of this essay to submit these assumptions to scrutiny. I will show that many medieval ways of thinking continued into the fifteenth century in the work of some of the best-known Renaissance architects. I will also show that, within the practice of Gothic architecture, the old theories and traditions were being challenged. In so doing, I will question the relationship between theory and practice.

## 1 Vitruvius and the Renaissance

Some scholars have argued that most of the fifteenth-century texts on architecture are not really architectural theory at all, but a branch of philological humanism aimed at interpreting classical texts for their own sake.[2] It is generally true that architects derive most of their stimulation from copying the work of others and depend on tried and tested structural techniques. It is unreasonably risky to design a whole building from scratch, and architects are reliant on craftsmen and the suppliers of their materials to have a good idea of what the finished building will look like and how to build it. Writers such as Alberti, Filarete (c.1400–69) and Francesco di Giorgio (1439–1501) did mix analysis of ancient texts with practical advice for builders and engineers, albeit in very

Plate 4.1 (Facing page) Nave of Milan Cathedral, begun 1385–6. Photo: Mauro Magliani, Alinari Archives, Florence.

different ways. On the other hand, it appears that an architect such as Brunelleschi created the basis for the Italian Renaissance style without recourse to theory based on antique precepts.

Theory plays a vital role in lending authority to an architect's design. Architects must share a language of description and evaluation with their patrons if they are to persuade them to invest large sums of money. In the medieval period, builders learned to appeal to Aristotle and the Church Fathers to defend design principles. As the French architect Jean Mignot declared in January 1401, when challenging the competence of Lombard masons on the site of Milan Cathedral, 'Ars sine scientia nihil est' (translated by James Ackerman as 'Art is nothing without science' but, better, as 'Practice is nothing without theory'). This was in response to their assertion that 'the science of geometry should have no part in these matters', since 'theory is one thing and practice another'.[3] Although he went on to talk about the solidity of the foundations, Mignot was asserting that beauty depended on precise and rational relationships. Plato had summarised this in the *Philebus* (*c.*360 BCE):

> By beauty of form, I do not refer to what most people consider beauty, such as the beauty of humans or certain paintings. By beauty I mean, rather, something square or circular, or surfaces and solids formed with the aid of a compass, straight-edge and set-square: such things are always beautiful in themselves, and embody artistic feelings of a very special nature.[4]

In the fifth century Saint Augustine reasserted the dependence of the arts on geometrical and musical harmonies. Geometrical figures such as the equilateral triangle, square, pentagram, hexagon and octagon (all enclosed by the circle) seemed to ensure such relationships. A series of debates in the office of works of Milan Cathedral from 1390 throughout the fifteenth century record similar appeals to traditional scholastic knowledge.

In periods of significant change, as in the first years of the fifteenth century in Florence, architects needed to work out not only how the new forms they imagined could be built, but also how to lend value to these new ideas in theoretical terms. In Italy, this theory lent heavily on the analogy between architecture and language, based on the humanist preoccupation with improving the quality of Latin and Italian by appeal to antique texts.

As the sculptor and architect Filarete put it in his treatise (*c.*1461–4):

> I advise everyone to abandon the modern style [i.e. Gothic] and not be advised by those masters who use this crude system. May he who invented it be cursed! I believe that none other than barbarians brought it into Italy ... The same occurred in architecture. The man who follows the ancient practice in architecture does exactly the same thing as a man of letters who strives to reproduce the classical style of Cicero or Vergil.[5]

To improve the 'language' of architecture, the two sources were the plentiful ruins of antique buildings and the text of Vitruvius' *Ten Books on Architecture*. Patrons versed in humanism were predisposed to consider both sources very favourably, but the problem for architects was how to make sense of them and adapt what they found to modern commissions.

Vitruvius' *Ten Books* were written between 33 and 23 BCE and dedicated to Emperor Augustus. Copies existed in many collections, and Vitruvius was discussed and copied throughout the Middle Ages from the Carolingian period (eighth–tenth centuries).[6] Vitruvius covered a wide range of subjects, from the design of water clocks and the proper location of buildings to the practical details of how to proportion buildings and their details. Two features of his text which particularly captured the imagination of readers in the Renaissance were his insistence that the architect must understand music and mathematics, with particular attention to 'perfect numbers' (such as 6 and 10),[7] and that architectural proportions should be derived from a study of the human figure.[8]

> For if a person is imagined lying back with outstretched arms and feet within a circle whose center is at the navel, the fingers and toes will trace the circumference of this circle as they move about. But to whatever extent a circular scheme may be present in the body, a square design may also be discerned there. For if we measure from the soles of the feet to the crown of the head, and this measurement is compared with that of the outstretched hands, one discovers that this breadth equals the height.[9]

This description provided a challenge for Renaissance artists and architects, many of whom attempted to draw it, with varying results. The Bolognese architect Cesare Cesariano, in his edition of Vitruvius (1521), places the square within a circle in turn bounded by another square

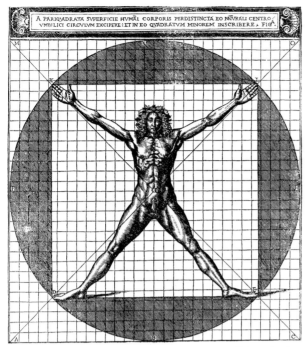

Plate 4.2   Drawing attempting to illustrate Vitruvius' description of human proportions determined by the square and circle (*Ten Books*, 3.1.3) from Cesare Cesariano, *Di Lucio Vitruvio Pollione de Architectura*, 1521 (Cesariano, 1968, bk 3, fol.Gii recto).

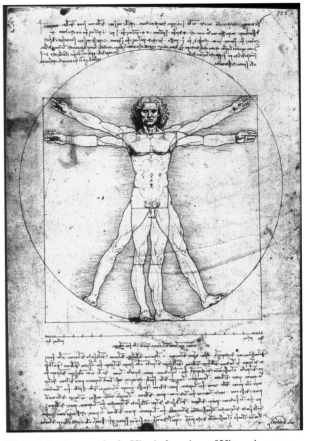

Plate 4.3   Leonardo da Vinci, drawing of Vitruvian man, 1492, pen and ink on paper, 34 × 25 cm, Accademia, Venice (228 29, R343). Photo: Bridgeman Art Library.

(Plate 4.2). His man stretches to reach the corners of the square, his arms and legs approximating to its diagonals. We will see that the relationship between the side of a square and its diagonal had particular fascination for medieval architects. Leonardo da Vinci's famous drawing better fits both the human body and the Vitruvian text (Plate 4.3).

Vitruvius declared: 'For without symmetry and proportion no temple can have a regular plan; that is, it must have an exact proportion worked out after the fashion of the members of a finely-shaped human figure.'[10] He also gave proportional relationships for the body. For example, he asserted that the face, from the chin to the hairline, went into the height of the male body ten times, while the foot went into the height six times.[11] Underlying this concern with human proportions is the assumption that there must be something linking beauty, mathematics and the human body.

The medieval interest in Vitruvius was mainly antiquarian, relating to what he had to say about ceremonies and customs. However, in the fourteenth century, the interest that the poet and humanist Petrarch and his friends Bocaccio and Giovanni Dondi began to show in Vitruvian

manuscripts was of a different order. Instead of treating it as a mysterious repository of antique practices, they initiated a process of trying to extract from Vitruvius' confusing text the principles of antique architecture.[12] This process was given dramatic publicity by the discovery of a manuscript of Vitruvius in the monastery of Saint Gall in Switzerland by the Florentine humanist Poggio Bracciolini in 1416. Understanding, interpreting and modernising Vitruvius was one of the obsessions running through architectural practice in the fifteenth and sixteenth centuries. Furthermore, delving among the ruins of antiquity and trying to reconstruct great antique buildings in the imagination became fashionable. The author of the sumptuously illustrated *Hypnerotomachia Poliphili* (*The Strife of Love in a Dream*, 1499), probably Francesco Colonna, used antique buildings, real or imagined, as metaphors for the tribulations and satisfactions of the erotic journey of his protagonist. Antiquity was sexy, not just a challenge for the intellectual but a gratification for the poet.[13]

143

By the time a satisfactory version of Vitruvius existed in Italian, however, the Renaissance style had been invented and practised for the better part of a century. This poses again the question of the relationship between theory and practice. I will return to this question and the sources of a Renaissance theory of architecture, but first I must establish how Gothic architects thought and built, not only before the Renaissance in Italy but throughout the fifteenth century and beyond in other parts of Europe.

## 2 Medieval theory and practice

In the medieval period, masons acquired great prestige all over Europe by building the series of soaring cathedrals and churches with which all major cities were identified. Organised in lodges and protected by both law and convention, the most successful master builders travelled Europe from site to site, taking charge of the work of local builders, training new apprentices, and giving advice to building committees seeking to resolve a local difficulty. The theory they appealed to was in part based on scholastic teaching: Aristotelian principles filtered through Christian interpretation. From this they derived the principle that the design of a building would be most pleasing to God if its proportions were based on simple geometrical relationships running right through the design (for instance, uniting the dimensions in plan – the horizontal plane – and section – the vertical plane).[14]

The other kind of theory they relied on, that of the masons' lodges, was not to be shared with lay persons. This was the knowledge built up by experience, by apprenticeship and by the years of travelling from site to site which were expected of a journeyman mason. Masons had to acquire an understanding of physics and geometry, and how to transfer designs from small drawings on parchment to full size on the wall or floor. The key to this was a grasp of elementary geometry and the use of compass, level and straight edge. Mastery of these 'mysteries' gave masons the authority to take charge of very expensive and risky undertakings, and this knowledge had to be protected from outsiders. For example, at a great convocation of masons from all over Europe at Regensburg in 1459, a statute was drawn up regulating every detail of the duties and education

of masons, and this was confirmed by Emperor Maximilian in 1498. One of the clauses stipulates that no mason, 'parlier' (assistant mason) or journeyman should divulge or teach strangers 'how to take the elevation from the ground plan', that is, how to make the vertical dimensions of a building or one of its parts conform to its horizontal ones according to a rule of proportion. This simply codified the common practice of many centuries at the moment when it was being threatened by new working practices. In fact, as we will see, the 'secret' of the masons was published 30 years after the Regensburg meeting.

I will look now at the biggest and most costly building site in Italy at the turn of the fifteenth century, that of Milan Cathedral. Although the events discussed here took place at the end of the fourteenth century, the attitudes they disclose remained in place throughout the fifteenth and most of the sixteenth centuries in northern Europe and parts of Italy.

### Milan Cathedral: crossroads of mentalities

Under Giangaleazzo Visconti (1347–1402) Milan extended its sphere of influence from Lombardy deep into Emilia, the Veneto and Tuscany. To celebrate this military and political resurgence, the foundation stone of a vast new cathedral was laid around 1386. At 158 by 67 metres, this was to be one of the largest churches in Christendom. The undertaking took several centuries to complete, the building committee persevering with the basic design idea through the Renaissance, High Renaissance, Baroque, Neo-classical and neo-Gothic periods, into the nineteenth century. The office of works, known as the Veneranda Fabbrica del Duomo (hereafter Fabbrica), was given its structure and rules in 1387 and has preserved its records, many of which were transcribed and published in the nineteenth century. The records of the Fabbrica are of particular interest because they record differences in approach to design and construction between the resident Lombard craftsmen and distinguished French and German masters who were called in either to run the site or to give their opinion on particular problems.[15]

The Fabbrica was well aware that it was undertaking something beyond the experience of the local masons, who were used to building

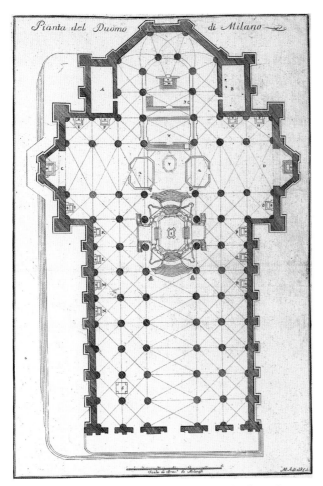

Plate 4.4  Plan of Milan Cathedral, as built, from *Pianta del Duomo di Milano*, vol.2, p.41, Raccolta Bianconi collection, Biblioteca Tribulziano, Milan. © Archivo Storico Civico-Biblioteca Trivulziana. Photo: Saporetti, Milan.

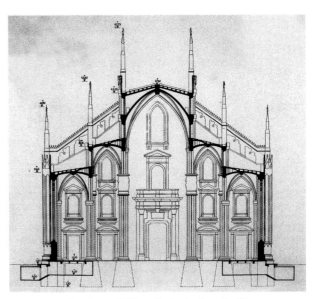

Plate 4.5  Section of Milan Cathedral, as built.

relatively squat churches in brick. Unlike the northern Gothic masters, who used a system of buttresses and flying buttresses to transfer the side thrusts of the stone vaults to the ground, the Lombard masons preferred to use wooden roofs, which exerted no side thrusts. Milan Cathedral was to be faced in marble and vaulted in stone. It was laid out with a nave and two pairs of aisles, and these aisles were thought of as buttressing the nave (see Plate 4.4). The triangular arrangement of the aisles and nave can be seen in the section (Plate 4.5).

In May 1389, within a few years of breaking ground at Milan, the Frenchman Nicholas de Bonaventure was called in to take charge. He was responsible for much of the detail of the east end (Plate 4.6). Between then and 1401, a number of the most influential German and French architects were commissioned to provide their expert advice or

take charge of the building. All were highly critical of the work of the Lombard masons and were dismissed. The debates between these foreigners and the local masons have been recorded in detail, providing a precious insight into the theory of architecture as practised in the north throughout the fifteenth century.

To review what was at stake in these debates, we must understand something of Gothic design practice. When planning Gothic churches, many of the dimensional relationships are straightforward. In the simplest kind of plans, advocated by Saint Bernard for the Cistercian Order (twelfth century), all the main elements are aligned with a simple grid of squares. The nave bays are usually twice the width of the aisle bays, and since the latter are usually square in plan, the nave bays have a proportion of 2:1 (twice as wide as they are deep). This system of squares would then be applied to the dimensioning of the height of the nave and aisles, according to the system known as *ad quadratum*. Typically, this would mean that the vault of the main nave would reach a height equal to the width of the church, while the aisles would be half as high to allow for tall clerestory windows. In Milan, this would have made the nave 96 braccia high (just over 57 metres, as 1 braccio = *c*.60 centimetres), equal to the internal width of the church. Most of the French and German experts invited to Milan argued for the *ad quadratum* system because it was a deep-rooted conviction among medieval architects that a simple geometric

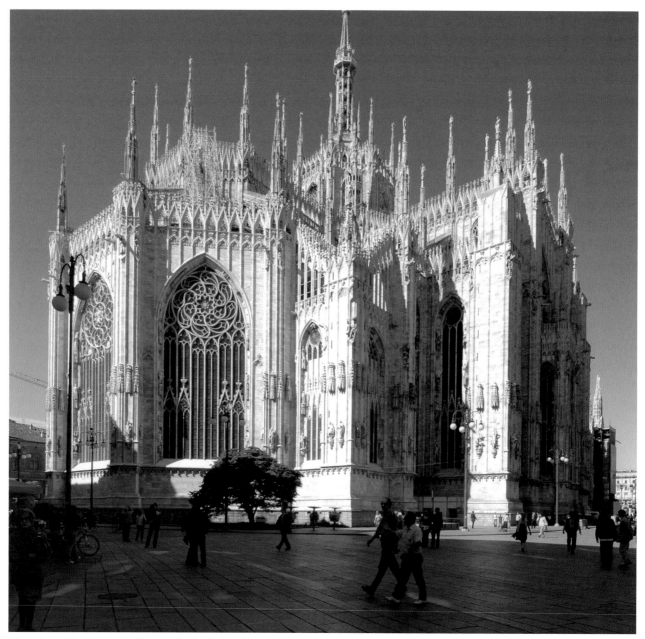

Plate 4.6    East end of Milan Cathedral, showing the first parts to be built (1386–92). Photo: Tim Benton.

proportion should bind together all the dimensions of a building.

Another geometric system common in Gothic building practice was *ad triangulum*, using equilateral triangles. This was the system referred to by the mathematician Gabriele Stornaloco, who was called to Milan from his native town of Piacenza in September 1391 to provide an opinion on how to adapt the *ad triangulum* system to the cathedral. He wrote a report, accompanied by a parchment drawing in section, which has survived (Plate 4.7). The *ad triangulum* method would produce a church less high than *ad quadratum*

(84 braccia instead of 96), which suited Italian taste. The satisfying thing about a section marked out in equilateral triangles is that it visually symbolises the hierarchy of the church interior, rising to the crown of the nave or beyond to a dome or tower and lantern above. But a disadvantage of the *ad triangulum* system was that the height of an equilateral triangle (root 3 divided by 2)[16] is incommensurable with its sides. Thus, the height of an equilateral triangle whose base was equal to the width of Milan Cathedral (96 braccia) would work out at 83.14 braccia (roughly 83 braccia and 2 inches).[17] In this period root 3 could only be approximated in fractions, and builders did not

Plate 4.7  Gabriele Stornaloco, drawing of *ad triangulum* section for Milan Cathedral, Raccolta Bianconi collection, Museo Civici, Milan. © Archivo Storico Civico-Biblioteca Trivulziana. Photo: Saporetti, Milan.

have slide rules for working these out. So builders needed a useful yardstick (literally, a folding ruler) scaled to the vertical dimensions of the church, subdivided into equal parts for the countless small measurements as work progressed. From a practical point of view, it did not matter that the yardstick used for vertical dimensions was different from that used for laying out the plan, as long as there was some logical relationship between the two.

To consider Milan Cathedral as a typical product of Gothic architecture, we would expect its dimensions to be related in one of the established geometric systems (such as *ad quadratum* or *ad triangulum*). In fact, there is evidence that the first design was based on a yardstick of 16 braccia for the horizontal dimensions and 10 braccia for the vertical ones. This seemed shocking to the German and French Gothic architects, since they could see no simple geometrical relationship between these dimensions. For the Lombard masons, it was a simple and flexible measure which would allow them to make the church considerably lower than the northern prototypes.

In the spring of 1391, Antonio da Vincenzo, an architect charged with preparing the plan for the Cathedral of San Petronio in Bologna, visited the

Milan site and measured it.[18] At this point, the plan would have been staked out in its entirety, and construction on parts of the east end had reached around 28 braccia in height. Antonio's plan and partial section is of great interest (Plate 4.8). Although not drawn to scale, he included measurements, and these are of two kinds. Most of the measurements of the plan, which Antonio could measure for himself on the ground, are given in the Bolognese feet and inches for which he was presumably equipped with a measuring rod. But he also included a sketch of the section of the nave, superimposed on the plan, and it has been established that these measurements are in Milanese braccia.  This must mean that he was copying these vertical dimensions off a model or an elevation drawing in the Fabbrica. Most scholars agree, therefore, that Antonio's drawing shows the original project. The model or elevation drawing which Antonio saw and copied in his section clearly had the vaults of the inner aisles higher than the outer aisles, giving a pyramidal effect (unlike, say, Cologne Cathedral – see Plate 4.11). But the measurements he gave ruled out either an *ad quadratum* or an *ad triangulum* system. Thus, Antonio noted the dimensions of the outer aisle piers as 30 braccia high (to the impost) and the inner aisles as 40 braccia high (plus 10 for the capitals, making 50 to the impost), with the nave vault springing at 60 braccia. But construction had stopped at the level of 28 braccia, the height of the outer aisle piers according to the *ad triangulum* system. Therefore, it seems that between the design of the model or drawing Antonio copied early in 1391 and September 1391, when Gabriele was called in, a decision was made to adopt the *ad triangulum* system.

Let us now consider Gabriele Stornaloco's report and the sketch which accompanied it. Interestingly, Gabriele begins with a general statement referring to geometrical figures not visible in his sketch. He explains that the equilateral triangle whose base was the width of the cathedral (96 braccia) could be contained in a circle which would also contain a square (with side AO – see Plate 4.9) and a hexagon (with side AN). These last seem to play no role in the design. This equilateral triangle is composed of 12 triangles, each one twice the width of its predecessor, beginning with triangle 1, of 8 braccia. The apex of triangle 4, whose side is equal to the width of the nave (32 braccia), defines the height of

Plate 4.8   Antonio da Vincenzo, plan of Milan Cathedral, 1391, Archivio della Fabbriceria di San Petronio, Bologna (cartella 389, no.1). Photo: Mario Berardi, Bologna.

the springing of the vaults of the outer aisle. The imposts of the vaults of the inner aisles and the nave are aligned with the apexes of triangles 6 and 8 respectively, and the height of the nave vault is aligned with triangle 12. To grasp the significance of this geometry, one has to absorb the medieval thought processes which saw a relation between the primary geometric forms and underlying laws or principles governing creation and the world.

Take the beautiful circular plan relating the world of the planets to the zodiac produced for King Wenzel IV of Bohemia around this time (Plate 4.10). At the centre of the circle and generating meaningful connections between the 12 points of the zodiac are the figures of the triangle, square and hexagon. For Gabriele, it would seem natural to place his section into a geometric structure of this kind, as if by so doing he could demonstrate the

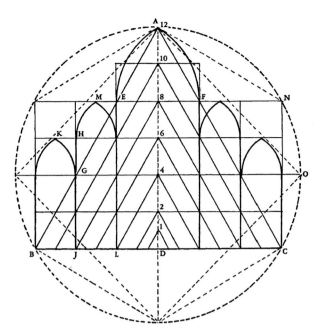

Plate 4.9 Diagram clarifying the Stornaloco design (Frankl, 1945, p.59).

natural 'rightness' of the design and its conformity with divine creation. Interestingly, the diameter of the circle sits at exactly the point the building had reached at this point: 28 braccia above the ground.

After indicating the hexagon, square and triangle, Gabriele jumps immediately to his formula. This takes a form which is incomprehensible to the modern reader: 'Therefore the line AD, which is the height of the summit of the church, will be root 600 700 1020 [27] sešara, because it is one thirtieth, which is somewhat less than 84.' This enigmatic form of words was finally explained by Erwin Panofsky, who concluded that not only was this a surprisingly accurate method for working out the vertical dimensions, but it did so converting from the yardstick used in the horizontal dimensions (8 braccia) to braccia in the vertical dimension.[19] Thus, if you enter a width of 1 yardstick unit (8 braccia), the formula produces a height of 6 braccia 11¼ inches. Stornaloco was therefore bringing together the two requirements of a medieval proportioning system: one that related width and height according to a geometrical ratio pleasing to God (in this case that of the equilateral triangle) with a practical method for working out actual dimensions. His formula was very accurate. Calculating for a width of 96 braccia, the formula would produce a figure of 83.168 braccia as opposed to the correct figure of 83.138, equivalent to an error of less than 2 centimetres over a height of nearly 50 metres.

In December 1391, shortly after Gabriele Stornaloco's report in September, Heinrich Parler from Gmünd arrived on site in Milan. Heinrich did not hesitate in criticising what he saw being constructed in Milan on structural and aesthetic grounds, and he was invited to put his concerns into writing. The ensuing debate on 1 May 1392 was scrupulously minuted and has been conserved. Heinrich was arguing for an *ad quadratum* section similar to the cathedral in Cologne with which he was familiar, with a high nave and clerestory windows rising above low aisles and a system of flying buttresses carrying the stresses from the vaults over the aisle roofs to the ground (Plate 4.11).

The conclusions of the debate of 1 May 1392 actually specified once and for all the heights of the outer and inner aisles and the nave vaults. The result was that the yardstick to be used above the 28 braccia level already reached was reduced from the 14 braccia (13 braccia 10¼ inches to be precise) of the *ad triangulum* system (or 16 braccia for the *ad quadratum* system) to 12 braccia. This vertical measure related to the width of the aisles (16 braccia) in the ratio of 3:4, but it could not now be claimed that all the vertical and horizontal dimensions were tied together in a single geometrical system. At least the vertical dimensions above the building line had their own pleasing proportional relationship to the horizontal yardsticks. The triangle with sides in the proportion 3, 4 and 5 (12, 16 and 20 braccia) was the so-called knotted rope or Pythagorean triangle known to every schoolboy and craftsman of the day as a simple way of drawing a right angle. Divide a length of rope into 12 equal divisions, form it into a triangle with sides 3, 4 and 5, and you will have a right-angle triangle. The ratio 3:4 had long been praised as a satisfying 'harmonic' proportion, and would receive further support as Plato's *Timaeus* came to be better known in the fifteenth century.[20] The fact that these proportions correspond to pleasing harmonics in music (the musical unison (1:1), fifth (2:3), fourth (3:4) and octave (1:2)) had persuaded Plato, and Pythagoras before him, that this was a system running through all creation. The impact of these ideas would be felt by Alberti and other architects later in the fifteenth century. From a practical perspective, the ratio 3:4 made it easy to calculate vertical dimensions relative to horizontal ones at any scale.

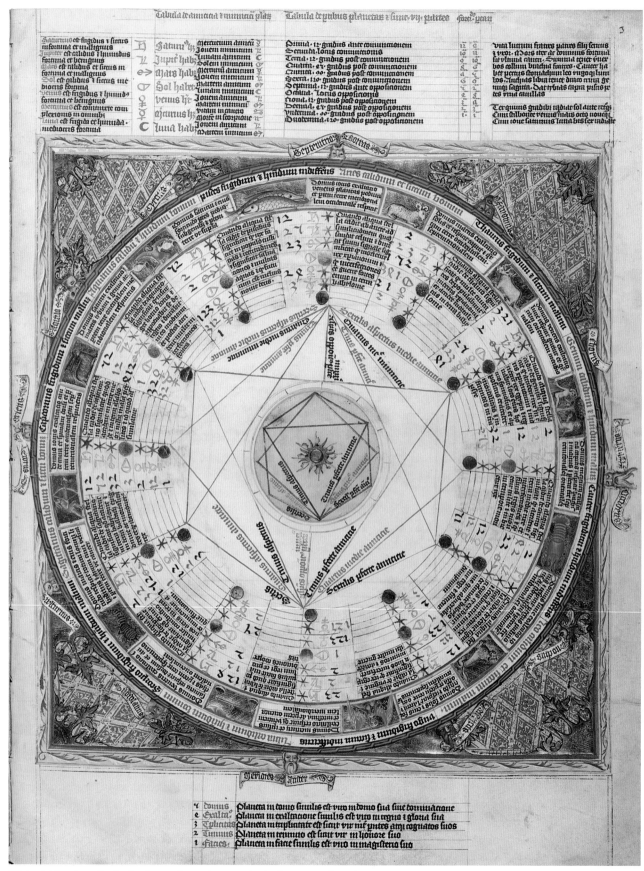

Plate 4.10   Astrological schema from the astrological manuscript of Wenzel IV of Bohemia, *c*.1400, Bayerische Staatsbibliothek, Munich (shelfmark Clm.826, fol.3r).

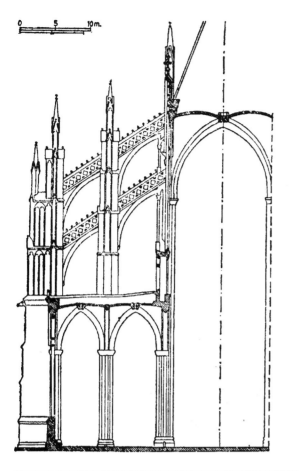

To sum up, although the patrons of Milan Cathedral were determined to build in the Gothic style (at least as far as its decorative details were concerned), they resisted the architectural theory which accompanied the style in the practice of the northern Gothic masters. In part this reflected a certain fear of using the daring structural engineering of the German and French masons, with their soaring interiors supported by flying buttresses, but in part it reflected a fundamentally different attitude to geometry. If you look again at the section (Plate 4.5), you can see how the squat proportions of the building leave very little space above the aisles for windows, making the interior very dark (Plate 4.12). On the other hand, support for the nave vaults is provided by buttresses which are aligned with the roofs of the outer and inner aisles.

The story does not end there, however, for as late as 1521, when Cesariano published his edition of Vitruvius illustrated with splendid woodcuts, he chose to select Milan Cathedral as an example of

Plate 4.11   (Left) Section of nave and aisles, Cologne Cathedral (Beltrami, 1964, p.78).

Plate 4.12   View of roof of inner aisles, Milan Cathedral, showing clerestory windows of nave and buttresses. Photo: Tim Benton.

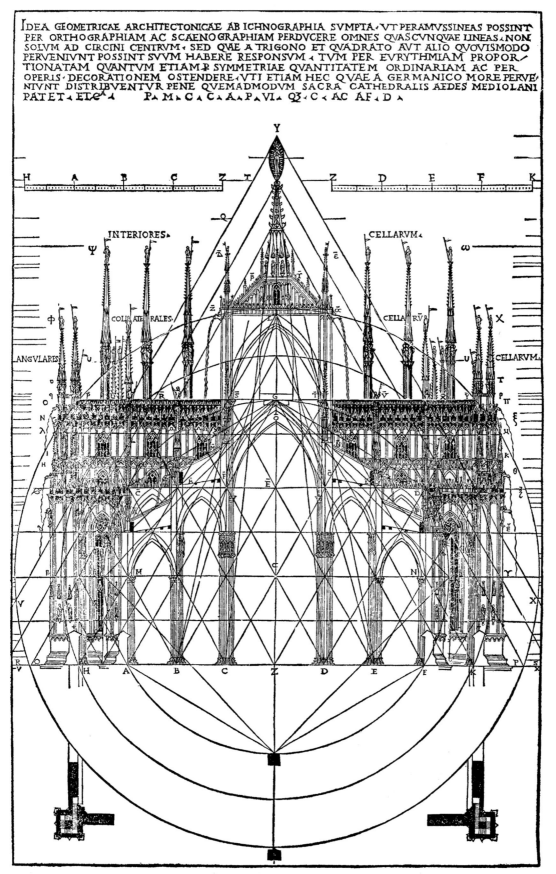

Plate 4.13   Section of Milan Cathedral from Cesare Cesariano, *Di Lucio Vitruvio Pollione de Architectura*, 1521 (Cesariano, 1968, bk 1, fol.XV verso).

a geometrical order linking plan and elevation. No doubt he was trying to please his Milanese patrons, but he was also calling on the best documented building site he knew. Cesariano picks up on Gabriele Stornaloco's equilateral triangles and reproduces an even more complicated version of Gabriele's scheme, this time including the crossing tower with an imaginary spire on top (Plate 4.13). Two points are worthy of note. A century into the Renaissance period, medieval geometric theories still carried prestige as a system of thought linking mathematics, philosophy and religion. Second, Cesariano's plate and descriptions provide evidence that the *ad triangulum* system never died out on the site of the cathedral. It seems that the *ad triangulum* system was more comprehensible and vivid to some Renaissance observers than the sequence of compromise decisions taken during construction.

## 'Quadrature' (rotating squares)

A technique used by craftsmen throughout the Middle Ages was the rotating square. With nothing more than a ruler and compass, one can easily create a nest of squares which expand or contract ad infinitum. Each square takes the diagonal of the square before it as its side (or vice versa).

In an approximation often used, the diagonal of a square of side 7 measures roughly 10, the diagonal of a square of side 10 measures roughly 14, the diagonal of the next square of side 14 is roughly 20, and so on. Squares of these dimensions are included on one of Cesariano's pages of explanatory geometric diagrams along with other geometric proofs based on Euclid (Plate 4.14, top row). A Latin translation of the complete works of Euclid had been made by Adelard of Bath as early as 1130, and Euclidean geometry was taught as part of the quadrivium (arithmetic, geometry, astronomy and music). Architects invariably provided a basic introduction to Euclidean geometry in their treatises. But whereas these shapes are easy to draw, they are difficult to measure precisely, since the diagonal of a square measures the side multiplied by root 2 (1:1.414).[21] For a modern craftsman used to measuring dimensions with a ruler, this would pose a problem, but for a craftsman used to working with straight edge and compass, this was a natural procedure. The squares would be drawn out at full size on the church floor (or on the surface of a stone block for smaller work)

and the dimensions taken from the drawing with dividers or cords. Medieval craftsmen believed that the dimensions thus derived were bound to produce pleasing proportions and coherence in the whole design. An example of a church plan with a nest of squares in the middle was drawn by Matthäus Ensinger, son of the master Ulrich von Ensingen, who was one of the foreign experts called in by the Milanese (Plate 4.15).

It is worth taking a little time to study this plan, based on an original drawing, and imagine how it might be extended towards both larger and smaller squares. Each square is drawn twice, once rotated by 45 degrees. In this design the nave bays are not square, and the relationship between width and depth is provided by the difference between a square and its diagonal (the same square rotated). The squares can be expanded in size to include the whole church, or reduced to the level of individual blocks of stone. This is a flexible system for ensuring that dimensions stand in a simple proportion to one another.

I noted earlier that one of the 'secrets' of the masons consisted in how to take the elevation from the plan and that this was confirmed at the convocation of Regensburg in 1459. Thirty years later two books had been published which claimed to reveal this secret. Matthäus Roriczer was the master mason of Regensburg Cathedral, and his book, which he published himself in 1486, is normally referred to as *Das Buchlein von der Fialen Gerechtigkeit* (*The Little Book of Correct Finials*) (Plate 4.16). Soon afterwards a goldsmith called Hannes Schmuttermayer published a rival booklet. Both books make clear that the secret depended on manipulating revolving squares. The publication of these pamphlets shows the weakening hold of the medieval 'mysteries' of the masonic lodges.

The habit of thinking in terms of the square and its diagonal died hard. When Filarete drew his plan of Sforzinda, an ideal town named for the Sforza family (the ruling family in Milan), and published it in his architectural treatise in the mid-fifteenth century, the site was first laid out in a diagram of rotated squares (Plate 4.17). We will see that Brunelleschi, too, used a sequence of rotated squares to dimension his first building.

The Gothic system encouraged individuality within guidelines. The individual craftsman

Plate 4.14   Diagrams illustrating the system of rotating squares based on the diagonal (top two and middle left) from Cesare Cesariano, *Di Lucio Vitruvio Pollione de Architectura*, 1521 (Cesariano, 1968, bk 9, fol.CXXXXIIII recto).

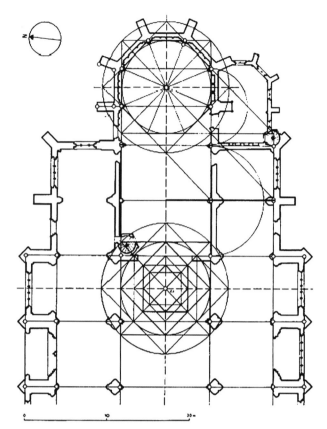

Plate 4.15   Matthäus Ensinger, plan of Bern Cathedral, founded 1421 (original probably drawn 1419–26) (Bucher, 1972, p.42).

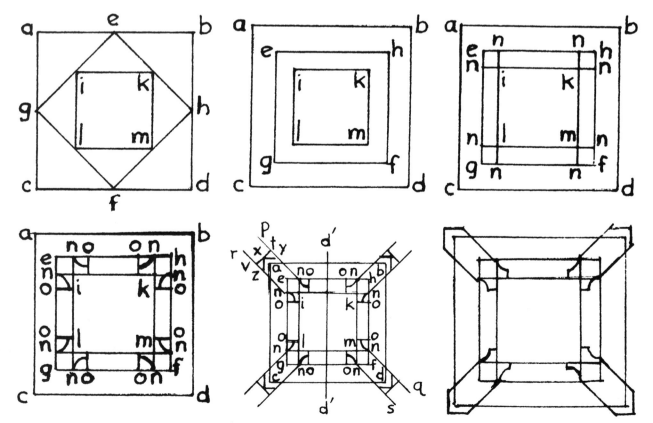

Plate 4.16   Roriczer's diagrams demonstrating the 'secret' of the masons (Shelby, 1977, pp.85–90). © 1977 by Southern Illinois University Press, reproduced by permission of the publisher.

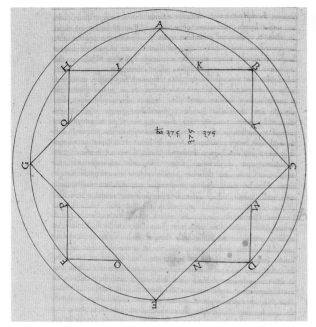

Plate 4.17 Filarete, plan of Sforzinda from *Trattato di architettura*, vol.II, *c*.1461–4, Biblioteca Nazionale Centrale, Florence, Codex Magliabechiano II.I.140, fol.13v. By concession of the Ministero per I Beni e le Attività Culturali della Repubblica Italiana. Photo: © BNC, Florence/Micro Foto, Florence.

was encouraged to invent the detail within the bounding lines of proportion imposed by the geometrical system. The late Gothic style of the end of the fourteenth and fifteenth centuries placed particular prestige on invention of forms. By contrast, many Renaissance architects believed that their task was to reproduce antique details accurately. An architect like Brunelleschi would himself carve the model for all the columns and capitals in his buildings, and expect his masons to faithfully reproduce it without deviation. Attention in the Renaissance focused on getting the details right (by the standard of antiquity) and composing buildings out of these fixed components, which had their own rules of proportion and dimensioning. As Paul Frankl puts it:

> In the Gothic style, all spatial parts and solid members are connected by 'division'; the Renaissance style returns to the principle of 'addition'… In the Renaissance style every single part is treated as an independent entity, while in the Gothic style every part is treated as a fragment of the whole, so that, finally, whole Gothic buildings were intended to be interpreted as mere fragments of some larger, outside entity – as fragments of the infinite.[22]

Frankl exaggerates to make his point, but he accurately demonstrates the fact that Gothic

masons aimed to unify all the details of their building within a system of related geometrical figures. In fact, as I will show, this 'medieval' way of thinking continued well into the fifteenth century in the work of Renaissance architects such as Brunelleschi.

# 3 The Tuscan Romanesque and the Renaissance

The Gothic style penetrated Italy along the French and German trade routes (for example, in Milan, Pavia, Bologna, Siena, Orvieto and Venice). But the political and social structure in the Italian states never allowed the northern masons to establish a stranglehold on these building sites. A continuing tradition, based on reusing or copying antique forms and details, extends in Italy from late antiquity through the Early Christian style into the Romanesque (eleventh and twelfth centuries). Thus, Florence Baptistery – probably constructed in the eleventh century and refaced in the twelfth, with further additions and changes early in the thirteenth century – has a Romanesque form and incorporates antique columns and capitals, as well as copies which are so close that only an expert can differentiate them (Plate 4.18).[23] A tradition extending at least as far back as the fourteenth-century chronicler Giovanni Villani maintained that the baptistery was originally a Roman temple dedicated to Mars. John Onians claims that during the low point of Florence's war with Milan around 1400, a spirit of nationalism led some Florentines (including Brunelleschi himself and his most important patrons in the silk guild) to favour a 'Tuscan' Romanesque style.[24] They may, therefore, have identified Romanesque buildings like the baptistery with an ancient Etruscan civilisation. Thus, the round arches carried on columns or pilasters, which can be seen on the exterior of the baptistery and in many Tuscan Romanesque buildings, may have seemed to them to carry as much authority as the ruins of antique Rome.

By the fourteenth century, Florentine masons had adapted local Romanesque forms to the Gothic decorative idiom. This freedom allowed them to combine features of different styles to incorporate subtle meanings. In Santa Maria Novella, both pointed and round arches are used, and there is none of the soaring height and delicate compound piers and rib vaults of

Plate 4.18   Interior of Baptistery, Florence. Photo: Alinari Archives, Florence.

the traditional northern Gothic church (Plate 4.19). Furthermore, the builders incorporated a mix of Gothic and Corinthian capitals. This mixture of Gothic and antique styles cannot be attributed to ignorance or conservatism. Ghiberti often used Gothic forms in his sculptural work (for example, in the tabernacle niche of his Saint Matthew statue on Orsanmichele), but he had taken the trouble to copy part of Vitruvius' *Ten Books* and also demonstrated a good knowledge of antique architectural forms in his work (see his *Flagellation* relief on the baptistery doors (Chapter 3, Plate 3.4) and his *Joseph* panel (Plate 3.14)). Michelozzo (1396–1472) worked for a time as foreman for Ghiberti on the baptistery doors, and it has been claimed that he is responsible for most of the architectural representations on these doors. Michelozzo used both Gothic and classical motifs in his architecture and was most original in his ornamental details, rarely using the same form twice. Men like Ghiberti and Michelozzo, for all their knowledge of antique theory and practice, were reluctant to abandon the medieval approach to decorative forms, picking and mixing their sources within an overall design framework. Brunelleschi, on the other hand, tried to develop a set of consistent practices governing every detail of his architecture. For example, he insisted on the standardisation of details, with little variation from one building to the next, and aimed to make the proportioning of his buildings in plan and elevation as clear as possible. It is this, rather than the close observation of antique fragments or a proper understanding of Vitruvius, which marks out his work.

## Filippo Brunelleschi

The Gothic style was seen by some Florentine humanists as a northern (or German, hence 'Gothic') corruption of good Italian practice. This was certainly the message asserted by most of the authors of architectural treatises in the later fifteenth century. It is traditional to see Filippo Brunelleschi as the one who restored the manner of building of the ancients. Several of his contemporaries say as much, including disinterested observers such as the wealthy Florentine merchant Giovanni Rucellai, Alberti and Filarete. Brunelleschi's biographer, Antonio Manetti, claims that, after his failure to win the competition for the baptistery doors in 1401, Brunelleschi set off for Rome with Donatello to study and measure the ruins. There 'he seemed to recognize very clearly a certain arrangement of members and structure just as if God had enlightened him about great matters'.[25]

There is no concrete evidence that Brunelleschi either read any Vitruvius or even studied the antique ruins in Rome, but it is clear that he made a huge effort to create a new system based on analysis of the antique and Romanesque examples he had seen. By a 'system', I mean an organisation of columns, with their capitals and bases, supporting arches or an entablature. When Manetti was writing, probably in the 1480s, copies of Vitruvius were circulating widely and many architects had begun to interpret the text. Similarly, many architects were beginning to make detailed surveys of ancient ruins in sketchbooks which have survived. By then, it was not possible to defend an architect as a correct interpreter of antiquity without assuming that he had read Vitruvius and been to Rome to measure the ruins. Thus, whether one believes (with John Onians) that Brunelleschi consciously turned his back on antique Roman examples in order to honour the native Tuscan Romanesque buildings in and around Florence, or whether one accepts Manetti's claim that he learned from genuine antique examples in Rome, what is certain is that by the

Plate 4.19  Interior of nave, Santa Maria Novella, Florence, begun 1279. Photo: Tim Benton.

1480s he was seen as the founder of a new style based on antiquity and the principles contained in Vitruvius' *Ten Books*.

One of the first buildings in which this new style was clearly seen was the Ospedale degli Innocenti in Florence, built as an orphanage or foundling hospital by the silk guild, of which Brunelleschi was a member from 1419 to 1427 (Plate 4.20). For Heinrich Klotz, whose monograph on Brunelleschi is one of the livelier books on Renaissance architecture, the whole shift of aesthetic around the turn of the fifteenth century could be boiled down to Brunelleschi's use of monolithic stone columns and Corinthian capitals in this building.[26] As Klotz writes:

> Even today, an observer used to the Gothic tradition finds this row of rounded columns on Attic bases with Corinthian capitals a breath of fresh air, a rebirth, almost a visual embodiment of the Renaissance ... The column is an architectural metaphor of the human form: the base is the foot, the shaft the trunk, the capital the head.[27]

However, Brunelleschi did not follow Vitruvius' description of the Corinthian order in its proportions. Vitruvius says that the height of a Corinthian column (including its capital) should be exactly ten times its width at the base of the shaft.[28] Brunelleschi's columns are close to $1:10\frac{3}{4}$. It is no accident that the large granite columns with their Romanesque capitals in the baptistery have a proportion of $1:10\frac{1}{2}$. In fact, the proportions Vitruvius specified for Doric, Ionic and Corinthian columns and their details were seldom respected even by Roman architects in antiquity, let alone their Romanesque derivatives. Vitruvius' instructions are very complicated: he adjusted the proportions of columns depending on their spacing and size. It took many years before Sebastiano Serlio laid down clear rules in Book IV of his treatise published in 1540.[29]

Another surprising feature of the foundling hospital is the system of proportion used. Howard Saalman argues that this is none other than the

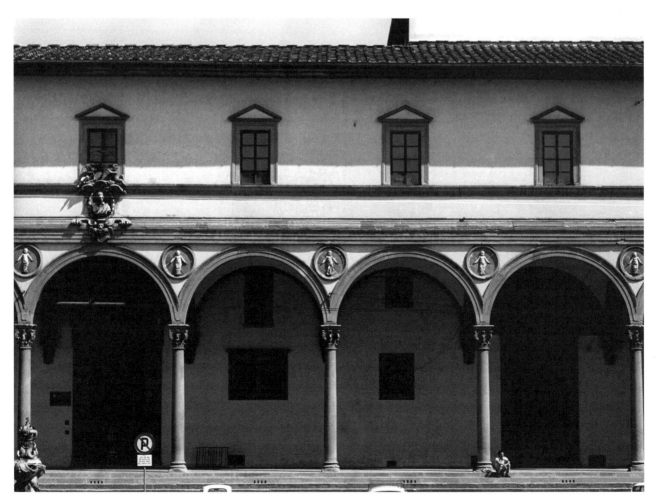

Plate 4.20   Filippo Brunelleschi, portico of the Loggia degli Innocenti, Florence, begun 1419. Photo: Tim Benton.

rotating squares beloved of medieval masons.[30] Beginning with the square representing the colonnade of the cloister (30 braccia), the diagonal (42.43) provides the approximate side of the cloister itself (42 braccia) (Plate 4.21).[31] The diagonal of a square of 42.43 is 60 (in fact, 59.31 braccia), and this is almost precisely half the width of the portico (120 braccia). Furthermore, Brunelleschi chose as his intercolumniations two 'perfect numbers': 6 braccia for the cloister and 10 braccia for the loggia.

Having staked out the plan in 'ideal' terms (i.e. marking the central points of the columns and not taking into account their thickness), he had to decide how thick and how high the columns and piers should be. Vitruvius would have been little help. For him, columns always supported a straight entablature, as in a Greek or Roman temple. Alberti would later condemn arches supported by columns for sacred architecture, arguing in his treatise on building that they were rarely used in antique temples. Christian churches, however, had been adapted from Roman basilicas (judicial halls), which were often built with columns supporting arches. Alberti used this as a loophole for accepting the use of arches and columns for church architecture.[32] Alberti insisted that arches should properly be thought of as part of a wall and therefore be supported by rectangular or square piers. Brunelleschi had to invent his own system, turning to Romanesque and Early Christian churches for help (Plate 4.22).

Having fixed the length of the loggia (at 120 braccia), it seems that he began by marking off two squares at either end (corresponding to the entrances) with a dimension of 15 braccia (half the inner square of the cloister). Then he subdivided the remaining 90 braccia into 9 bays of 10 braccia each. Each bay was thus 10 braccia wide and 15 braccia high (a square and a semicircle) (see Plate 4.21).

All this is at the 'theoretical' level of lines drawn on paper. Passing to the practicalities of the site and construction, the dimensions changed slightly. The side bays turned out to be slightly less than 15 braccia wide, at $14\frac{2}{3}$ braccia. But the height to the underside of the entablature was also *exactly*

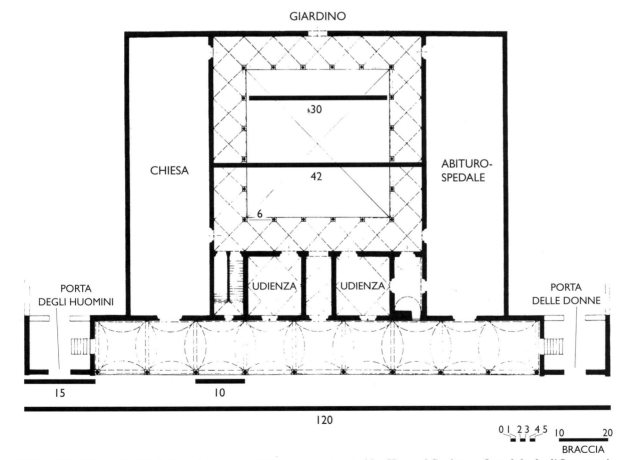

Plate 4.21 Plan of first building phase up to 1427 as reconstructed by Howard Saalman, Ospedale degli Innocenti, Florence (drawn by Marsha Berger from Saalman, 1993, Figure 1; annotated by Tim Benton). The dimensions marked are 'theoretical'; actual dimensions vary slightly.

$14\frac{2}{3}$ braccia (Plate 4.23 – see 'b'), which confirms the underlying thinking of the 'theoretical' diagram suggested above. Then there was the problem of inserting solid columns and piers over the centre points staked out on the plan. Saalman notes that the width between the columns (in the clear) is *exactly* the same as their height to the springing point of the arches (see 'a', Plate 4.23). Again, this suggests that the 'theoretical' figure of a square of 10 braccia surmounted by a semicircle 5 braccia high was reproduced at a slightly diminished scale between the columns. But the problem now was how to fit the elements of classical architecture – the columns, capitals and entablatures – into this geometric framework while still respecting the rules of proportion which apply to these elements.

The thicker the columns, the less space would be left between the columns, on their 10 braccia centres. At the same time, to maintain a proportion for the columns comparable to antique or Romanesque examples, the thicker the column base, the taller the column. But Brunelleschi had to fit in the column height and a series of arches, including their archivolts (the moulding on the front face of the arch), underneath the entablature

Plate 4.22   Interior of San Miniato al Monte, Florence, eleventh century. Photo: © Museo di Storia della Fotografia Fratelli Alinari, Florence.

fixed at a height of $14\frac{2}{3}$ braccia (see 'b', Plate 4.23). He might have chosen columns 1 braccio wide and 9 braccia high, to which he would have added $4\frac{1}{2}$ braccia for the arches (half 9 braccia) and 1 braccio for the archivolt, giving a total of $14\frac{1}{2}$ braccia. Instead, he preferred taller and thinner columns $\frac{5}{6}$ of a braccio wide and $9\frac{1}{6}$ braccia high (equal to the width 'in the clear' between the columns). To fit these arches under the entablature, Brunelleschi had to make them less than semicircular. These slightly depressed arches are convincing testimony that Brunelleschi had difficulty adapting his medieval proportioning system to the fixed elements of classical architecture. Not having a clear rule for the height of the entablature, Brunelleschi made this very deep, equal to the depth of the arches or half the height of the columns.

The loggia was completed in its initial form by 1424, and work went on building the dormitories and corridors inside the hospital. On 29 January 1427, Brunelleschi received his last payment from the silk guild. Over the next 20 years, the plan was considerably enlarged, the façade extended and raised, and the dormitory over the portico added.

The Loggia degli Innocenti was a revolutionary design in its clarity of conception and the impact of its columns and arches. But it was also 'unclassical' (i.e. unlike antique practice) in many of its details, and this was noted at the time. One such detail, in the bay added on the right side of the façade,

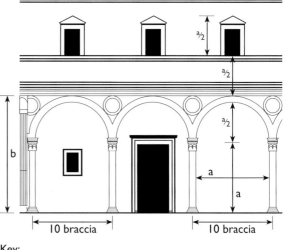

Key:
a = $9\frac{1}{6}$ braccia
b = $14\frac{2}{3}$ braccia

Plate 4.23   Diagram of the Loggia degli Innocenti, Florence (adapted from Gärtner, 1998, p.28).

was a form recognisable not only in the baptistery but also on the façade of San Miniato al Monte and other Tuscan Romanesque buildings. Here the architrave (the bottom third of the entablature), which in classical thinking represents a solid beam carried by columns, was turned round the corner as if it was a simple decorative moulding (Plate 4.24). Vasari, in his life of Brunelleschi, recounts an anecdote in which Brunelleschi, returning to Florence after an absence, criticised the man responsible for incorporating this detail. Vasari writes:

> Wherefore Filippo, on returning, reproved him for having done such a thing, and he answered that he copied it from the Church of S. Giovanni [the baptistery], which is ancient. 'There is one sole error,' said Filippo, 'in that edifice, and thou hast followed it.'[33]

What this anecdote reveals is that Brunelleschi clearly considered the baptistery as a legitimate source, but that he felt able to criticise it based on his knowledge of other antique and Romanesque buildings.

Architectural historians have noted Brunelleschi's reliance on Tuscan Romanesque buildings not only for certain habits of mind but even for the most classical-looking details in his architecture. Howard Saalman comments on the unique quality of Brunelleschi's capitals, unlike any antique examples.[34] For example, although the capitals of the Loggia degli Innocenti can be identified as Corinthian (Plate 4.25), they reveal peculiar errors which anyone who had read Vitruvius was unlikely to have committed. Vitruvius recounts the myth of the origin of the Corinthian order (Plate 4.26):

> A young Corinthian girl of citizen rank, already of marriageable age, was struck down by disease and passed away. After her burial, her nurse collected the few little things in which the girl had delighted during her life, and gathering them all in a basket, placed this basket on top of the grave. So that the offering might last there a little longer, she covered the basket with a roof tile. This basket, supposedly, happened to have been put down on top of an acanthus root. By springtime, therefore, the acanthus root ... began to send out leaves and tendrils, and its tendrils, as they grew up along the sides of the basket, turned outward; when they met the obstacle of the corners of the roof tile, first they began to curl over at the ends and finally they were induced to create coils at the edges. Callimachus [the well-known sculptor] passed by this monument and noticed the basket and the fresh delicacy of the leaves enveloping it.[35]

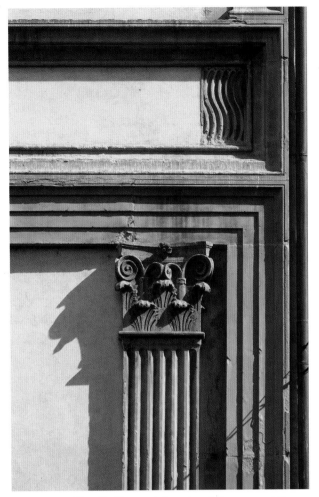

Plate 4.24   Detail of 'turned down' architrave moulding, Ospedale degli Innocenti, Florence. Photo: © 1990 Scala, Florence.

In an antique Corinthian capital, various details confirm the understanding of this myth (Plate 4.27). The core of the capital should be in the form of a bell-shaped basket. The tendrils (both the inner and outer volutes) should be relatively delicate and possess their own stalks with sprouting leaves. The stalks from which the volutes sprout are barely indicated and carry no sprouting leaves along the stem. Brunelleschi turned the volutes into thick spirals, almost as deep as those of the Composite order, in which the features of the Ionic and Corinthian orders were combined. Many examples of Composite capitals exist in antique and Romanesque architecture, but Vitruvius does not mention them because they were only just coming into fashion when he was writing. Brunelleschi reinvented the Corinthian capital in his own way to make the maximum impact and to combine the best elements of the Corinthian and Composite orders.

161

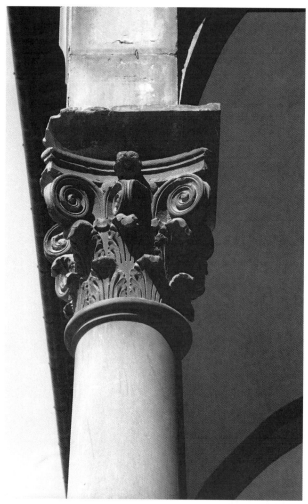

Plate 4.25 Filippo Brunelleschi, capital on *Loggia degli Innocenti*, Florence. Photo: Tim Benton.

Plate 4.26 Illustration of Callimachus legend from Perrault's edition of Vitruvius, 1684, Figure 11. Photo: V&A Images/Victoria and Albert Museum, London.

Brunelleschi also made another invention for which there was no authentic antique precedent. Antique Greek architecture was essentially a trabeated system depending on horizontal beams carried on columns. As Early Christian and Romanesque architects adapted the Roman form of the basilica for Christian use, it was common to lighten the structure by placing arches directly onto columns and piers (see Plate 4.22). Brunelleschi realised, however, that something was missing in the logic of this arrangement. A column seemed incomplete without the architrave, frieze and cornice of an entablature above it. Thus, in his later buildings, he added 'dosserets' (chunks of entablature) above his columns (see Plates 4.25 and 4.28). These had the effect of creating a virtual entablature running from column to column, and also increasing the height of the arcade and increasing the sense of delicacy in the arrangement. Saalman argues that, at least in the cases of the Florentine churches of San Lorenzo and Santo Spirito, these dosserets were required to make up height to meet a fixed dimension which Brunelleschi had set as equal to the diagonal of the crossing.[36]

Santo Spirito is a classic case of the difficulty of matching a geometric scheme to the details of classical architecture (Plate 4.29). In 1436 the *operai* (building committee) were nominated for the rebuilding from scratch of the Augustinian church. The patrons consisted of the wealthy families in the Santo Spirito quarter in the south of the city. Although the first column was only delivered on site in the year of Brunelleschi's death, according to Manetti the plan was measured out with chords under Brunelleschi's supervision, and a wooden model was made of the whole church. The plan was very simple: a nave composed around a grid of bays 22 × 11 braccia surrounded all the way round by bays 11 × 11 braccia square. These bays ran round the ends of the transept and choir, and it may have been intended that they would run round the west end as well. This, at least, is how the Florentine carpenter and architect Giuliano da Sangallo drew out the plan (Plate 4.30).

Each aisle bay had a semicircular chapel framed by half-columns matching the nave columns (Plate 4.31). The semicircular chapels were originally intended to project on the exterior, giving a scalloped effect to the external walls (see Plate 4.30), and the first chapels to be built were begun on this basis. In construction, all the chapels would

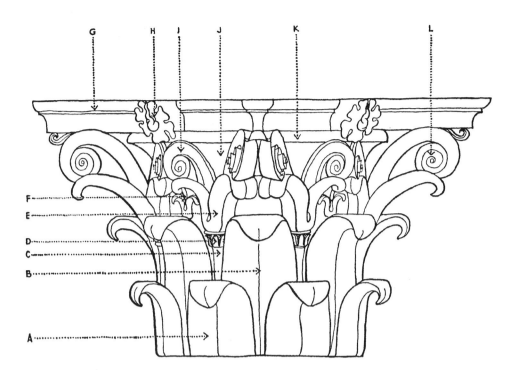

A. LOWER LEAVES (FOLIA IMA)
B. UPPER LEAVES (FOLIA SECUNDA)
C. STALKS (CAULES)
D. STALK CREST LEAVES
E. FOLIA PROJECTA
F. BLOSSOM STALK (CAULICULUS)

G. ABACUS
H. ABACUS BLOSSOM (FLOS ABACI)
I. INNER VOLUTES (HELICES)
J. CAPITAL CORE (CALATHOS)
K. CALATHOS LIP
L. OUTER VOLUTES (VOLUTAE)

Plate 4.27 Diagram of Corinthian capital (Saalman, 1958, p.113; illustration by Marsha Berger).

be enclosed behind a straight wall. To understand how radical this plan was, you only have to think of conventional liturgy. Religious architecture depends on a notion of hierarchy, according to which there should be a central window in the four arms of the cross and a central door at the west end for ceremonial entrances. Brunelleschi's plan created a kind of unhierarchic uniformity where each bay was the same. This idea perfectly suited the patrons whose chapels lined the church and whose arms were represented both inside and outside. Most troublesome was the consequence of the plan at the west end (bottom of plan, Plate 4.30), where the continuation of the arcade would have created four doors. When, in 1482, the decision was taken to run against Brunelleschi's wishes and construct three doors, perhaps eliminating the arcade in the last bay of the nave, a debate ensued which divided Florentine architects and patrons. The Signoria (as the principal magistracy) was drawn into the debate, since the façade was to be built with public money, and after four years a decision was finally

taken to reject Brunelleschi's four doors and build the conventional three. In a revealing letter to Lorenzo de' Medici, Giuliano da Sangallo pleaded to respect Brunelleschi's wishes; his plan shows how Brunelleschi would have liked the church completed (Plate 4.30).

Saalman argues that here, as at the Loggia degli Innocenti, Brunellschi used medieval methods of proportion.[37] Manetti tells how Brunelleschi staked out the plan and then orally explained to workmen what the elevation would look like. The columns with Corinthian capitals were $14\frac{2}{5}$ braccia high on shafts $1\frac{1}{2}$ braccia wide, a ratio of 1:9.57, neither 1:10 nor 1:9, as Vitruvius would have stipulated. Thus the columns at Santo Spirito are identical in height to the pilasters in the Innocenti loggia but considerably fatter. The four big piers of the crossing were 2 braccia square (plus attached half-columns $\frac{3}{4}$ braccio deep). Therefore, since the piers and columns were laid out on a regular grid of lines, the last bay before each of the four piers around the crossing was necessarily less wide than

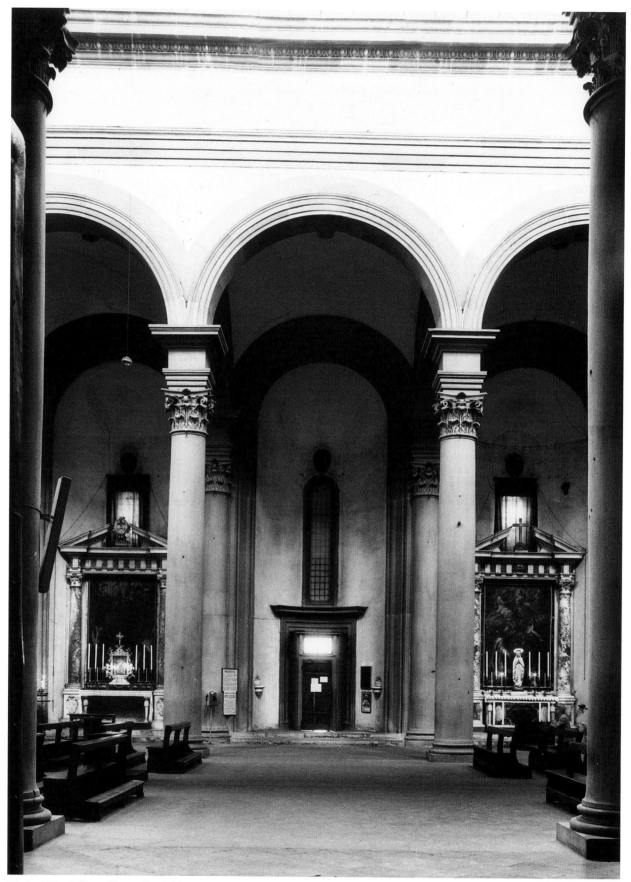

Plate 4.28  Filippo Brunelleschi, interior of nave, Santo Spirito, Florence, showing columns with dosserets. Photo: Tim Benton.

the others, because the piers with their attached half-columns were thicker than the columns alone. But the height of the columns had to match all the others, so the inevitable result was that these arches are stilted (squeezed into a horseshoe curve rather than semicircular – see Plate 4.32).

As at the Innocenti loggia, Brunelleschi used geometric proportions to establish certain fixed points in the interior elevation, and then had difficulty making his classical details fit. For example, Saalman believes he set the springing of the main arches over the crossing (also the top of the main entablature) at exactly the diagonal of the crossing ($28\frac{1}{2}$ braccia). He also believes that the height to the underside of the nave arches was fixed by the diagonal of the nave bays ('in the clear':

the diagonal of a rectangle $9\frac{1}{2}$ braccia by 20 braccia = $21\frac{1}{4}$ braccia). Brunelleschi selected a column $1\frac{1}{2}$ braccia wide at the base, leaving $9\frac{1}{2}$ braccia 'in the clear' between the columns rising to a height of $14\frac{1}{3}$ braccia (a ratio of 1:9.57). The arches, spanning the clear space of $9\frac{1}{2}$ braccia, could only be expected to make up another $4\frac{3}{4}$ braccia, a total of just over 19 braccia, leaving $4\frac{1}{2}$ braccia to fill plus the depth of the main entablature (5 braccia) to make the $28\frac{1}{2}$ braccia to the top of the entablature and the springing of the crossing arches. Brunelleschi's solution was to add dosseret blocks ($c.2\frac{1}{3}$ braccia deep) and make up the rest with the archivolt, a further band of grey stone around the archivolt, and a slight gap below the entablature. The presence of this gap, and the thickening of the archivolt, indicate that the masons perceived a problem. They would have been happier if the top of the arches had touched the underside of the entablature (as at the Innocenti loggia – see Plate 4.20), because then it would seem as if the geometry controlling the crossing arches was

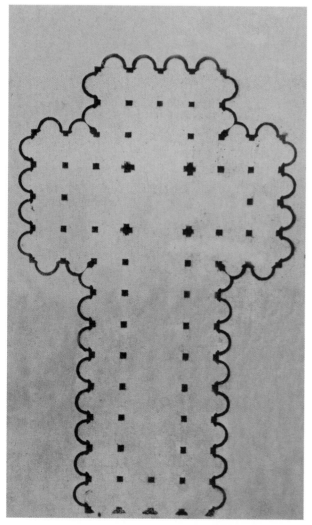

Plate 4.30   Giuliano da Sangallo, plan of Santo Spirito, Istituto Germanico, Florence. Photo: © 1990 Scala, Florence.

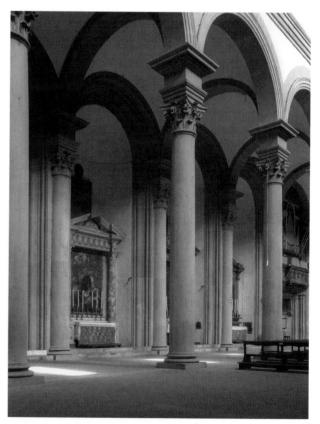

Plate 4.31   Filippo Brunelleschi, view of side chapels, Santo Spirito, Florence. Photo: Tim Benton.

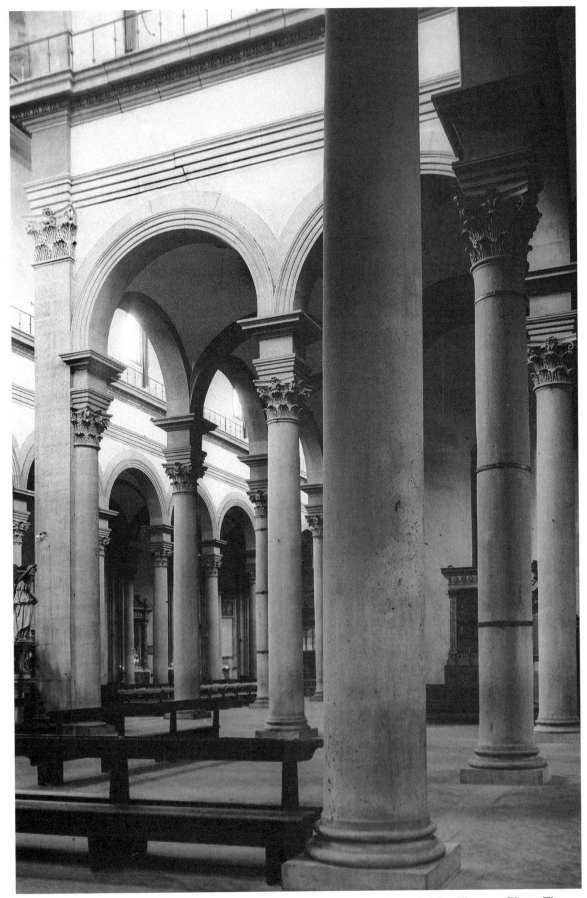

Plate 4.32    Filippo Brunelleschi, bay of transept next to crossing pier, Santo Spirito, Florence. Photo: Tim Benton.

integrated with that of the smaller columns and nave arches.

There is no question that Brunelleschi was a startling innovator whose work radicalised architectural practice in the fifteenth century. The extremism of his ideas rests not on their classical references, but on the coherence with which he tried to develop certain simple principles. There is very little close observation of antiquity and no obvious reference to Vitruvius. There is nothing of humanist interest in number theory or proportional systems beyond what would have been shared by any medieval architect. The next generation of architects and treatise writers would learn much more about antiquity and antique architecture and employ a much wider vocabulary of forms in their work, but few would match the simplicity and impact of Brunelleschi's architecture.

# 4  Pienza

I will conclude this essay by considering the use of both Gothic and Renaissance styles at Pienza. Aeneas Silvius Piccolomini (1405–64), raised to the papacy as Pius II in 1458, was born in the small hill town of Corsignano, south-east of Siena.[38] As one of the foremost humanists of the day – he studied Greek for two years with Filelfo, a leading scholar of the language, and was a member of the humanist Cardinal Albergati's staff in Florence – he was predisposed to be receptive to the new architectural ideas propounded by Alberti and others in Rome. (Alberti's Latin treatise *De re aedificatoria* or *On Building* (1450–72) is both a commentary on and a modernisation of Vitruvius' *Ten Books*.) But Aeneas had also travelled widely in northern Europe in his earlier years as a clerk and diplomat, and had acquired a taste for the light, airy spaces of the south German and Austrian hall churches. Thus, when he decided to rebuild the centre of Corsignano in 1459, renaming it Pienza, he chose as his builder and architect Bernardo Rossellino (1409–64). Rossellino had worked for Pope Nicholas V and was responsible for supervising the construction of Alberti's Palazzo Rucellai in Florence.

The pope's residence in Pienza, the Palazzo Piccolomini (1460–2), is so close in design to the Palazzo Rucellai (traditionally dated 1446–51) that debate continues as to the share of authorship of Alberti and Rossellino in the buildings (Plates 4.33 and 4.34).[39] Unfortunately, the Palazzo Rucellai is insufficiently well documented to date the construction of the façade precisely, let alone attribute an architect. The site of the current palace incorporates seven different properties which were gradually acquired by Rucellai. The first work (1446–55) seems to have been on the organising of some of these properties and the introduction of a cortile (interior courtyard). Charles Mack attributes the building to Bernardo Rossellino from documentary and stylistic evidence.[40] It has been argued that the façade was built only after the marriage of a member of the Medici family to Giovanni Rucellai's son in 1461, since emblems associated with the Medici (interlinked diamond rings) are included in the frieze.[41] This would make the construction of the façade of the Palazzo Rucellai in Florence virtually simultaneous with the Palazzo Piccolomini in Pienza. Some authors are convinced that Bernardo Rossellino designed both. Others have argued for an earlier date for the façade of the Palazzo Rucellai (1452–8), using evidence of the breaks in stonework and relationship of the façade to the existing houses, which suggests that the first five bays (on the left) would have been built before the acquisition of a house at the right-hand end in 1458.[42] The emblem of the entwined diamond rings already featured on a tondo in the courtyard of the palace in 1452, and Brenda Preyer argues that these emblems were common in other courts, for example the d'Este in Ferrara, with whom Rucellai had close relations.[43]

In both the Palazzo Rucellai at Florence and the Palazzo Piccolomini at Pienza, three orders of pilasters are used, supporting straight entablatures and framing windows. Alberti distinguished clearly in his treatise between beauty, which is 'an inherent property, to be found suffused all through the body of that which may be called beautiful', and ornament, which is 'attached or additional'.[44] The former was defined by 'a reasoned harmony of all the parts within a body, so that nothing may be added, taken away or altered, but for the worse'.[45] Of all forms of ornament, Alberti preferred columns and pilasters, which he understood as representations of solid colonnades or arcades applied to a wall surface. The kind of thing he had in mind was the Colosseum or

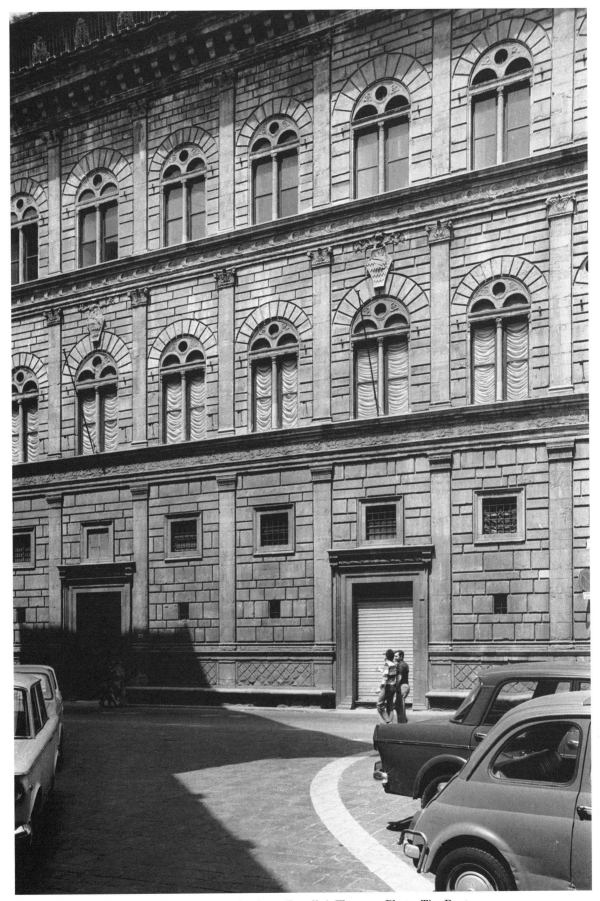

Plate 4.33   Leon Battista Alberti, façade of Palazzo Rucellai, Florence. Photo: Tim Benton.

Plate 4.34   Bernardo Rossellino, façade of Palazzo Piccolomini, Pienza, 1460–2. Photo: Tim Benton.

the Theatre of Marcellus in Rome, both of which
feature superimposed rows of arches with half-
columns or pilasters supporting entablatures. At
the Colosseum, the sequence of orders, from the
ground upwards, was Doric, Ionic, Corinthian
and Composite, and this was to become the fixed
sequence in later Renaissance work. In both the
Piccolomini and Rucellai palaces, however, the
sequence was Doric followed by two variants of
Corinthian. Alberti described the ornamentation
of houses as employing flattened representations
of colonnades or arcades of this kind applied to
the wall surface. To this extent, both the Palazzo
Rucellai and the Palazzo Piccolomini are up-to-
the-minute evocations of antiquity according to the
latest ideas of Alberti.

The cathedral, however, was designed on quite
different principles. As Pius's published memoirs,
the *Commentarii*, explained, the interior of the
church 'was according to the directions of Pius,
who had seen the plan among the Germans in
Austria'.[46] Various possible south German models
of hall churches have been proposed, but it seems
that Pius's intentions were less to copy specific
German examples than to distil from them the
principle of a bright, well-illuminated interior. The
hall church principle, of having the aisles as high
as the central nave, allowed plentiful light to enter
from all four sides. Rossellino was not comfortable
with the Gothic idiom and made little effort to copy
Gothic details precisely. He also made what Pius
cheerfully called an error: the insertion of short
pillars and dosseret blocks above the capitals and
below the vaults (Plate 4.35). In all probability
these were needed, just as Brunelleschi's dosserets
and arches had been, to make up the necessary
height while retaining a reasonably classical
proportion for the piers. Once again, we encounter
an architect trying to work out ways of adapting a
style of architecture designed for trabeated temples
to serve duty in a modern building type.

Most Renaissance churches were left with
their façades unfinished. Pienza Cathedral was
unusual in that, in the very short building period
(1460–2), a monumental façade in an antique
style in travertine stone was added to the Gothic
building (Plate 4.36). Pius is not specific in his
*Commentarii* about where the design of the façade
came from, but we must assume that he was
closely in touch with Rossellino and accepted its
classical form. Humanist patrons such as Pius saw

Plate 4.35  Bernardo Rossellino, interior of Pienza
Cathedral, showing detail of dosseret block and pillar.
Photo: Tim Benton.

nothing odd about mixing architectural styles in
their commissions. The hall church profile helped
Rossellino deal with a difficulty facing architects
such as Alberti in the design of the façades of
Santa Maria Novella and San Francesco Rimini,
where the tall naves and lower aisles provided
difficulties for the application of superimposed
rows of pilasters or columns. At Pienza, Rossellino
superimposed two orders of pilasters, framing
attached columns and surmounted by a triangular
pediment. On the lower storey, the height of the
columns was augmented by adding tall pedestals,
while on the upper storey, the gap from the capitals
to the entablature was made up by arches. Despite
some awkwardness – for example, the bays are
of unequal width so the arches have an awkward
profile – this was one of the best attempts to use
the classical style to articulate a façade in the
fifteenth century.

Plate 4.36  Bernardo Rossellino, façade of Pienza Cathedral, 1460–2. Photo: Tim Benton.

# 5  Conclusion

We have seen that, although there were some dramatic changes in building style in the early fifteenth century and although many artists and intellectuals were conducting scholarly research into the principles of antique architecture, many habits of thought from the medieval period continued. The fact that Italian masons and architects had always interpreted the Gothic style and the rules of the medieval masons in their own way made this flexibility possible. Thus, the Gothic Milan Cathedral was the product of a more Italian mental set than any northern Gothic church, and Brunelleschi's Renaissance buildings retain aspects of a medieval approach to proportion and measurement. The work of men like Rossellino demonstrates a sensitivity to situation and place in which Gothic and Renaissance principles could be selectively used and adapted to the needs of a particular client or audience.

# Chapter 5
# introduction

During the fifteenth century, most western European painters of any status and standard were involved in the making of altarpieces at some point in their careers and, for many, altarpiece production constituted an essential part of their livelihood. Demand for altarpieces was strong throughout western Europe, not just from ecclesiastical authorities but from private individuals and families who wished to leave for posterity some tangible remembrance of themselves and their patronage of an altar or chapel.

Altarpiece making involved compliance not only with the expectations of an individual or corporate patron, but with what was judged to be apt for a particular setting or function and with the conventions of a generic type – or indeed with the impulse for innovation in competition with existing altarpieces. It is usually well nigh impossible to chart the various stages in the making of a particular altarpiece, however. Contracts, where they survive at all, are often no more than financial statements specifying how much and in what manner an artist was to be paid. The exceptionally full documentation connected with the Sienese painter Sassetta's altarpiece of the *Madonna della Neve* in Siena Cathedral that Diana Norman explores in this chapter provides a rare opportunity to study the final appearance of an altarpiece in relation to issues of patronage, function, generic type, setting and local traditions. Conversely, in the absence of comparable documentation, contextual evidence is used to elucidate the making of the Ghent altarpiece by Hubert and Jan van Eyck. These two altarpieces also serve to illustrate differences in technique north and south of the Alps, for during the fifteenth century tempera painting remained the staple medium for Italy while oil painting was almost invariably used in the Netherlands and in some other areas of northern Europe.

The Renaissance altarpiece has traditionally been presented in terms of the development in Florence of a single-field format or *pala*, such as Fra Angelico's San Marco altarpiece (Plate 5.28), and with it the emergence of a unified, illusionistic spatial system, in contrast to the less spatially convincing, multi-panel altarpieces of the fourteenth century.[1] Sassetta's altarpiece shows that Siena was not immune to this single-field format. Through her analysis of altarpieces made north and south of the Alps, Diana Norman demonstrates, however, that there was considerable variety in the making of Renaissance altarpieces, and that the multi-panel altarpiece was neither redundant nor incompatible with the spatial experiments associated with the single-field altarpiece.

*Kim W. Woods*

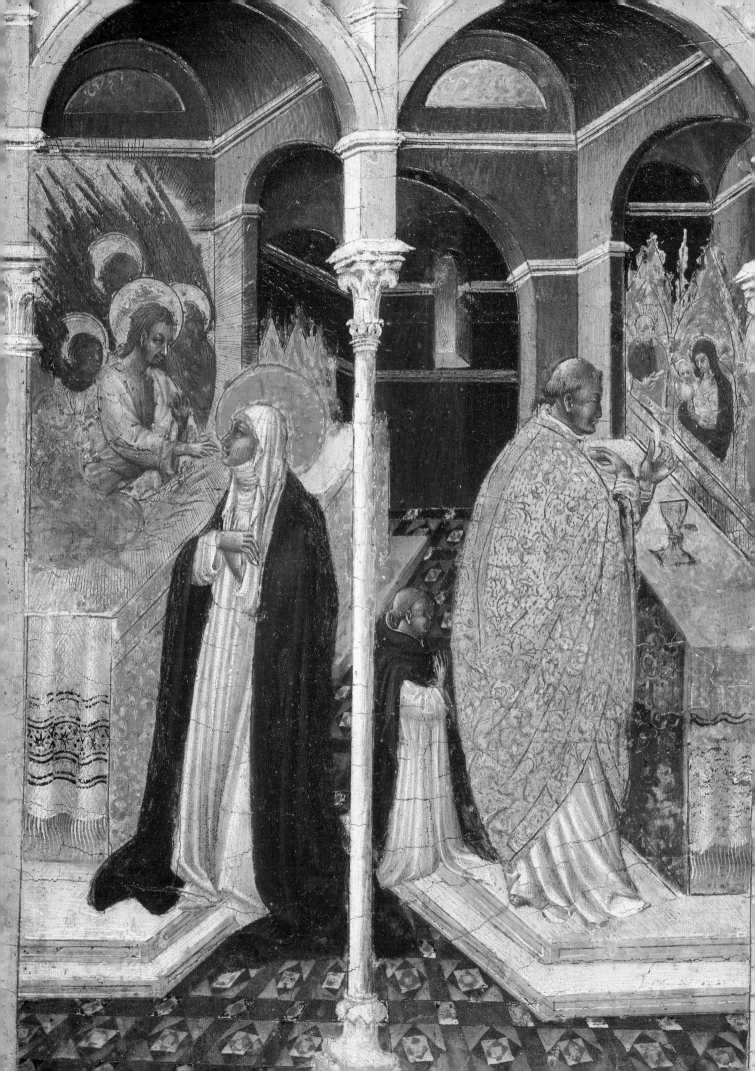

# Chapter 5

# Making Renaissance altarpieces

*Diana Norman*

As by the grace of God we are able to reveal to the uneducated and illiterate the miraculous things achieved by virtue and in virtue of our Holy Faith … let it be said that nothing, no matter how insignificant, can ever be taken up or brought to a conclusion without these three prerequisites: having the means to do it, knowing how to do it, and having the will to do it.

So runs the opening preamble to the statutes of the painters' guild of Siena.[1] Based on a statement written by Pope Gregory the Great in the late sixth century that images should be encouraged by the Church because 'in a picture, they who know no letters may yet read',[2] it offers a powerful rationale for the profession of painting. It also implies that an important part of painters' work was to create images that 'reveal … the miraculous things … of our Holy Faith'. One of the most popular and successful types of painting to achieve such an aim was the altarpiece, which was produced in large numbers during the fifteenth century in both northern and southern Europe. Well-known painters, ranging from van Eyck to Dürer in the north and Masaccio to Raphael in the south, readily took on altarpiece commissions. In addition, numerous other painters working in areas that have hitherto been viewed as more peripheral for the history of Renaissance art – such as the extreme north and south of Italy, France, Spain or, indeed, England and Scotland – were involved in the manufacture of altarpieces.

For this reason, the altarpiece has long been an object of particular interest to historians of Renaissance art. An influential study has been Jacob Burckhardt's essay 'Das Altarbild', written

between November 1893 and March 1894, published in 1898, and translated from the original German into English by Peter Humfrey in 1988.[3] Since then – particularly from the 1980s onwards – there have been numerous publications on altarpieces, covering not only Italy but other parts of Europe as well.[4]

What has particularly fascinated art historians about this genre of painting is that altarpieces had to fulfil a set of well-defined religious functions relating to their location over altars and their close physical relationship to the celebration of Mass that took place there. The liturgical history of the altarpiece is complex and open to varying interpretations. It is generally agreed, however, that the official confirmation of the doctrine of transubstantiation[5] at the Lateran Council of 1215 encouraged a change in liturgical practice, whereby it became much more common for the priest to officiate at Mass with his back mainly turned to the congregation, instead of facing them from the other side of the altar table. Thereby began a process where existing altar frontals were removed and placed at the back of the altar to act as a kind of dignified backdrop for the celebration of Mass.[6]

Probably even more influential was the increase in the number of altars in churches during the second half of the thirteenth century, resulting in a church having not merely a main or high altar, but also a series of side altars set against the walls of the church or in simple niches – again facilitating a demand for painted altarpieces to embellish them.[7] A small painting by the Sienese Giovanni di Paolo, probably once part of a composite altarpiece

Plate 5.1 (Facing page) Giovanni di Paolo, *The Miraculous Communion of Saint Catherine of Siena*, 1460s, tempera and gold leaf on panel, 29 × 22 cm, Metropolitan Museum of Art, New York. Photo: © 1985 The Metropolitan Museum of Art. The Friedsam Collection, Bequest of Michael Friedsam, 1931 (32.100.95).

honouring Saint Catherine of Siena,[8] illustrates on the right-hand side how an altarpiece would function during the celebration of Mass (Plate 5.1). Many such altars were endowed by private individuals who paid members of the religious order to whom the church belonged for the right to be buried in the vicinity of the altar and to have regular post-mortem masses celebrated on their behalf as a means of reducing time spent in purgatory.[9]

In other words, altarpieces were expected to conform to certain kinds of norm, particularly in terms of subject matter and content. They were, however, also susceptible to changes over time and to regional diversity. In addition, because the altarpiece was such a popular art form and attracted the attention of so many potential customers – many of whom had very specific personal requirements for their altarpiece or wanted it to demonstrate their taste and knowledge of art – the Renaissance altarpiece also became a vehicle for technical and artistic experiment.

Many can now only be seen in the carefully controlled environment of the modern art gallery – the cumulative result of changes in fashion for altarpieces and, more devastatingly, of the suppressions of religious orders that took place in the sixteenth century in northern Europe and in the late eighteenth and nineteenth centuries in Europe as a whole. In such settings, altarpieces tend to be displayed at a height that does not always take account of their original situation over an altar or of the original lighting conditions in churches that were largely dependent on natural light augmented only by candles or oil lamps. They are also very far removed from the liturgical and devotional 'performance' that took place in front of them and for which they were specifically designed. Their present mode of display and conservation does, however, allow one to learn a great deal about their technical make-up and to assess the formal and stylistic developments of the painters responsible for the altarpieces' execution.

In this essay I want, therefore, to examine and discuss a number of Renaissance altarpieces produced during the fifteenth century, some of which are still in the churches for which they were commissioned while others are now kept in art galleries. In so doing, I will focus particularly on the issue of the *making* of Renaissance altarpieces,

ranging from the practicalities of the contractual process for their commissioning to the techniques and materials used by their makers. In addition, I will consider, in some detail, altarpieces produced in both Italy and the Netherlands in order to demonstrate that the production and development of this highly successful and prolific artistic genre was by no means confined to Renaissance Italy.

# 1 Custom and practice: Sassetta's *Madonna della Neve* altarpiece

The benefits of reconstructing an altarpiece in its original setting and being aware of its wider artistic context are clearly illustrated in an early fifteenth-century Italian altarpiece (Plate 5.2) painted by the Sienese Stefano di Giovanni, better known by his nickname, Sassetta (active 1423 – d.1450). The painting's authorship is clearly signalled by an inscription at the centre of the lower frame of the main panel which reads 'STEPHANUS DE SENIS [ME] PINXIT' (Stefano of Siena painted me). Now housed in a special collection belonging to the Uffizi Gallery in Florence, the painting is known from its subject as the *Madonna della Neve* (Our Lady of the Snow). An unusual number of documents survive to chart the actual process of the making of this altarpiece and the wishes and intentions of the person who paid for it to be made. For this reason, it is worth analysing this written evidence in some detail.

The first of these documents is a formal contract drawn up in Latin by a local notary on 25 March 1430 and agreed between the patron of the altarpiece, Ludovica, daughter of Francesco Vanni Bertini of Siena and widow of Turino di Matteo, former *operaio* or clerk of works for Siena Cathedral, and the master painter Stefano di Giovanni.[10] Written and formally witnessed in Ludovica's house in Siena, the document records Sassetta's agreement to paint a panel (*tabula*) for the altar of the chapel of Saint Boniface in the cathedral, which is near the door called the Porta del Perdono. On the panel, he is to depict a number of specified figures: the Virgin Mary and her son Jesus Christ in her arms, Saints Francis, Peter, Paul and John the Baptist. In addition, he is to paint the Saviour above the Virgin Mary and five narrative paintings (*storie*) of the legend of Saint Mary of the Snow on the predella. He undertakes to use a quantity of gold and good colours and to paint

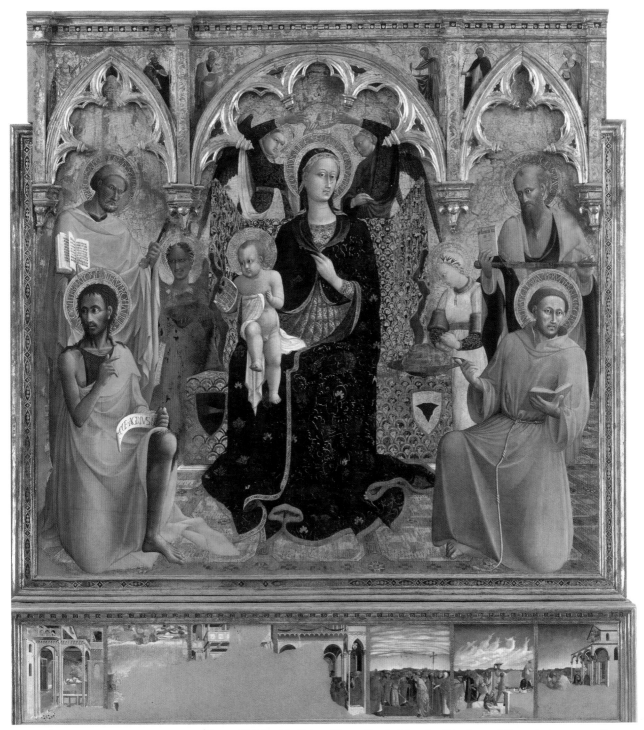

Plate 5.2   Sassetta, *The Virgin and Christ Child with Saints Peter, Paul, John the Baptist and Francis*, known as the *Madonna della Neve*, 1430–2, tempera and gold leaf on panel, 240 × 216 cm, Collezione Contini-Bonacossi (inv. no. C.B.1), Uffizi Gallery, Florence. Photo: akg-images/Rabatti – Domingie.

and ornament the panel well. He further promises to finish it within a year and accept no other work. Ludovica, for her part, promises to pay Stefano and his heirs the necessary amount of money owing to them, and it is agreed that the final price is to be assessed by two non-Sienese experts, one chosen by the patron and the other by the painter.

In many respects, this document is typical of altarpiece contracts at that time – identifying, as it does, the major parties involved, the fact that it is an altarpiece painting on panel, its intended location, its principal subject matter, the patron's concern to have good quality materials used, the time allowed for completion, and the means of

payment. Other contracts follow this basic shape, although there are variations due to local custom and to the individual demands of the particular commission.[11] The lack of information on how and when the initial payments are to be made is relatively unusual, although – as will be seen below – a final price was put on record. Usually painters received an initial and precisely specified sum of money in order to purchase the materials and begin the work.

Also lacking is a reference to any agreed model or drawing or any indication of who will manufacture the panel itself and the frame. There are many examples of contracts where specific reference is made to a preparatory drawing made by the painter himself or more occasionally by another artist.[12] There are also examples of contracts where the painter is instructed to follow the model of an existing altarpiece.[13] A later document relating to the *Madonna della Neve* commission (dated 29 October 1432) refers to Sassetta's expenditure for the 'ornament' of the panel. This is likely to refer to his collaboration with a woodworker for the actual manufacture of the panel and its frame. In other contracts, this task was often either assigned to a named sculptor or delegated to the painter, who would then subcontract this work to such a specialist.[14] This was particularly the case for the altarpieces that were set in very elaborate architectonic frames (see, for example, Plates 5.22 and 5.30).

As was often the case, Sassetta failed to meet the deadline of a year in which to complete Ludovica Bertini's altarpiece. A document, dated 23 October 1432 and issued by the Sienese guild of judges and notaries, records that the panel was now ready and that – following the terms of the 1430 contract – Ludovica had elected a Pisan painter, Gualtiero di Giovanni, as her assessor of the altarpiece's worth and Sassetta a Veronese painter, Cecchino di Francesco.[15] On 29 October, the two declared that Ludovica should pay Sassetta 180 gold florins.[16] Ludovica was apparently not satisfied with this valuation. She accordingly made a petition to the Curia dei Pupilli, a court that took care of minors and women in Siena, for this valuation to be reviewed. The record of their decision, now written in Italian and dated 30 December 1432, describes how two Sienese painters, Martino di Bartolommeo, elected by Ludovica, and Sano di Pietro, elected by Sassetta, together with Jacomo

di Meio di Nanni acting as a third neutral party, agreed unanimously that the price of 180 florins was a correct valuation for the painting of the chapel and its walls.[17] It seems, therefore, that Sassetta had also embellished the wall behind the altar in some way – perhaps with the 'Saviour' stipulated in the initial contract of 25 March 1430. Ludovica, together with her agent or procurator, was instructed to pay this sum of money, minus what Sassetta had already received. Ludovica died a month later in January 1433 and probably never saw the altarpiece installed. It was left to the heir of her estate – the civic hospital of Santa Maria della Scala – to make the final payments to Sassetta between 30 April and 20 August 1433.[18]

The wording of the 1430 contract makes it is clear that Ludovica commissioned the altarpiece of the *Madonna della Neve* both in memory of her deceased husband and also in her own right as a pious Franciscan tertiary.[19] The coat of arms of her own family thus features on the richly ornamented fabric to the right of the Virgin's throne (Plate 5.3) and that of her husband to the left (Plate 5.2). Saint Francis – the founder of the Franciscan Order – appears as a prominent figure kneeling in the right foreground of the painting directly beside Ludovica's coat of arms. Recent research by Machtelt Israëls has also revealed that the idea for a new altar chapel in which to house the altarpiece had originated during Turino di Matteo's lifetime and that Ludovica was apparently fulfilling her husband's last wishes, which were made in somewhat dramatic circumstances on his deathbed.[20] According to an entry in a Sienese chronicle, Turino had also been given a magnificent funeral in 1423 and had been buried in front of the Porta del Perdono and therefore in the close vicinity of the altar for which Sassetta's altarpiece was destined.[21]

The painting was originally commissioned for one of the oldest and most venerated altars in Siena Cathedral, in close proximity to a doorway known popularly as the Porta del Perdono – an entrance that provided the most immediate access both to the baptistery and to the civic centre of the Palazzo Pubblico (Siena's town hall) and the Piazza del Campo. This doorway no longer survives, but its site is marked by the entrance to the seventeenth-century chapel of the Madonna del Voto (Plate 5.4). A number of art historians, including myself, assumed that the location of this altar was to

Plate 5.3  Sassetta, *Madonna della Neve*, detail of the main panel (Plate 5.2).

the right of the Porta del Perdono (as stated in a number of descriptions of it) but against the west wall of the south transept (Plate 5.5 – see point A shown on the plan). However, Machtelt Israëls's discovery of a document dated 1616 where the altar is described as in the entrance of the doorway, together with her careful examination of that part of the cathedral and of the altarpiece frame, has led her to make a plausible case for the altar being located on the south wall to the immediate right of the Porta del Perdono (Plates 5.4, 5.5 – see point B).[22]

The earliest surviving cathedral inventories, dating to the late fourteenth and early fifteenth centuries, name the altar as the Madonna delle Grazie (Our Lady of Thanks, in the sense of favours received). The reason for the title appears to have been that at that time it housed an ancient image of the Virgin and Child. This was probably the early thirteenth-century panel painting known as the *Madonna degli Occhi Grossi* (Our Lady of the Big Eyes), in front of which it was believed the Sienese civic authorities had dedicated the city to the Virgin in 1260 before winning a decisive victory at the

Plate 5.4   View of the entrance to the chapel of the Madonna del Voto (former site of the Porta del Perdono), Siena Cathedral, south transept. Photo: Lensini, Siena.

Plate 5.5   Plan of Siena Cathedral in the fifteenth century (Israëls, 2003, Figure 2). The Porta del Perdono is indicated by point C. Used with permission.

battle of Montaperti.[23] The site for Sassetta's new altarpiece was, therefore, one that carried with it a number of prestigious historic associations.

The painting depicts the familiar subject for Renaissance altarpieces of the enthroned Virgin with the Christ Child on her lap surrounded by angels and saints. It also echoes very strongly the imagery of one of Siena's most revered civic icons – the front face of Duccio's *Maestà* of 1311 for the high altar of the cathedral (Plate 5.6). That such an association was explicitly intended is further demonstrated by the inscription engraved on the Virgin's halo which reads: 'If you trust me, Siena, you will be full of favour' (Plate 5.2).[24] This message of reciprocity closely mirrors that of the painted inscription on the lower edge of the *Maestà*.[25] It would also have acted as a reminder to the Sienese of the dedication of their city to the Virgin in 1260, and the traditions surrounding the ancient image of the *Madonna degli Occhi Grossi* that had previously been on the altar.

The imagery of Sassetta's altarpiece also paid honour to two more of the Virgin's titles – that of 'Queen of Heaven' and of 'Our Lady of the Snow'. Two angels behind the throne hold a crown over the

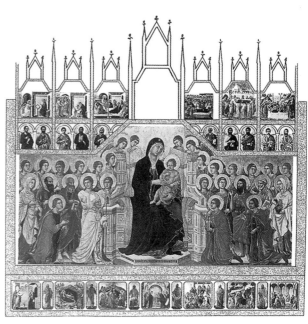

Plate 5.6   Reconstruction of the front face of Duccio's *Maestà* (*c*.1308–11) by John White with modifications by Christa Gardner von Teuffel and the author (Norman, 2003, Figure 35).

Virgin's head. The angel on the left of the throne, meanwhile, carries a dish filled with snow and the angel on the right makes a snowball (see Plate 5.3). The seven narrative scenes of the predella – two more than the five prescribed in the 1430 contract – describe in detail the legend of 'Our Lady of the Snow'. They show how, in the reign of Pope Liberius (352–66), the Virgin caused snow to fall miraculously in the heat of August on the Esquiline Hill in Rome. The snow fell, moreover, precisely

in the pattern of the ground plan of a church. The Virgin then instructed a wealthy layman and his wife, and Pope Liberius, to build a church in her honour upon this site – a church that subsequently became Santa Maria Maggiore, one of Rome's major basilicas (Plate 5.7).[26] As *operaio*, Turino di Matteo would have been closely involved with building work in Siena Cathedral, and therefore the subject matter of the predella would have carried personal associations for him and his widow. Since the

Plate 5.7    Sassetta, *Pope Liberius Marks out the Snow in a Ground Plan*, 31 × 28 cm, detail of the predella of the *Madonna della Neve* (Plate 5.2).

Plate 5.8   Masaccio and Masolino, *The Foundation of Santa Maria Maggiore with Saints Jerome, John the Baptist, John the Evangelist and Martin of Tours*, reconstruction of one face of the Santa Maria Maggiore altarpiece, *c.*1428–30, tempera, oil and gold leaf on panel, 145 × 76 cm (centre), 114 × 55 cm (sides). Centre: Masolino, *Pope Liberius Founding the Basilica of Santa Maria Maggiore*, Museo e Gallerie Nazionali di Capodimonte, Naples. Used with the permission of the Ministero Beni e Attività Culturali. Photo: © 2000 Scala, Florence. Left: Masaccio, *Saints Jerome and John the Baptist*, National Gallery, London. Photo: © The National Gallery, London, bought with a contribution from the National Art Collections Fund, 1950. Right (facing page): Masolino, *Saints John the Evangelist and Martin of Tours*, John G. Johnson Collection 1917 (inv. 409), Philadelphia Museum of Art. Photo: Joseph Mikuliak.

miraculous event was held to have taken place on the feast of the Assumption, the subject would also have appealed to the Sienese, who had long celebrated this feast as the high point of the civil and religious calendar.[27]

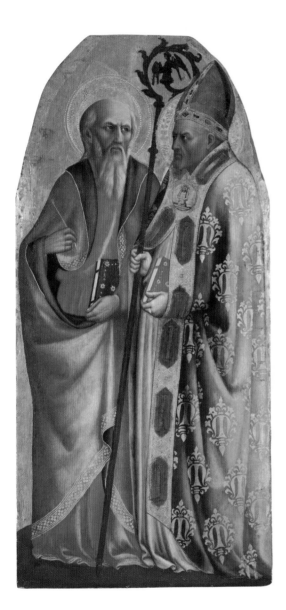

At the same time, however, the choice of subject also arguably had a more specific and immediate political dimension to it. In 1430, when the altarpiece was commissioned, the pope was Martin V (1417–31). Some years earlier, Siena Cathedral had been the location for a church council summoned by him. Significantly, as a member of the noble Roman family of the Colonna, this pope had a particular fondness for the church of Santa Maria Maggiore. This association was commemorated very spectacularly on a double-sided altarpiece in that church, executed around 1428–30 by the Florentine painters Masaccio and Masolino.[28] This altarpiece included both a depiction of the miraculous fall of snow and a large number of visual references to Martin himself. Thus, it appears that Pope Martin is portrayed as Pope Liberius marking out the ground plan of the new church in the snow on the central panel of the back face of the altarpiece (Plate 5.8). His name saint, Martin of Tours, is represented on the right panel wearing a cope embellished with the initial M and columns, a punning reference to the pope's family name of *colonna*, Italian for column. Saint John the Baptist, meanwhile, is represented on the left panel with his customary cross mounted on a column as well. It is possible, therefore, that one of the reasons for choosing the novel subject of 'Our Lady of the Snow' for an altarpiece for Siena Cathedral – and indeed changing the title of the altar on which it stood – was to commemorate and honour Siena's close connections with Rome and the papacy.

Recent examination of the carpentry of the *Madonna della Neve* has revealed that what survives today is the altarpiece in its entirety.[29] Thus, it comprises a single panel set over a box-like base or predella and has no upper tier of pinnacle panels or buttresses to the sides – anticipating, at a relatively early date, the form that many later Italian altarpieces would characteristically take. Its simple structure was also highly appropriate for the relatively restricted location into which it was to be placed (Plate 5.5, point B).[30] The upper framework is more elaborate and is constructed in an unusual way with layers of wood of greater

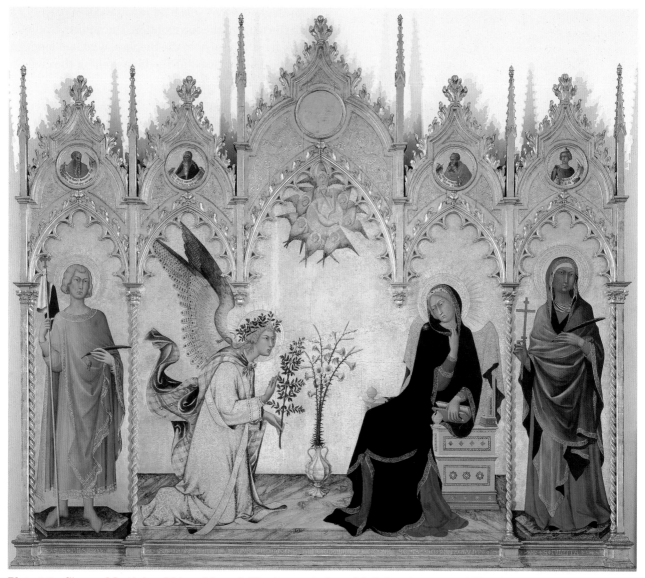

Plate 5.9   Simone Martini and Lippo Memmi, *The Annunciation with Saints Ansano and Massima*, 1333, tempera and gold leaf on panel, 260 × 305 cm, Uffizi Gallery, Florence. Originally over the altar of Saint Ansano in Siena Cathedral and now in a nineteenth-century frame. Used with the permission of the Ministero Beni e Attività Culturali. Photo: © 2002 Scala, Florence.

thickness on the central part of the panel.[31] It thus functions like a shallow canopy that both protects the painting and emphasises the importance of the Virgin and Christ Child. The design of the upper frame also echoed that of fourteenth-century altarpieces that stood over other venerated altars in the cathedral (Plate 5.9). Even more strikingly, the broad painted frame that surrounds the sides and lower edge of the main part of the panel probably directly mirrored the framework of Duccio's *Maestà*, which was still the most prestigious altarpiece in the cathedral (Plate 5.6).

The poses of the major figures in the main painting of the *Madonna della Neve* would also have related

in subtle but dynamic ways to its original position over the altar beside the Porta del Perdono (Plate 5.5, point B). Devotees, particularly those leaving the cathedral, would have been keenly aware of the kneeling figure of Saint John the Baptist, portrayed looking intently in the direction of the doorway (Plates 5.2, 5.4). The significance of his pointing gesture towards the Christ Child is underlined by the text on his scroll that reads 'Ecce Agnus D[ei]' (behold the lamb of God). His status as the forerunner and baptiser of Christ is further advertised by a text taken from the Gospel of Matthew inscribed in his halo (11:11, 'Among them born of women, there is no greater than John'). The

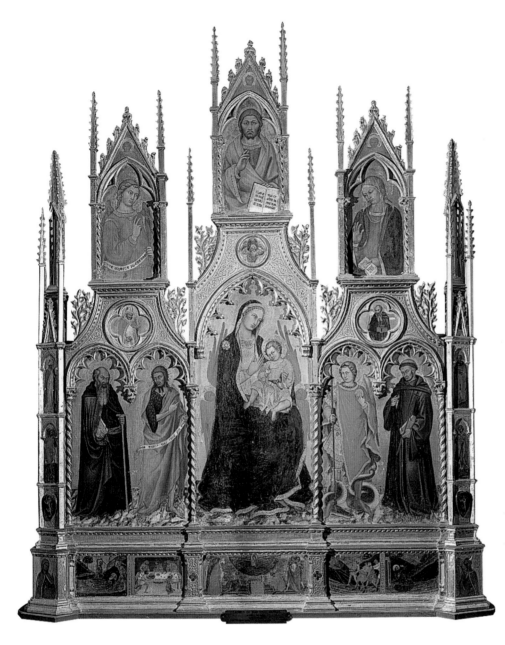

Plate 5.10   Taddeo di Bartolo, *Virgin and Christ Child with Saints Anthony Abbot, John the Baptist, Michael Archangel and Francis*, 1411, tempera and gold leaf on panel, 330 × 270 cm, Pinacoteca, Volterra. Photo: © 1990 Scala, Florence.

Christ Child, who also appears intently involved with those approaching from the left, carries a scroll on which is written another verse from the same chapter of Matthew (11:28, 'come to me, all you who labour and are heavy laden, and I will give you rest'). This message of comfort and welcome would have been highly apposite for an image placed close to one of the principal thoroughfares of the cathedral.

This use of a single panel for the main painting allowed Sassetta to represent the subsidiary figures of the saints not as single figures set on separate panels, but as existing within the same pictorial space as that of the Virgin and Christ Child. The very narrow gold bands that provide

the predella with the minimum of internal framing show a similar desire to establish an illusion of continuous space – seen most strikingly in the three landscape scenes on the right (Plates 5.2, 5.7).[32] Sassetta thus showed an awareness of recent developments in local Tuscan altarpiece design. Late fourteenth- and early fifteenth-century Sienese painters such as Bartolo di Fredi and Taddeo di Bartolo had already produced altarpieces depicting the Virgin and Christ Child with saints gathered together in a common setting, but also still retaining framing that separated the central group from the side figures (Plate 5.10). Altarpieces painted in the 1420s and 1430s by neighbouring Florentine painters such as Masaccio and Fra

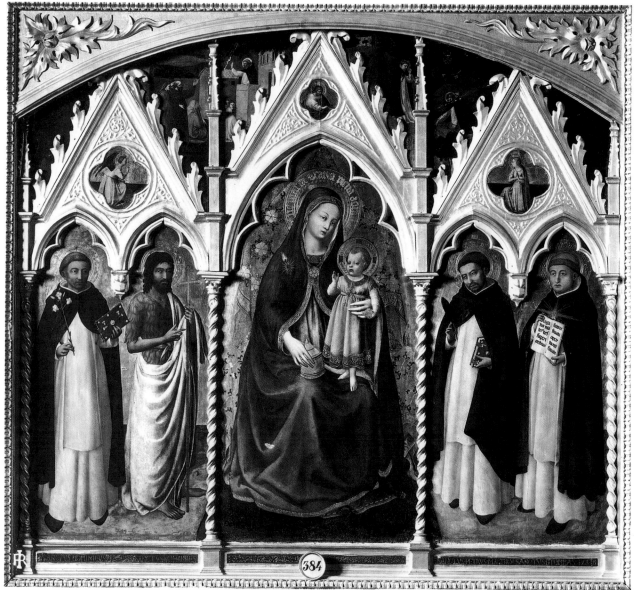

Plate 5.11    Fra Angelico, *Virgin and Christ Child with Saints Dominic, John the Baptist, Peter Martyr and Thomas Aquinas*, *c*.1428, tempera and gold leaf on panel, 137 × 168 cm, Museo di San Marco, Florence. Photo: Alinari Archives, Florence.

Angelico (*c*.1395/1400–1455) pursued similar aims (Plate 5.11).

Gentile da Fabriano's greatly admired *Adoration of the Magi* of 1423 for the sacristy of the Florentine church of Santa Trinita (which also functioned as a funerary chapel for the Strozzi family) provided a striking precedent for an altarpiece comprising a single panel surmounted by three richly decorated arches (Plate 5.12). This, however, had a narrative subject as its main image – a type that was already well established in earlier Sienese altarpiece design (Plate 5.9).

The impression of the holy figures in the main part of the altarpiece all coexisting within a single environment is further supported by the consistent viewing point used by Sassetta whereby everything above the centre of the painting is seen as if 'from below' and everything below the centre is seen as if 'from above' (Plate 5.2). The illusion of an orderly, clearly defined setting for the holy figures is also enhanced by the precisely delineated pattern of the carpet, the steep orthogonals of which appear to recede deep into open space. The latter feature suggests familiarity with Brunelleschi's invention of single-point perspective,[33] and implies that Sassetta had carefully studied Donatello's recently executed relief of *The Presentation of the Head of Saint John the Baptist to Herod* for Siena's

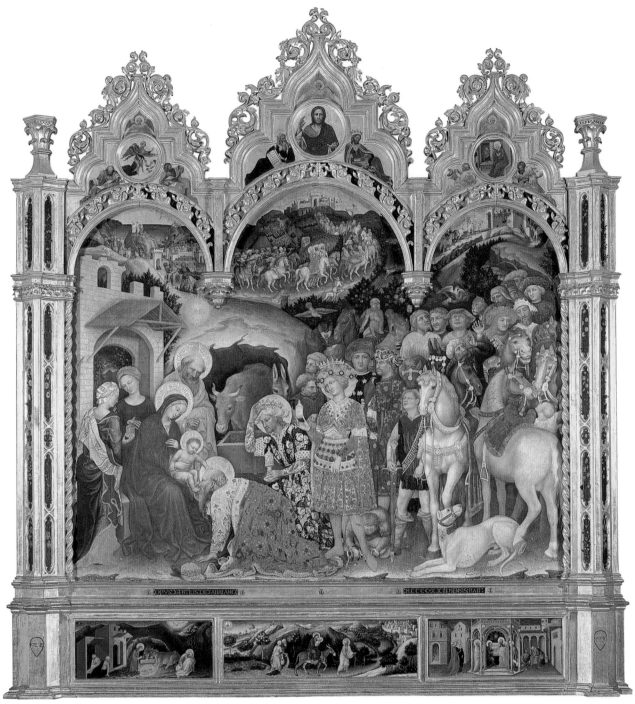

Plate 5.12  Gentile da Fabriano, *The Adoration of the Magi*, 1423, tempera and gold leaf on panel, 300 × 282 cm, Uffizi Gallery, Florence. Used with the permission of the Ministero Beni e Attività Culturali. Photo: © 1990 Scala, Florence.

baptistery font (Plate 5.13).[34] A small painting by Sassetta of *Saint Martin Dividing his Cloak for a Beggar* that can be dated securely to 1433 provides good evidence that Sassetta was intrigued by a figure in one of Masaccio's celebrated frescoes for the Brancacci Chapel in Florence, and was thus very receptive to the example of contemporary Florentine painting (Plates 5.14, 5.15; see also Chapter 2, Plate 2.20). Nevertheless, in the

*Madonna della Neve* Sassetta was undeniably paying tribute to the pictorial traditions of Siena itself, demonstrated most strikingly by his apparent indebtedness to the example of fourteenth-century altarpieces such as Duccio's *Maestà* (Plate 5.6).

Sassetta's *Madonna della Neve* thus provides a compelling case for the benefits of careful

Plate 5.13   Donatello, *The Presentation of the Head of Saint John the Baptist to Herod*, 1423–7, gilded bronze relief, 60 × 60 cm, Baptistery, Siena. Photo: Bridgeman Art Library, London.

Plate 5.14   Sassetta, *Saint Martin Dividing his Cloak for a Beggar*, 1433, tempera and gold leaf on panel, 34 × 36 cm, Collezione Chigi Saracini, Siena: Photo: © 1990 Scala, Florence.

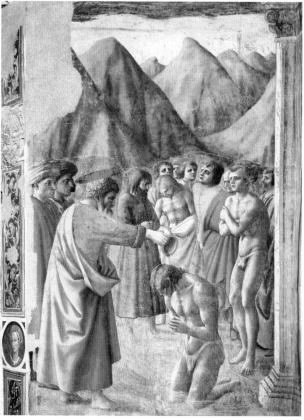

Plate 5.15   Masaccio, *Saint Peter Baptising the Neophytes*, *c.*1425–7, fresco, Brancacci Chapel, Santa Maria del Carmine, Florence. Photo: © 1990 Scala, Florence.

reconstruction of the original circumstances surrounding the commissioning and making of Renaissance altarpieces. By carefully investigating why the altarpiece was commissioned, where it was to be placed, and what kinds of past and present models the painter was drawing upon, the modern viewer is better able to appreciate the reasons for the subtle design and novel treatment of the altarpiece and understand how – despite its present condition – this work of art represents an important milestone in the history of the Renaissance altarpiece.

## 2   The triumph of the oil technique: Jan van Eyck and the Ghent altarpiece

Visitors to the cathedral of Saint Bavo in Ghent wishing to view and admire the famous Ghent altarpiece (Plates 5.16, 5.17) by the Netherlandish painters Hubert and Jan van Eyck might be forgiven for assuming that – unlike the case

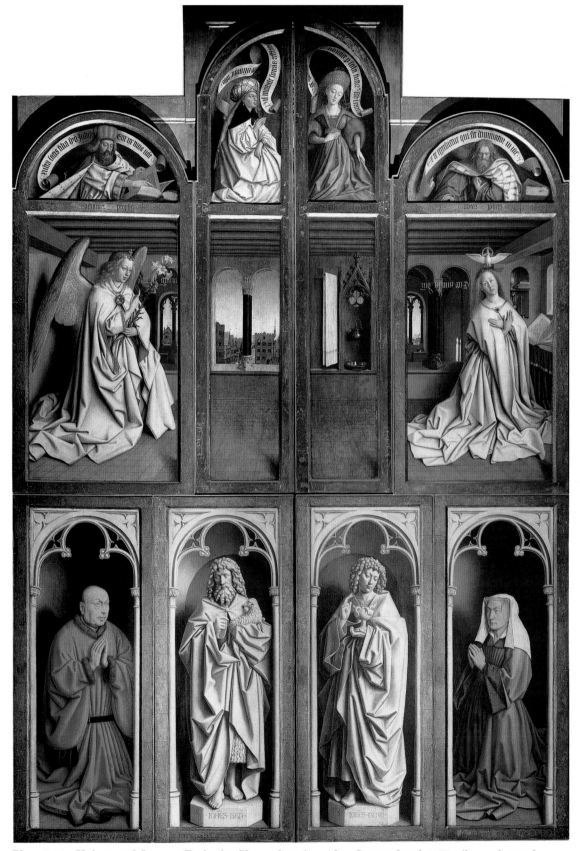

Plate 5.16   Hubert and Jan van Eyck, the Ghent altarpiece (closed), completed 1432, oil on oak panel, 375 × 260 cm, Saint Bavo Cathedral, Ghent. Upper tier: *Prophet Zechariah, Archangel Gabriel, Erythraen Sibyl, Interior with Townscape, Cumaean Sibyl, Interior with Niche, Prophet Micah, Virgin of the Annunciation.* Lower tier: *Jodocus Vijd, Saint John the Baptist, Saint John the Evangelist, Elizabeth Borluut.* Photo: © 1991 Scala, Florence.

of Sassetta's closely contemporary *Madonna della Neve* – they are witnessing a Renaissance altarpiece unchanged in its original ecclesiastical setting. However, its present location in a glass case in a chapel in the first bay of the north aisle (Plate 5.18, point B) is but the last of a long history of numerous moves for this complex and famous work of Renaissance art.[35] The earliest evidence for its commissioning comes in the form of an inscription painted along the lower frame of the panels of the closed altarpiece, and only recovered in 1823 during the restoration of these panels (Plate 5.16). This takes the form of a quatrain, written in Latin and in the poetic form of hexameters, and can be translated as: 'The painter Hubert van Eyck greater than whom no one could be found, began [this work]; Jan [his brother], second in art, completed the heavy task at the wish of Jodocus Vijd, who by this verse places under your protection what was completed on the sixth of May.'[36] The last line gives the date 1432 once the letters painted in red are combined. An entry in a contemporary register for 13 May 1435 states that a daily Mass in honour of God, the Virgin and all the saints was to be celebrated for the benefit of the souls of Jodocus Vijd (d.1439) and his wife Elizabeth Borluut (d.1443) in the chapel and at the altar they had erected in the church of Saint John.[37] Saint John was the original name of the church of Saint Bavo, which only took this name in 1540 (later becoming a cathedral in 1559). The Vijd Chapel – for centuries the location of the Ghent altarpiece and still containing carved coats of arms of the Vijd and Borluut families in the keystones of the vaulting – is the westernmost chapel on the south side of the raised chancel at the east end of the present cathedral (Plate 5.18, point A). The entry of 1435, meanwhile, offers an insight into the motivation for the commissioning of this monumental altarpiece, and also provides identification of the two kneeling donor figures on the outer panels of its lower tier when shut (Plate 5.16).

The reference to two painters in the inscription has caused much scholarly controversy, even to the extent of casting doubt over the authenticity of the painted text. This is due to the fact that there is very little documentary evidence for Hubert van Eyck and his work, which is limited to a few archival references between 1424 and 1426, the year of his death in Ghent. The career of Jan van Eyck, by contrast, is considerably

better documented. Lasting over a period between 1422 and 1441, several of his signed paintings survive. Suffice it to say that thanks to the clear-sighted work of modern scholars such as Elizabeth Dhanens, it is now generally accepted that the Ghent altarpiece is the work of two brothers, Hubert and Jan van Eyck.[38]

How and when they actually collaborated still remains a subject of discussion. One approach

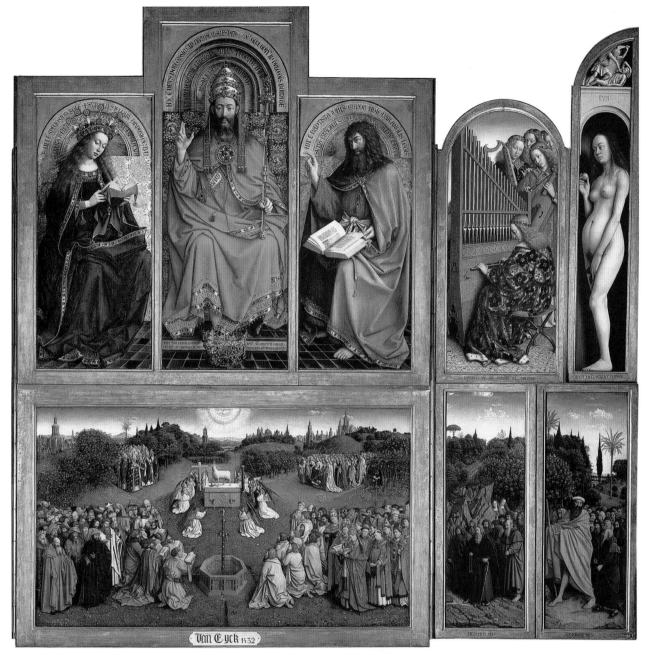

Plate 5.17   Hubert and Jan van Eyck, the Ghent altarpiece (open), completed 1432, oil on oak panel, 375 × 520 cm, Saint Bavo Cathedral, Ghent. Upper tier: *Adam with Sacrifice of Cain and Abel, Singing Angels, Virgin Mary, God the Father, Saint John the Baptist, Music-making Angels, Eve with Murder of Abel.* Lower tier: *Just Judges* (modern copy), *Knights of Christ, Adoration of the Mystic Lamb, Hermit Saints, Pilgrim Saints.* Photo: © 1994 Scala, Florence.

has been to attribute particular parts of the painting to one or other artist – often based on particular stylistic qualities that the art historian in question has wanted to ascribe to either Hubert or to Jan. Thus, it has been argued that Hubert was responsible for the overall conception of the work and that he worked on most of the panels which can be seen when the altarpiece is open, particularly the central panel of the *Adoration of the Mystic Lamb,* where the treatment of space

and attention to detail appear to be indebted to a fashionable style of painting prevalent in Europe at the turn of the century and known as International Gothic (Plate 5.17). Jan, meanwhile, was responsible for many of the exterior panels because of their perceived greater sophistication in terms of representing space and the sculptural treatment of the figures. Yet even this simple division of labour has been challenged and modified. Thus, it has been maintained that

Plate 5.18   Plan of Saint Bavo Cathedral (Dhanens, 1973, Figure 6b). © Prof. Smidt.

Jan – on the basis of other securely attributed paintings (see, for example, Chapter 1, Plate 1.5, and Chapter 2, Plate 2.27) – must also have had a hand in the skilled use of the oil paint medium on the interior panels and was also responsible for the highly realistic representation of the nude Adam and Eve figures on the upper panels. Likewise, the fictive sculpted figures of the two Saint Johns on the exterior panels have been assigned to Hubert because of their so-called old-fashioned appearance (Plate 5.16).[39]

Although there are good technical grounds to support the suggestion that a painter – assumed to be Jan – made considerable alterations to an existing design and to details that had already been painted, in many ways the apportioning of parts of the altarpiece to one or other artist shows a reluctance to accept the way that fifteenth-century painters were trained and how they worked, particularly on large-scale projects of the complexity of the Ghent altarpiece. It has to be noted that it was very common at that time for members of a single family to embrace the profession of painter and therefore to collaborate closely with one another. Fathers would naturally encourage their sons to follow in their footsteps, and close family members would set up workshops together, sharing the costs, particularly the purchase of expensive tools of the trade. Painting was often a family business and could also extend to relationships formed by marriage and even adoption. A famous example of such family ties occurs in the case of the Venetian painter Giovanni Bellini, who was the son of the painter Jacopo Bellini, and brother to another painter, Gentile.[40] In addition, their sister married the famous Paduan painter Andrea Mantegna. It was, therefore, entirely logical and practical that Hubert and Jan van Eyck should work together on Jodocus Vijd's altarpiece, and that Jan, as the younger brother, should take responsibility for bringing it to completion after Hubert's death in 1426.

As the 1430 contract between Sassetta and Ludovica Bertini indicates, patrons were concerned that their work should be executed by the painter's own hand. This, however, was more an expression of a concern that the work should be of a sufficiently high quality than a reflection of reality. It is clear from such sources as the late fourteenth-century treatise on art by Cennino Cennini that apprentices were taught to paint by closely emulating the work of their master or the work of other painters.[41] In other words, they were positively encouraged to copy and mimic the work of others, and they first had to learn a language of painting before they began to experiment and branch out on their own. This essential aspect of Renaissance painting practice is often hard to appreciate today, since such a premium is placed upon the concepts of originality and individuality when assessing modern works of art. In the case of the Ghent altarpiece, both Hubert and Jan van Eyck would be thoroughly conversant with the way the other painted, having probably been trained in a very similar way.[42] They were, therefore, more than capable of working together on this enterprise, even to the extent of both contributing to the painting of a single panel, albeit at different times.

Otto Pächt's careful analysis of all of the panel paintings on the Ghent altarpiece, based closely on the findings of the 1950–1 restoration report, led him to the conclusion that the formal and technical repertoire employed is so similar that in the case of certain figures and details it is

often impossible to distinguish the work of one painter from another.[43] Pächt's case is supported by the pioneering technical investigation of the underdrawing of the Ghent altarpiece undertaken by J.R.J. van Asperen de Boer in the late 1960s and early 1970s,[44] and also more generally by recent work carried out on other fourteenth- and fifteenth-century panel paintings. Using modern techniques such as infrared reflectography, it has been discovered that – even in the case of quite small paintings which were part of a much larger altarpiece complex – several painters characteristically worked together on them, although at different stages of the production cycle.[45] This, in turn, raises the interesting issue of whether Hubert and Jan van Eyck also employed others to work on the Ghent altarpiece, which was, after all, a project of some size and complexity. Although Renaissance painters' workshops were quite small business enterprises in terms of personnel, they usually included apprentices and fully trained but relatively inexperienced painters. Their involvement in a prestigious commission such as the Ghent altarpiece might only entail the grinding of the pigments and the preparation of the panels. However, if their experience and expertise allowed, it might extend to the actual application of paint and therefore to a share in responsibility for the final impressive result. Only the names of the master painters who were legally responsible for completing the commission – namely, Hubert and Jan van Eyck – would be included in the inscription on the painting, however.

What the Ghent altarpiece does demonstrate unequivocally is the advantages of the use of the oil technique for the art of painting in general, and the production of religious imagery in particular. This much is acknowledged in the famous passage in Giorgio Vasari's *Lives* (1568), where the Italian artist and author attributes the invention of oil painting to Jan van Eyck and his brother Hubert.[46] Though it is now accepted that the use of the oil medium was already known and practised in thirteenth- and fourteenth-century painting, particularly in northern Europe, it is still worth stressing how the painters of the Ghent altarpiece exploited the potential of this technique to its fullest advantage.

In order to appreciate this aspect of the Ghent altarpiece, it is helpful to review briefly the techniques by which the closely contemporary

*Madonna della Neve* was executed (Plate 5.2). This Sienese work (although having suffered considerable damage to its surface during various stages of its history) embodies the technique of tempera painting. This was characteristically employed in Italian panel painting until the example of imported Netherlandish works encouraged Italian artists to use oil painting much more extensively than they had hitherto.[47]

Sassetta's altarpiece was executed on poplar, a favourite type of wood for Italian artists because of its quick growth and therefore easy availability.[48] Once the carpentry had been completed, the panel was covered with a ground of gesso (calcium sulphate) and animal glue, the manufacture and application of which is vividly described by Cennino, who refers to two stages, the initial thicker layer of *gesso grasso* and the final, finer layer of *gesso sottile*.[49] After the ground had been worked to a smooth and polished surface, a preliminary underdrawing was generally executed – usually quite simple in the case of most Italian panel paintings of the first half of the fifteenth century. This would indicate the areas to be gilded and where a layer of greasy brown clay, known as bole, would be applied as an adhesive surface on which to lay the gold leaf. This precious commodity – supplied to the painter by specialist gold beaters known as *battilori* – would then be applied and burnished with a tooth or polished stone. In the case of the halos and borders of the painting, the gold leaf would be worked upon further with metal punches to create the complex patterns much favoured in earlier Renaissance altarpieces. In the case of the ornate hanging behind the Virgin, Sassetta also employed the specialised technique of *sgraffito*, where paint is applied to the gold leaf and then delicately scraped away in order to reveal the gold and to create an intricate pattern (Plate 5.3).

In this respect, it worth noting proportionately how much less gold leaf was used on the Ghent altarpiece – restricted to the thrones of the figures of God the Father, the Virgin and Saint John the Baptist on the upper central panel of the interior of the altarpiece, and details such as the rays of heavenly light in the *Adoration of the Mystic Lamb* (Plate 5.17). Instead, the artists have created a simulacrum of metallic gold and gold thread simply by paint alone and by their considerable skill in creating an illusion of these precious materials (Plate 5.19). Michael Baxandall's shrewd

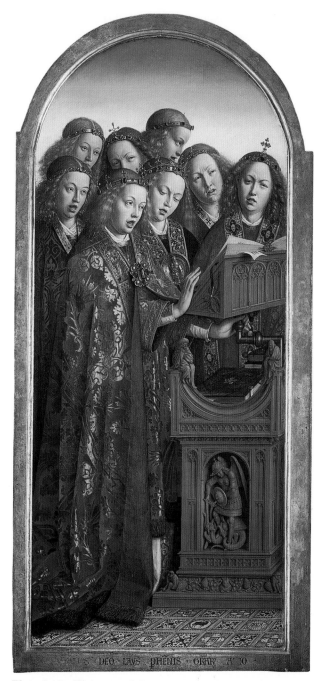

Plate 5.19   Hubert and Jan van Eyck, *Singing Angels*, 165 × 72 cm, detail of the Ghent altarpiece (Plate 5.17).

observation of the perceptible shift in the art and culture of the period from a preoccupation with material value to a preoccupation with, and taste for, artistic skill is well borne out by the Ghent altarpiece and the painterly techniques it embodies.[50]

In Sassetta's altarpiece, the type of paint used and the way that it has been applied is very typical of Italian altarpieces at that date. The technique is that of tempera, where pigments derived from a variety of mineral and plant substances have been ground up into a fine powder and mixed with the yolk of an egg.[51] The way that the paint has been applied on the surface of the panel with a brush in a system of parallel lines and cross-hatching is also very standard for Italian tempera, and can be found on many earlier examples of fourteenth-century Italian panel painting. In addition, the modelling of the paint on the draperies of the figures in order to represent the rotundity of the body beneath and the play of light falling upon the folds of material corresponds closely to the instructions given by Cennino in his treatise on the art of painting. Since in egg tempera the colours cannot be blended and modelled during the actual act of painting, each colour had to be prepared in advance and applied on its own. Thus Cennino instructs the painter to work first with a pure, saturated colour and then with lighter and lighter versions of this same colour – the latter achieved by adding extra amounts of white each time.[52] The way that the strongest, most saturated reds have been used for the shadowed areas of John the Baptist's mantle demonstrates Sassetta's faithful adherence to the tempera technique (Plate 5.2).

By contrast, the Ghent altarpiece provides a compelling demonstration of the technique and advantages of oil painting (Plates 5.16, 5.17). The panels, manufactured in oak, the preferred material used in the north for altarpieces, had received a preparatory ground of chalk (calcium carbonate) and animal glue. This ground provided the surface for the detailed, carefully modelled underdrawing much favoured by Netherlandish artists as a guide for the final painting (see Chapter 1, Plates 1.5–1.6). On top of this, an extremely thin priming layer would have been applied consisting principally of oil, lightly tinted with coloured pigment and still allowing the underdrawing to be seen through its translucent surface. The function of this priming was to form a barrier between the paint and the ground, which might otherwise soak up the paint.[53] Some Netherlandish artists still used pigments mixed with egg yolk, especially for the first, most opaque layers. Technical studies of the Ghent altarpiece have revealed, however, that the principal medium for the pigments was oil. The first colour applied was usually a mid-tone over which several tinted glazes were applied to achieve both lighter and darker variations of the same colour – rather like the effect of layers of coloured

glass being superimposed one over the other. This allowed the painters to extend the tonal range of any of their colours. Since oil paint remains malleable for much longer than fast-drying egg tempera, they could also manipulate it on the surface of the painting with a brush or fingertip, so that further subtle transitions of tone could be achieved.

This skilful use of the oil painting technique enabled the artists of the Ghent altarpiece to convey a sense of the physicality of the figures, the weight and materiality of their draperies, the different textures of flesh, muscle and bone. It also enabled them to describe in extraordinarily vivid detail objects such as the carved wood choir-book stand, the glint of jewellery and gold thread worked in conjunction with crimson velvet on an embroidered ecclesiastical cope (Plate 5.19). This link between the technique of oil painting and the possibilities it allows for realistic representation of a figure is nowhere better realised than in the portrait of Jodocus Vijd, where his age and character have been tellingly conveyed by the fine layers of oil paint and tinted glazes used for the lined face and veined hands of this middle-aged man (Plate 5.20).

The complexity of the subject matter of the Ghent altarpiece has also given rise to much speculation on what the meaning of the altarpiece was for its first audience – Jodocus Vijd and his wife Elizabeth and also the clergy who celebrated daily Mass before it in their chapel in the ambulatory of the church. The general scholarly consensus is that its imagery was intended to focus upon Christian teaching about the redemption of humanity.[54] When closed, the altarpiece acts as a kind of painted demonstration of the prefiguration of Christ's Incarnation (Plate 5.16). The prophets and the sibyls, taken in conjunction with their carefully chosen inscriptions, thus perform the function of foretelling the coming of Christ, and the scene of the annunciation marks the beginning of that process. The presence of John the Baptist, as the last of the prophets, also contributes to this general theme. In this part of the altarpiece, the message of redemption, meanwhile, takes on a much more personal note for the donor and his wife, showing them with the two Saint Johns – John the Baptist representing the patron saint of both the church of Saint John and the city of Ghent, and John the Evangelist, the author of the New Testament

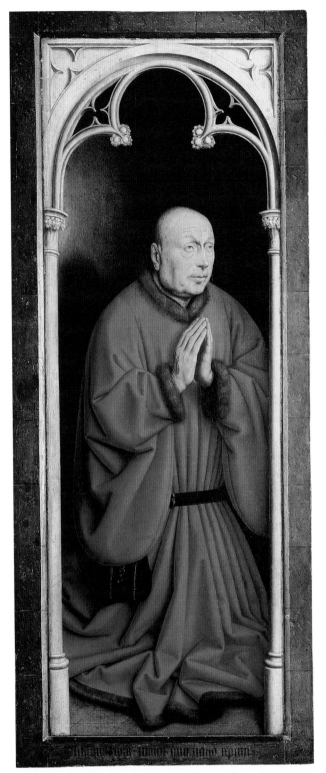

Plate 5.20   Hubert and Jan van Eyck, *Jodocus Vijd*, 149 × 54 cm, detail of the Ghent altarpiece (Plate 5.17).

Book of Revelation, a biblical text which describes in apocalyptic terms the events heralding the Last Day of Judgment when all humanity will be assigned either to heaven or to hell. The painting of these two saints in monochrome so as to

simulate stone sculpture – a common practice for the exterior wings of northern altarpieces – was another way of indicating that this part marked the first stage of a process that would be superseded by the rich, jewel-like colours of the altarpiece when fully opened.

Once in this position, the imagery encompasses a complex iconographic programme based on a number of biblical and later theological sources (Plate 5.17). The entire width of the lower part is devoted to the depiction of a cultivated landscape setting intended to invoke the heavenly Jerusalem. The paschal lamb – symbolising Christ and his sacrifice on the Cross – is portrayed on an altar in the upper part of the composition, together with the dove of the Holy Spirit hovering above. Since it was believed that the daily ritual act of Mass, celebrated at the instruction of the donor, Jodicus Vijd, was a commemoration of that very sacrifice, the close and obvious link between this imagery and Christian liturgy could not be more clearly stated. Around the altar and extending onto the side panels of this part of the altarpiece are depicted the hierarchies of saints, apostles, patriarchs, first martyrs, confessors, virgins, judges, knights, hermits and pilgrim saints. On the upper part, meanwhile, appear the Virgin, God the Father, and John the Baptist enthroned, with singing and music-making angels on either side of this heavenly group and the striking figures of the first members of humanity, Adam and Eve (and their offspring, Cain and Abel), who disobeyed God and thus began the whole history of humanity's spiritual and moral redemption.

The unusual complexity of this programme and the proliferation of texts throughout the altarpiece have led art historians to believe that it is unlikely that either the two artists or the merchant Jodocus Vijd, whose theological expertise would have been limited, could have been responsible for such an erudite choice of religious subject. It has been proposed, therefore, that Oliver de Langhe, the contemporary prior of the church of Saint John in Ghent and author of a treatise on the Eucharist, may have been responsible for choosing the subject matter and the texts that accompany almost half of the altarpiece's paintings.[55] Notwithstanding de Langhe's putative contribution to the project, it remains the achievement of the van Eyck brothers to translate complexities of belief and theology surrounding the meaning and significance of the Eucharist and its symbolic role in respect of the whole history of Christ's Incarnation into a series of powerfully compelling paintings that still awe and captivate viewers today.

## 3 The north–south divide: two triptychs compared

It could appear from the study of these two closely contemporary works of art – the relatively modest *Madonna della Neve* and the far more complex Ghent altarpiece – that in the early decades of the fifteenth century Netherlandish altarpieces were far more ambitious and, in terms of the oil technique in which they were executed, much more effective in terms of pictorial realism. It has to be acknowledged, however, that the Ghent altarpiece represents quite an exceptional work and that it is not at all typical of other surviving Netherlandish altarpieces in terms of size, complexity and subject matter (see, for example, Chapter 2, Plates 2.26, 2.29, 2.33). A comparison of two altarpieces produced within a decade of one another – the Donne Triptych by the German-born painter Hans Memling (*c.*1430/40–94), who settled in Bruges in 1465, and the Frari Triptych by the Venetian painter Giovanni Bellini – offers a fairer demonstration of two artists' technical accomplishments and priorities (Plates 5.21, 5.22).

The altarpieces share a common religious subject. Known in Italy as a *sacra conversazione*,[56] it was a popular theme and accounts for the subject matter of the majority of Renaissance altarpieces. Its popularity stemmed from the veneration in which the Virgin was held at that time, particularly regarding her supposed power as intercessor or advocate for humanity. Accordingly, from the mid-thirteenth century onwards, paintings of this subject were produced in order to convey the nature and significance of the Virgin's role as the Mother of God, Queen of Heaven and Divine Mediatrix. Many such Marian images were further elaborated upon by the inclusion of other saints and music-making angels.

Both altarpieces also belong to a subcategory of altarpiece known from its tripartite structure as a triptych. This particular format enabled painters to arrange their holy figures so that the Virgin appears at the centre and the saints on either side of her. In this way, a compelling pictorial

Plate 5.21   Hans Memling, *The Virgin and Christ Child with Saints John the Baptist, Catherine of Alexandria, Barbara, John the Evangelist and Sir John Donne and his wife Elizabeth*, known as the Donne Triptych, *c.*1478, oil on oak panel, 72 × 72 cm (centre), 72 × 31 cm (sides), modern frame, National Gallery, London. Photo: © The National Gallery, London.

equivalent was created of the hierarchical nature of this kind of spiritual intercession, which involved first the prayers of the devotees themselves, then the particular saints to whom the devotees directed their prayers, and finally the Virgin and Christ Child, who received the petitions made by the saints on behalf of the devotees. This kind of spiritual relationship is explicitly represented in the Donne Triptych, with its representation of the Welsh nobleman John Donne, his wife Elizabeth and their daughter shown kneeling humbly before the Virgin and in the act of being introduced to her by Saints Catherine of Alexandria and Barbara, and also accompanied in the side panels by John Donne's name saints, John the Baptist and John the Evangelist (Plate 5.21). In the Frari Triptych, meanwhile, other kinds of evidence are required in order to appreciate that the saints represented there were the name saints of the patrons of the altarpiece, Nicolò, Benedetto and Marco Pesaro, and of their deceased father Piero (Plate 5.22).

More striking than the similarity of subject matter and format of the two altarpieces are the distinctive differences. A very obvious contrast appears in the design of the frames: the Donne Triptych is very plain while the Frari Triptych is much more elaborate. The frames also signal substantial differences in the structure of the two triptychs. The Donne Triptych is clearly made up of three panels connected to one another by sets of hinges. It is thus a movable structure, which allows the side panels or wings to fold over the central panel. When this has been done, the triptych presents an image of two saints, Christopher and Anthony Abbot, painted in monochrome so as to simulate marble sculpture (Plate 5.23). In the case of the Frari Triptych, the ornate frame provides a splendid architectonic façade for a 'fixed' triptych of three panels with the central panel being much taller than the two side panels. It thus maintains the hierarchy of size established by the format of earlier polyptychs (Plate 5.10).

Although the frame of the Donne Triptych is modern, its very plain design, modelled on that of a simple wooden window frame, is a faithful copy of the type characteristically used on Netherlandish altarpieces. The chamfered profile of the lower frame – closely simulating a window sill – provides added support for the powerful illusion that Hans Memling has created of the holy figures gathered together in a spacious building, the back wall of which is an open loggia. The frame thus supports and controls the viewer's appreciation of the painter's confident use of perspective, established by the strongly delineated orthogonals of the side walls, the roof beams and intricate pattern of the pavement.[57]

Plate 5.22   Giovanni Bellini, *The Virgin and Christ Child with Saints Nicholas, Peter, Mark and Benedict*, known as the Frari Triptych, 1488, oil and tempera on panel, 184 × 79 cm (centre), 115 × 46 cm (sides), original frame, sacristy chapel of the Pesaro of San Benetto family, Santa Maria Gloriosa dei Frari, Venice. Photo: © 1990 Scala, Florence.

Plate 5.23 The Donne Triptych closed displaying *Saints Christopher and Anthony Abbot*, 1478, oil on oak panel, 71 × 71 cm, National Gallery, London. Photo: © The National Gallery, London.

By contrast, the frame of the Frari Triptych is far more elaborate. Simulating contemporary Italian Renaissance architecture, derived in turn from ancient Roman models, it displays a sophisticated and highly developed vocabulary of composite piers with capitals supporting an entablature together with lavish decorative detail in the form of an ornamental urn and fantastic sea creatures supporting candelabra.[58] The visual impact of the frame is also made more stunning by virtue of the fact that it is entirely covered in gold leaf. In terms of its design and colour, it closely mirrors that of the architecture represented in the painting itself. Thus the painted capitals on the piers behind the figures of the saints on the side panels are identical in design to those of the altarpiece frame. The gold mosaic of the barrel vault and semi-dome of the niche behind the Virgin's throne echoes the gold on the frame. Here, however, it appears that Bellini wanted to emulate the decoration of prestigious churches in his home town of Venice, such as San Marco, whose mosaics were executed by Byzantine artists specially brought from Constantinople. In addition, it has plausibly been suggested by Rona

Goffen that the painted architecture conforms closely to that of Byzantine architecture. In her view, the enclosed spaces on the side panels, which appear to be adjacent to and accessible to the central barrel-vaulted space on the central panel, are like the chambers (pastophories) where the liturgical elements of the bread and wine were kept in Byzantine churches and therefore situated in the holiest part of the building beyond the *iconostasis*.[59]

Although the two altarpieces share a religious subject in common, the way the holy figures have been represented and the actual environment in which they are portrayed are strikingly different. While John the Baptist and the Virgin appear in the Donne Triptych in the generalised costume of a tunic or gown and a mantle adopted for the representation of apostolic and Christian saints, significantly all the other figures – including John the Evangelist and the angels – appear in costume that is more contemporary in style. The donor figures, in particular, are dressed in the height of contemporary fashion. In the case of the Frari Triptych, the Virgin and Saints Peter

and Mark appear in their traditional robes, while Saint Nicholas wears the ecclesiastical vestments of a contemporary bishop and Saint Benedict the black habit of the religious order he founded. Significantly, in the Donne Triptych the Virgin appears in a relatively informal manner, with her hair loose and her head uncovered, whereas in the Frari Triptych her hair is covered by both a white headdress and her mantle. Such differences provide further clues as to the different intended functions and locations of these two altarpieces.

The different ways in which the music-playing angels and the Christ Child in the two paintings have been represented are also significant. In the Donne Triptych the infant Christ and musician angels were probably indebted not only to Memling's observation of young infants and children, but also to his knowledge of figural types favoured by other painters working in the Netherlands. In the Frari Triptych the well-rounded forms of the Christ Child and the music-making angels at the foot of the throne, while undoubtedly based on empirical observation and the example of other Italian painters, also provide evidence of Bellini's receptivity to the way in which

young children were portrayed in ancient Roman sculpture (Plate 5.24).

The scale of the figures and the viewpoint that the spectator is given of them are also very different. In the Donne Triptych the figures appear relatively close but from a high viewpoint. Thus the viewer is allowed to see the top surface of the book which the Virgin holds and on which the Christ Child places his hand. In addition, a large amount of the surface of the pavement is on show. In the case of the central group, the holy figures appear nearer to the viewer – particularly the members of the Donne family – than the figures of Saints John the Baptist and John the Evangelist on the side panels. In the Frari Triptych, meanwhile, the holy figures appear on a much larger scale, taking up much of the painted surface. In fact, they appear to dominate their environment, particularly in the side panels where the four saints are nearly the height of the chambers in which they are located. The viewpoint that the spectator is given is a very low one. Thus, for example, it is not possible to see the top surface of the ornate octagonal pedestal on which the Virgin's throne is placed. The viewer looks up physically as well as metaphorically to the holy figures.

Plate 5.24  *Putti*, Amoretti from Throne of Saturn, Roman relief from San Vitale, Ravenna, first to second century CE, Museo Archeologico, Venice. In the fifteenth century this relief was on the wall of a house in the Piazza San Marco, Venice. Photo: Elio Ceolin, Foto Attualità Ottica Ceolin, Treviso.

Interestingly, both painters have created an enclosed architectural space in which to place their holy figures and make them palpably 'real' and 'near' to the spectator, but one which is also lit by natural light. In the case of the Donne Triptych, Memling's painted architecture opens out onto a landscape setting which is so brightly lit and so detailed that it is possible to observe not only a bridge, a water mill and a gatehouse in the background but also two swans on the river. It also enabled him to represent in a very accurate manner the behaviour of light when it enters a building through apertures, such as an open loggia or a half-shuttered window, and reflects on a shiny surface, such as a tiled pavement. In addition, Memling portrays the holy company as if lit from a light source that is directed from the left and in front of the painting. In the case of the Frari Triptych, the light appears to be filtered from the left-hand side of the open architectural setting. It offers a sense of a much more modulated lighting situation than the one depicted on the Donne Triptych, and therefore creates a rather different atmosphere.

What is striking from this comparison is that both altarpieces provide evidence of the way in which by the 1470s and 1480s painters of Renaissance altarpieces had embraced a highly naturalistic way of representing the holy figures, their physical appearance and general demeanour. Both altarpieces also demonstrate fifteenth-century artists' facility in creating a convincing sense of a spacious environment in which to place their holy figures – and one, moreover, which gives the strong illusion of being coexistent with that of the spectator.

One way of accounting for the high degree of naturalism in Hans Memling's work would be to refer to his skilful use of the technique of oil painting. This medium and technique, which allowed Memling to achieve precisely the detailed and naturalistic landscape, portrait and still-life detail in the Donne Triptych, was indeed the preferred way of painting in the Netherlands from the early fifteenth century onwards. By 1488, Giovanni Bellini – like a number of fifteenth-century Italian painters – was also experimenting with the use of oils and varnishes. Indeed, the subtle visual effects of the Frari Triptych with its fine gradations of tone and colour could only have been achieved by a mixture of the traditional technique of tempera painting with that of oil.

The stylistic differences between the two are rather harder to pin down. One senses in the Donne Triptych a stronger impulse to describe everything that is represented in very precise and well-observed detail. In the Frari Triptych there appears to be a greater willingness to imply or suggest the forms of figures and drapery. There also appear to be a greater monumentality of form in terms of the way in which the figures are represented and a greater indebtedness to the art of antiquity – in terms of both architecture and sculpture.

There remains one further distinctive difference between the two altarpieces. This is the question of size – easily overlooked when viewing works of art as reproductions and thus conveniently sized to suit the design of a book – but very obvious when actually in front of the works of art themselves. The Donne Triptych, when fully open, is of relatively modest dimensions while the Frari Triptych is much larger. This immediately prompts questions about the original location of the two altarpieces. The Frari Triptych is relatively unusual in being still located over the altar for which it was originally designed (Plate 5.25). This is the altar in the chapel of the Pesaro family, which was founded in memory of Francesca Tron Pesaro by her three

Plate 5.25   View of the entrance to the sacristy chapel of the Pesaro of San Benetto family, Santa Maria Gloriosa dei Frari, Venice. Photo: Francesco Turio Böhm, Venice.

sons, Benedetto, Nicolò and Marco. Francesca's tomb slab is still located in front of the chapel altar together with its inscription describing her sons' act of filial piety.[60] The chapel itself was built at the expense of this wealthy Venetian family as an addition to the existing sacristy of Santa Maria dei Frari, which was the principal Franciscan church in Venice. Dedicated – like the church itself – to the Virgin, the chapel's walls were frescoed with scenes from her life which – apart from the Virgin of the Annunciation and the Archangel Gabriel on the entrance arch – are now lost.[61] Seen in its original setting, it becomes much easier to understand why the particular saints have been chosen for the altarpiece and why – in terms of increasing its presence and overall visibility – the altarpiece boasts such a sumptuous and eye-catching frame.

The Donne Triptych is now located on the walls of one of the rooms in the National Gallery in London devoted to fifteenth-century Netherlandish painting (Plate 5.26). Unlike a number of Renaissance altarpieces displayed in this way, this does not place it at a great disadvantage. It is clear from its relatively modest dimensions that the width was not necessarily determined by the measurements of a substantial altar in a church or chapel. It seems more likely that it once functioned as an altarpiece which could be folded up and transported with the Donne family as they moved between their various residences. Once in residence, a member of

Plate 5.26   The Donne Triptych in its present location in the National Gallery, London. Photo: A.C. Cooper (colour) Ltd.

the family could then have it placed over a small altar in a private oratory or in some other domestic setting – wherever he or she wished to conduct their religious devotions. The informal dress of the Virgin and the very intimate view given of the holy figures in the central panel support such a reading of this particular painting's original function as a religious image – as does the highly personalised detail also included in the painting. It has been observed that the Donne Triptych appears to be a version of a larger altarpiece produced by Memling in the 1470s for Saint John's Hospital in Bruges (Plate 5.27) – one reduced and adapted

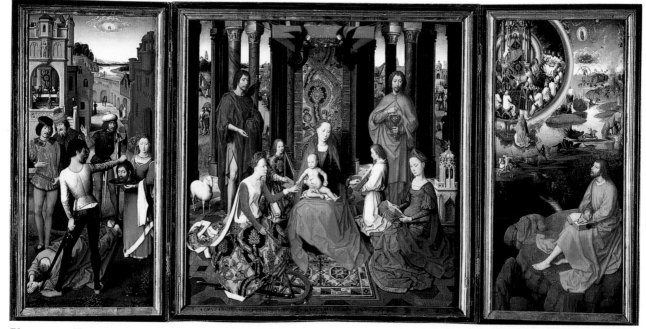

Plate 5.27   Hans Memling, *The Virgin and Christ Child with Saints John the Baptist, John the Evangelist, Catherine of Alexandria and Barbara* with (left wing) *Scenes from the Life of Saint John the Baptist* and (right wing) *Saint John the Evangelist Writing the Book of Revelation*, known as the Saint John altarpiece, completed 1479, oil on panel, 176 × 332 cm, Museum of Saint John's Hospital, Bruges. Photo: © 1996 Scala, Florence.

to the personal requirements of John Donne and his wife.[62] Not only are their portraits and that of their daughter included (and perhaps one of their retainers in the left-hand background), but they are also depicted wearing the livery collars presented to them by Edward IV in recognition of Donne's loyal service as a diplomat. Both their coats of arms appear on the capitals of the loggia and in the glass of the window on the right. In short, this is a devotional painting produced by Memling for wealthy clients who wanted to advertise their status and identity while at the same time mirroring their daily act of praying and honouring the Virgin and saints.

# 4   The development of the Renaissance altarpiece

One influential model for the history of the Renaissance altarpiece has been that of a logical development from the multi-panelled Gothic polyptych of the fourteenth century to the unified, single panel or *pala* of the fifteenth and early sixteenth centuries. The latter format offered painters a chance to demonstrate their ability to use perspective to good effect in order to create a spacious setting in which to group the holy figures together in a decorous and graceful manner. Sassetta's *Madonna della Neve* altarpiece offers evidence of a transitional moment in this development (Plate 5.2), while Fra Angelico's now badly damaged panel of c.1438–43, which was originally the high altarpiece for the church of San Marco in Florence, provides an early example of the Renaissance *pala* (Plate 5.28). A 1466 altarpiece painted by Benozzo Gozzoli (1421–97) for the parish church of Sant'Andrea near the Tuscan town of San Gimignano provides a rare example of a *pala* still in its original frame (Plate 5.29). The classicising style of this altarpiece's frame, which closely mirrors that of contemporary Tuscan architecture, is entirely typical of frames for this type of altarpiece.

The Ascoli altarpiece, commissioned in 1472 by the bishop of this Italian town, Prospero Cafarelli, from the Venetian Carlo Crivelli (active 1465 – d. before September 1495) provides a corrective to this tidy picture of the history of altarpiece design (Plate 5.30).[63] Painted for the chapel of the Holy Sacrament in the cathedral of Sant'Emidio and still there, this altarpiece presents – at a relatively late

date – an example of the survival of the polyptych in Italy. Hugely popular among patrons in the regions of Emilia and Marches and commanding high prices for his work, Crivelli should not be dismissed as an old-fashioned and provincial painter out of touch with the mainstream of Renaissance art. Indeed, on other occasions he produced altarpieces of the *pala* type, set in carved wooden frames embellished with classical detail and ornament. Despite its conventional format and the intricately worked gold leaf background for all the holy figures, the Ascoli altarpiece also provides a demonstration of Crivelli's mastery of the latest techniques and inventions of Renaissance painting. This can be seen in the convincingly rounded forms of the Christ Child, the confident use of perspective and foreshortening in such details as the model church held by Saint Jerome in the upper tier, and the anatomical observation of the torso of the dead Christ supported by the Virgin and two other saints.

The multi-panelled altarpiece was also preferred among patrons in Spain and those areas of Europe ruled by the Aragonese royal family such as Sicily and Sardinia – as can be seen in the early fifteenth-century altarpiece honouring Saint George attributed to Andrés Marçal de Sas, a painter of German origin recorded working in Valencia between 1393 and 1410 (Plate 5.31).[64] Belonging to a class of altarpiece usually designated as a *retablos* (retable), this provides an interesting example of how the imagery of an altarpiece could be reworked in order to focus upon a specific saint as the central and most important religious figure.

Altarpieces produced in northern Europe, particularly in the Netherlands and in other areas where Netherlandish painters worked or where their work was influential, also provide compelling evidence for the sheer versatility of this painted genre – offering examples of single panels (see, for example, Chapter 2, Plate 2.29), triptychs (Plates 5.21, 5.27, see also Plate 2.26) and multi-panelled edifices (Plates 5.16, 5.17, 5.31). As already noted, however, the hinged structure of the Donne Triptych, together with its simple frame (even if an accurate modern copy), is quite typical of Netherlandish altarpieces (Plate 5.21). Precisely because such altarpieces would be seen both open and closed, the backs of the movable wings also had to be painted. They would characteristically be decorated with figures of saints or – as in the

Plate 5.28 Fra Angelico, *The Virgin and Christ Child with Angels, Saints Cosmas and Damian, Lawrence, John the Evangelist, Mark, Dominic, Francis and Peter Martyr*, known as the San Marco altarpiece, *c.*1438–43, tempera on panel, 220 × 227 cm, Museo di San Marco, Florence. Used with the permission of the Ministero Beni e Attività Culturali. Photo: © 1990 Scala, Florence.

Ghent altarpiece – images of the Virgin of the Annunciation and the Archangel Gabriel, often represented in monochrome to simulate either stone or wooden sculpture (Plates 5.16, 5.23). This intermingling of sculpture and painting – albeit here rendered entirely in terms of paint – alerts us to another major characteristic of Renaissance altarpieces, which frequently combined sculpture and painting together.[65] Much more common in areas of Europe where there was a plentiful supply of oak or limewood, such as the Netherlands or

Austria, and also used for the monumental retables favoured in Spanish churches, there are examples of Italian Renaissance altarpieces where paintings appear alongside sculpted figures and details.[66] Thus while Renaissance altarpieces have many features in common relating to their religious function, they also have many differences that can best be explained by their contexts – relating to patronage, local artistic tradition, and availability of materials.

Plate 5.29  Benozzo Gozzoli, *The Madonna of Humility and Christ Child with Saints Andrew and Prospero, and Angels* (predella: *The Man of Sorrows with the Virgin and Saints John the Evangelist, Jerome and Onofrio*), 1466, tempera on panel, 137 × 138 cm, Museo Civico, San Gimignano (on loan from the parish of Santa Maria Assunta). Photo: Lensini, Siena.

65
↓ 41 →

136

2m

Plate 5.30   Carlo Crivelli, Ascoli altarpiece, 1473, oil, tempera and gold leaf on panel, chapel of the Holy Sacrament, cathedral of Sant'Emidio, Ascoli Piceno. Upper tier: *Saint Catherine of Alexandria*, *Saint Jerome*, *The Lamentation*, *Saint George*, *Saint Ursula*, each panel 65 × 41 cm. Central tier: *Saint Peter*, *Saint John the Baptist*, *Virgin and Christ Child*, *Saint Emidius*, *Saint Paul*, 136 × 66 cm (centre), 136 × 39 cm (sides). Predella: *Christ Blessing and Saints*, 29 × 280 cm. Photo: Bridgeman Art Library, London.

290 × 280

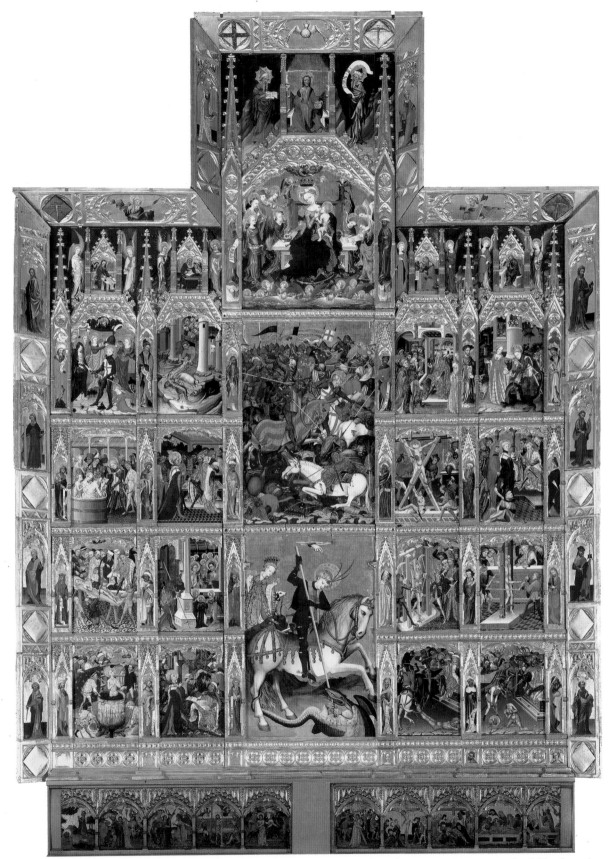

Plate 5.31   Attributed to Andrés Marçal de Sas, Saint George altarpiece, *c.*1410–20, tempera and gold leaf on pine panel, 660 × 550 cm, Victoria and Albert Museum, London. The three central scenes are (from top to bottom): *The Virgin and Christ Child Enthroned with Angels*, *The Defeat of the Moors by James I of Aragon*, *Saint George Kills the Dragon*. The remaining paintings show scenes of the *Life and Martyrdom of Saint George* and on the predella ten scenes from the *Passion*. Photo: V&A Images/The Victoria and Albert Museum.

# 5  Conclusion

At the beginning of this essay, I suggested that one reason for the success of the Renaissance altarpiece was the balance that its makers achieved between its traditional role as an object supporting and maintaining certain kinds of well-established liturgical and religious practice, and its role as an object susceptible to artistic and technical change. Many of the altarpieces studied here prove this rather well. By the sixteenth century, however, this balance apparently became much more difficult to sustain. Due to the religious upheavals of the period, the very rationale of religious images was called into question. This, of course, had serious consequences for the preservation and continuing manufacture of altarpieces, particularly in those countries which adopted a version of the Protestant faith where imagery was frowned upon because it was thought that it might encourage the veneration and worship of the images themselves. At the other end of the spectrum, the very fact that many altarpieces had become vehicles for artists self-consciously displaying their artistic skill and virtuosity at the expense of all else again called into question how effective altarpieces were as religious artefacts.[67] The example of the Ghent altarpiece is instructive in this regard. In 1566 the altarpiece was removed from the Vijd Chapel, taken apart and hidden in the tower of Saint Bavo in order to save it from local Calvinists who were intent on destroying it. Although there were undoubtedly many complex reasons why the paintings from the altarpiece were preserved, a major factor must have been the admiration for their technical and formal achievement. It seems, therefore, that in the last analysis it was the sheer artistry of many Renaissance altarpieces that ensured their remarkable survival.

# Chapter 6 introduction

Of all the media and art forms analysed in this book, the making of prints probably constitutes the most varied practice. This is not because the techniques were necessarily more complicated than those involved in, say, painting or sculpture; rather it is because prints varied most widely in terms of status, form and use. Prints might be aimed at prosperous or lowly social classes; they might be the printmaker's own original designs or reproduce the designs of others; they might be produced by artists, specialist craftsmen, goldsmiths or those in religious orders; they were designed for purposes ranging from decorative ceiling paper to prints integrated into printed or handwritten books or sold as collectors' items. With paper costing approximately one-sixth the price of the vellum used for illuminated manuscripts, and both woodblocks and copper plates capable of reproducing large numbers of prints, sometimes over a considerable period of time, the potential profitability and marketability of the printed image was immense.[1]

Woodcuts ranged from the cheap, functional souvenir from a pilgrim shrine or religious house to the formidably accomplished works of Albrecht Dürer. Engravings of precocious sophistication were produced by the so-called Master ES as early as the mid-fifteenth century, while further north, engravings of only modest quality, often hand-coloured, were produced for inclusion in handwritten books as substitute loose-leaf miniatures.[2] From the mid-fifteenth century, printmaking was increasingly associated with the growing trade in printed books. Woodcut technology was used in northern Europe from this time to produce blockbooks, in which both image and minimal text were cut from the same woodblock. The didactic text the *Ars Moriendi*, or *Art of Dying*, appeared in a blockbook version in the 1460s with woodcut illustrations derived from engravings by the Master ES. The advent of movable type also offered lucrative opportunities for printmakers. It can be no accident that one of the greatest printmakers of the period, Dürer, grew up in the same Nuremberg street as his godfather, the publisher Anton Koberger, and trained with Michael Wolgemut, who was regularly employed by Koberger to design woodcut illustrations for his books. Even the distribution of single-leaf prints may have followed patterns established in the book trade.[3] From *c.*1525, print production took on a new character, as its potential for reproducing individual paintings was exploited, particularly after the death of Raphael. The importance of prints as tools in the making of other art forms, particularly in disseminating both styles and designs, remained crucial throughout the Renaissance period.

In this chapter, Charles Harrison focuses on one aspect of this diverse print production: the emergence of what were later called 'fine art prints', that is, collectors' items produced by artists who were also printmakers. The extent to which artists were involved in the actual labour of print production rather than simply as designers and overseers is a matter of debate, as Charles Harrison shows; later artists such as Hans Holbein the Younger continued to provide designs for publishers and even for entrepreneurial block-cutters, but without necessarily being involved in the actual processes of printmaking at all.

*Kim W. Woods*

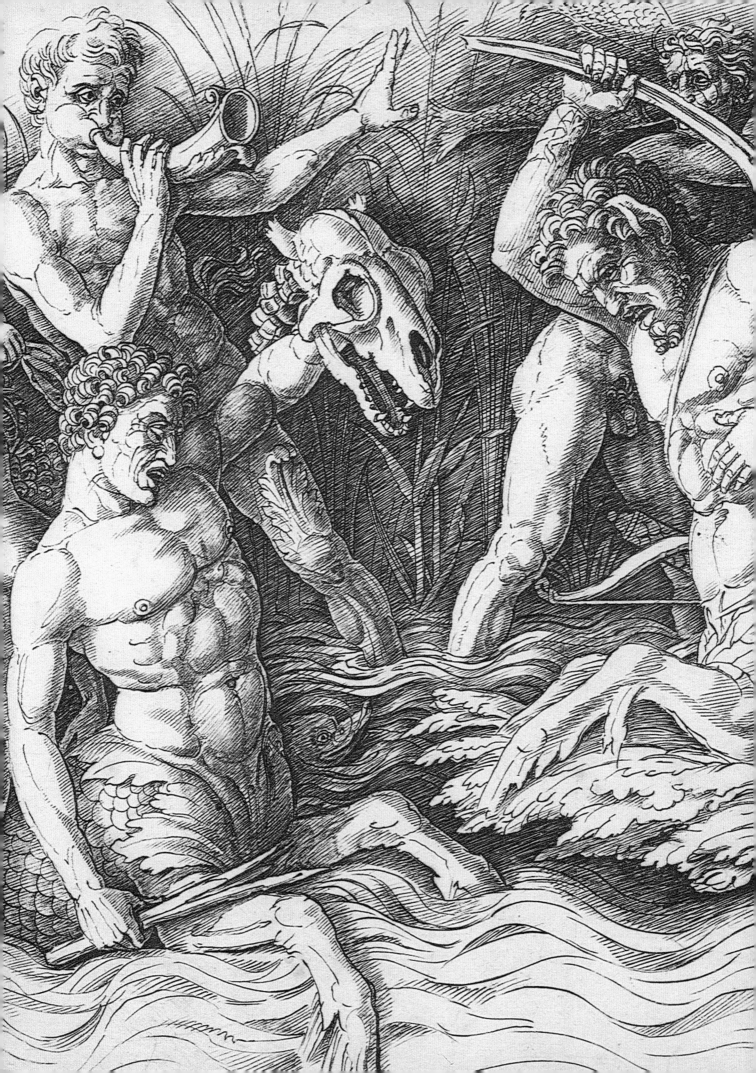

# Chapter 6

# The printed picture in the Renaissance

*Charles Harrison*

The aim of this chapter is to introduce the two principal modes of printmaking employed during the Renaissance, to explain their distinctive properties, processes, techniques and potential, and to discuss a selection of works by notable artist-printmakers. Consideration is given to the early history and development of woodcuts and engravings both in northern Europe and in Italy, to the part played by the artist's print in the international transmission of styles and designs, and to the connections of printmaking with book publishing. This discussion of printed pictures in the Renaissance will be grounded in an initial comparison of two similar images, one by a German and one by an Italian artist.

## 1 A practical comparison

The first printed picture in this comparison (Plate 6.2) is a work by the German painter and printmaker Albrecht Dürer (1471–1528). It illustrates a scene from the life of the Virgin, as recounted in *The Golden Legend* of the thirteenth-century Dominican writer Jacopo da Voragine. The principal figure is the Virgin's supposed father, Joachim. According to the legend, Joachim's offering at the temple had been rejected on the grounds that the childlessness of his wife Anna must be a punishment from God for his sinfulness. In shame, Joachim retired to the mountains with his flocks. But after five months an angel

appeared to inform him that Anna would after all bear a child. Dürer has represented the angel's announcement in the form of a written covenant: as though it were a contemporary legal document inscribed on vellum, complete with appropriate seals.

The second printed picture (Plate 6.3) is a work by the Italian Marcantonio Raimondi (*c.*1480–*c.*1534). It is clearly based very closely on Dürer's work. There are telling differences, however. It is a useful exercise to register these, to consider their effects and to try to explain them. The differences might be divided into two kinds. First, there are discernible differences in *what* is depicted. In the top right quarter of Dürer's work, the sky is full of birds. None of these appears in Marcantonio's version. Slightly lower down, Dürer's image shows three boats. The nearest of the three is omitted in Marcantonio's copy, though there are two very faint lines at right-angles to mark where it would have been.

Second, there are differences in the manner and style of the two images. These might be summed up by saying that the outlines in Dürer's work are generally stronger than in Marcantonio's, and that the lines used for modelling and shading are thicker, darker and fewer. Compare, for instance, the shading of Joachim's garment, especially beneath his left shoulder and around his right knee. Marcantonio's work has much finer lines, a

Plate 6.1   (Facing page) Andrea Mantegna, *Battle of the Sea Gods* (detail from Plate 6.21).

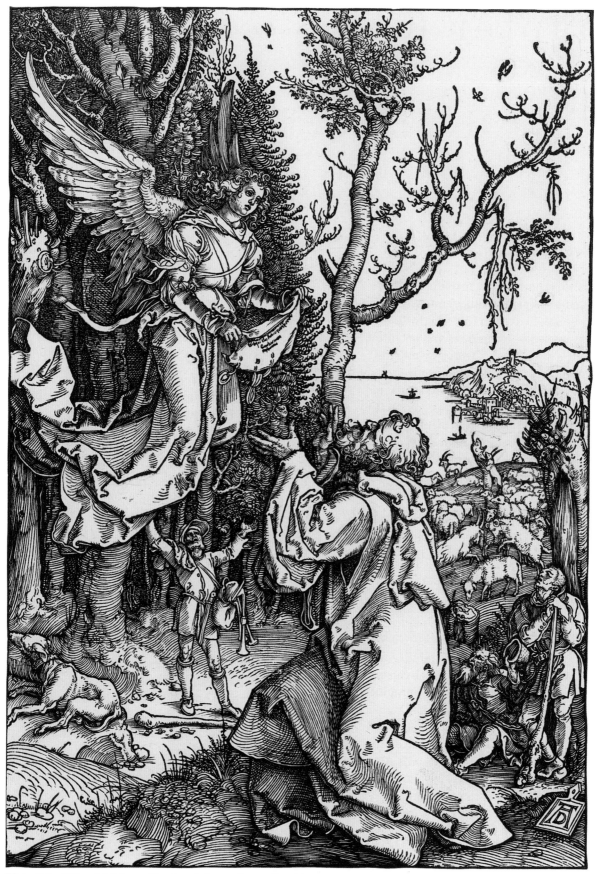

Plate 6.2    Albrecht Dürer, *The Angel Appearing to Joachim*, *c.*1504, woodcut, 30 × 21 cm, Museum of Fine Arts, Boston. Photo: © 2007 Museum of Fine Arts, Boston. Maria Antoinette Evans Fund, 30.1155.

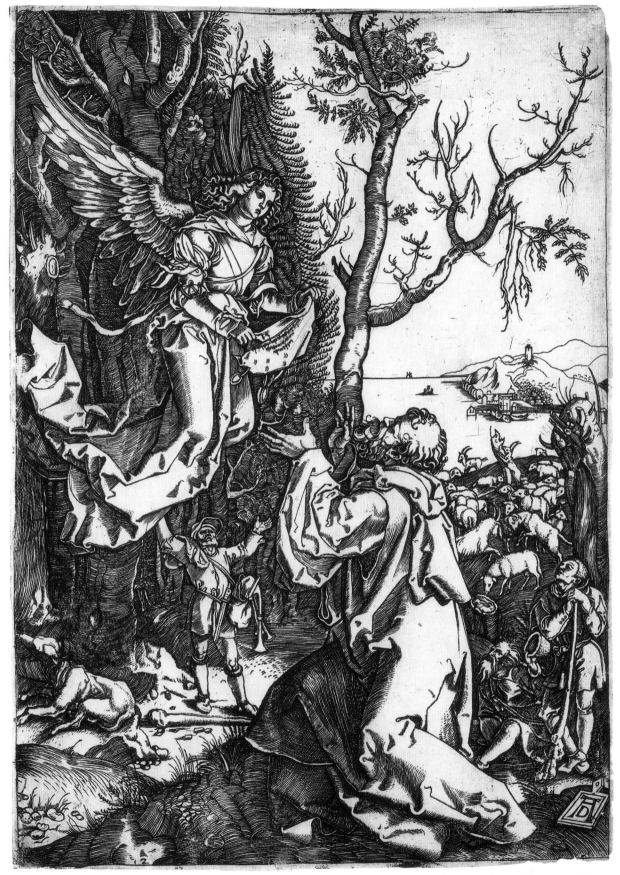

Plate 6.3   Marcantonio Raimondi, *The Angel Appearing to Joachim*, *c.*1508, engraving, 30 × 21cm, Museum of Fine Arts, Boston. Photo: © 2007 Museum of Fine Arts, Boston. Harvey D. Parker Fund, P1293.

more velvety texture and a more gradual passage from light to dark. In such details as the fringed edge of the tree to the right of the hovering angel, Marcantonio's line is crisper and the rhythm of the curlicues more repetitive. The background tone of his image is a variegated pale grey, whereas in Dürer's it is a uniform off-white. In general, the tonal contrast or chiaroscuro is more clear cut in Dürer's image.

It is a consequence of these various differences, I think, that the scene as interpreted by Marcantonio *feels* slightly calmer than it does in Dürer's original, Joachim and his shepherds a little more graceful, the wood behind the angel not quite so wild and dark, the pollard willow tree at the right less bizarrely creature-like. It is tempting to suggest that what is apparent here is a kind of broad cultural difference between north and south: between the 'Gothic' or Germanic tendencies of the one and the 'classicising' or Italianate tendencies of the other. This would be tantamount to saying that the differences between the two images can be explained in terms of the different national origins and cultural tendencies of the two artists.

It is certainly likely that differences in training, in individual style and even perhaps in taste will register in otherwise similar images, even where one is closely copied from the other. But it is not a good idea to treat assumptions about cultural differences as though they were *explanations* for such specific differences as may be observed in pictures – if only because one is then the less likely to pay attention to crucial differences in materials and technique and to their consequences. In this case, for all the evident similarities between the two images, there is an all-important practical distinction to be made – a distinction which, once it *is* made, will go a long way to explain the observable differences between them. They were in fact executed using quite different materials and by radically different means. To review the practical differences in question is to distinguish between the two principal avenues through which the printing of pictorial images developed in the fifteenth and early sixteenth centuries.

The work by Dürer is a woodcut, which is a type of relief print. This is to say that the image derives from the projecting surface of a carved block. It was made from a design that would have been either executed by the artist on paper and pasted onto a plank of wood (typically from a fine-grained species such as box, maple or some variety of fruitwood) or drawn directly by him onto the wooden surface. Since the design would be reversed by printing, it would have been necessary either to execute it in reverse or, if paper were used, to paste this onto the plank face-down and oil it so that the paper would be rendered transparent and the drawing would show through. An expert block-cutter – usually not the artist himself – would then have excavated the unmarked areas of the design, first with a pointed knife bevelled on one side to isolate the black lines, and then with a chisel or gouge to remove the blank areas. Finally, the detailed surface thus left outstanding would have been carefully inked and impressed on a sheet of damp paper, resulting in the image reproduced here (Plate 6.2).

Marcantonio's copy, on the other hand, is an intaglio print, which is to say that the image is produced from a design incised into a flat plate. Three principal forms of intaglio print were made during the Renaissance: drypoint, engraving and etching. While there are surviving European woodcuts datable to the later part of the fourteenth century, the earliest surviving intaglio prints date from around the late 1430s. They were made in drypoint. This is the term used where a design is scratched into the metal plate with a pointed needle. The first engravings were probably made a few years later, using a sharp steel tool known as a burin, usually on a copper plate. Its pointed blade-like form gives a particular aspect to the engraved line: it is not so much scratched *into* the copper as carved or gouged *out* of it. In the third form of intaglio print, etching, the design is drawn with a stylus into a waxy or resinous covering laid over a metal plate. When the plate is immersed in acid, this design is bitten into the plate wherever the protective covering has been removed. Following its employment in the decoration of armour, etching was first used to produce prints from iron or steel plates around 1500. The technique was not widely developed until after the end of the period covered by this book, however, so it will not figure again in this chapter.

Marcantonio's print is an engraving. It was made by incising Dürer's design – in reverse – into a copper plate, using a burin. When the design was complete the plate would have been inked all over and then wiped so as to leave a residue in the incised lines. The plate would then have been covered with a sheet of dampened paper and put through a press – probably a roller press – under sufficient pressure to ensure that the paper took the residue of ink from the incised lines on the plate. That pressure would have been considerably greater than was required to print the woodcut, which was inked on its outstanding surface. In a heavy press the woodcut would in any case have been vulnerable to damage in areas of outstanding detail.

This vulnerability apart, and so long as the material remained stable, a woodcut block would generally yield many more good impressions than a copper plate – possibly running into many thousands. In the case of engravings, and more particularly of drypoints, the quality of impressions tends to decline far sooner due to the relative softness of the metal and the fineness of the incised lines. There is no entirely reliable evidence on the number of impressions a Renaissance printmaker might expect to take from a single plate, nor, given the number of variable factors, is it easy to generalise on the basis of any specific case. Besides designing woodcuts, Dürer was a celebrated maker of intaglio prints. In 1519 he sent the plate of a portrait engraving to its subject, Cardinal Albrecht of Brandenburg, together with 200 impressions, following this four years later with a second plate and 500 impressions.[1] But in these instances as in any other there may have been some trade-off between quantity and quality. While a deeply engraved and carefully managed plate might yield several hundred impressions of comparable quality, a decline in a particularly fine or lightly engraved composition might actually be noticeable after the printing of as few as 50 copies. For this reason impressions made early in the life of a copper plate are nowadays prized much more highly than those taken later – often centuries later – when wear has usually led to considerable loss of detail and of subtlety of tone, or when the plate may have been re-engraved so as to strengthen its design

(both eventualities being more likely in the case of those celebrated images for which demand has been high). In some early impressions of intaglio prints – and particularly of drypoints – there is a rich velvety quality to the printed line. This is due to the fine ridge of metal – or burr – left along the edges of the incised lines, which, if not burnished away, will tend to catch the ink. This burr wears down very quickly in printing.

What should now be clear is that many of the observable differences between the two images under consideration are attributable to differences in the technical processes involved. It might be said that Dürer's design contains about as much detail as the most skilled of block-cutters could achieve, while Marcantonio's engraving exploits the finer lines and textures possible in work with a burin on copper. In the case of the woodcut, each line in each passage of detail had to be separately isolated by the cutter, whereas a skilled engraver such as Marcantonio was able to maintain a constant rhythm in passages of shading or of repetitive detail, such as the fringe of leaves to the right of the angel, or the lines of shading on the trunk of the central tree. In the woodcut, the birds dotting the otherwise empty areas of sky served a practical purpose: they would have maintained the level of the relief surface so that an even pressure could be kept on the sheet of paper. With an engraved plate an even pressure is in any case ensured, so such details could be dispensed with unless otherwise justified. In Dürer's work there is a clear contrast between printed and unprinted areas – a contrast enhanced by his use of a particularly glossy black ink. Marcantonio's technique, on the other hand, allows for a greater tonal subtlety and variation than is present in the original. A woodcut is inked only on its relief surface, and care must be taken to prevent run-down from the outstanding areas, which can lead to blurring of the printed design. An engraved plate, on the other hand, is inked all over before being wiped. The uneven background tonality seen in Marcantonio's version of the composition was produced by a light film of ink left on the surface of the plate after wiping. (Since a plate has to be separately inked for each printing, individual impressions may well vary in the amount of background tone they display.)

## 2 Authorship and the division of labour

Each of these two different media in its own way shaped and qualified the relationship between artistic inventiveness and artisanal skill. In the case of the current comparison, it is significant that the woodcut is known as a work by Dürer, while the names of his block-cutters are generally known only to specialist researchers, if at all. The authorship of the print is thus conventionally associated with its design rather than with the actual execution of the woodcut. On the other hand, the engraved copy of that design is known as a work by Marcantonio, despite his repetition of Dürer's monogram in the bottom right-hand corner. This apparent contradiction reveals something of the complexity of the divisions of labour in the production of engravings and woodcuts in the late fifteenth and early sixteenth centuries. It would seem on the face of it that the artisans responsible for executing engravings during this period have generally been more readily recognised – and recognised as artists – than those responsible for the cutting (as opposed to the design) of woodblocks, this despite the considerable skills developed by many block-cutters. These skills were at a particular premium in Germany, where demand was driven by the expansion of book-publishing and by rapid improvements in the technology of printing.

Some explanation for this apparent discrepancy is suggested by the nature of the respective processes and by the different practical conditions under which the relevant skills were exercised. Despite the rise in the demand for book illustrations, the principal employment of the block-cutter in the later fifteenth century might well have been in the making of type punches for book printing, or in the decorative aspects of furniture making. In the early stages in the development of the woodcut, the functions of invention and transcription were on the whole less easily distinguished, but then the images in question were very much less sophisticated than Dürer's. By the late fifteenth century few recognised artists cut their own blocks. Of course, enterprising block-cutters might on their own initiative undertake the translation into the woodcut medium of celebrated designs by other artists that were originally produced for other purposes. But in cases where the artist was producing a design specifically for the woodcut medium, the typical block-cutter, however skilled, was someone who slavishly followed a drawn or pasted-on design from which there must be no departure.

On the other hand, the development of engraving both in northern Europe and in Italy during the later fifteenth century was largely driven by artists – Andrea Mantegna (c.1431–1506) in Italy, Martin Schongauer (1450–91) and Dürer again in Germany – who, as will be seen, were the originators of the images they engraved, and who had established careers as painters. At a time when the market for artists' drawings was in process of establishment, an engraving was like a highly finished and pristine drawing from the artist's own hand that could be issued in multiple copies. While many engravers, including Dürer himself, were the offspring of goldsmiths or were trained as goldsmiths, by the end of the fifteenth century they tended, like Marcantonio, to have been trained in drawing and to emerge from artists' workshops. Even where engravers were following existing images by other artists, they were generally working on the plate by eye. They could hardly help but interpret, and in interpreting, to impart an idiosyncratic character to the outcome, even, as in the case of *The Angel Appearing to Joachim*, where it was another print that was being transcribed.

It should not be assumed, however, that the skills of block-cutters went wholly unrecognised or unrewarded. A specific case examined by David Landau and Peter Parshall provides some indication of the rates at which different stages in the production of a typical woodcut were valued and rewarded. For a large and ambitious illustrated publication planned in 1494 under the patronage of the humanist Sebald Schreyer in Nuremberg, proposed rates of pay were specified for the supply of wooden blocks, for the provision of initial designs, for the exact drawing of these designs onto the blocks and for the cutting of the blocks for printing. On Landau and Parshall's calculations, the proposed fee for the initial design of each illustration (10 to 11 denar) was set only slightly higher than the payment to be made to the carpenter for the prepared but uncut block (8 to 9 denar for larger blocks and half that for smaller ones). About three times the price of each design was allocated to the illustrator for the crucial work of drawing the finished composition onto the block (34 denar for large blocks and half that for

smaller). Finally, around four times the amount of the illustrator's fee was to be paid for the laborious work of the cutter (135 denar for large blocks and half that for small). In this case, then, the block-cutter stood to earn about 12 or 13 times as much from each illustration as was paid for its initial invention.[2]

It should also be noted that there were significant exceptions both to the tendency for artists to delegate the work of block-cutting to others, and to the relative anonymity of specialist block-cutters. Dürer himself was trained in the workshop of Michael Wolgemut in Nuremberg, where catering to the growing demands of the book-printing business led to rapid advances in the techniques of woodcut illustration. It may well be the case that the blocks for Dürer's earliest prints were cut by the artist himself,[3] while it is clear that the brilliant designs of his later works in the medium were grounded in substantial practical experience. His esteem for the relevant skills is certainly a matter of record:

> A man may often draw something with his pen on a half-sheet of paper in one day or cut it with his little iron on a small block of wood, and it shall be fuller of art and better than another's great work whereon he has spent a whole year's careful labour, and this gift is wonderful.[4]

Later, during the first decade of the sixteenth century, the potential of the chiaroscuro woodcut was developed by certain artists both in Germany and in Italy. This involved the composing of images from two or more blocks, each differently inked, so that when the impressions were superposed, a middle range of tone could be introduced to mitigate the normal dark–light contrast. The varied effects of the resulting prints were comparable to those of brush drawings and even of paintings, and their designers tended to claim an appropriate status as inventors. An early chiaroscuro woodcut designed from three blocks by Hans Burgkmair of Augsburg (1473–1531) was marked conspicuously by the artist with his own name (Plate 6.4). The image is composed of four graded tones of brown, with the pale buff colour of the uninked paper providing the lightest of these.

However, there are extant impressions of this print that bear the overprinted name of Jost de Negker (c.1485–c.1544), a block-cutter from Antwerp. What

this demonstrates is not that de Negker necessarily cut the original blocks for Burgkmair's composition, but rather that he took possession of them at some point and issued impressions on his own behalf. There are other later prints that bear the signatures of both artists, testifying to a productive collaboration, while Landau and Parshall note that 'Probably at some point after 1512 de Negker began to commission designs from Burgkmair directly, printing and publishing them under his own auspices.'[5] In this case, then, the artist was working under the effective direction of the professional block-cutter.

Both severally and jointly the two works compared at the outset of this chapter represent a high point in the making of printed images. It will be the remaining business of this chapter to address the development of the respective media during the immediately preceding period, and to consider some notable examples of their use. An important point should first be registered. In their relative similarity, the two versions of *The Angel Appearing to Joachim* represent a moment of greatest convergence in the development of the two principal printmaking media. This is not simply because one is a copy of the other. Rather, the very fact that Marcantonio thought Dürer's woodcut design worthy of engraving serves to demonstrate just how far the technique of block-cutting had advanced by the early sixteenth century, particularly in Germany. In fact, by the first decade of the century the monochrome woodcut had been brought to a point of sophistication that was never really to be surpassed. On the other hand, it is in the differences between the two images that the further potential of engraving is made clear. Marcantonio's version of *The Angel Appearing to Joachim* is a relatively early work in the engraver's career, but it provides ample indication of the possibility for combining graphic detail with tonal range and subtlety that engraving offered to the skilled practitioner, and that was to be further exploited by Marcantonio and others over the ensuing quarter century. As command of the medium increased, so did the engraver's ability to capture nuances and gradations of tone, and thus to convey complex effects of modelling and illumination.

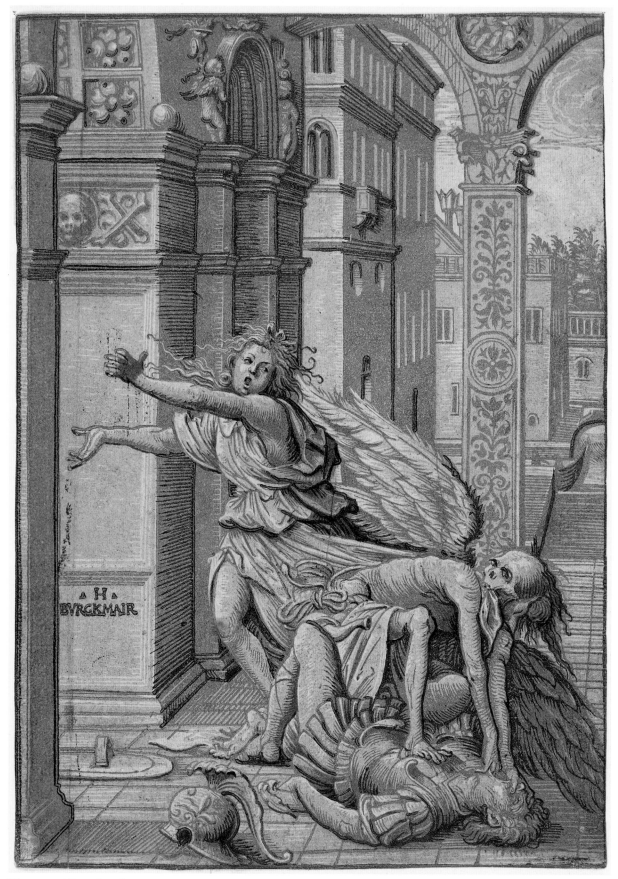

Plate 6.4  Hans Burgkmair, *Lovers Overcome by Death*, c.1510, chiaroscuro woodcut from three blocks, state III, 21 × 15 cm, British Museum, London. Photo: © The Trustees of the British Museum.

## 3 Early woodcuts and the emergence of intaglio printing

I have already discussed differences in the practical implications of woodcutting and engraving. These differences are underlined when account is taken of the various ends for which the techniques of block-cutting and engraving were largely employed before the last third of the fifteenth century, which is to say before printmakers began fully to exploit the potential of independent and repeatable pictorial images. Apart from the stamping of designs on textiles, the principal early uses of woodblocks were for the multiple printing of playing cards and of simple religious images, the latter issued as tokens for indulgences, as souvenirs at shrines or as talismans of one kind or another. All these uses were already widespread by the end of the fourteenth century, though in no instance were the printed images liable to be preserved for their intrinsic value as artistic pictures. The woodcuts that have survived from the early fifteenth century represent a very small proportion of what must have been a massive output, and very few of those can be dated with precision. A talismanic image of Saint Christopher, the patron saint of travellers, originating from south Germany is exceptional in bearing a date (Plate 6.5). The legend translates as an assurance that a sight of Saint Christopher – presumably such as the print itself has to offer – will provide daily protection from the risk of sudden death. Among the probable makers of images such as this were monks trained as scribes, working for the most part in monasteries.

As a means of replicating pictorial images the intaglio print emerged in Europe considerably later than the woodcut. The principal established uses for techniques of engraving during the early Renaissance were in the decoration of armour and weaponry, and of such items of fine metalwork as were employed in religious observance: crosses, candlesticks, chalices, reliquaries and so forth. Impressions taken from designs incised into objects such as these were probably the first pictures made on paper from engraved surfaces. They were taken by goldsmiths, not to provide multiple copies for distribution, but rather to record designs or to check their quality. In Italy the early development of drypoint and engraving is closely connected to the established practice of work in *niello*, a technique in which a kind of black enamel is melted into the excavated areas of fine relief work in silver. An example of *niello* work (Plate 6.6) has been attributed to the Florentine artist Baccio Baldini (*c.*1436–87), who was also to make a number of engravings, among them a set of 19 after Botticelli's illustrations to the *Divine Comedy* of Dante. In his *Children of Mercury* (Plate 6.7), metalworkers are pictured in a goldsmith's shop, one at work on the engraving of a plate for printing.

The earliest surviving intaglio print that appears to have been purpose made and that bears a date is an engraving of *The Flagellation*, made in Germany and marked 1446 (Plate 6.8). This was preceded, however, by undated designs for playing cards that were made in drypoint in the Upper Rhine region of south-west Germany, probably in the late 1430s (Plate 6.9). These are the very earliest intaglio prints known to have survived. (The majority are

Plate 6.5  Unknown south German, *Saint Christopher*, 1423, hand-coloured woodcut, image 29 × 21 cm, John Rylands University Library, University of Manchester. Photo: reproduced by courtesy of the University Librarian and Director, The John Rylands University Library, The University of Manchester.

Plate 6.6   Florentine, attributed to Baccio Baldini, *Mary Magdalene*, *c*.1464–5, detail of processional cross; decorated with 20 niello plaques, silver, partly gilded; niello; copper with traces of gilding over wood, 55 × 32 cm, Metropolitan Museum of Art, New York. Photo: all rights reserved, The Metropolitan Museum of Art. Gift of J. Pierpont Morgan, 1917 (17.190.499).

now held in collections in Dresden and in Paris.) Extant impressions can be divided into four suits: beasts of prey (lions and bears), birds, deer and flowers. The close parallel strokes of the drypoint needle produce a texture similar to contemporary brush drawings, with solid modelling and marked highlights.

It seems clear that as soon as woodcut and intaglio techniques could be practically compared as means to the making of repeatable pictures, drypoint and engraving were relatively esteemed for their ability to transmit a finer level of detail. Card games were introduced into Europe from the Islamic world in the fourteenth century and their popularity rapidly became widespread. In the late fourteenth and early fifteenth centuries countless cheap packs of cards must have been produced. At the time the most efficient way to reproduce the designs would have been by means of woodcut blocks. These packs would presumably have been regarded as

disposable once no longer fit for use, and they have thus left little trace. (An exceptional survival helps to support the general case. An uncut printed section from a woodcut design for a series of playing cards has been discovered in a sixteenth-century house in Antwerp, where it had been recycled as ceiling paper.[6]) The survival of the drypoints, on the other hand, testifies to the relative value that these fine images were accorded as designs in their own right. Not only were they repeated by various subsequent engravers, evidence of their early and widespread use as patterns for illumination has been found in manuscripts produced before 1455 in Holland, Savoy, Saxony, the Tyrol, the southern Netherlands, the Rhinelands and England.[7] The date ascribed to the playing-card designs is due in part to the repetition of specific beast, bird and flower motifs in manuscript illuminations that can be dated with certainty. These borrowings provide clear evidence both of the early and rapid circulation of certain engraved images across Europe, and of the readiness of their adoption and adaptation by artists working in various fields.

From this specific case there are also some general points that may be made regarding the different markets, distribution and rates of survival of woodcuts and intaglio prints respectively. Generally speaking, engravings tended from the first to attract a more sophisticated and wealthier audience, and they were more liable to be saved by being pasted into books. Copper is more expensive than wood, the techniques of engraving allow for more independent development and initiative than those of woodcutting, and the printing of engravings requires more equipment, time and skill than the printing of a woodblock. As A. Hyatt Mayor has noted,

> In 1520 Dürer's price per sheet for his engraved Passion was four and a half times that for his little woodcut Passion … The typical engraving of the later 1400s has survived in two or three impressions, the typical single-sheet woodcut in one.[8]

The principal developments in the intaglio print in the third quarter of the fifteenth century were made by artists working in the Upper Rhine region of south-west Germany who are now identifiable only by their individual styles, or in rare cases by the initials with which they signed their plates. Notable among these is the engraver who signed some of his work 'ES', and

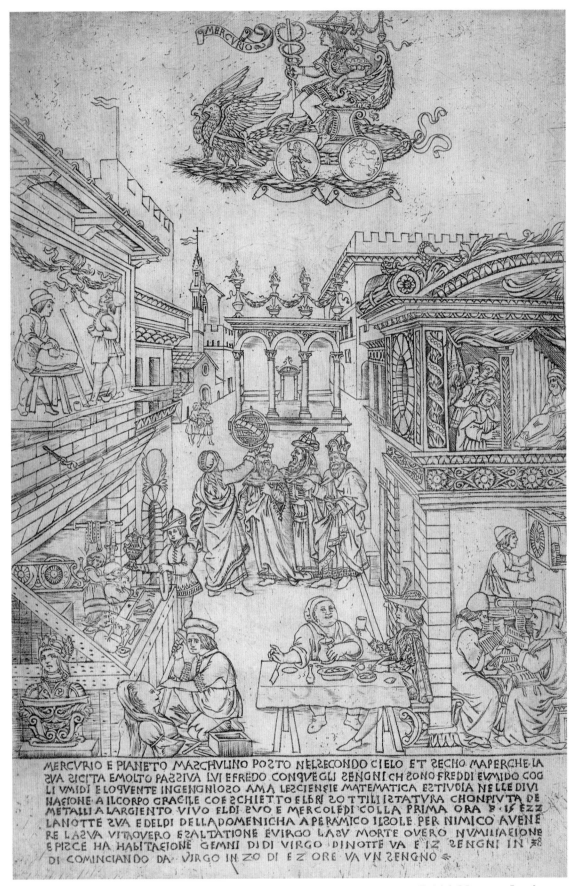

Plate 6.7   Baccio Baldini, *Children of Mercury*, c.1480, engraving, 32 × 22 cm, British Museum, London.
Photo: © The Trustees of the British Museum.

Plate 6.8   Master of 1446, *The Flagellation*, 1446, engraving, 10 × 8 cm, Kupferstichkabinett, Staatliche Museen zu Berlin. Photo: © 2007 bpk/Staatliche Museen, Berlin/Jörg P. Anders.

Plate 6.9   Master of the Playing Cards, *Nine of Beasts of Prey*, c.1435–40, drypoint, Bibliothèque Nationale, Paris. Photo: Bibliothèque Nationale.

who is thought to have worked from the 1450s until the late 1460s. Although his monogram appears on only 18 surviving engravings, some 300 have been attributed to him. It is probable that he was trained as a goldsmith, and that he then pursued the professional opportunities that arose once suitable paper was available for the printing of pictorial designs from metal plates. His engraving of the dedication of the Einsiedeln monastery in Switzerland (Plate 6.10) must have been produced on commission. Copies of this and two other images were sold to pilgrims attending the 500th anniversary celebrations of the founding of the monastery in 966. This followed a supposed miraculous appearance of the Virgin and Child attended by angels, for which a papal indulgence was granted.[9] In the engraving, the representation of the miraculous event is deliberately conflated with an image of pilgrims worshipping at the shrine built to commemorate it, while the Trinity is represented on the balcony above.

Technically, the work of Master ES is marked by the kind of systematic hatching and cross-hatching that would from that point on be typical of the use

of the burin. The distinctive style of his draped figures is reminiscent of Netherlandish painting – and of the work of Rogier van der Weyden in particular. It has also been associated with the work of the Netherlandish sculptor Nicolaus Gerhaerts of Leyden, who was working in Trier and Strasburg in the 1460s, and who executed the high altar of Constance Cathedral in 1465–6 at a time when Master ES was also in Constance. In turn, his engravings were to be mined for figure-types by an ensuing generation of German sculptors working in a late Gothic idiom, among them Veit Stoss (*c.*1445/50–1533), Michael Pacher (active 1462 – d.1498) and Tilman Riemanschneider (*c.*1460–1531) (see Plates 6.11 and 6.12). The prints of Master ES thus formed a significant bridge in the transmission of styles and designs for the representation of the human figure in northern Europe. It was even suggested at one time that

Plate 6.10   Master ES, *Large Einsiedeln Madonna*, 1466, engraving, 21 × 13 cm, Art Institute of Chicago. Photo: © The Art Institute of Chicago. Kate S. Buckingham Fund, 1972.1.

the apparent unity of style in German sculpture in the late fifteenth century might be attributed to the common resource that his work represented.[10] Though this thesis is not now widely supported, there is plenty of evidence to suggest that prints were among the valued resources of sculptors' workshops throughout Europe at the time.

While the majority of early intaglio prints were devoted to religious subjects, one of the most remarkable of early northern printmakers is distinguished by the number of his works that are on profane and courtly themes, and by the evident interest that these held for his contemporaries. He is known as the Housebook Master (after

Plate 6.11   Master ES, *Madonna with the Book (Virgin Mary on a Crescent)*, c.1450–67, engraving, 20 × 14 cm, British Museum, London. Photo: © The Trustees of the British Museum.

the illustrations in pen and ink on vellum in a surviving manuscript known by that name) or as the Master of the Amsterdam Cabinet (after the nearly comprehensive collection of his surviving prints that is held in the Rijksmuseum in Amsterdam). He may have been of Netherlandish origin, though he seems to have worked in the Middle Rhineland in Germany during the period between 1470 and 1495. His prints are made exclusively in a delicate drypoint style that suggests the training of an illustrator rather than a goldsmith (see Plate 6.13). They appear to have been executed on plates that must have been even softer and thus more vulnerable than unalloyed copper, and they cannot therefore have been intended for circulation in more than a very limited number of copies, where they were intended for circulation at all. (Out of a corpus of some 89 prints attributed to the Housebook Master, 70 are known in only one impression.) Although the implication is that these were images made for an elite clientele, they must have achieved sufficient currency for their highly refined style and technique to draw the attention of other artists, Dürer certainly among them.

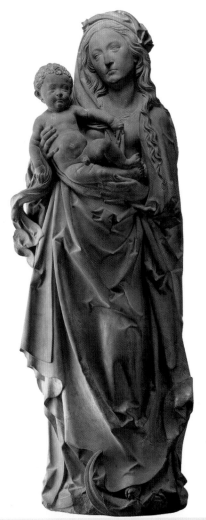

Plate 6.12   Tilman Riemenschneider, *Madonna and Child*, 1516–22, sandstone, Liebighaus, Frankfurt.

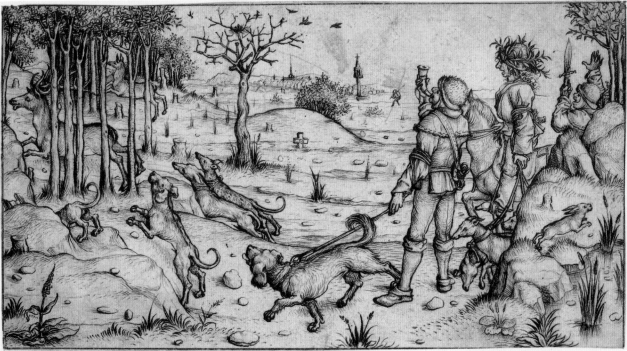

Plate 6.13   Housebook Master, *Stag Hunt*, c.1485–90, drypoint, 17 × 9 cm, Rijksprentenkabinet, Rijksmuseum, Amsterdam. Photo © Rijksmuseum, Amsterdam.

# 4   The engraving as independent work of art

In consideration of the development of intaglio printing in the later fifteenth century, two further German engravers are deserving of particular attention, one for the inventive quality of his work, the other for his remarkable success in exploiting the work of others. The first, Martin Schongauer, may have been apprenticed to the Master ES. He was the son of a goldsmith, though trained as a painter. Like the Master ES he clearly had first-hand acquaintance with the work of Netherlandish painters, though he worked in Colmar (now in eastern France, but at the time in south-west Germany). It is an indication of the importance he attributed to his authorship that he signed all of his prints with his monogram. In devoting to his engraved work an attention equal to that required for the making of a painting, he both advanced the status of the printmaker's art and established a precedent that other painter-engravers were quick to follow. Schongauer's distinctive contribution to the printmaker's technique was further to establish the rhythmic properties of the engraved line –

possibly by introducing the practice of rotating the plate on a leather cushion against a steadily held burin, so as to gouge out regular and continuous curves from the copper plate. He also situated his animated and roundly modelled figures within the kind of coherent pictorial space that distinguished the advanced Netherlandish painting of the time. Like the work of the Master ES, his single figures and even entire compositions were widely used as models by sculptors (see Plates 6.14 and 6.15).

Altogether Schongauer made 116 engravings between 1470 and 1491, among them some of the most complex and ambitious compositions to have been attempted in any European art form at the time. His large *Christ Carrying the Cross* contains over 50 figures (see Plate 6.16). In their survey of Renaissance printmaking during the period 1470–1550, Landau and Parshall refer to this as 'the most influential print made in northern Europe throughout the full span of our inquiry'.[11] Schongauer's engravings have survived for the most part in several impressions, while the majority of them were copied within his lifetime by other engravers, most of whom signed the resulting

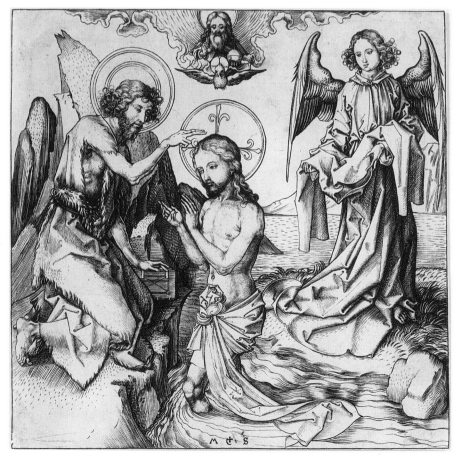

Plate 6.14   Martin Schongauer, *The Baptism of Christ*, c.1480–90s, engraving, 16 × 16 cm, Rosenwald Collection, National Gallery of Art, Washington, DC. Photo: © 2005 Board of Trustees, National Gallery of Art, Washington, DC.

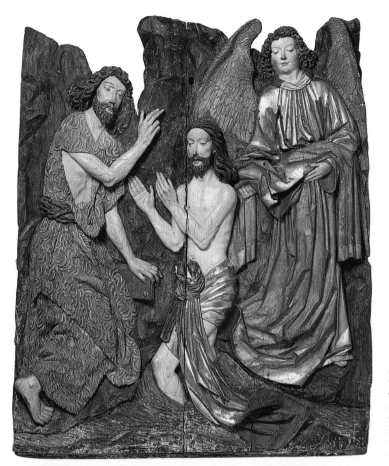

Plate 6.15    Follower of Veit Stoss, *The Baptism of Christ*, 1480–90, limewood with polychromy and gilding, 122 × 102 × 8 cm, Metropolitan Museum of Art, New York. Photo: © 1985 The Metropolitan Museum of Art. Rogers Fund, 1912 (12.130.1).

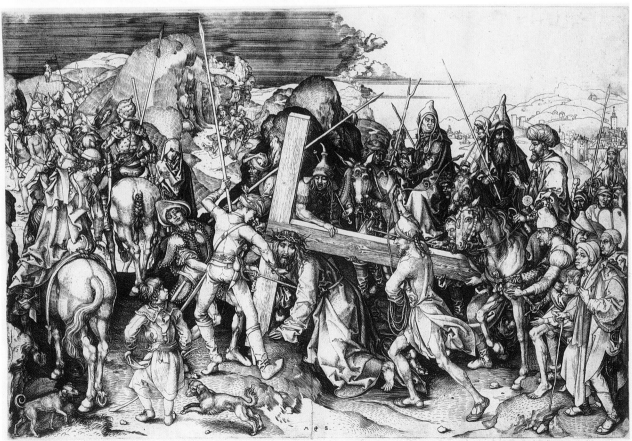

Plate 6.16    Martin Schongauer, *Christ Carrying the Cross*, *c.*1470–5, engraving, 28 × 43 cm, Kupferstichkabinett, Kunstmuseum, Basle. Photo: Kunstmuseum, Basle.

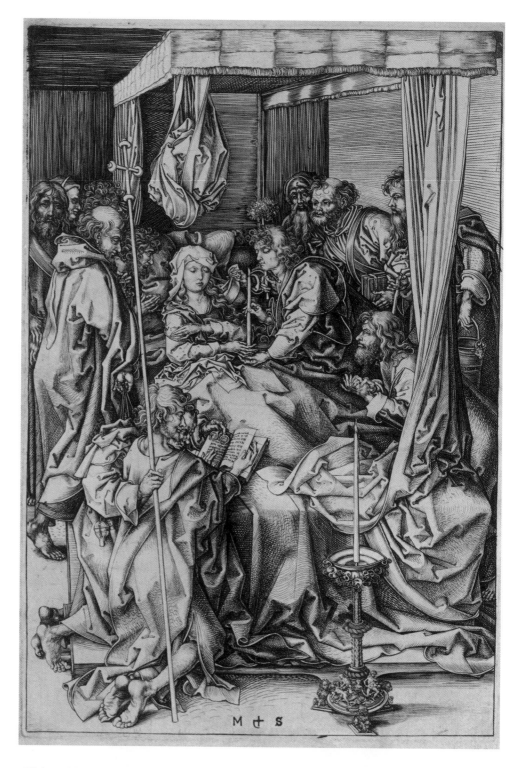

Plate 6.17 Martin Schongauer, *Death of the Virgin*, c.1480, engraving, 26 × 17 cm, Preußischer Kulturesitz, Kupferstichkabinett, Staatliche Museen zu Berlin. Photo: © 2007 bpk/Staatliche Museen, Berlin/Jörg P. Anders.

compositions as their own. This evidence suggests that the independent print had now acquired real value as a marketable and collectable commodity, and that it was with Schongauer's personal style that that value was principally associated. When in 1490 the 19-year-old Dürer completed his apprenticeship, he set off on a lengthy journey through Germany and possibly the Netherlands.

In the autumn of 1491 he arrived in Colmar to visit Schongauer. Given Dürer's own ambition it may well have been that his aim was to join the older artist's workshop. But Schongauer had died earlier that year.

The second German figure deserving of particular attention was among those who made copies of Schongauer's prints – 58 in all. He was a goldsmith

Plate 6.18   Israhel van Meckenem, after Schongauer, *Death of the Virgin*, c.1490–1500, engraving, 25 × 17 cm, Ashmolean Museum, Oxford. Photo: Ashmolean Museum, Oxford.

by trade, working in the town of Bocholt near the border with the Netherlands between 1465 and 1503. His name, conspicuously displayed in full or in initials on the copies in question, was Israhel van Meckenem (c.1440/5–1503). The same signature appears on some 200 copies of prints by the Master ES, on some 30 copies from the Housebook Master and on numerous other prints that appear to have been made from the heavily

re-engraved plates of other artists, including a further 41 by the Master ES. Altogether, over 600 prints were issued in Israhel's name, of which over 90 per cent are somehow identifiable as versions of the work of other engravers, leaving a remainder of less than 10 per cent as his own original designs. Schongauer's widely imitated *Death of the Virgin* was copied in reverse by Israhel van Meckenem (Plates 6.17 and 6.18).

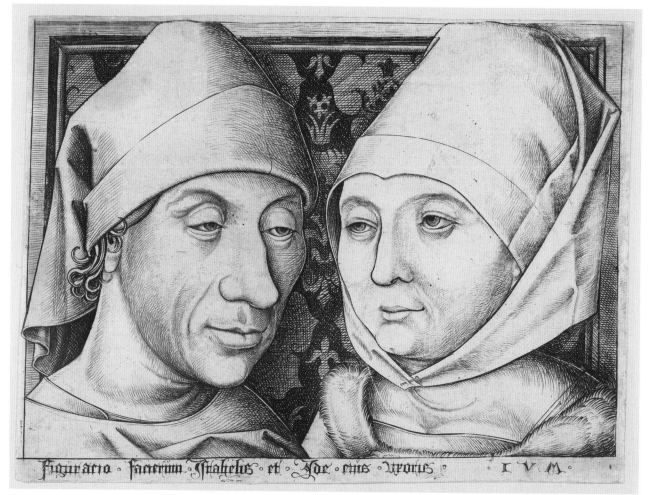

Plate 6.19   Israhel van Meckenem, *Self-Portrait with his Wife Ida*, *c.*1490, engraving, 13 × 17 cm, British Museum, London. Photo: © The Trustees of the British Museum.

As this copy demonstrates, Israhel was not the most sensitive of engravers. He was concerned rather with clarity and firmness of impression than with subtlety of line and tone. He was nevertheless by far the most successful printmaker working anywhere at the end of the fifteenth century, and one of the most influential. The crucial factor in his success was his realisation that it was the owner of engraved plates rather than the inventor of compositions who controlled the distribution and sale of printed images. There is evidence from the last decade of the century that prints he had issued were in use by painters and illustrators 'in an area extending from the Baltic to Spain'.[12] A close relationship exists between certain of his prints and elements of the Weingartner Altar, made for Augsburg Cathedral by Hans Holbein the Elder (*c.*1460/5–1534) in 1493. This has led to suggestions that there might have existed a working relationship between painter and printmaker not unlike that which was later to develop in Rome

between Marcantonio and Raphael.[13] While the tendency of early commentators was to disparage Israhel as a pirate, the emphasis of more recent studies has been on the significance of his role as an entrepreneur. It has also been persuasively argued by Landau and Parshall that those of his prints for which no previous author has been established are innovative in bringing a sharp intelligence and wit to the interpretation of up-to-date and vernacular subjects, and that they thus helped to free the audience and market for printed pictures from its virtual domination by religious interests.[14] Israhel's double portrait of himself and his wife certainly appears to be a strangely advanced image for its time (Plate 6.19). Among known engravings, it is both the first signed self-portrait and the first double portrait. From a modern perspective this image may suggest the unabashed self-confidence of a successful business partnership. However, given that husbands at that period became the legal owners of their wives'

earnings after marriage, it would be inappropriate to think in terms of partnership in any economic enterprise. It is more likely that the engraving relates to the kind of painted marriage portrait that patricians tended to commission, and that it thus serves both as an advertisement for Israhel's abilities as a provider of low-cost images, and as a claim on his own behalf to the status of a respectable and well-married burgher.

In establishing the printed design as a substantial work of art in its own right, Schongauer's equivalent and approximate contemporary in Italy was the painter Andrea Mantegna, whom Vasari credited with the invention of copperplate engraving (a mistake he corrected in the second edition of his *Lives of the Painters, Sculptors and Architects*). However, where Schongauer's output can confidently be numbered at 116 prints, all of them signed, Mantegna's considerable status in the history of printmaking rests on a corpus of at most 23 known images (the number attributed to the artist by Adam Bartsch in his volume on the early Italian engravers, published in 1811). Even this slender body of work is disputed. In 1992 a major exhibition of Mantegna's work was organised by the Metropolitan Museum of Art in New York and the Royal Academy of Arts in London. The catalogue included two essays on his activity as a printmaker.[15] The author of one of these, David Landau, attributed ten plates at most to the artist's own hand, some of them clearly unfinished, but the majority highly ambitious in size and scope. Among these were the *Entombment with Four Birds* (Plate 6.20), which is generally dated to around 1465, the *Battle of the Sea Gods* (Plates 6.1 and 6.21) and the *Virgin and Child* (Plate 6.22), described by Landau and Parshall as 'the artist's last and most beautiful print'.[16] The author of the second essay, Suzanne Boorsch, argued that there were no surviving prints actually from Mantegna's own hand, and attributed 23 prints – not all of them the same as those catalogued by Bartsch – to a single professional engraver working from Mantegna's designs.

There is a general consensus of opinion that Mantegna employed engravers in his workshop in Mantua, perhaps from as early as the mid-1470s. (The same craftsmen may well have been employed in engraving the ceremonial armour visible in contemporary portraits of Mantegna's Gonzaga patrons.) We can be more certain that engravings both from his own drawings and from the earlier prints associated with his name were made in the 1490s by others working in his employ. There are surviving drawings from his hand that are closely followed in prints definitely attributable to other printmakers, among them the professional engraver Giovanni Antonio da Brescia (*c*.1460–*c*.1520). What can also be said with confidence is that the limited number of prints nowadays attributed to Mantegna's own hand by the majority of scholars – including the three reproduced here – show a remarkable range and inventiveness overall, together with a considerable development in technical sophistication and subtlety from the earliest to the latest. It is a reasonable conclusion that Mantegna cut his own prints while he was exploring and developing the potential of the medium, and that later in his career he employed other engravers to reproduce and to publicise his work.

The relatively crisp style and parallel hatching of the *Entombment* recalls the work of the early German engravers, and particularly of the Master ES, contrasting markedly with the so-called Fine Manner of cross-hatching that was prevalent in the contemporary work of Florentine niellists and printmakers. (The term 'Fine Manner' refers to a method of printmaking with a goldsmith's tool that tended to produce a fine and shallow groove in areas of shading. The resulting relatively thin and fragile lines wore down quickly in printing. For an example, see Plate 6.7. In contrast, the Broad Manner was produced with a burin that cut a deeper groove, leading to a less abrupt distinction between outlines and shaded areas and encouraging the use of firm parallel strokes. The resulting incisions retained more ink, enabling stronger contrasts (see Plate 6.3). The Florentine engraver Francesco Rosselli (1448–before 1513) has been credited with introducing the Broad Manner to Florence in the early 1480s, following a trip north of the Alps. It is suggested that he learned the use of the burin with lozenge-shaped section from German engravers.)[17]

If the *Entombment* is a large print by the standards of the time, the extraordinary *Battle of the Sea Gods* is massive, measuring not far short of a metre when the two adjoining plates are printed together (see Plate 6.21). Notwithstanding the boldness of Mantegna's composition, the mixture of engraving with drypoint produces considerable subtlety

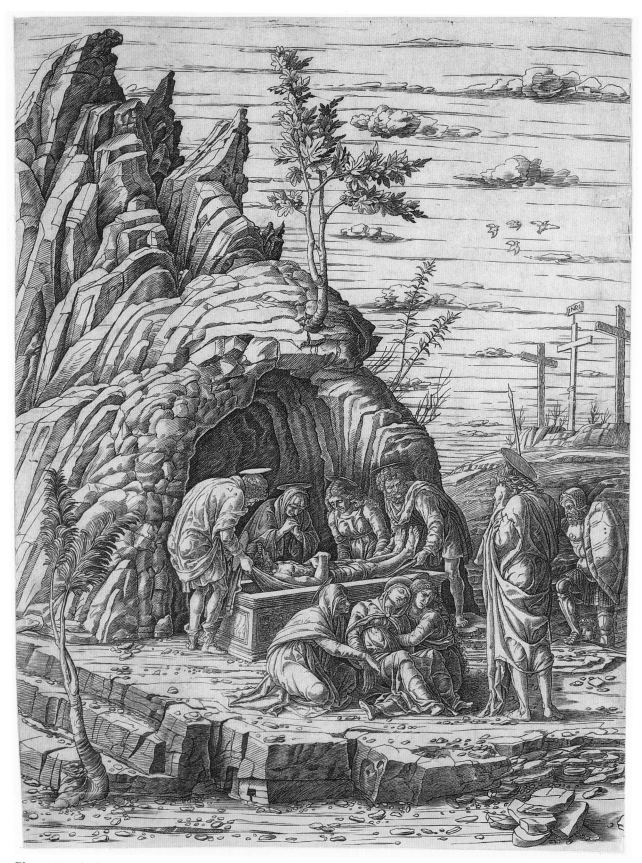

Plate 6.20    Andrea Mantegna, *Entombment with Four Birds*, *c.*1465, engraving, 45 × 36 cm, Albertina, Vienna.

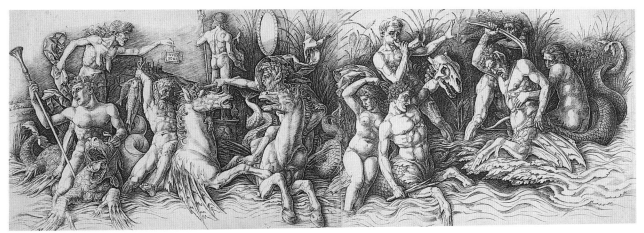

Plate 6.21   Andrea Mantegna, *Battle of the Sea Gods*, 1470s, engraving and drypoint, 28 × 83 cm, © The Devonshire Collection, Chatsworth. Photo: reproduced by permission of the Chatsworth Settlement Trustees.

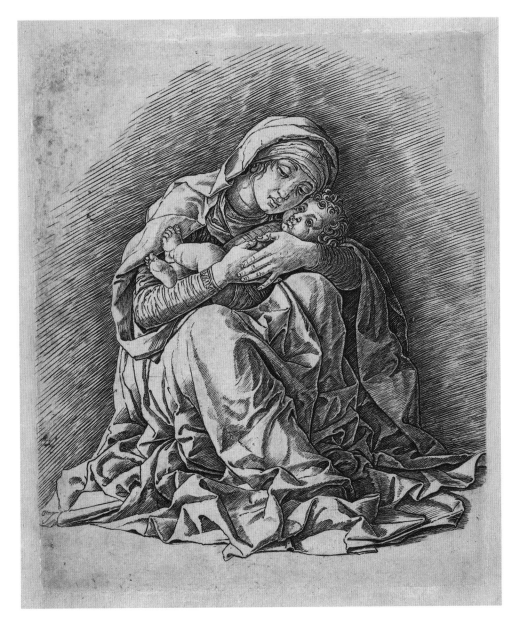

Plate 6.22   Andrea Mantegna, *Virgin and Child*, c.1480–5, engraving and drypoint, 25 × 21 cm, British Museum, London. Photo: © The Trustees of the British Museum.

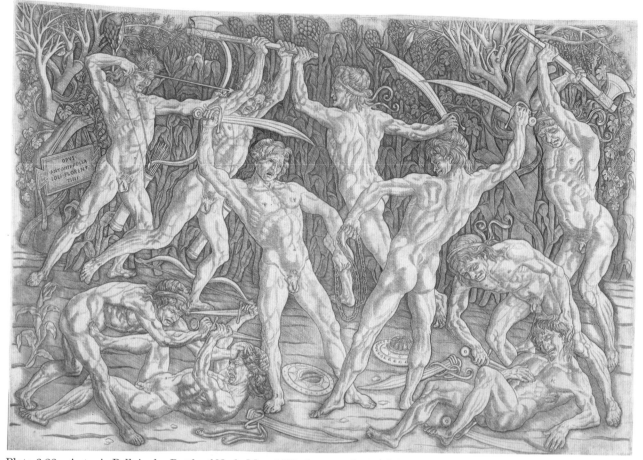

Plate 6.23    Antonio Pollaiuolo, *Battle of Nude Men*, 1470–5, engraving and drypoint, 42 × 60 cm, Cleveland Museum of Art. Photo: © The Cleveland Museum of Art, 2002. Purchase from the J.H. Wade Fund, 1967.127.

and range of tone in early impressions. The only other Italian print of comparable size and scope is the *Battle of Nude Men* (Plate 6.23), originally engraved in the Fine Manner by Antonio Pollaiuolo (1432–98) in Florence in the early 1470s. (The plate was subsequently reworked with a burin in the Broad Manner, probably by another engraver.) Mantegna's print also invites comparison with Schongauer's *Christ Carrying the Cross* (Plate 6.16) in terms of its ambition and complexity. It is clearly identifiable as Italian work, however, reflecting the courtly and literate milieu in which it was produced. It is distinguished not only by the references to classical precedents in the treatment of nudes and grotesques, but by the more marked plasticity of the figures and the more articulate organisation of the pictorial space. The artist's clear intention was to produce a graphic equivalent for the kind of carved frieze with which Roman sarcophagi were ornamented.

While the *Virgin and Child* offers a clear contrast to the *Battle of the Sea Gods* both in its theme and in its expressive aspect, it testifies in equal measure to Mantegna's remarkable ability to hatch relief-like figurative compositions out of the flat surfaces of his copper plates. Whether or not the artist had the actual reliefs of Donatello and his followers in mind, the *Virgin and Child* offers a reminder of the continual cross-fertilisation with sculpture that coincided with the emergence of the print as an independent work of art. (Mantegna may well have been specifically interested in the bronze reliefs that Donatello produced in Padua, where he himself worked on the Ovetari Chapel in the 1450s.)

## 5   Paper, printing and publication

While relief and intaglio printing tended to develop along relatively independent lines during the fifteenth century, with Dürer and a few other (mostly German) artists exceptional in exploring both techniques, certain background factors were common to the development of both media. The

first of these – and the most crucial – was the increasing availability of paper, and specifically of paper of sufficient quality to preserve detailed impressions. This was a factor of particular significance in the development of intaglio printing. It took some while for the invention of paper in China to spread through the Islamic world to North Africa and thence to Europe, where its manufacture and use were slowed by Christian prejudice against all things associated with Muslim civilisation, and by restrictions on the transmission of the papermaker's craft. The first paper mill in Italy was established in 1276, in France in 1348, and in the Holy Roman Empire beyond Italy not until late in the fourteenth century. Italy remained the main European source for paper throughout the fifteenth and sixteenth centuries. It was not until the end of the sixteenth century that paper was made in any appreciable quantity in either Holland or England.

The major factors that drove expansion of papermaking across Europe were the invention of movable type by Johann Gutenberg of Mainz around 1440, the ensuing development of the printing press, and the resulting rapid spread of book publishing from the mid-century onwards. It has been estimated that between 15 and 20 million books were printed in Europe in the second half of the fifteenth century.[18] Paper quality remained variable, however, and demand for material of suitable standard tended to outstrip supply throughout the Renaissance. Artist-printmakers must have been among the most demanding of purchasers. Under the technical conditions of the time it would have required a paper of quite exceptional fineness and consistency in order to capture the full and remarkable refinement of an engraving such as Dürer's *Virgin and Child with a Monkey* (Plate 6.24).

It should also be kept in mind that the care Dürer must unquestionably have exercised in the selection and acquisition of his paper would have been wasted had he not also had recourse to ink of an appropriate opacity and oily consistency. The manufacture of fine printing inks followed the development of oil painting, with which certain materials and techniques were shared, and was similarly governed by closely guarded recipes. (Typical basic ingredients were linseed or walnut oil, burnt pitch residue or lampblack, and turpentine.) While the demand for inks was

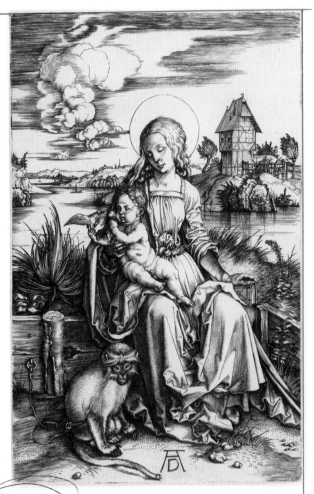

Plate 6.24   Albrecht Dürer, *Virgin and Child with a Monkey*, c.1498, engraving, 19 × 12 cm, British Museum, London. Photo: © The Trustees of the British Museum.

intensified, like the demand for paper, by the rapidly developing printing industry, the artist-printmaker would have expected to exercise at least as much care over the selection or making of his own ink as he would over the medium for a painting.

The development of book publishing in itself provided a further major impetus to the development of the fine-art print, as has already been suggested. The major factor here was the demand for illustration. At least one-third of all books printed before 1500 were illustrated in some fashion,[19] though since books published during this period were made using relief printing techniques, where pictures were required they were supplied almost exclusively by woodcuts. (A woodblock could be bound into the printing form and inked together with the type. The inking and printing of an engraved plate required a quite separate process.) The demand for illustrations grew dramatically

during the 1470s, particularly in Germany and Italy. In many cases these amounted to little more than simple decorative vignettes, but by the later 1480s enterprising publishers in Mainz, Nuremberg and Venice were beginning to plan lavish editions that required substantial pictorial designs.[20] The *Peregrinationes in terram sanctam* of Bernard von Breydenbach provides an important early instance. Published in Mainz in 1486, this was an account of the author's pilgrimage to the Holy Land three years previously. It was copiously illustrated with woodcuts by Erhard Reuwich (1455–*c*.1490), who had been employed to accompany von Breydenbach on his travels. The most impressive of these illustrations were fold-out views of townscapes, including a view of Venice which opened to a metre and a half in length.

As has already been suggested, the rapid evolution of the woodcut followed upon a tendency for different specialisations to emerge in what had previously been one integrated practice. It was during the later fifteenth century that the named artist-designer emerged as a generally distinct figure from the cutter of the resulting blocks, in the process laying claim to a status denied to the anonymous craftsman responsible for woodcut pictures earlier in the century. A further significant point in this evolution is marked by Dürer's *Apocalypse*, printed in the name of the artist himself in 1498 and published by Anton Koberger in Nuremberg. This consisted of a cycle of illustrations to the Revelation of Saint John the Divine, with text printed on the back in separate German and Latin versions (see Plate 6.25). While this might still be taken as the illustrated form of a religious text, the clerics and humanists who acquired copies at the time presumably saw its religious value as greatly enhanced by the designs of the celebrated German artist.

A further high point in the development of the woodcut is marked by the extraordinary *View of Venice*, commissioned by the Nuremberg merchant and sometime bookseller Anton Kolb from the Venetian artist Jacopo de' Barbari and printed in Venice itself in 1500 (Plate 6.26). This provides the most dramatic of exceptions to the generalisation quoted earlier to the effect that woodcuts were addressed to a poorer clientele than engravings. Based on perspective studies made from the highest buildings of the city, the design was presumably either pasted or copied

directly onto the six walnut blocks from which it was eventually printed. Even individually these were of dimensions – approximately 66 by 92 centimetres – that required the manufacture and supply of paper of an unprecedented sheet size. The remarkable quality of the block-cutting has led to suggestions that German craftsmen may have been employed, in which case this was all the more clearly an international enterprise. The work of what must have been several years was rewarded by exemption from Venetian customs duties and by the granting of a four-year privilege (a kind of monopoly intended to protect an enterprise or to prevent copying, similar in effect to modern copyright but usually of much shorter duration). Kolb priced the printed sets at 3 ducats each (this might be estimated as the approximate equivalent of two months' wages for an unskilled labourer). The first state of the print is recorded in 12 surviving impressions. It is significant that although this was an independent print designed as a potential wall display, the immediate precedent for its publication lay in the cartographic illustrations to books published in Mainz and in Nuremberg in the 1480s and 1490s, such as those that Erhard Reuwich made for the *Peregrinationes*. In the year that the *View of Venice* was published, Jacopo de' Barbari moved north to Dürer's home town of Nuremberg to work for the Emperor Maximilian. The first Italian artist of note to travel to the German courts, he spent his last working years in the Netherlands.

Clearly, the development of a market in printed books could only increase the potential for circulation of independent prints of all kinds. The thinnest of lines divided printed books from printed broadsheets, and where books were distributed and sold, prints could be also. The person who funded the production of the one was increasingly likely to consider investing in the other, particularly as the improving technical quality of artists' prints attracted the attention of an educated and wealthy clientele. While intaglio plates might not have been generally used in book printing, it is reasonable to deduce that the rapid development of book publishing during the last quarter of the fifteenth century must in due course have provided a certain impetus to the development of engraving. Much of the evidence of acquisition of prints by collectors before *c*.1520 is furnished by impressions pasted into manuscripts or printed books, typically to

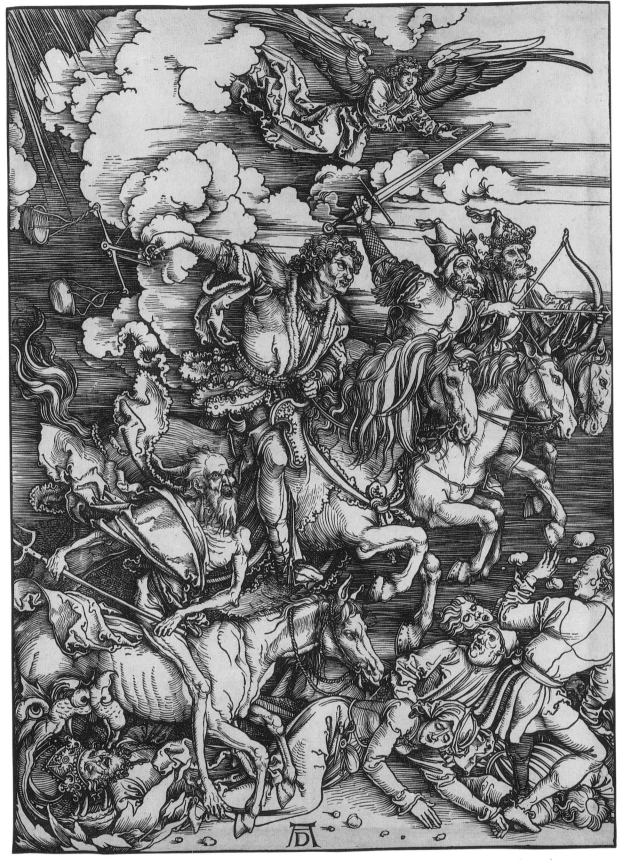

Plate 6.25    Albrecht Dürer, *The Four Horsemen of the Apocalypse,* from the *Apocalypse,* 1498, woodcut, sheet
39 × 29 cm, Metropolitan Museum of Art, New York. Photo: all rights reserved, The Metropolitan Museum of Art. Gift
of Junius S. Morgan, 1919 (19.73.209).

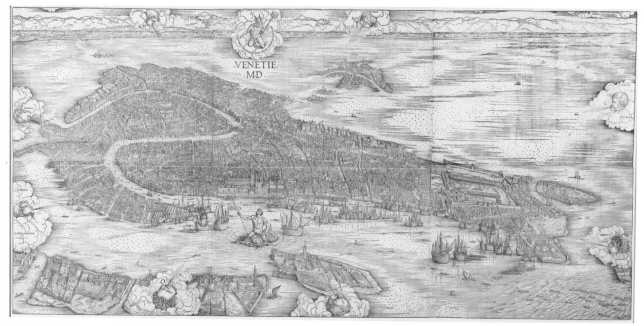

Plate 6.26   Jacopo de' Barbari, *View of Venice*, 1500, woodcut from 6 blocks, 139 × 282 cm, British Museum, London. Photo: © The Trustees of the British Museum.

serve as a kind of illustrative accompaniment to the text.

What can be stated with confidence is that wherever in Europe the printing industry flourished – in Antwerp, Strasburg, Basle, Augsburg, Mainz, Nuremberg, Venice, Florence and, later, Rome – artist-printmakers tended also to emerge. The demand for illustration was one clear reason for this, the establishment of appropriate means of distribution and sale was presumably another. One further reason should also be taken into account. Landau and Parshall make the point that 'The publishing world in general stood at the advanced edge of entrepreneurial experiment and conflict in early modern Europe.'[21] To put the point another way, the development of a dynamic publishing industry required the presence or the emergence of an inquisitive and discriminating audience, which was a condition also highly favourable to the emergence of the print as an independent work of art.

## 6   Distribution and collection

As noted earlier, there is clear evidence that prints were in circulation among the workshops of painters, illustrators and sculptors from before the mid-fifteenth century. Particularly as techniques for the modelling and shading of form were developed by engravers, their works offered a

significant addition or replacement to the resource of graphic patterns and models upon which any practice would largely depend, and which the ambitious artist would always aim to enlarge and to update. Those prized drawings that served as fertile repositories of figure types and poses were by their nature unique. As was shown in Chapter 1, they tended to be guarded among artists' valued possessions and often to be handed down to their named heirs. Through the medium of engraving, on the other hand, distinctive compositions and inventions could circulate more widely and more rapidly, speeding the transmission and exchange of images and styles, not only in painting and sculpture but in goldsmiths' work, in the painting of majolica dishes, and in the design of marquetry.

The work of Marcantonio offers one mature instance of this transmission and exchange in operation. His engraving *The Climbers* (Plate 6.27) was completed some two years after his version of *The Angel Appearing to Joachim*. In this case the figures are derived from Michelangelo's celebrated cartoon for the *Battle of Cascina*, which was made for a fresco in the Palazzo della Signoria in Florence. Marcantonio must have studied this work when he was in Florence in 1509. The background, on the other hand, is closely based on an engraving by the Netherlandish printmaker Lucas van Leyden (*c.*1494–1533) (see Plate 6.28). In considering the force of this example, it should

be borne in mind, first, that Lucas's engraving was made in Leiden in the north Netherlands a mere two years previous to Marcantonio's use of it in Italy and, second, that he was then far from being a well-known artist. *Mahomet and the Monk Sergius* is his earliest dated engraving, and for all its accomplishment he may have been a mere teenager when it was made.[22] (The story that provides the subject is taken from the fourteenth-century *Travels* of Jean de Mandeville. This tells how Mahomet became fascinated by the sermons of the Christian hermit Sergius. His resentful servants murdered Sergius, then, by showing the prophet his own bloodstained sword, deceived him into believing that he had done the deed himself after falling into a drunken sleep.) In fact, this may not have been the first instance of Marcantonio referring to Lucas's work, and it was certainly not to be the last. (His copy after Lucas's *The Pilgrims* is generally ascribed to the year 1508 or 1509.)

It seems clear enough that by the early sixteenth century prints were among the goods being rapidly carried and traded from one end of Europe to another. But what is particularly remarkable in the light of this example is the evident speed and sureness with which specific innovative prints came into the hands of fellow professionals, wherever they might be. One likely explanation for this is suggested by a passage in Vasari's 'Life of Marcantonio Bolognese and other engravers of prints'.[23] (While this is the text that furnishes much of the material from which a picture of the engraver's career has been constructed, it was not published until the 1568 edition of Vasari's *Lives of the Painters, Sculptors and Architects*. Its reliability as testimony should therefore not be taken for granted.) The passage in question concerns Marcantonio's first encounter with Dürer's *Life of the Virgin* series. According to Vasari's account, Marcantonio saw prints by Dürer 'cut and printed in wood and in copper' that were being offered for sale by some 'Flemings' in the Piazza San Marco in Venice.[24] In the transmission of pictorial styles and inventions in Renaissance Europe, it is likely that travelling dealers such as these played an easily overlooked but nevertheless significant part. Before the documented emergence of specialist print dealers in the later sixteenth century, these were people whose livelihoods depended in part on knowing where to look for attractive wares and new technical developments, who took the

risks involved in travelling with the resulting commodities, and who brought these commodities to the attention of those who might be attracted by them.

The investment of already well-regarded artists in the medium of engraving was certainly a major factor driving the market for prints in general and thus in ensuring their circulation. As to evidence for significant print collecting before the early sixteenth century by interested parties other than artists, this is patchy, though it is sufficient to confirm that a market was in process of development. Two substantial collections that have survived more or less intact from the late fifteenth century testify to the practice of pasting numbers of prints into books and manuscripts. The first of these was formed by Hartmann Schedel, a medical doctor and author of the *Weltchronik* – a major illustrated book published by Anton Koberger in Nuremberg in 1493. He appears mostly to have acquired prints by artists from the locality, though Dürer is a notable and surprising exception. The other was made by Jacob Rubieri, a much travelled notary born in Parma, who seems mostly to have acquired relatively low-grade images relevant to his travels. What is clear is that patterns of connoisseurship and patronage were changing around 1500, and that the development of the independent print was a factor in the relevant processes. As dealers and the artists themselves travelled between the various courts of Europe, prints were increasingly available to inform an enlarging community of interested parties outside the immediate circle of practitioners. They thus played an important part in narrowing the social and cultural gap between the practical pursuits of the workshop and the sophisticated intellectual interests of the humanist's studiolo. (This is the name given to a small private study often decorated with pictures.)

It is entirely to be expected, then, that the rise of the independent print in the last third of the fifteenth century should have coincided with the beginnings of a non-professional interest in and appreciation for the signs of individuality in artistic production. It is a telling symptom of this development that patrons who might formerly have restricted their interest to end results began to conceive of artist's drawings as objects of value in themselves, and accordingly to collect and to preserve them. In turn, as artists such as

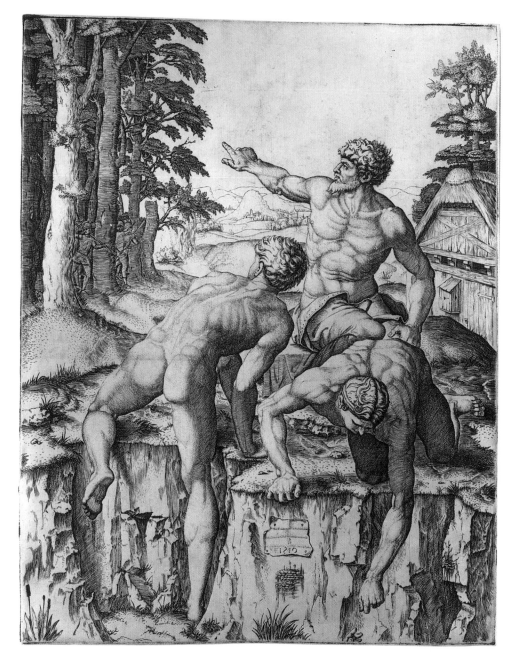

Plate 6.27   Marcantonio Raimondi, *The Climbers*, 1510, engraving, 29 × 23 cm, Metropolitan Museum of Art, New York. Photo: all rights reserved, The Metropolitan Museum of Art. Purchase, Joseph Pulitzer Bequest, 1917 (17.50.56).

Schongauer, Mantegna and Dürer devoted to the production of prints the same level of skill and attention as might be required in the execution of small panel paintings, engravings also began to be prized and collected by interested humanists and others outside the circle of fellow artists.

It has to be emphasised, however, that whereas artists tend to provide evidence of their print collecting through emulation and quotation, information about specific acquisitions is rarely available for collections made by amateurs before the second quarter of the sixteenth century. On the other hand, strong evidence of the status

potentially accorded to engravings is provided by a letter from Mantegna to the marquis Francesco Gonzaga on 21 December 1491. It concerns a 'small picture' (*quadretino*) that the artist had given him and that the marquis had then in turn presented to a contact in Milan:

> Having heard that your Excellency has sent the small picture to Milan, I am sending another, since I have the plates [*stampe*] to produce others in honour of the Virgin Mary.[25]

If it can reasonably be inferred that the original 'small picture' was an engraved image, what is implied is, first, that a print by Mantegna

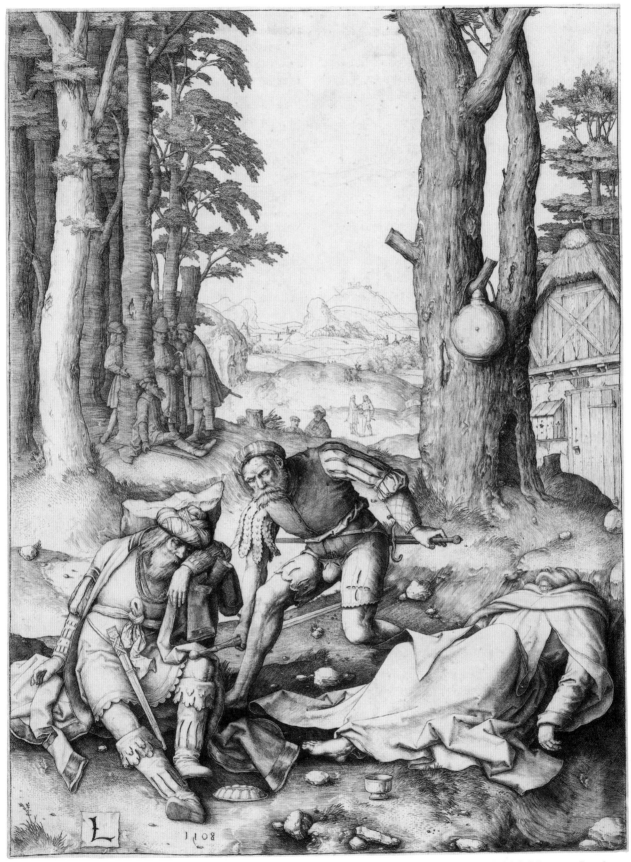

Plate 6.28   Lucas van Leyden, *Mahomet and the Monk Sergius*, 1508, engraving, 29 × 22 cm, British Museum, London.
Photo: © The Trustees of the British Museum.

– possibly the image of the Virgin and Child reproduced here (Plate 6.22) – was considered as a suitable gift not only *for* but *from* a person of the standing of Francesco Gonzaga and, second, that the marquis was not likely to be offended by being offered a repetition of the same image.

# 7 Invention and reproduction

The comparison of Dürer's woodcut and Marcantonio's engraving at the beginning of this chapter left a significant question to be addressed. It concerns the latter's motivation. Why should the Italian engraver have devoted such time and care to the copying of woodcuts by the German artist? It is easy enough to accept that he would have been impressed by Dürer's work and that he might have made a copy or two to familiarise himself with the character and intricacies of his style. This is indeed how Vasari represents the matter, in the text cited previously:

> Stupefied by Dürer's manner of working, he spent almost all the money he had brought from Bologna on these prints ... Considering how much honour and usefulness one would be able to acquire if he devoted himself to that art in Italy, Marcantonio turned his attention to every detail of those prints in all diligence, and thus to copying Albrecht's prints, carefully studying stroke by stroke how the whole of the prints he had bought had been made.[26]

But *The Angel Appearing to Joachim* is only one of 17 images that Marcantonio copied from Dürer's series on the life of the Virgin. If his aim was to learn the secrets of the other artist's technique and invention, he was being thorough to the point of obsession. Some idea of the investment of time involved may be gained from a surviving contract signed with the engraver Bernardo Prevedari (1439–1554) for a print to be made in Milan after a drawing by the architect Donato Bramante (c.1443/4–1514) in 1481 (see Plate 6.29). A substantial fee was promised to Prevedari on the understanding that he would work on the plate 'day and night' and that it would be completed within two months.[27] The work in question was unusually large by the standards of the late fifteenth century, but even the smallest of compositions might take a week to engrave. Marcantonio was to be responsible for a large workshop in Rome from which almost 1,000 engravings issued in the course of some 15 years, but it has been estimated

that in the course of his busy career as a full-time printmaker he averaged no more than ten plates a year from his own hand. Dürer probably averaged fewer than four, though we should bear in mind that he maintained a highly successful career as a painter and designer of woodcuts.

Should it be assumed that Marcantonio was simply acting as a pirate, as Israhel van Meckenem is sometimes supposed to have done, and that his aim was to pass Dürer's designs off as his own? That suggestion seems inconsistent with the fact that he included Dürer's signature in his first copies. Vasari's account implies, rather, that Marcantonio aimed to profit from the fact that the German artist's works 'were highly regarded for their novelty and their beauty, so that everyone sought to have them',[28] and thus to pass his own work off as the other man's. He further records that Dürer saw copies of Marcantonio's versions, and that he travelled to Venice expressly to bring a suit against the Italian. 'However,' Vasari concludes, 'he got nothing but the sentence that Marcantonio could no longer add the name or monogram of Albrecht to his works.'[29]

There can be no doubt both that Marcantonio responded early to Dürer's work and that he was assiduous in copying it. His own version of the *Life of the Virgin* appeared *before* Dürer had completed and published the full set of 20 woodcuts. It is also true that in 1506 Dürer was in Venice and that he brought an action against the Italian in defence of his privilege. Although the Venetian senate might not have been much impressed by a privilege claimed by a German artist in the name of the Emperor Maximilian, Marcantonio does seem to have been forbidden from signing his later versions with the German artist's name. Thus, where the initials 'AD' appear in the tablet at the bottom right-hand corner of Marcantonio's *The Angel Appearing to Joachim*, in his later versions of Dürer's compositions the tablet is either left empty or bears the legend 'MAF', for 'MarcAntonio Fecit'.

Vasari's evidence should nevertheless be treated with some caution. Written some time after Marcantonio's death, his account encourages us to imagine a possibly hot-headed young Italian excited by the originality and evident accomplishment of Dürer's work and moved to speculative adventure, to the development of comparable skills, and to profit at the other artist's expense. But by 1506 Marcantonio was at least in

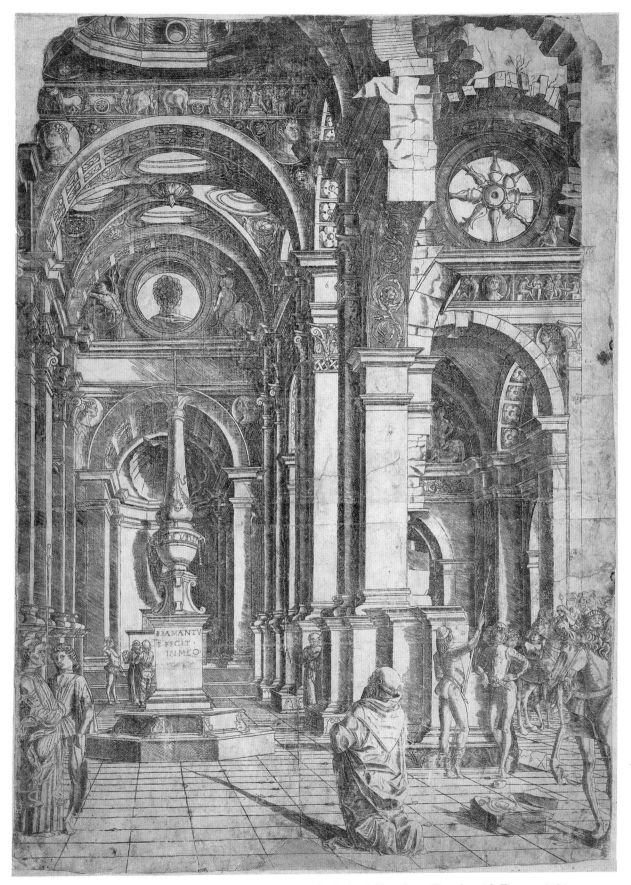

Plate 6.29    Bernardo Prevedari, after Bramante, *Interior of a Ruined Church, or Temple, with Figures*, 1481, engraving, 71 × 51 cm, British Museum, London. Photo: © The Trustees of the British Museum.

his mid-twenties (his date of birth is not clearly established) and had already served a considerable apprenticeship. Dürer was certainly assiduous in the pursuit of his own interests, though if he complained about the use made of his work by Italian artists, the complaints were not unmixed with pride at the recognition that such usages implied, while he himself drew freely on the work of Italian artists that he had seen on his first voyage to Venice in 1494–5. He may actually have been more concerned with the authenticity of his work and with his status as its originator than he was with controlling the distribution of the images in question. It seems to have been generally accepted both by artists and by those who regulated their practices that the *imagery* of prints might circulate in a kind of public freehold.

As for Marcantonio, he may have been less concerned to exploit the cachet of Dürer's authorship than to provide a series of high-grade images of the life of the Virgin from which multiple copies could be made. It has recently been claimed by Lisa Pon that the copies Marcantonio made of Dürer's illustrations to the *Life of the Virgin* were actually published – and presumably financed at least in part – by Niccolò and Domenico Sandri dal Jesus. These Venetian brothers were responsible for the production and sale not only of books concerned with the lives and teachings of the saints, but also of devotional images of the kind that had been made mostly in woodcut for over a century.[30] The suggestion is that the attraction of the project to the brothers lay less in its pirating of Dürer's style and invention than in its use as ready-made illustration to a religious narrative.

This is of course not to rule out the possibility that Marcantonio was independently motivated by interest in the German artist's work. He was certainly not discouraged by Dürer's action from making engraved copies after his work. Altogether he was to issue 74 engravings based on the German artist's prints. The one conclusion that can safely be drawn is that Marcantonio saw himself from the first not, like Dürer, as an *inventor* of pictorial images, but as a skilled agent of their interpretation and dissemination. I suggested earlier that the development of engraving in the later fifteenth century was largely driven by artists who engraved their own designs. Working in the first three decades of the sixteenth century, Marcantonio did more than

any other printmaker to contradict this tendency. But he was neither a straightforward copyist nor a dealer in plates engraved by others. He was the first fully *professional* engraver. His qualifications for this original career – and the impetus that drove it – are to be found in his combining of two abilities, each exercised at a high level: he had a discriminating eye for the work of others, and he brought both method and imagination to the representation of this work in printed form.

In fact, Marcantonio's response to Dürer's work in 1506 may well have been a factor not simply in defining his own vocation but in establishing a certain dependent function for the engraved image. It is certainly the case that from that point on the vitality of Marcantonio's business would depend upon a ready supply of original graphic images by considerable artists. Continuing as he did to draw upon the German artist's output, he was to be highly instrumental in the assimilation of Dürer's oeuvre by Italian artists of the sixteenth century. As suggested earlier, his print *The Climbers* (Plate 6.27) provided one articulate demonstration of how graphic resources from north and south might be fruitfully brought together. No one did more than Marcantonio to extend the *currency* of High Renaissance pictorial style at its most accomplished. After about 1510, when he settled in Rome, he was to establish a practical relationship with another of the most celebrated artists of the time. It was principally through the medium of Marcantonio's prints – engravings that were repeatable, easily transportable and relatively cheap to acquire – that the distinctive character of Raphael's graphic style was conveyed during the sixteenth century throughout Christendom and beyond.

A note of caution should be entered here. Marcantonio has been widely seen as establishing the technical apparatus of the reproductive engraving – a vocabulary of hatching and shading and dots and flicks by means of which heightened effects of modelling could be brought to the transcription of drawings, and a wide tonal range and variety of texture used as suggestions of the colour of paintings and the character of brushwork. It should be noted, however, that it was not until some time after the death of Raphael in 1520 that any reproductive prints were actually made after paintings, and not until the development of substantial print-publishing businesses some 30

years later that reproductive prints after paintings were issued in any quantity. The many engravings that Marcantonio made after Raphael and his school were based more or less closely on drawings that must have been made available to him, and that were not necessarily complete in all the details shown by the resulting prints. These were in a very real sense collaborative exercises, in which the engraver had a distinctive contribution to make to the character of the composition as printed. It is a paradoxical consequence of this collaboration that among its most remarkable outcomes are works, like *The Judgement of Paris* (Plate 6.30), for which no full compositional studies survive, so that in such cases the presumed accomplishment of Raphael's invention is recoverable *only* through the articulate medium of Marcantonio's engravings.

Where there are surviving drawings by Raphael that clearly relate to engravings by Marcantonio, the impression the evidence gives is by no means of the complete subordination of engraver to artist. It seems clear, on the contrary, that the distinctive competences of both parties were exercised in what

was clearly a highly fruitful working relationship. The most notable instance is provided by a composition on the Massacre of the Innocents which has been much studied.[31] It is recorded in a number of surviving drawings by Raphael and his workshop – ranging from preliminary figure sketches to carefully worked compositional studies – and in two engraved versions by Marcantonio, both of which are oriented in the same direction as the drawings, suggesting that the engraver may have traced an original composition. Both complete the scene with detailed background material missing from even the fullest studies attributed to Raphael (see Plates 6.31 and 6.32).[32]

It is argued by Landau and Parshall that the engraved compositions are derived from a complete drawing by Raphael that has not survived – and that was perhaps destroyed in the process of transcription.[33] There are two reasons for rejecting this argument, however. The first is that there are significant variations between Marcantonio's two engravings, which are known as 'with fir tree' and 'without fir tree', in recognition of the most

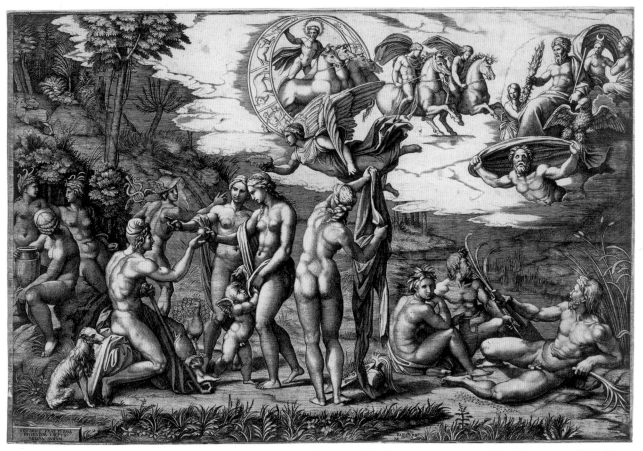

Plate 6.30 Marcantonio Raimondi, after Raphael, *The Judgement of Paris*, c.1515–20, engraving, 30 × 44 cm, British Museum, London. Photo: © The Trustees of the British Museum.

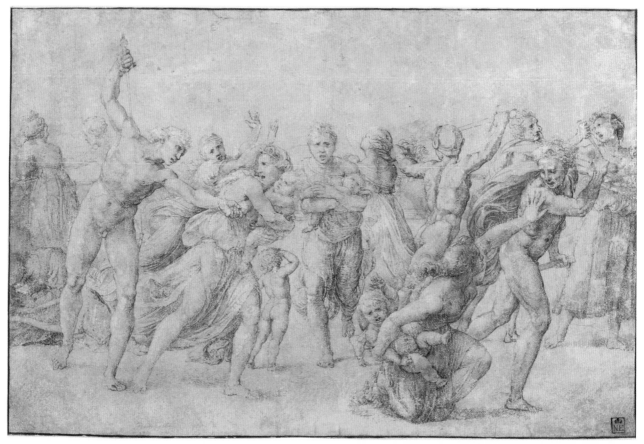

Plate 6.31   Raphael or workshop, study for *The Massacre of the Innocents*, c.1510, pen and ink, 27 × 40 cm, Szépmüvészeti Múzeum, Budapest. Photo: András Rázsó.

conspicuous differences. The second is that it seems simply unnecessary to posit the existence of a complete drawing for Marcantonio to follow. It is evident both that he was quite capable of providing an appropriate background from his own resources, and that there is no strong reason to believe that his working relationship with Raphael was such as to prevent his exercising a degree of initiative. That relationship must have been based on a considerable degree of mutual reliance and trust. While the highly employed Raphael could have had no time for the business of engraving, even had he had the inclination, there was no question of the engraver claiming credit for what he had not himself produced. In the empty pedestal near the left-hand edge of the print Marcantonio's monogram appears beneath a clear acknowledgment of the other artist's invention of the composition: 'Rapha[el] Urbi[nas] inven[it]'. In the case of Marcantonio's engravings after Raphael, the status of the artist as inventor seems in most cases to have been reinforced in the ownership of

the plates. A substantial number of these were held by Raphael's agent, il Baviera.

An interesting footnote will serve to conclude this discussion – and to close the loop opened by the comparison with which this chapter commenced. The artist Tommaso Vincidor (active 1517– c.1534/6) was a minor member of Raphael's workshop who travelled to Flanders in 1520, where he met Dürer. On hearing from Vincidor of the death of Raphael, which occurred in that year, Dürer offered to exchange copies of his own entire graphic production for a set of prints in which Raphael's designs were recorded.[34] The implication is that he regarded these designs as indispensable contributions to the common and developing graphic resource upon which he and others would draw. It may safely be assumed that a significant number of the prints that Dürer thus aimed to acquire had been engraved by Marcantonio Raimondi.

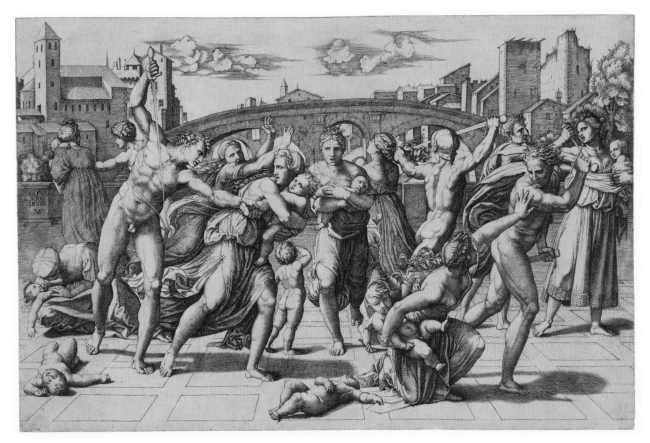

Plate 6.32   Marcantonio Raimondi, *The Massacre of the Innocents* (without fir tree), *c.*1513–15 or after 1520, engraving, 28 × 43 cm, British Museum, London. Photo: © The Trustees of the British Museum.

# Chapter 7
# introduction

There is a certain logic in the fact that treatises on art began gently to proliferate in the fifteenth and early sixteenth centuries during the same period that the nature of artistic activity came under renewed scrutiny alongside a complementary literary Renaissance. Evidence that methods of training artists really did change in response to a more theoretical agenda and the availability of treatises is more elusive. The first official art academy was founded only in 1563 in Florence and, even then, practical workshop-based training continued to be the norm in many parts of Italy, let alone in Europe as a whole.

If the number of surviving manuscripts is an indication of how important a treatise was, in most cases it must be deemed slight, but rates of survival are in fact very difficult to interpret. Only one copy of Ghiberti's *Commentaries* survived for posterity, yet Vasari appears to have drawn information for his *Lives* from a fuller version, suggesting that there was at least one other copy in circulation from 1450 to 1550. Alberti's treatise *On Painting* has survived in 20 Latin manuscripts and only 3 Italian. Does this suggest that of the two it was the Latin version that was the more important, or simply that artists to whom the Italian version was directed transmitted its contents orally or wore their copies out through frequent use, while patrons preserved their Latin copies in their libraries? Such uncertainties make it no easier to establish the importance of treatises and artists' biographies to the making of Renaissance art.

Whatever the questions over circulation and influence, the number and geographical diversity of the treatises – whether biographical histories or theoretical writings – brought together in this chapter by Catherine King are impressive, and together they bear witness to a discernible trend in literary reflections on the activity of making Renaissance art. Even the latest mentioned predates the first edition of Vasari's *Lives* by more than two decades, and the earliest predates it by some 150 years. Even today, the Renaissance tends to be viewed partly through the eyes of Vasari, but his work was in fact part of a long history of writing about art, whether by artists like himself or members of the literate classes for whom art had evidently become an increasingly intellectually respectable topic of debate.

While most of the authors in this volume – with the benefit of hindsight – are cautious about the concept of a decisive change in artistic practice over the Renaissance period, the fifteenth- and early sixteenth-century commentators on art that Catherine King discusses in her chapter seem to have been in no doubt that they were witness to a revival in the making of works of art, and that this revival encompassed painting, sculpture, architecture and even printmaking. Most of all, the writings examined in this chapter show that at least some makers of Renaissance art had attained sufficient status for their names, and sometimes their lives and achievements, to merit recording for posterity.

*Kim W. Woods*

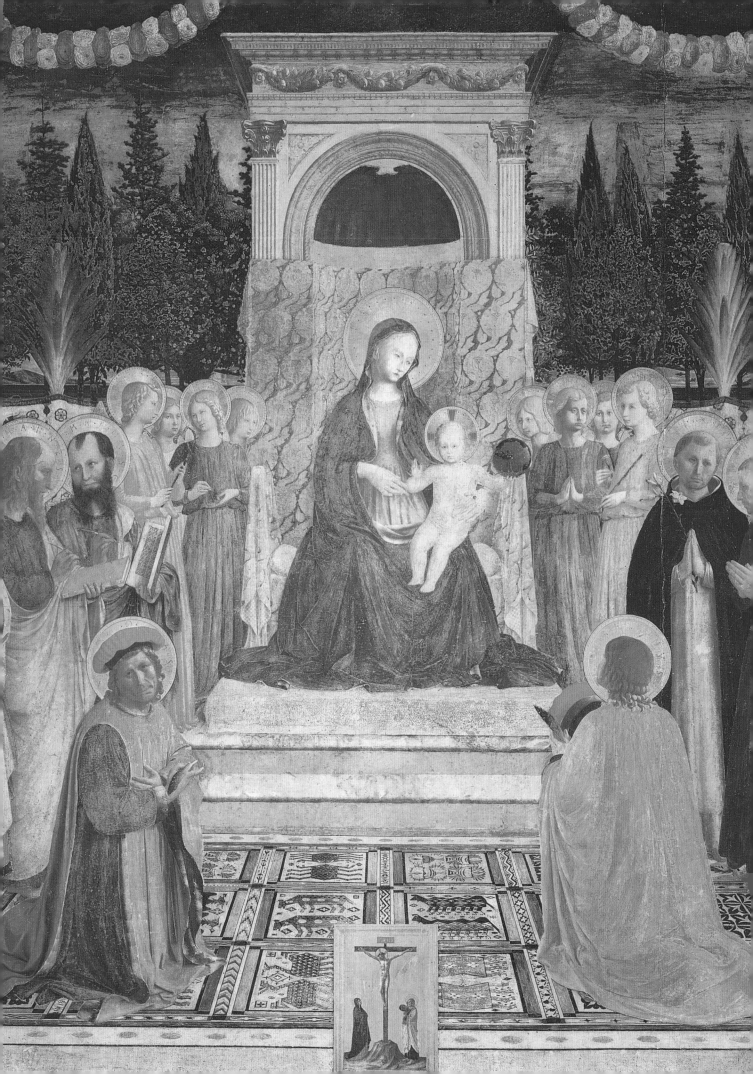

# Chapter 7

# Making histories, publishing theories

*Catherine King*

If the painter wishes to see beauties that charm him it lies in his power to create them, and if he wishes to see monstrosities that are frightful, buffoonish, or ridiculous, or pitiable, he can be lord and God thereof; and if ... he wants valleys, if he wants from high mountain tops to unfold a great plain extending down to the sea's horizon, he is lord to do so.[1]

With these words, written around 1490, Leonardo asserted the supreme creative power of his art as part of a debate on the rival merits of painting and poetry. Such interest in recording one's theories marks a significant shift towards more literate practices among artists. During the period *c.*1420–*c.*1520 some artists and architects began to write more frequently about their arts, and numerous scholars joined them in this enterprise.[2] Their texts included self-standing treatises devoted to painting, sculpture or architecture, or to techniques such as linear perspective. Guidebooks to cities also began to include reference to the visual arts or architecture, and biographies of rulers started to describe their artistic taste along with their military or political achievements.

Manuscript circulation was characterised by writers producing polished versions of their texts, often sending them with fulsome dedications to powerful patrons. The author might have copies made to send to other influential people. Although it was prestigious for the owners of libraries to make their manuscripts available to a select public, their circulation was relatively limited. For example, only 20 Latin manuscript versions survive of Alberti's 1435 treatise *On Painting*, ten of which date from the second half of the

fifteenth century and the others from the sixteenth century.[3] The development of printing from the 1470s meant that larger numbers of books became available, although the sizes of editions were still only in the hundreds. And despite the advent of printing, people continued to consult manuscripts throughout the sixteenth century.[4]

Were such texts as important for artists as for patrons and viewers? Was it a 'top down' shift initiated by patrons and scholars, or was it a 'bottom up' development fuelled by artists themselves? Could the presence of written histories and theories of art change artists' identities: the ways they saw themselves and were seen in professional, social and intellectual terms? How, if at all, did this growth in publicising theory, recording histories of art and commemorating artists change the practice of art and architecture? Did the appearance of buildings, paintings or sculptures change in response to the increase in book circulation and in publication on artistic matters? This chapter will present the evidence we possess in order to try to answer these questions.

## 1 The partnership between writing histories and composing treatises

### Education and the communication of ideas

Whereas those with university education or access to scholarly tutors wrote and read Latin with some competence as well as the vernacular, the

Plate 7.1   (Facing page) Fra Angelico, detail from the San Marco altarpiece (Plate 5.28).

education of painters, sculptors and architects was often confined to primary level and finished at about the age of 11. This gave them literacy in their vernacular language, numeracy and, infrequently, some acquaintance with Latin. Artists might cultivate forms of oral learning. For example, Ascanio Condivi, the approved biographer of Michelangelo, reported that his hero knew long passages of Dante's *Divine Comedy* and the Bible by heart.[5] Some artists – such as Brunelleschi, who was originally destined to be a notary – were educated beyond primary level and knew Latin, arithmetic and geometry. Artists could be informed by scholars concerning the contents of Latin texts. Ghiberti displayed knowledge of the Latin text of Vitruvius' *Ten Books on Architecture*, and it has been surmised that the scholar Niccolò Niccoli may have informed him of its contents. The manuscripts of Leonardo show knowledge of Latin and vernacular texts, whether through reading (he set out to teach himself Latin to some degree) or being informed by scholars in his circle.[6] Among the inventories or wills listing artists' possessions, we find both examples in which no books are mentioned – such as the estate of the Netherlandish painter Dieric Bouts in 1475 – and instances where many are listed, such as that of the Florentine sculptor Benedetto da Maiano (c.1442–97) in an inventory dated 1498.[7]

## Communicating orally, in visual images and in writing

Increasing literary publication joined the two other ways of transmitting ideas about art which had always existed: that is to say, talking about artistic matters and demonstrating new aims and methods in completed art works. The importance of oral histories of art is suggested by the way in which Vasari relied in his *Lives* on what was recalled as well as what was documented. His information on Luca Signorelli and Piero della Francesca was partly derived from his father Lazzaro Vasari, who knew both men.[8] There are glimpses of conversations in records of artists being asked to rehearse the merits of different schemes for patrons. In 1388, for instance, a group of Sienese artists – including woodworkers, painters, stoneworkers, a glassworker, goldsmith and clockmaker – were invited to advise on the merits of two designs for choir stalls, one on a panel and one on a drawing, so as to inform the verdict

of those in charge of the building and decoration of Siena Cathedral.[9] In Chapter 4, Tim Benton considered several debates about design principles with regard to building strategies for Milan Cathedral. Records also survive of the debate by a group of invited artists in 1504 concerning the best place for the government to position Michelangelo's *David* on the Piazza della Signoria in Florence.[10]

Ideas also travelled with artists. For example, Donatello's period of working on the high altar of Sant'Antonio in Padua in the mid-fifteenth century seems to have provided an opportunity for him to transmit ideas about the new perspectival constructions developed in Florence to Paduans such as Francesco Squarcione and Andrea Mantegna (see Plates 7.2 and 7.3). There was considerable geographical mobility and presumably an interchange of ideas about different traditions. In 1508 in Brescia, we find 'Aminadeb,[11] son of the late Master Giovannino from Martinengo' along with 'Master Giovanni from Flanders, master of figured textiles' gathering in the house of fellow painters Gerolimo and Giovanni Romanino to witness the signing of a contract for an apprentice from Parma.[12]

Works of art could also demonstrate different standards and effects. For example, Italian painters such as Piero di Cosimo emulated Netherlandish models for representing landscape which he was able to study in Italy, where there were no Netherlandish treatises to give written recipes or instructions (see Plates 7.4 and 7.5). Artists were skilled at making visual statements about different styles of working. Fra Angelico contrasted contemporary Turkish, fourteenth-century Italian, and recent Florentine approaches to representation in the altarpiece he made for San Marco in Florence c.1438–43 (see Plate 7.1 and Chapter 5, Plate 5.28). The whole scene, which originally had a separate classicising frame, suggests that the painting is a window in the wall, demonstrating the latest illusionistic goals of Florentine painters. The carpet, which is depicted as before the Virgin's throne, displays the interest in the techniques of abstraction valued in expensive textiles from the eastern Mediterranean. The Crucifixion at the centre-base, however, shows another style of representation: the little 'painting within a painting' has the distinctive fourteenth-century features of a gold ground and a frame

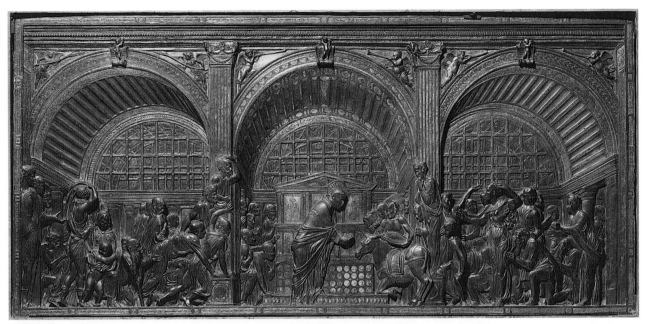

Plate 7.2   Donatello, *Miracle of the Mule*, 1446–50, silver and gilt bronze, 57 × 123 cm, high altar, Sant'Antonio, Padua. Photo: © 1990 Scala, Florence.

Plate 7.3   Andrea Mantegna, *The Crucifixion*, 1456–9, tempera on panel, 67 × 93 cm, Louvre, Paris (originally predella from the San Zeno altarpiece, Verona). Photo: © RMN/Jean-Gilles Berizzi.

Plate 7.4 Piero di Cosimo, *Virgin and Child with Saints Alexandria, Rose of Viterbo, Peter and John the Evangelist*, c.1495–1500, oil on panel, 203 × 197 cm, Galleria dello Spedale degli Innocenti, Florence. Photo: © 1990 Scala, Florence.

which is integral to the panelled surface on which the scene is painted.

The appearance of increasing numbers of texts on art circulated in manuscript and, from the 1470s, in print offered new opportunities to transmit ideas and approaches. Throughout the previous centuries some texts had referred to the visual arts: in technical treatises (like that of Theophilus), in accounts of important buildings, or in theological discussions of the uses of art (for example, by Saint Bernard of Clairvaux).[13] However, an increase in written discourses about the figurative arts and architecture from the 1380s onwards was accompanied by significant changes in the ways paintings, sculptures and buildings were produced and consumed. The growing presence of books about art in societies which associated book learning with leadership in church and state produced literary traditions carrying new authority in which authors could quote precedents or pick up issues for debate introduced by earlier writers and

continue the argument. The production of a series of books about, or referring to, art created certain expectations – written traditions – concerning the kinds of headings under which artists' works might be judged (were they good at perspective or good at colouring, for instance), the favoured terms for discussing art (like 'symmetry' and 'composition'), or what was important about a career.[14] Through book publication, ideas about art could travel across distance and time – and we should not forget that some of these were illustrated. In Chapter 4, Tim Benton described how Matthäus Roriczer, master mason of Regensburg, published in 1486 the trade secrets of proportional calculations using rotated squares in *Das Buchlein von der Fialen Gerechtigkeit*.[15] Procedures relating to techniques of perspective and proportional studies which were previously jealously guarded by guilds and individuals began to be published. In 1505 Canon Jean Pélerin made the rules for drawing accurate perspectival constructions available in French and Latin. By 1508 Gregor Reisch had already pirated

Plate 7.5  Hugo van der Goes, *Saints Catherine, Mary Magdalene and Donors*, right wing of the Portinari altarpiece, *c.*1475–6, oil on panel, 253 × 141 cm, Uffizi Gallery, Florence. Used with the permission of the Ministero Beni e Attività Culturali. Photo: © 1990 Scala, Florence.

Pélerin's Latin text and inserted it into his Latin encyclopaedia, the *Margarita philosophica* or *Philosophical Pearl*. In 1509 the Nuremberg printer Jörg Glockenden purloined Pélerin's diagrams and translated the work into German.[16] Dürer prepared a treatise on human proportion which was published by his widow in 1528. Dürer had tried to learn more about perspective and proportion from secretive Italian colleagues in the 1490s, and had attempted to obtain Jacopo de' Barbari's drawing book on proportions from Margaret of Austria, Governor of the Netherlands, when he visited her collection in 1521, but was told that she had

already promised it to another painter.[17] Guilds and patrons could be 'gate-keepers', but print could offer artistic 'freedom of information'.

## The liberal and practical arts

The world of theoretical treatises and histories belonged to the so-called liberal arts, as opposed to the mechanical arts. The categories originated in the educational vocabulary of both the free and enslaved in Imperial Rome, and had been transposed in medieval and early modern Europe to indicate the gentlemanly classes versus the servants. Hence the liberal arts were fields of knowledge supposedly worthy of a 'free-born' gentleman. The liberal arts were defined as comprising the literate trivium and the numerate quadrivium. The trivium included logic, rhetoric (meaning the rules for writing as well as speaking well) and grammar, while the quadrivium comprised geometry, arithmetic, astronomy and music (entailing not lowly instrumental music but the mathematical theory of music). Liberal arts were claimed to require not only the learning of skill by constant practice – *ars* – but also *ingenium* – that is, the innate personal talent for a profession which some are born with as individuals. Liberal arts were defined as depending on theory – that is, *scientia* – versus mere dexterity. Mathematicians might wield a pen to draw a diagram, but the demonstration of a theoretical proposition was their aim. Practical arts were termed 'mechanical' and considered manual rather than cerebral. Whereas a 'liberal artist' was called 'artist' or *artista* in Italian, a 'practical artist' was called 'artificer' or *artefice*. Even in the *Lives*, Vasari referred to 'painters', 'sculptors', 'architects' and 'artificers', never 'artists'. The Dominican Saint Antoninus, Bishop of Florence (1389–1459), stated that 'the mechanical arts are seven in number: weaving, armature, navigation, agriculture, hunting, medicine and theatre. It is said that a mechanical art is an adulterated form of science rather than a liberal one.'[18]

Throughout the period many held that visual artists and architects who were trained in craft workshops within the guild system belonged to the category of practical arts. Architecture, painting and sculpture were considered to be subsets of armature in Antoninus' list, for it covered the building of everything from ships and fortresses to houses, civic buildings and churches as well as their decoration in painting and sculpture.

Others, however, argued that painting, sculpture and architecture had so much in common with music, geometry and arithmetic that they should be redefined as liberal arts. Comparison was also made with poetry – an art form which was closely related to rhetoric. Writings on art at this period were therefore at the heart of a contest over changes in status.

## Histories and *ingenium*, treatises and *scientia*

The fact that those professing the liberal arts were supposed to demonstrate exceptional personal talents – as, say, distinctive named poets, mathematicians or philosophers – had meant that they automatically qualified as worthy of commemoration in historical accounts of their individual achievements along with other leaders in society. Consequently, when the Florentine scholar Filippo Villani (1325–1405) made the landmark decision to write a series of 35 biographies of famous Florentines around 1380 which included painters, he was asserting a significant shift in attitude. In *De origine civitatis Florentiae et de eiusdem famosis civibus* or *On the Origins of the City of Florence and its Famous Men*, Villani claimed ancient Roman precedent in recording artists among illustrious citizens, and he praised them along with statesmen, doctors of medicine, jurists, orators, astronomers and musicians. He honoured Giotto, including as his followers Stefano, Tommaso di Stefano and Taddeo Gaddi. He began by describing the role of Giotto's teacher Cimabue: 'who with skill and talent began to call back ancient painting to that likeness to nature from which for so long it had wandered and strayed'.[19] Villani stated his view robustly: 'In the estimation of many, and not indeed foolishly, painters are not regarded as of inferior talent with respect to those whom the liberal arts make masters.'[20]

While many treatises on art continued to offer practical instruction on the best procedures and materials following medieval traditions, they also increasingly discussed theories and the 'sciences' governing procedures, as well as comparing architecture and the visual arts to the liberal arts. To the extent that treatises and discussions about art in other literary texts considered general principles rather than recipes for grinding colours, they were redefining painting, sculpture and architecture as cerebral activities comparable with the liberal arts. When the Florentine painter Cennino Cennini began his *Il libro dell'arte* in the 1390s with a theoretical statement about the role of painting in the scheme of the arts and placed it second only to poetry, he too was signalling a challenge to beliefs about the lowly status of his skill. Cennino explained that Adam and Eve had invented the earliest practical skills in digging and spinning, and that afterwards other occupations were pursued which were more worthy since they were theoretical. In between the practical and theoretical came

> painting, which requires the exercise of fantasy and manual skill … and it was reasonable that it merited being placed to sit in second place to theory and to be crowned beside Poetry. This is because the Poet, given that he partakes of some theoretical knowledge, has the status and freedom to be able to compose and put together as he pleases according to his will. In just the same way the painter is given the freedom to be able to compose a figure upright, or seated, half man, half horse, just as he pleases, following his fantasy.[21]

Cennino was quoting the Roman poet Horace in his *Ars poetica* or *Art of Poetry*, who had compared poetry to painting on the basis that both were free through their fantasy to conjure up anything, whether with words or visual images. The term *fantasia* was chosen because it was considered that the brain employed imagination to conceive of things which could exist in the real world (i.e. human figures), while fantasy invented things which did not actually exist and made them appear plausible by combining features of reality (i.e. a centaur made from bits of horses and people).[22] Cennino emphasised the cerebral side of painting – 'the intellect will take delight in drawing'[23] – and stressed the social status possible for panel painters: 'doing a panel is really a gentleman's job, for you may do anything you want to with velvets on your back'.[24] Theorising and history writing were therefore complementary activities in easing the visual arts and architecture towards loftier status. I shall now consider the ways in which fifteenth- and early sixteenth-century scholars and artists presented the history of recent art.

## 2   Commemorating artists

Only seven artists recorded the earliest 'histories of art', and only one of their accounts was printed.

The historians were mostly scholars holding respected positions: bishops, canons, friars, priors, university professors or government officials. So art histories tended to derive from the educated elite. The fact that many texts were dedicated to powerful patrons suggests that commemorating artists met the approval of leaders in society. A small majority of the texts were written in Latin, and therefore for erudite readers who might be in charge of or advise on commissioning works of art. However, a large minority were written in the vernacular – a few in French and the rest in Italian – so these texts could reach literate viewers, patrons who were not Latinate, and artists. It seems, then, that this process was more 'top down' than 'bottom up' but that attention was paid to communicating to vernacular readers. Consequently, written histories had the potential to change the way many regarded artists. Not surprisingly, historians often transposed literary conventions from the traditions for commemorating artists of ancient Greece, rulers, poets and philosophers, as well as occasionally inventing fresh approaches to fit their new subjects.[25]

The earliest texts derived from Florentine writers and date from the late fourteenth century. Florentines continued to celebrate their prowess and that of ancient Greek and Roman artists during the fifteenth and early sixteenth centuries. These histories were joined from the mid-fifteenth century by Italian writers from other areas of the peninsula who praised the skills of Italian artists in and outside Florence and in the Netherlands in a more even-handed manner. From around 1500, writers from France and Germany started to publish their views on ancient and recent art history. French writers extolled artists from Italy, France, the Netherlands and Germany, while the German writers tended to laud German artists; both praised ancient Greek artists. Many texts are brief and list artists with a few words of commendation, but this period also saw the earliest autobiography (by the sculptor Ghiberti c.1450) and the earliest full-length biography of an artist (by Antonio Manetti for the architect Brunelleschi c.1480), in contrast to Villani's previous brief if significant 'thumbnail' biographical sketch of Giotto.

The majority of authors were Florentines, yet by the end of this period readers could find texts written from a range of locations commemorating artists from Italy, France, the Netherlands and Germany. While some writers claimed the pre-eminence of one artist (Leonardo, Mantegna and Dürer were candidates), others assumed that different artists might be equally excellent in different ways. It is important to emphasise the existence of this diversity by the 1520s, because there is an anachronistic tendency to view the period through the lens of Vasari's account in the *Lives*, which claimed the unchallenged pre-eminence of Florence and proposed one artist – Michelangelo – as superior in quality to all the rest.

## Florence c.1380–c.1480

As stated above, the earliest histories consisted of brief commemorations by Florentines of a handful of Florentine artists recorded between the late fourteenth and mid-fifteenth centuries. Writers presented recent artistic change in optimistic terms as having revived the standards of ancient Greek and Roman art, and quoted ancient precedents for commemorating the lives of artists in literary texts. Parallels were drawn between art and a revival in literature, and achievements were represented as reflecting civic prowess. The trends in scholarship that have been labelled as 'humanist' had their parallels here in 'artistic humanism'. By comparison, 'Gothic' or 'German' transalpine styles and 'Greek' eastern Mediterranean modes were claimed to be in decline.

As the founder of post-antique European art history, Villani introduced many of the themes and approaches which were reiterated in successive texts. First, there was the use of the 'thumbnail' biography – in his case of Giotto – and the stress on individual inventiveness. Villani also employed the image of a revival of art through Giotto, which he compared to a renewal of literature in the poetry of Dante – both of whom had revived the standards of ancient Rome. Villani considered that ancient writers provided the precedent for treating artists as worthy of commemoration and claimed that, after Cimabue, 'Giotto was not only comparable to the painters of ancient times in illustrious fame but was their superior in skill and personal talent. He restored painting to its pristine dignity and greatest renown.'[26] We glimpse the way artists saw the triumphant beginnings of their new artistic tradition when in his introduction Cennino explained that Giotto had 'changed the profession

of painting back from Greek to Latin'. For him, then, medieval painting was associated with recent Greek – that is, Byzantine – styles, and the new art recalled the good standards of the Roman Empire in Italy.[27]

Villani had been praising painters who had flourished more than 50 years before he wrote as well as their followers who were his contemporaries. Writers in early fifteenth-century Florence followed suit. The Florentine civic official and historian Matteo Palmieri (1406–75), in his *Della vita civile* or *On Civil Life* (1435), described in Italian how the Florentine scholar and chancellor Leonardo Bruni had 'restored to men the sweetness of the Latin language'. In the same way, Giotto had renewed painting when it was dead, which had since become excellent 'either through the grace of God or through industry'.[28] Comparing the revival of painting with that of Latin scholarship was even more prestigious than comparing it with the renewal of Tuscan verse. Alberti's Italian *Della pittura* (1436) described his delight in seeing the art of his contemporaries – Brunelleschi, Donatello, Ghiberti, Luca della Robbia and Masaccio – as 'talents worthy to rank with ancient artists and the more laudable since they had no good teachers or models to help them'.[29]

In the next phase of the histories of art, writers experimented with biography and autobiography, and related the story of revival to the progress of sculpture and architecture as well as that of painting. It fell to Ghiberti around 1450 in his *Commentaries* to write the first surviving autobiography of an artist in the European tradition as well as the most detailed account to date of the rise and fall of ancient art and the recent Tuscan revival (Plate 7.6). Ghiberti quoted the (erroneous) precedent that the ancient Greek sculptor Phidias had composed 'Commentaries' (Ghiberti called him 'Pytios'). He may also have heard of the *Commentaries* of Julius Caesar, which had recounted his military exploits. Ghiberti's autobiography is in one sense an extension of the habit of keeping *ricordi* or 'family histories', which Florentine patricians wrote at this period.[30] However, it is one of a three-part treatise which seems to have aimed at a wider public than his family workshop, because it begins in Part One with a short history of ancient Greek art and ends in Part Three with a dissertation on optics. The manuscript is known in one unfinished draft

so its circulation was minimal. Nevertheless, it represents the earliest discussion in some – if garbled – detail of the development of ancient art, about which Ghiberti appears to have been informed second-hand by a scholar who retailed to him elements of Pliny the Elder's *Natural History*. In Part Two Ghiberti turned to recounting his own career, prefaced by a survey of the history of

Plate 7.6  Lorenzo Ghiberti, portrait signature from the east doors of Florence Baptistery, *c*.1447–8, fire-gilded bronze, Opera del Duomo, Florence (positioned by the inscription of his authorship on the door frame). Photo: © 1990 Scala, Florence.

The inclusion of a portrait signature is a highly traditional addition dating from antiquity so it was not innovative, except insofar as the realism of the self-portrait may have indicated Ghiberti's worldly fame rather than the artist's expectation of earning reward for his work in heaven.

art in Florence and Siena during the fourteenth century; he included praise of the sculpture of Master Gusmin of Cologne for the Duke of Anjou in the early fifteenth century (see Chapter 3, p.109). Significantly, as a sculptor, he widened Villani's focus on a revival of painting to present a parallel revival through the sculpture of Nicola Pisano (c.1220–c.1284) and his son Giovanni (c.1245–1319). Ghiberti narrated his own early struggles and his great works for the baptistery, giving details largely of their subject matter. These histories present an artist working in a highly self-conscious way with a sense of ancient and contemporary precedent and his role in further progress. The ancient Greek artists such as 'Ulixe di Macedonia' are represented as intellectuals: 'learned in letters and especially in arithmetic and geometry', while Apelles 'composed books which he published containing the doctrine of the art of painting'.[31]

Three decades later, the first lengthy biography of an artist in the European tradition was written on the Florentine architect Filippo Brunelleschi. The unfinished life, which has survived in three manuscripts, has been attributed to the amateur architect and mathematician Antonio Manetti. Manetti's biography showed that Brunelleschi had done for architecture what Giotto and Nicola Pisano had done for painting and sculpture. As well as recounting the history of Brunelleschi's buildings, Manetti provided a brief history of the development of architecture which suggests knowledge of Vitruvius' *Ten Books on Architecture*. From pristine beginnings in thatched huts via the grand works of the Egyptians and Assyrians, architecture had achieved success in the Greek republics because of the 'great talents and judgement of the most worthy men'.[32] After a period of prosperity in the Roman Empire, it had declined under the weight of barbarian invasion, had been briefly revived by Charlemagne initiating the Romanesque style following ancient models, but had then reverted again in adopting the Gothic: 'the German style gained strength and lasted until our century, up to the time of Filippo'.[33] Brunelleschi is represented as a respected professional who undertook research to seek solutions to architectural problems by studying the architecture of ancient Rome, 'so great was his desire for honour and excellence and the glory of his personal talent'.[34]

Ghiberti and Manetti strengthened the nascent traditions of 'art history' both by trying out biographical models and by confirming the notion of revival: Giotto is now joined by Nicola Pisano, his son Giovanni, and Brunelleschi. Manetti's interest in updating these developing traditions is suggested in a further manuscript written between 1494 and 1497 and attributed to him: *XIV uomini singhularii* or *Fourteen Famous Men*. This provided an Italian translation of Villani's biographies of famous Florentines and added 14 more recent citizens, most of whom were painters and sculptors.[35] These artists were praised along with scholars, the most prestigious of whom were chancellors of Florence: Leonardo Bruni and Poggio Bracciolini.[36]

The *Trattato di architettura* or *Treatise on Architecture* (c.1461–4) by the Florentine sculptor and architect Filarete shows that Manetti's view of a revival of architecture was shared. The treatise purported to tell Francesco Sforza – Filarete's original patron in Milan – about the excellent architects of ancient Greece and Rome which current patrons should be emulating. He explained that there had been a long period of decline in the theory (*scientia*) of building because of the barbarian invasion of the Roman Empire, as a result of which German and French architects had worked in 'the modern mode' making buildings like incense burners and tabernacles. Only recently, around 1400, had there been an improvement in learning since Brunelleschi had 'revived in our city of Florence the antique way of building'.[37] Filarete mentioned numerous ancient artists derived second-hand from Pliny the Elder and, suppressing his Florentine allegiances somewhat for the benefit of the Milanese ruler, spoke of many contemporary artists who might be called to work at Sforzinda from 'Italy, France, Germany – so many masters from so many places'.[38]

There had been considerable interest in the ancient Greek and Roman artists described by Pliny the Elder in his encyclopaedia, the *Historia naturalis* or *Natural History*. For example, in his praise of famous women, *De mulieribus claris*, written between 1360 and 1374, the Florentine poet, scholar and storyteller Giovanni Boccaccio (1313–75) had included the Roman artists Cyrene, Thamar and Marcia mentioned by Pliny. This text circulated in manuscript in Italian and French, and went through many editions following the first

printing in 1473. In the late fifteenth century the Florentine scholar Cristoforo Landino (*c*.1424–98) compiled the first printed edition of the *Historia naturalis* in Italian (Venice, 1476).[39] Although the Latin text of the *Natural History* was relatively well known in manuscript (and from 1469 in print), making a vernacular printed version available of this key history was an important step. (Landino announced that he had translated the Latin into 'Florentine', not into 'Italian'.) Italian artists could now read the sole surviving substantial account by a classical writer of ancient Greek and Roman art. An anecdote by the sixteenth-century Florentine sculptor Francesco da Sangallo measures something of the impact of Landino's translation. He recalled how in 1506 in Rome he rode on his father's shoulders when they went with Michelangelo to the excavations in the ruins of the palace of Titus to identify a large statue (Plate 7.7). In his memoir it was his father Giuliano, a Florentine architect, who said:

> 'This is the Laocoön of which Pliny speaks.' The opening was enlarged so that it could be taken out, and after we had sufficiently admired it, we went home to breakfast.[40]

Pope Julius II bought the statue and placed it in the Vatican palace.

Landino also has the distinction of having recorded in print a repertoire of critical terms for differentiating the styles and working practices of Florentine artists of his day. In the preface to his edition of Dante's *Divina Commedia* (Florence, 1481), Landino surveyed the history of art from ancient Egypt to Greece and then Rome, relying on Pliny's *Natural History*. Having lamented the decline of art, he then recounted its revival following the narrative of Villani. Landino ended by praising the painters and sculptors of his time from Masaccio to Antonio and Bernardo Rossellino (Plate 7.8). Landino recorded a wide critical vocabulary for differentiating the distinctive skills and interests of artists. Some categories have to do with achieving realism (such as the ability to convey three-dimensionality or 'relief'), but other criteria relate to artists' ways of working (with 'facility' or 'promptness' – a ready flow of ideas), the kinds of compositions they produce ('charming' or 'unadorned'), their skills in drawing or colouring, and whether they like demonstrating the virtuoso resolution of difficulties, such as feats of foreshortening.[41]

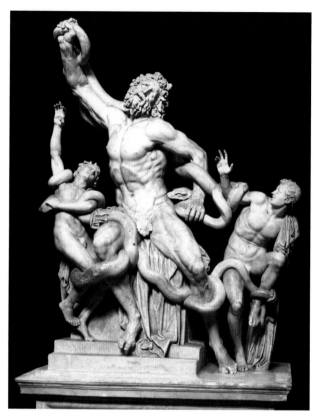

Plate 7.7   Hagesander, Athenodorus and Polydoros of Rhodes, *The Death of the Priest Laocoön and his Sons*, first century BCE, marble, height 242 cm, Vatican Museums and Galleries, Vatican City. Photo: Bridgeman Art Library/Alinari.

Florentines continued to play an important role in the second half of the fifteenth century with the scholar Alamanno Rinuccini (1426–99) reiterating the idea of the progress of Florentine art since the time of Giotto as the triumph of realism. In the preface to his 1473 Latin translation of the Greek *Life of Apollonius of Tyana* by Philostratus, he wrote:

> The arts of sculpture and painting, graced in earlier times by the talents [*ingeniis*] of Cimabue, of Giotto and Taddeo Gaddi, have been carried to such greatness and excellence by painters who flourished in our own age that they may well deserve to be mentioned beside the ancients. Nearest to our own period there is Masaccio, whose brush could express the likeness of anything in nature.[42]

Rinuccini proceeded to praise the painters Domenico Veneziano, Filippo Lippi and Fra Angelico, the sculptors Donatello, Ghiberti and Luca della Robbia, and the architect Brunelleschi. He ended by commemorating Alberti as a writer on architecture and painting.

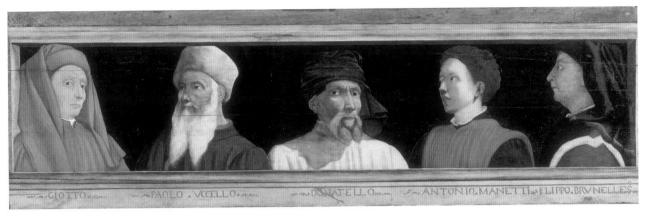

Plate 7.8   *The Founders of Florentine Art*, portraits of (from left to right) Giotto, Uccello, Donatello, Manetti and Brunelleschi, late fifteenth century?, panel, 42 × 210 cm, Louvre, Paris. Photo: © RMN/Daniel Arnaudet. This work was attributed by Vasari to Masaccio and first recorded by him as in the house of the architect Giuliano da Sangallo.

## Wider views of the prowess of Italian and Netherlandish artists c.1450–1506

The first histories were bound up with Florentine patriotism. However, from the 1450s six scholars and one painter writing in Naples, Rome, Urbino and the Veneto represented a variety of wider views of artistic prowess, mentioning artists based all over the peninsula and beyond in the Netherlands.

Lorenzo Valla (1407–57), a scholar at the Neapolitan court, set the scene in his 1437 treatise on the elegance of the Latin language when he considered how 'those arts, that is to say the arts of painting, sculpture, modelling and architecture, which approach most closely to the liberal ones, degenerated to such an extent and for so long a time and almost died out along with literature itself and now they awake and revive'.[43] In the mid-1450s Bartolomeo Facio, also writing in Latin at the Neapolitan court, had transposed Villani's idea to a broader topographical canvas. In his manuscript collection of lives of famous men, he included thumbnail biographies of what he judged to be the four most illustrious painters of his time: Pisanello, Gentile da Fabriano, Rogier van der Weyden and Jan van Eyck. He praised Donatello and Ghiberti as the two most prominent sculptors. Facio dwelt on the illusion of reality produced by his chosen artists, praising the portrait of Battista Lomellini painted by van Eyck 'which lacked only a voice', the depictions by Pisanello of 'animals of various kinds that you would think alive', and the way Rogier van der Weyden painted a Passion of Christ 'in which you can easily discern a variety of feelings and emotions matching the variety of events'.[44] Soon after in 1460, Michele Savonarola (c.1384–1468), a

Paduan scholar at the Ferrarese court, included an account of artists in his manuscript description in Latin of the beauties of Padua, noting the works of fourteenth-century painters like Giotto on show in this favoured city (Plate 7.9).[45]

Two decades later in 1483, a court painter at Urbino, Giovanni Santi, the father of Raphael, composed a rhymed manuscript chronicle in Italian praising the life of his patron, Duke Federico da Montefeltro. His praise of current artists was introduced at the point in his poem when he described the duke's visit to the Palazzo Ducale at Mantua, where Federico had admired the vault of an apartment decorated by Andrea Mantegna (Plate 7.10). Santi explained that the duke's preference for Mantegna, an artist trained in Padua, was entirely justified since: 'He possessed the entire and noble body, indeed all the members, of that art, without rival either in Italy or elsewhere.'[46] Santi then gave brief descriptions of the prowess of these lesser artists in Italy and beyond to offer what was the most inclusive statement about contemporary art to date, covering painters working in the Netherlands, Tuscany, Rome, the Veneto, Umbria, and Emilia.[47] The fact that Santi, as court painter, was able to take the role of court historian and express himself in poetic form was in itself a token of changing social and intellectual status.

Santi's breadth of view was soon reiterated, but this time for many to read in print, by Fra Luca Pacioli, a Franciscan friar writing in the Veneto who had spent time in Milan and Urbino. Pacioli published his praise of Italian artists in general in the prestigious context of a treatise

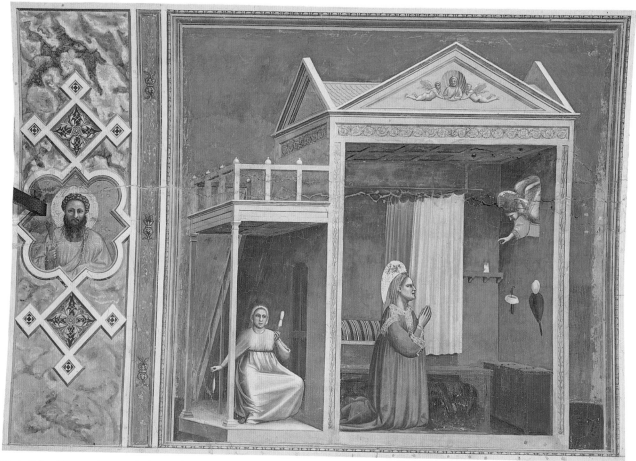

Plate 7.9    Giotto, *Annunciation to Saint Anne,* 1304–13, fresco, 200 × 185 cm, Arena Chapel, Padua. Photo: © 1990 Scala, Florence.

in Italian on the liberal art of arithmetic, which he dedicated to Duke Guidobaldo of Urbino. In the preface to his *Summa di arithmetica* (Venice, 1494), Pacioli outlined the kinds of people who displayed expertise in arithmetic such as orators and musicians, but he began with the architects Vitruvius and Alberti and the painter Piero della Francesca, who had composed a treatise on perspective and had worked for the duke. He went on to praise painters from Venice, Florence, Perugia, Cortona, Mantua and Forlì,[48] and then applauded sculptors skilled in arithmetic, starting with Andrea del Verrocchio and the other Florentines Antonio Pollaiuolo and Giuliano and Benedetto da Maiano. He ended with the Venetians Antonio Rizzo and Alessandro Leopardi.[49]

Pacioli was followed by the scholar Camillo Leonardo from Pesaro, who inserted a section on the art of the Israelites, of ancient Rome and of what he called the 'moderns' (*moderni*) in a survey of the uses of stones, *Speculum lapidum* (Venice, 1502), which he dedicated to Cesare Borgia.[50] Camillo especially admired Piero della

Francesca and Melozzo da Forlì, because 'they have established, as their works patently show, the method of painting according to arithmetical, geometrical and perspectival rules with marvellous order, industry and learning, nor was this a matter fully dealt with by ancient artists'.[51] Perspectival skills are therefore acknowledged to make some painters the superiors of the ancients. Giovanni Bellini and Perugino are claimed to equal Zeuxis in the ability to make the painted seem real. Mantegna is praised for his *grisaille*: that is, monochrome pictures. Similarly, in a commentary on urbane behaviour, *Commentariorum urbanorum* (Rome, 1506), the Tuscan scholar Raffaele Maffei da Volterra added some information on artists of recent times in his section on different kinds of productive work; he dedicated his book to Pope Julius II. Raffaele's account ranged across Italy from Giotto to Michelangelo and Donatello to Cristoforo del Gobbo of Milan, reeling off a few of their famous works in each case and also mentioning Piero della Francesca's treatise on perspective.[52]

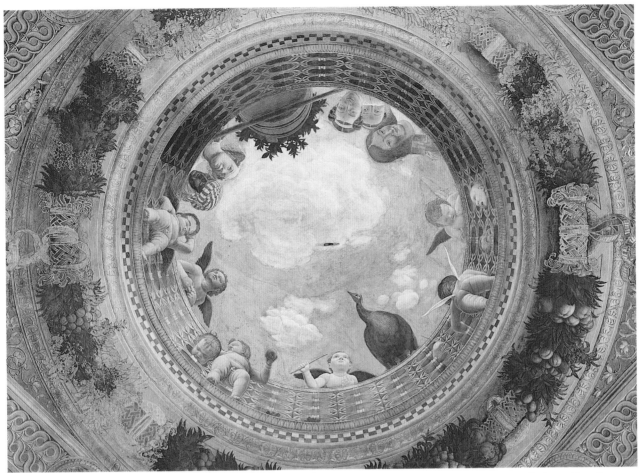

Plate 7.10   Andrea Mantegna, Camera degli Sposi, central section, 1471–4, fresco, diameter 270 cm, Palazzo Ducale, Mantua (for Ludovico Gonzaga, Marquis of Mantua). Used with the permission of the Ministero Beni e Attività Culturali. Photo: © 1990 Scala, Florence.

So far there had been some emphasis on painters. However, in 1504 the young Neapolitan scholar Pomponio Gaurico recorded the prowess of numerous sculptors in his treatise *De sculptura*, published in Florence but dedicated to Duke Ercole d'Este of Ferrara. Gaurico's varied topographical allegiances (he had been educated at Padua University) may help to explain his ecumenical approach. Following Pliny the Elder, he treated casting separately from carving and modelling, and he ended his technical discussions with an account of ancient and modern practitioners. Greeks were placed alongside contemporary Florentines, Venetians and Lombards.[53] Taking a familiar trope, Gaurico saw current heroes as reviving the wonders of ancient art: 'The talents of the past, the marvels of those days, have they not returned?'[54]

Despite these more catholic views, civic allegiance in Florence still counted, and the Florentine scholar Ugolino da Verino circulated a rhymed history of his city in 1503 entitled *De illustratione urbis Florentiae*. His encomium began predictably

with Giotto (who 'called back painting from the infernal regions'), moved to Taddeo Gaddi, and then lingered on the achievements of the second half of the fifteenth century. These were described in terms of a comparison between the brilliant talents of Florentine artists and those of ancient Greece.[55]

### French views 1503–21: Mechelen and Toul

French scholars began circulating tributes to artists about the same time as did German scholars – at the very beginning of the sixteenth century. The French texts take pan-European views recalling the standpoints of Facio and Santi. Following Italian precedent, one French text was part of a treatise on art, while two were attached to poetry in praise of the power of rulers.

During the period 1503–11 when he was poet and historian at the court of Margaret of Austria, Governor of the Netherlands, Jean Lemaire composed a poem in honour of his patron which took the conceit of an artificial debate as to which

artists could advise on the making of her crown. The manuscript, entitled *Couronne Margaritique* or *Crown of Pearls* as a pun on the name of the governor (*Margarita* means 'pearl'), was eventually printed in 1549. Lemaire had some knowledge of Italian art since he had travelled to Venice in 1506 and Rome in 1508, and he included one Italian in his survey (the deceased Donatello). He also included the names of other artists with a range partly calculated to reflect the scope of the Habsburg domains of his patron: Rogier van der Weyden, Jean Fouquet (*c.*1415/20 – before November 1481) (Plate 7.11), Jan van Eyck, Hugo van der Goes of Ghent, Gilles Steclin of Valenciennes, Hughes Martin of Frankfurt, and Antoine of Bordeaux.[56] Lemaire wrote a further poem entitled *La Plainte du desiré* or *The Complaint of One Desirous* (Lyons, 1509) in which Painting praises her modern pupils as *alumnes modernes*. This was also a panegyric in praise of a ruler, only this time it commemorated Louis of Luxembourg at his death. In this elegy a personification of Painting seeks out the best artists to paint the dead man's portrait, and again a host of famous artists are mentioned whom the reader is expected to recognise: the ancient Greeks Parrhasius and Apelles are included, as are Rogier van der Weyden, Hugo van der Goes and Jan van Eyck ('who was so elegant') followed by Leonardo and Gentile Bellini.[57]

Jean Pélerin (*c.*1445–1524; see p.254 above) took the opportunity when he printed the third edition of his *De artificiali perspectiva* or *Concerning Artificial Perspective* (Toul, 1521) to provide a French poem dedicating the book to contemporary artists in France, Germany, the Netherlands and Italy, whom he compared with Zeuxis and Apelles. Pélerin was a canon of the cathedral at Toul in charge of the fabric. He had been trained in the service of the well-travelled historian Philippe de Commines, and had been a diplomat and a secretary to Louis XI of France and Renée II of Lorraine. Among those whom he cited it has been possible to identify the Italians Mantegna, Leonardo, Michelangelo and Perugino; the Netherlander Hugo van der Goes; the German speakers Albert Dürer and Hans Baldung, and the French Jean Fouquet, Jean Poyet, Colin d'Amiens and Simon du Mons.[58]

## Views from German speakers 1505–32

The commemorations of artists by German speakers were all by scholars in Latin. They drew

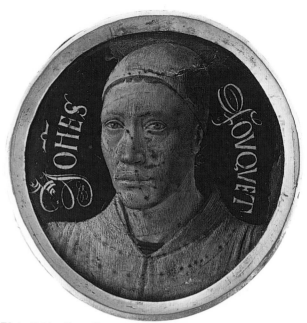

Plate 7.11  Jean Fouquet, portrait signature inscribed 'Joh[ann]es Fouquet' (comparable to that of Ghiberti, Plate 7.6), 1450–60, enamel on copper (among enamels of saints on a frame padded with velvet and decorated with pearls), diameter 6.8 cm, Louvre, Paris (possible on the frame of an altarpiece for Étienne Chevalier in Notre Dame, Melun). Photo: © RMN/Jean-Gilles Berizzi.

on Italian traditions in some ways – for example, comparing contemporary artists with ancient Greeks – but innovated in drawing attention to the German forte of printmaking. The two earliest statements were produced by Jakob Wimpfeling in a printed work and by Johannes Butzbach in a manuscript surviving in one copy for a community of nuns, both dated 1505.

Jakob Wimpfeling (1450–1528) entitled his account of the history of German-speaking peoples *Epithoma rerum Germanicarum usque ad nostra tempora* or *The Epitome of Things Germanic up to Our Times* (Strasburg, 1505). It celebrated contemporary literature and included a chapter on painting, which praised Israhel van Meckenem, Martin Schongauer (Plate 7.12), Albrecht Dürer and Hans Hirtz. Wimpfeling valued acclaim by those outside Germany and stressed the success of the northern inventions of woodcuts and engravings (see also Chapter 6, Plate 6.18):

The images [prints] of Israhel van Meckenem are desired, and held by painters to be worthy of the highest price, across the whole of Europe. What shall I say of Martin Schongauer of Colmar, who was so excellent in this art that panel paintings by him have been taken to Italy, Spain, France and Britain and other places …

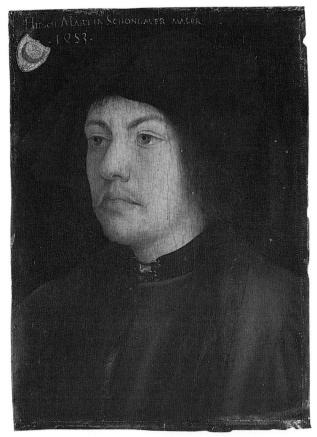

Plate 7.12 Attributed to Hans Burgkmair or his circle, portrait of his teacher Martin Schongauer, panel, 30 × 22 cm, Alte Pinakothek, Munich. Photo: © Joachim Blauel – Artothek.

His disciple Albrecht Dürer of Nuremberg is also a most excellent German [artist] at this time, and he made the most perfect prints which have been transported by merchants to Italy, and thence have been compared to no less than the panels of Apelles and Parrhasius by the most worthy painters.[59]

Johannes Butzbach (1478–1526) was prior of the monastery of Laach near Bonn, and he wrote his manuscript account for the miniature painter Gertrud von Nonnenwurth and the writer Adelheid Rayscop, who were both nuns in a Benedictine convent close to Bonn dedicated to the Virgin Mary. Entitled *Libellus de praeclaris picturae professoribus* or *Little Book concerning the Eminent Professors of Painting*, the narrative referred to the work of ancient Greek and Roman artists derived from a reading of Pliny the Elder, including the three women whose fame Boccaccio had spread in his treatise on famous women. Butzbach then moved to Christian artists, praising the painting of Saint Luke and that of 'Zetus' who had worked for the papacy at Avignon, and adding praise for the

skills of Israhel van Meckenem as well as of recent painters of the Benedictine Order.[60] Since Butzbach spoke of 'Zetus' as 'being said with the utmost talent to have led painting back to its ancient dignity', it has been argued that Butzbach had garbled information about Giotto.[61]

In 1508 Christoph Scheurl published a tribute to the importance of Dürer in an account of Germany and the dukedom of Saxony in Leipzig entitled *Libellus de laudibus Germaniae et ducum Saxonae*. Scheurl (1481–1552) was a teacher of law who had studied at Heidelburg and Bologna, finally taking up a post as Professor at Wittenberg in 1512. Scheurl claimed Dürer as the outstanding painter and printmaker of his age, and again it is clear that what Italians think about quality is important: 'Both in painting and printmaking the first place has been conferred in our time to him by common consent. When he returned to Italy recently, I was informed that he was greeted as another Apelles by both Venetian and Bolognese artificers.'[62] Scheurl compared anecdotes from Pliny the Elder to the feats of his hero. Dürer's dogs, for instance, reacted to his self-portrait as if it was real, just as ancient artists had painted grapes which birds had pecked at and painted curtains which people tried to draw aside: 'Just as Zeuxis, according to Pliny in Book 35, Chapter 10, fooled the birds with painted grapes, and Parrhasius fooled Zeuxis with the curtain, so my Albrecht deceived dogs.'[63] Scheurl gloried in the way Dürer attracted the friendship of the scholar Willibald Pirckheimer, and represented Dürer as a German Giotto who enabled 'such great skill in painting, which had been neglected for many centuries, to be called back for the sake of the people of Nuremberg'.[64]

Scheurl also gave prominence to Lucas Cranach the Elder (*c*.1472–1553), painter to the Duke of Saxony, in part of a Latin letter addressed to Lucas in praise of contemporary literature and the beauties of the Allerheiligenkirche at Wittenberg (*Oratio attingens literarum praestantiam nec non laudem Ecclesiae Collegiatae Vittenbergensis*, Leipzig, 1509). As we have seen, this association of excellence in letters with prowess in painting followed Italian precedents. However, unlike most of the Italian texts, the emphasis is on possessing a pan-European reputation. Scheurl dwelt on Cranach's leadership in painting, always excepting Dürer, and compared him to ancient Greek artists (Plate 7.13): 'To you, I consider, our century gives

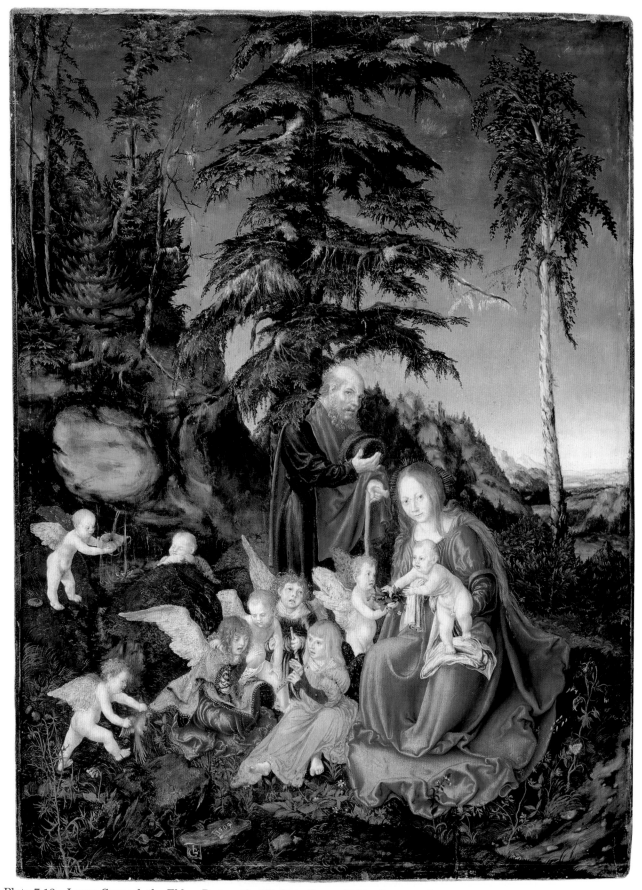

Plate 7.13   Lucas Cranach the Elder, *Rest on the Flight to Egypt*, 1504, oil on panel, 71 × 53 cm, Gemaldegalerie, Staatliche Museen, Berlin. Photo: © 2007 bpk/Staatliche Museen zu Berlin.

prime position, since the rest of Germany cedes victory, Italians (otherwise avid for compliments) surrender, and French people consult you as master.'[65]

Scheurl repeated his praise of Dürer as another Apelles in his biography of the jurist and theologian Anton Kress, priest of the Lorenzkirche in Nuremberg and friend of the artist (*Vita Reverendi Patris Domini Anthonii Kressen*, Nuremberg, 1515). Scheurl quoted Wimpfeling's text approvingly, and expatiated on Dürer's personal qualities: his 'probity, eloquence, friendliness, facility and humanity'. He added brief biographical information on Dürer's father's origins in Hungary and his training.[66]

On the precedent perhaps of the adulation of Giotto by Florentines, German scholars concentrated their praise on Dürer – a circumstance encouraged by his early death, when Latin elegies and epitaphs were composed in his honour. By the year of Dürer's death in 1528, the Netherlandish scholar Desiderius Erasmus (*c.*1466–1536) had even recommended his book on measurement (see p.276 below) to teachers as a school text (*De recta latini graecique sermonis pronuntiatione* or *Concerning the Correct Pronunciation of Greek and Latin Speech*, Basle, 1528).[67] Arguably, Dürer's inventive brilliance met the desire to celebrate artistic achievement in German-speaking areas. Significantly, Camerarius (see Chapter 1, p.53) provided a semi-biographical tribute in the preface to his Latin translation of Dürer's *Vier Bücher von menschlicher Proportion* or *Four Books on Human Proportions*: *De symmetria partium humanorum corporum* (first published Nuremberg, 1528). This is the earliest lengthy personal tribute to an artist to have been printed in the western European tradition. Camerarius stated that he wanted to tell something of 'the life and habits of a remarkable man' and began with Dürer's personal appearance, which he said displayed strength, intelligence and elegance, while his conversation was witty and amiable.[68] Camerarius then turned to the qualities of Dürer's mind, and celebrated his learning in mathematics and physics and his clear exposition of geometry in his treatises. Camerarius set great store by the way Dürer gained the favour of the highest princes and the fact that he had a morally sound approach to his art, suggesting that this soundness was expressed in his works: 'What single painter has there ever been who did not reveal his character in his works?' Camerarius then praised Dürer's technical virtuosity in drawing with the brush, dwelling on the tributes to him of the Italian painters Mantegna and Giovanni Bellini. But the admiration of skill is balanced by the commendation of theory and rules. Whereas previous German painters had taught good ways of working based on their personal experience and specific workshop wisdom, Dürer is seen as one who used his treatises (discussed below) to demonstrate techniques based on mathematical and geometrical theories for representing space, proportions and complex solids. While previous painters had shown apprentices how 'this worked for me and will work for you', the proposition here is that rules based on theory are universally applicable:

> All these perfections he attained by reducing mere practice to art and method, in a way new at least to German painters … he had brought painting into the fixed track of rule and recalled it to scientific principles.

Camerarius ended by representing Dürer as generous in wishing to 'publish to all nations', and related his own deathbed promise to the artist to translate his work on proportion into Latin.[69]

In his Latin edition of Pliny the Elder's *Natural History* (Basle, 1526), the historian and philologist of Strasburg and Basle, Bildius Beatus Rhenanus (1485–1547), explained why he praised artists. He applauded Dürer, Cranach, Hans Baldung and Hans Holbein, affirming his belief that 'Honour feeds the arts.'[70] Honouring artists makes them emulous and encourages them to work well. Just as the Greeks and Romans had valued their artists and preserved good standards, so we should do likewise. In praising recent artists, modern rulers and writers might therefore see themselves as imitating the successful cultural and political strategies of the ancient past. As in the case of French speakers, no German artists wrote histories of art.

## Italian views 1510–30

In Italy the commemoration of contemporary artists continued to flourish, although no single current artist received the treatment awarded Dürer. While Florentines were still publishing, writers in the Veneto and Lombardy made their mark.

Francesco Albertini, who was a canon of San Lorenzo in Florence, pioneered a new genre for commemorating artists who had worked since the fourteenth century when he published two guidebooks. In his Latin guide to Rome (*Opusculum de mirabilibus novae et veteris urbis Romae* or *Little Work concerning the Marvels New and Old of the City of Rome*, Rome, 1510), the new strand of interest in recent artistic marvels joined the traditional fascination with ancient pagan and Christian wonders. The book celebrated the new and old sights, especially works by Florentines, and contained an appendix praising recent artists, musicians and scholars of his native Florence and Savona in Liguria – the birthplace of Pope Julius II, who was the dedicatee.[71] Whereas there had been many guidebooks published for Rome (though aimed more at devout pilgrims), Albertini's Italian guidebook to Florence (*Memoriale di molte statue e pitture che sono nell'inclyta città di Florentia* or *Record of Many Statues and Paintings in the Illustrious City of Florence*, Florence, 1510) was a first for the city. With some precedent in Savonarola's description of Padua in 1460, Albertini took visitors round Florentine churches and private collections, identifying works by architects, painters and sculptors of the fourteenth and fifteenth centuries.[72] Albertini had an unusual 'crossover' background, as he had trained as an artist in the workshop of Ghirlandaio, and he dedicated the Florence guide to his friend, the sculptor Baccio da Montelupo.

In another landmark text, in his commentary to the first vernacular translation of Vitruvius – here into Italian (Como, 1521) – the architect Cesare Cesariano took the opportunity to describe painting as 'a holy and sacred science' which 'has by the grace of nature and the help of study been allowed to become most rare and to exceed all prizes and rewards in the way it shows how nature may be imitated'.[73] Cesariano followed a well-worn path by ranging excellent painters city by city: 'Antonello da Messina and Giovanni and Gentile Bellini in Venice, Andrea Mantegna in Mantua and Pietro Perugino in Perugia, Florence and Rome, Pietro il Borgo [Piero della Francesca] who left a work on perspective, and also Raphael of Urbino and Michelangelo'.[74] However, he showed some partiality in citing many of his Milanese and Lombard countrymen.[75]

Whereas some writers had been keen to range artists in order of precedence (for example, Santi had put Mantegna in the lead), other writers put forward the idea that different artists may stand for different kinds of excellence. Most influentially, the diplomat and writer Baldassare Castiglione took this view in his treatise on the proper behaviour of courtiers, *Il cortegiano*, when he included knowledge of the best modern art in his catalogue of courtly accomplishments. This text circulated in manuscript from 1516 and was first printed in 1528 in Venice.

> Note then that, in painting, Leonardo da Vinci, Mantegna, Raphael, Michelangelo and Giorgione are all excellent. Nevertheless all of them are different from one another in their work. Each one of them appears in his own particular manner to lack nothing, because each one is regarded as being most perfect in his own style.[76]

By contrast, Giovio (see Chapter 1, p.45) arranged artists in descending order – with Leonardo first, followed by Michelangelo and then Raphael – in his manuscript tributes to choice modern artists which he composed 1523–7. During our period, therefore, two models for judging modern art were explored: one tending to rank criteria to decide on the primacy of one artist and the other celebrating difference.

Giovio was also important in continuing the idea of composing the lives of artists and associating it with his new idea – the first European 'museum' since antiquity, which would hold portraits of famous people, including artists, and summaries of their achievements. Giovio began to establish his museum at his house in Como near Milan in the 1530s. Although his Latin biographies were not finished, he seems to have circulated his ideas, and he was instrumental in encouraging Vasari to write his *Lives* as an improvement on his own attempts when they met in Rome in the 1540s. Giovio provided pen portraits of his heroes, summing up their strengths and mentioning some of their works. Although they are short, these bear some comparison with the tribute to Dürer by Camerarius. For example, the account of Leonardo begins with Giovio admiring Leonardo's learning in the liberal arts, detailing his university-level understanding of 'optical theories' and 'his dissection of bodies in the schools of medicine'.[77] He then notes that Leonardo was preparing to make engravings of anatomical researches, which would have taken his ideas to

a wide public through printing. Giovio sets great store by the way Leonardo attracted the loftiest patronage, relating that Louis XII coveted the *Last Supper* while Francis I bought 'a panel of the baby Jesus with his mother and grandmother'. He also notes Leonardo's commission for the government of Florence of the *Battle of Anghiari* and his equestrian monument for Ludovico Sforza. All these points match those in which Camerarius showed interest. Like Camerarius too, Giovio dwelt on Leonardo's individual character in representing him as a perfectionist who left work unfinished because of the 'changeability of his nature and his innate fastidiousness'. Leonardo is presented like Dürer as having a pleasing personality:

He had a character which was very amiable, impressive and generous, and he had the most beautiful appearance. He was a splendid critic and inventor of all things elegant and delightful, especially in theatrical displays. He sang to his own accompaniment on the lyre, and he was on an excellent footing with all the princes of his time.[78]

Distinctively, however, Giovio makes Leonardo the leading artist notwithstanding his failure sometimes to complete polished works. In his account, the use of flawed mural experiments spoiling the surface of the *Battle of Anghiari* is claimed to have 'added to its grace', while the clay model for the incomplete Sforza monument shows 'the loftiest understanding both of the skill of making statuary and of the objects of nature'. Both material and functional values are therefore being rejected in some circumstances. The mural of the *Battle of Anghiari* cannot function as a grand narrative of military victory in the seat of government in the city, and the plaster and paints have been misused. However, the qualities of artistic understanding represented in the work are being put forward as more important and so relate to the development of the idea of artistic genius. The recording of these discriminations went hand in hand with the development of interest in collecting drawings (Plate 7.14).

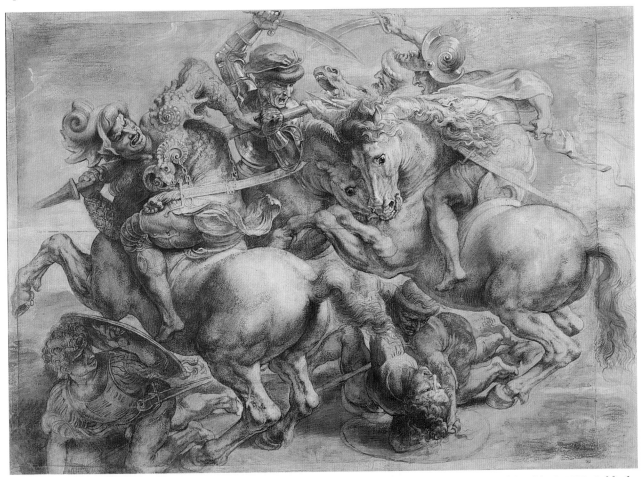

Plate 7.14   Peter Paul Rubens, copy of the central group from Leonardo's cartoon of the *Battle of Anghiari*, 1600–8, black chalk, pen and ink and white paint, 45 × 64 cm, DAG, Louvre, Paris (Leonardo's *c.*1504 original was a commission from the government of Florence but not completed). Photo: © RMN/Michèle Bellot.

The quite wide acceptance of the commemoration of artists in the second half of the period is evinced in the survival of a manuscript belonging to a Florentine merchant called Antonio Billi. The *Libro di Antonio Billi* seems to have been composed between 1506 and 1532, and comprises jottings by various scribes. They appear to have relied on Villani, Manetti and Landino for their thumbnail biographies of artists from Cimabue and Giotto to Leonardo and Michelangelo.

The spread of written histories in manuscript and print furthered a 'historicised' practice where artists might see themselves as fitting into recorded as well as oral traditions of revival and innovation. Such behaviour may be identified in Leonardo, for example. At some point – probably in the 1490s when planning his treatise on painting – Leonardo rehearsed the trope of the decline of art, explaining that painters had stopped observing nature after the time of Constantine. Painting, he went on, had been rescued by Giotto, who had returned to nature as his standard. However, painting had declined again as successive painters just copied Giotto. Matters improved when Masaccio returned to examine the visible world. Leonardo used this view of history to argue that all painters, including himself, should observe nature.[79] It is also indicated in the writing of Dürer, who in his treatise on measurement in 1525 explained that 200 years previously Italians had revived the art of the Greeks and Romans, forgotten for a thousand years, and that he intended to inform German artists of the Italian discoveries.[80]

The presence of written histories seems to have been related to, and furthered interest in, personal talent (*ingenium*), the person behind the style, and the growth in the value of drawings. This is signalled in the way Isabella, Marchioness of Mantua, set out to obtain paintings by each of the most acclaimed Italian painters of her day (Plate 7.15). Her contemporary in the Netherlands, Margaret of Austria, collected works by deceased masters such as the *Arnolfini Portrait* by Jan van Eyck and the painted marriage portrait of the Master of Frankfurt (Plate 7.16). At the same time, the fact that Israhel van Meckenem printed his marriage portrait for wide circulation assumed that less rich collectors than Isabella and Margaret might want to have an engraver's portrait (see Chapter 6, Plate 6.19).

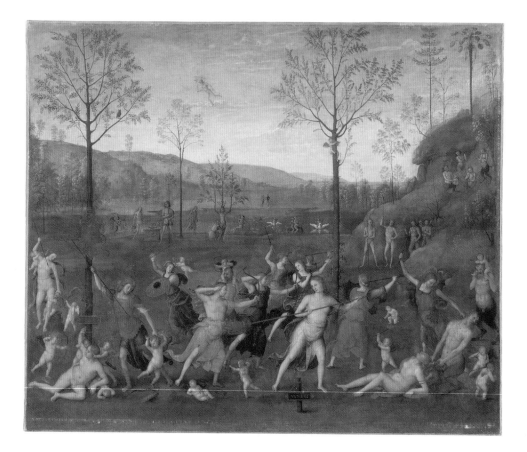

Plate 7.15   Pietro Perugino, *Combat between Love and Chastity,* 1505, canvas, 160 × 191 cm, Louvre, Paris (originally for the studiolo of Isabella d'Este). Photo: © RMN/ René-Gabriel Ojéda.

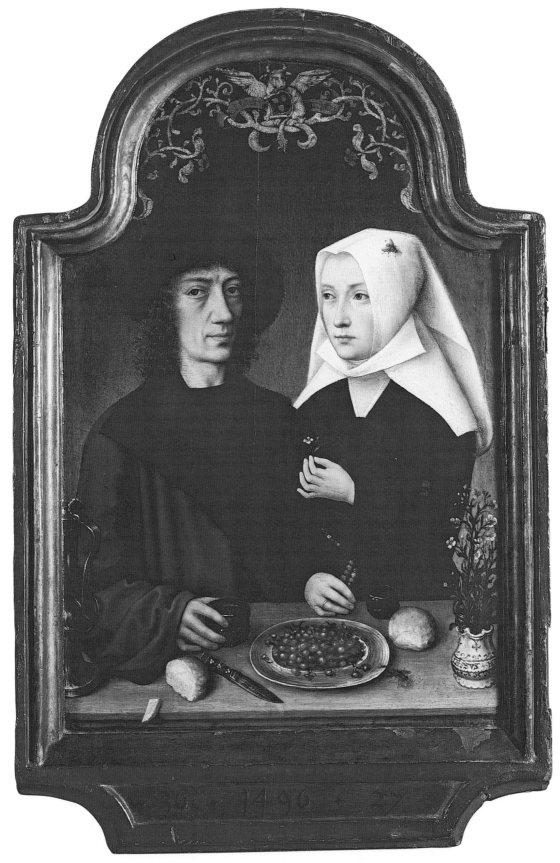

Plate 7.16  Master of Frankfurt, *Portrait of the Artist and his Wife*, 1496, oil on panel, 38 × 24 cm,
Koninklijk Museum voor Schone Kunsten, Antwerp (inscribed on the lower frame '36 1496 27' – his age,
the date and her age – and with the heraldry of the guild of Saint Luke, Antwerp at its apex).

# 3  Treatises

Some authors contributed texts which both charted the history of recent art and examined best practice in art and architecture. In some cases, therefore, in this section I will consider texts which have been already been mentioned from a different angle. Again, as with the historical accounts, while many treatises followed conventional literary models, others experimented with new approaches in order to handle new ideas.

Treatise authorship was quite evenly divided between artists and scholars. Six artists completed treatises while two produced drafts. Alberti – who is difficult to categorise given his status as a painter, sculptor, architect and scholar – wrote on painting, sculpture and on architecture; the last text was printed, as were all three books by Dürer. Four scholars wrote treatises, all of which were printed. Vitruvius was initially printed in Latin in 1486; the first Italian edition, by the architect Cesariano, was not published until 1521. The impetus to produce treatises therefore came both 'top down' from the intellectual elite and 'bottom up' from aspiring artists.

Were they as important for artists as for patrons and viewers? Here one needs to ask who could read the treatises. Those solely in a vernacular could be used by artists and others, but unless they were printed (and only three of them were) could reach few readers. Texts that were in both vernacular and Latin versions could be read anywhere in Christendom by the erudite as well as anyone sharing the writer's mother tongue, but again, if they were only in manuscript, they had a limited readership. Latin texts that were printed (and four of them were) had a large scholarly audience. However, potentially the most influential books were those printed in Latin and the vernacular (of which there were three – or four if you count Vitruvius).

## Treatises in one language

The treatises by Ghiberti and Leonardo in the vernacular were the most limited in circulation. Ghiberti's manuscript survives in one incomplete copy, though it is surmised that a more complete original was still available in the early sixteenth century. The treatise comprises the last section of the manuscript entitled the *Commentaries* – the book discussed earlier as a historical text, since

Part One and Part Two presented his history of ancient Greek and Roman art and the art of his own times. Part Three dealt with the sciences of perspective, anatomy and proportion. It relied mainly on the theories of Ibn al-Haytham, known as Alhazen, in the *Kitab ul Manazir* or *Discourse on Optics*; the *Qānūn* or *Canon of Medicine* by the Arabic physician Ibn Sina, known in western Europe as Avicenna (980–1037); and Vitruvius' *Ten Books*. Although the text by Alhazen had been translated into Italian, the other authors were only available in Latin, so that Ghiberti required scholarly assistance in employing them.[81] Ghiberti's treatise highlights the considerable dependence of late medieval and early Renaissance science on Arabic research, and on the translations which Arab scholars had made of ancient Greek texts.

Leonardo's drafts for a treatise on painting were fragmentary, although his heir Melzi treasured the manuscripts for much of the sixteenth century (see Chapter 1, p.45). They were known to his workshop and also a few others. For example, they were cited by the scholars Giovio and Pacioli and also by the Florentine sculptor Benvenuto Cellini, who had bought a copy of selections from the manuscripts by 1542 and lent it to the architect Sebastiano Serlio.[82] Leonardo's treatise instructed artists on how to achieve convincing illusions of pictorial reality by observation of the visual world, and through following rules as to how objects and people should be represented. To give some examples, he analysed the movement and the anatomical structures of animals and humans as well as figural proportions (see Chapter 1, Plates 1.24–1.26). He generalised about the ways in which humans showed their emotions following physiognomic theory: as lions were famous for their courage in medieval bestiaries,[83] a warrior could be made to look brave by modelling his face on the lion's muzzle (Plate 7.17). He analysed problems of the distribution of light and shade in the abstract (Plate 7.18). Leonardo also drafted comparisons between the liberal arts and painting and between painting and sculpture which he may have intended for inclusion in the treatise.

More widely available were completed manuscript treatises. I have already discussed Cennino's *Il libro dell'arte*, which survives in one copy (see p.251). Another treatise which was appreciated by artists was the *Trattato di architettura civile e militare* or *Treatise on civil and military*

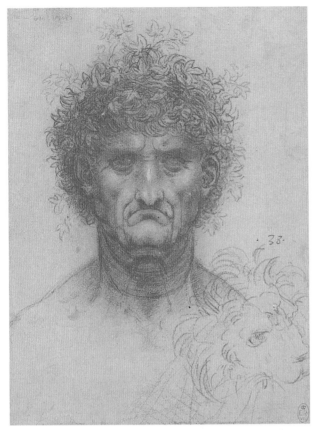

Plate 7.17   Leonardo da Vinci, man with a wreath of ivy and a lion, *c.*1498, red chalk heightened with white on pink prepared paper, 19 × 15 cm, Royal Library, Windsor. Photo: The Royal Collection © 2005 Her Majesty Queen Elizabeth II.

*architecture* by Francesco di Giorgio. Francesco was a Sienese sculptor, painter and architect in the service of the court at Urbino when he composed this work. It was circulated in two versions, one composed 1478–81 and a second written 1487–89, which included a translation into Italian of parts of Vitruvius. Francesco enthused about centrally planned churches and included many drawings of Imperial Roman buildings. He included all types of edifices, especially fortifications and bastions of his own invention allowing defenders the better to attack besiegers. Six copies made before about 1520 survive, including one belonging to Leonardo.[84]

A few vernacular treatises were printed; the first was Roriczer's 1486 booklet publicising the way to employ rotated squares for laying out the ground plans of buildings (see Chapter 4, p.153). A short poem by Francesco Lancillotti entitled *Tractado di pictura* or *Treatise on Painting* was printed in Rome in 1509 and dedicated to the Florentine

nobleman Francesco Tommasi. Little is known about Lancillotti, but it seems that he was a soldier (probably from a painter's family) who had travelled widely. In the poem a personification of Painting lamented her exclusion from the liberal arts, and Lancillotti praised both Netherlandish and Italian artists.[85] If soldiers could write on art, then artists could advise on defending cities and castles. Thus, Dürer published a treatise on fortifications dedicated to Ferdinand of Hungary entitled *Etliche Underricht von Befestigung der Stett, Schloss und Flacken* or *Some Instruction on the Fortification of City, Castle and Plain* (Nuremberg, 1527).[86]

Texts in Latin were confined to the elite, and all but one of these were printed. Alberti wrote the earliest treatise on sculpture, *De statua*, sometime in the mid-fifteenth century.[87] This demonstrated a new way of measuring human bodies and statuary which was taken up by architects for measuring buildings. He was also responsible for the first treatise on architecture to be circulated in Latin since antiquity: *De re aedificatoria* or *On Building*. This is both a commentary on and a modernisation of Vitruvius' *De architectura*. The first five books were completed by 1450 and were in circulation in Rome in the 1450s. Alberti continued to work on the remaining five books until his death in 1472. While two late fifteenth-century Latin manuscripts and an early sixteenth-century Italian manuscript survive, the book was also printed in Latin (Florence, 1485; Paris, 1512); it was printed in Italian after the end of our period (Venice, 1546). A manuscript was first presented to Pope Nicholas V, and Latin copies were made for King Matthias Corvinus of Hungary, Duke Federigo da Montefeltro, and the Venetian ambassador to Florence, Bernardo Bembo. The posthumous 1485 edition was dedicated to Lorenzo 'the Magnificent', the de facto Medici ruler of Florence, by the scholar Angelo Poliziano, who stated that Alberti was 'an excellent painter and sculptor' himself. Alberti imitated the range of Vitruvius as well as interpreting the Roman author's ideas on architectural decorum, the orders and proportional theories. The interest in architecture among erudite patrons may be registered by the success of the treatise by Francesco Mario Grapaldi entitled *De partibus aedium libri duo* or *Two Books concerning the Elements of Houses* (Parma, 1494) – it achieved six further editions.[88] Grapaldi

Plate 7.18   Leonardo da Vinci, theoretical studies of the reception of light on a sphere, *c.*1492, pen and ink with wash and traces of stylus, folios 24 × 38 cm, Bibliothèque de l'Institut de France, Paris (BN 2038, fol.13v and 14r photographed together as a double-page spread). Photo: © RMN/René-Gabriel Ojéda.

(1465–1515) was a scholar from Parma, and was officially acclaimed as a poet by Pope Julius II. He provided etymological discussions of Latin terms and covered buildings (such as the dining room and women's quarters of ancient Roman houses) as well as the garden, dovecot and fish pool.

The interest in sculpture is indicated by Gaurico's treatise *De sculptura* or *On Sculpture* (Florence, 1504), which I have already considered (see p.263). It featured a dialogue supposedly taking place in the University of Padua between two actual scholars. One was 'Regio' – commentator on the Roman writer on rhetoric, Quintilian – and the other the Aristotelian specialist 'Leonico Tomeo'. Gaurico knew contemporary sculptors such as Tullio Lombardo and also drew on the authority of Alberti as well as ancient writers. Whereas painting had been compared to poetry as early as Cennino, Gaurico was the first to argue in print that sculptors and writers were also comparable: 'writers work with words and sculptors work with things: the former narrate while the latter portray and exhibit'.[89] He demonstrated that ancient Greeks employed the one term 'graphein' to denote

both the writing of words and the carving and painting of images, and he described sculpture as 'the eighth liberal art'.[90]

Fra Luca Pacioli dedicated *De divina proportione* or *On Divine Proportion* (composed 1497) to Ludovico Maria Sforza, Duke of Milan. Pacioli was a Franciscan whose *Summa di arithmetica* I examined earlier since he used the preface to commemorate current artists (see pp.261–2). Pacioli reported demonstrating the ideas in this work to fellow Franciscans at the Frari in Venice. Born in Borgo San Sepolcro in Tuscany, Pacioli had worked in the courts of Milan and Urbino, where he had been in contact with Leonardo, whose 'treatise on art', *Last Supper* and equestrian monument to Ludovico Sforza he commended. He had met Alberti and enthused about the treatise on perspective by Piero della Francesca. Printed in Venice in 1509, his illustrated text demonstrated the cosmic and spiritual significance of certain proportions with reference to music, geometry and neo-Platonic ideas about relationships between terrestrial and divine beauty. The text recommended ideal proportions for human figures,

the letters of the alphabet, and columns, and it argued that painting was equal to music because of painting's use of perspective.[91] It seems likely that Pacioli presented the writings of Piero della Francesca (who had died in 1492) as his own in this work. To adapt the adage, plagiarism might be the most sincere compliment a scholar could pay to a painter.

## Latin and vernacular treatises – manuscripts

Texts that were circulated both in Latin and the vernacular were more widely available. There were three manuscripts of this sort. The first was Alberti's *On Painting*, the Latin version of which was completed in 1435 and dedicated sometime between 1438 and 1444 to Gianfrancesco Gonzaga, Marquis of Mantua. Alberti wrote of painting as among 'these liberal arts' and begged to enter the marquis's service.[92] Twenty manuscripts survive from the second half of the fifteenth century or later. The Italian translation was made by Alberti and dedicated to Filippo Brunelleschi in 1436. The fact that the Italian text survives in only three manuscripts may mean that scholars, who were more likely to preserve manuscripts, did not have the Italian version. By contrast, artists were not likely to be so careful about preserving manuscripts or else, perhaps, used them to the point of disintegration. We do not know. Alberti noted that ancient precedents (treatises by the philosopher Demetrius and the artists Euphranor, Antigonus, Xenocrates and Apelles) had not survived. He demanded 'philosophical understanding of painting' and claimed that 'painting is the mistress of all the other arts'.[93] Quoting Pliny the Elder, he asserted that Greek and Roman citizens were taught 'painting along with letters, geometry and music'.[94] Alberti assured his learned and influential readers that in antiquity, 'philosophers and kings took great pleasure not only in seeing and possessing paintings, but also in painting themselves'.[95]

In Part One Alberti explained the single-point perspectival construction. In Part Two he advised on the use of line to circumscribe components to be represented, the way these components should best be put together in 'compositions', and the way they should be shaded and coloured. In Part Three he counselled on the mode of life and education of the painter.[96]

Filarete's *Treatise on Architecture* (c.1461–4) had been written in Italian for Francesco Sforza to be read aloud to his patron and his son Galeazzo. I considered this earlier since he included an account in passing of the activities of acclaimed contemporary artists (see p.259). Another copy of the treatise was dedicated to Piero de' Medici, and this version was copied in the late fifteenth century for Duke Alfonso of Calabria, heir to the throne of the Kingdom of Naples. Filarete cited the only precedents for treatises on architecture (Vitruvius's *Ten Books* and Alberti's *On Building*), pointing out that his was the first in the vernacular. It was, however, translated into Latin in 1484 for King Matthias Corvinus of Hungary by Antonio Bonfini d'Ascoli. Five Latin copies were made from this manuscript. Like *On Painting*, the treatise laid out something of a manifesto, only this time the idea was to persuade rulers to espouse classicising styles of architecture. Unlike *On Painting*, this was richly illustrated (Plate 7.19). In the treatise Filarete has the architect explain the building of the ideal city of Sforzinda to his patrons. The architect is treated with respect – indeed, as teaching the young 'lord' drawing, like a tutor. Filarete represents him as responsible for planning and making drawings while mere builders execute his ideas.[97] The architect claims, following Vitruvius, that he 'needs the seven sciences' of the liberal arts.[98] The treatise is full of references to ancient buildings and writers, and ends by explaining the arts of representation following 'my Baptista Alberti' but substituting sculpted for painted examples.[99]

In his treatise *De prospectiva pingendi* or *On the Perspective of Painting*, Piero della Francesca demonstrated a higher level of mathematical competence than that previously attempted in discussing perspectival constructions for painters; it was the first time a whole work had been devoted to the topic. Written in Italian *c.*1474 and dedicated to Guidobaldo da Montefeltro, Duke of Urbino, it is the first to treat this subject using complex mathematics in a way that artists could understand and apply. Piero was from Borgo San Sepolcro and had worked at the court of Federico da Montefeltro and then his son Guidobaldo. Based on the geometry of Euclid, the work was praised by Pacioli in 1494 in his treatise on arithmetic. Just as with Filarete it was amply illustrated, written by a respected professional, and regarded

Plate 7.19   Filarete, *Trattato di architettura*, c.1461–4, Biblioteca Nazionale Centrale, Florence, Codex Magliabechiano II.I.140, fol.145r. Used with the permission of the Ministero Beni e Attività Culturali. Photo: Microfoto, Florence.

The diagrams show the ground plan and elevation of the House of Virtue, which was the name given to the house designated in the city for the architect himself.

as so important that a Latin translation was made by Matteo del Borgo, from which two surviving fifteenth-century copies derive.[100] The promotion of Piero's book was linked to civic allegiance, for Piero, Pacioli and his translator were all from Borgo San Sepolcro.

## Latin and the vernacular – printed treatises

Treatises printed in the vernacular and Latin could reach many readers. In 1505 Jean Pélerin published the first printed account of linear perspectival construction in *De artificiali perspectiva* or *Concerning Artificial Perspective* at Toul (see p.264 for a discussion of his historical contribution).[101] This work, which publicised a

Plate 7.20   Jean Pélerin, Toul Cathedral, from *De artificiali perspectiva*, 1505, woodcut, British Library, London, fol.Eii recto, C24.c21. Photo: by permission of the British Library.

variation of Alberti's method with some similarities to that of Piero, was rapidly plagiarised by Reisch and Glockenden.[102] Pélerin produced his own further editions in 1509 and 1521 to meet demand. All Pélerin's editions were in Latin and French, so he was able to broadcast the technique of linear perspectival construction widely and prise it away from Italian associations by demonstrating it on illustrations of French buildings (Plate 7.20).

In 1525 Dürer published *Underweyssung der Messung, mit dem Zirckel und Richtscheyt, in Linien, ebenen unnd gantzen Corporen* or *Course in the Art of Measurements, with Compasses and Rule, in Lines, Areas and Solids* at Nuremberg. There were further editions in 1533 and 1538 as well as a Latin translation by Camerarius entitled *Elementa geometria* or *Geometrical Elements* (Paris, 1532).[103] Dürer dedicated his treatise to his friend, the scholar Pirckheimer. Dürer intended his book to inform young artists of new theoretical principles. He showed how to draw one, two and

mit einem anderen puncten aber also piß das du die ganßen lauten gar an die tafel punctirst / dann zeuch all puncten die auf der tafel von der lauten worden sind mit linien zůsamē / so sichst du was daraus wirt / also magst du ander ding auch abzeychnen. Dise meynung hab ich hernach aufgerissen.

Vnd damit günstiger lieber Herr will ich meinem schreyben end geben / vnd so mir Got genad verleycht die bücher so ich von menschlicher proporcion vñ anderen darzů gehörend geschriben hab mit der zeyt in druck pringen /vnd darpey meniglich gewarnet haben /ob sich yemand vndersteen wurd mir diß außgangen büchlein wider nach zů drucken /das ich das selb auch wider drucken will / vñ auß lassen geen mit merern vnd grösserem zůsatz dañ ietz beschehen ist /darnach mag sich ein yetlicher richtē /Got dem Herren sey lob vnd eer ewigklich.

N iij

Gedruckt zů Nůremberg. Jm. 1 5 2 5. Jar.

Plate 7.21   Albrecht Dürer, how to draw a lute, from *Underweyssung der Messung,* 1525, woodcut, Beinecke Rare Book and Manuscript Library, Yale University, New Haven, fol.Qiii recto.

three-dimensional figures, assisting them to design ground plans, Gothic and antique lettering, and complex forms in wood, stone or metal. He ended by demonstrating linear perspectival constructions as well as devices invented by himself and by Jacob Keser for ensuring accurate representations directly from nature (Plate 7.21).

Dürer's *Vier Bücher von menschlicher Proportion* or *Four Books on Human Proportions* was published

in German a few months after his death by his widow Agnes; during the sixteenth century it was issued in six editions in Latin (the first in 1528 in Nuremberg) and translated into French (Paris, 1557) and Italian (Venice, 1591). This too was dedicated to Pirckheimer. Here Dürer drew on the ideas of Vitruvius using the head as module or basic unit of measurement. He set out to enable artists to produce convincing representations of

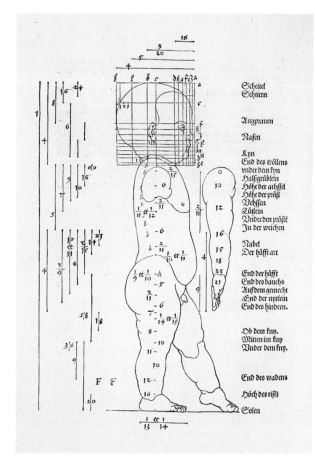

Plate 7.22 Albrecht Dürer, the proportions of a child, from *Vier Bücher von menschlicher Proportion*, 1528, British Library, London, fol.Fiii verso, C.119.H7(2). Photo: by permission of the British Library.

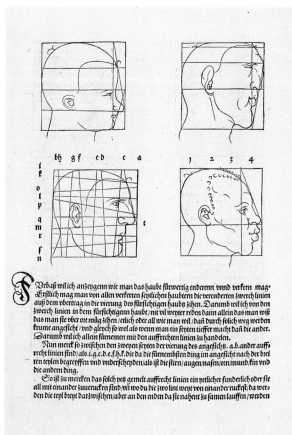

Plate 7.23 Albrecht Dürer, various proportions for men's heads, from *Vier Bücher von menschlicher Proportion*, 1528, British Library, London, fol.Niv verso, C.119.H7(2). Photo: by permission of the British Library.

any figure they should require in their scenes – beautiful, ugly, old, young, thickset, slender (Plate 7.22). Dürer was the first to publish guidance on proportion which emphasised difference; to do so he had generalised from research on hundreds of people (Plate 7.23). Dürer linked the varied requirements of effective storytelling to an aesthetic of diversity acknowledging different viewpoints:[104]

> As there are different beauties, all of equal grace in different bodies, different judges, of like intelligence, will judge them to be of great variety among themselves, each according to their predilection.[105]

As we saw in section 2 above, other contemporaries of Dürer such as Castiglione also affirmed diversity when evaluating painters.

## 4 Conclusion

Who valued treatises? Artists testified to the importance of treatises for them, with Cennino quoting Horace's treatise on poetry, Alberti lamenting the loss of ancient treatises which had not survived, and Ghiberti following Vitruvius. Filarete quoted Alberti's treatises on architecture and painting, while Albertini reported that when a young man he had begun a design for Florence Cathedral façade by reading Vitruvius and 'Baptista Leo Alberti de Architectura'.[106] Alberti's *On Building* was also cited by other architects, including Flavio Biondo (1392–1463), a scholar who researched the antiquities of Rome, Leonardo, Manetti and Francesco di Giorgio.[107] Treatises were important to patrons, as documented by the many eminent dedicatees, some of whom presumably valued their contents. Lorenzo de' Medici's secretary reported that 'he [Lorenzo] is very fond of it and reads it [*On Building*] often'.[108] Treatises were admired by scholars, with Rinuccini

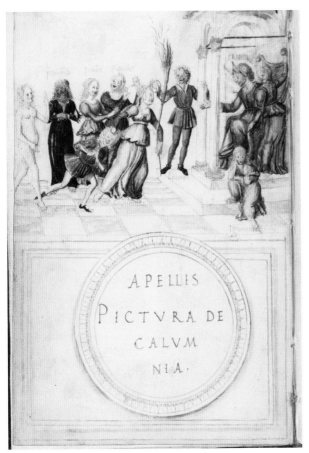

Plate 7.24   Unknown artist, *The Picture by Apelles concerning Calumny*, c.1472, watercolour on parchment, 21 × 14 cm, title page of the Italian translation by Bartolommeo della Fonte of Lucian's essay, 'On not believing rashly in slander', for Duke Ercole d'Este, Kupferstichkabinett, Staatliche Museen, Berlin. Photo: 2007 bpk/Kupferstichkabinett, Staatliche Museen zu Berlin/Jörg P. Anders.

praising those of Alberti, Pacioli commending Leonardo's and plagiarising Piero's, while Camillo applauded Piero's. Giovio highlighted Leonardo's publishing plans for his anatomical research, while Camerarius and Erasmus admired Dürer's writing.

Did treatises introduce new techniques to artists? It is virtually impossible to pin down changes which occurred because artists read about techniques rather than because they watched someone working. However, the activity of Roriczer in publishing his geometrical secrets or Glockenden in pirating Pélerin suggests that some at least thought treatises were effective. Did treatises affect the content of works of art? Again this is difficult to pinpoint, although in one case it does appear that Alberti's recommendation to emulate Apelles' invention of his own allegory in his *Calumny* encouraged the adoption of

this subject (Plate 7.24).[109] (Apelles had been accused of a crime, and in answer to his accuser, he had invented an allegory of false accusation. Since artists were usually told by patrons what subjects to depict, Apelles' leadership in inventing his own subject matter was widely admired.) Did treatises introduce new styles and forms? I suggest that indirectly they sometimes did. Alberti's *On Building* was probably a factor in convincing Ludovico Gonzaga, ruler of Mantua, to erect the church of San Sebastiano on a central plan. More directly, Ludovico accepted the plan Alberti recommended to him for the rebuilding of Sant'Andrea in Mantua following the model of 'the Etruscan temple' described in his treatise (Plate 7.25).[110] Both of these church designs were widely emulated.

Did treatises change the behaviour of patrons and viewers to artists? I suggest that the increase in treatise writing contributed to some artists being considered as more like practitioners of the liberal arts, and therefore to be valued for the personal talent and cerebral understanding they displayed in their work. Did treatises change viewers' behaviour in other ways? It seems possible that treatises disseminated a range of critical categories. In 1436 *On Painting*, for example, presented new and traditional terms. There were terms taken from Pliny the Elder's descriptions of ancient art such as 'symmetry' (meaning proportionality), terms from geometrical treatises such as 'equidistant', and terms transposed from literary theory such as 'composition'. By 1509 we find a mere soldier in Francesco Lancilotti following some of the Albertian categories in admiring painters who were learned in drawing ('in disegno esser docto'), accomplished at colouring ('bel coloritore'), and good at composition ('buon componitore').[111] Treatises could have been one way of informing the gentleman in society, who (Castiglione advised), now needed to know how to discuss art.

By the early sixteenth century art had became 'good copy', with readers keen to learn about scientific and antiquarian ideas regarding perspective and proportional theories or ancient Roman orders. Patrons and scholars who wanted to know about ancient art needed learned artists who could excavate, record and restore it – in other words, 'artistic humanism'. In this situation artists might refer to their theory and history to command respect. Thus in 1507 the Sienese painter

Plate 7.25    Leon Battista Alberti, interior view of nave showing side chapels and part of barrel vault, Sant'Andrea, Mantua, first phase of erection 1470–94. Photo: © 2005 Scala, Florence/courtesy of Diocesi di Mantova.

Bernardino Pintoricchio quoted Cicero to acquire tax exemption from the Sienese government:

> Most respected officers, it is argued with due reverence by Master Bernardino Pintoricchio as servant of Your Lordships and one of the most worthy painters, that the republic is accustomed to esteeming such artificers dearly who may be compared to those of ancient times and so should treat them as did the Romans. As Cicero wrote, at the earliest period they took little delight in painting, but as the empire grew after the oriental victories and the conquest of the Greek cities, the Romans took pains to gather in from all parts of the world the most famous works of painting and sculpture (not hesitating to plunder them). They held painting to be the most distinguished and similar to other liberal arts and to compete with poetry.[112]

# Notes

## Introduction

[1] The prime example of such a fruitful partnership is the National Gallery publication, *Giotto to Dürer* (Dunkerton *et al.*, 1991).

[2] Vasari, 1996, vol.1, p.252.

[3] Ibid., p.254.

[4] Hartt, 2003.

[5] Belozerskaya, 2002, p.68.

[6] Ibid., p.109.

[7] Ibid., p.67.

[8] For further information on artistic education, see Chapter 7 of this book and Ames-Lewis, 2000, Chapter 2.

[9] Portrait of Margaret van Eyck, the artist's wife, in the Groeninge Museum, Bruges.

[10] For the extent of humanists' interest in art, see Baxandall, 1971. For Poggio's collecting, see Gilbert, 1980, pp.167–9.

[11] Bober and Rubinstein, 1986, p.31.

[12] Kemp, 1997, p.210; originally cited in a slightly different translation in Sperling, 1992, pp.218–19.

[13] Kemp, 1997, p.210.

[14] Bober and Rubinstein, 1986, p.34.

[15] See Wolf, 2000.

[16] For a fuller consideration of this point, see Harbison, 1991, pp.158–62, and Evans, 2004, pp.588–90.

[17] Borchert, 2002, cat.27.

[18] For the three copies by Petrus Christus, now lost, see Ainsworth and Martens, 1994, p.15, and Evans, 2004, pp.582–6 (for the section on the relationship between Netherlandish artists and Byzantium, see pp.545–607).

## Chapter 1 Introduction

[1] Quoted in Levy, 1984, p.20.

## Chapter 1 Drawing and workshop practices

[1] Holt, 1957, vol.1, p.153.

[2] Oertel, 1940, pp.217–314.

[3] Degenhart, 1950, pp.93–158.

[4] Ames-Lewis, 1981, p.17.

[5] Hunter, 1947, pp.170–1. Papermaking was transported to Spain in the twelfth century, probably by Arabic craftsmen. Hunter charted the spread of the earliest paper mills in Italian, French, German and Netherlandish areas: Fabriano 1276; Bologna 1293; Troyes 1348; Nuremberg 1390; Huy 1405.

[6] Ames-Lewis and Wright, 1983, p.13. A wooden block would be prepared with a thin coating of ground bone, or tablets of parchment ready made which had been prepared with gesso and lead white in oil would be employed. See Dunkerton *et al.*, 1991, p.141.

[7] Goetschalckx, 1903, pp.245–9.

[8] My translation from de la Grange, 1897, p.287: 'Item je donne à Haquinet de Haulterue, fil Thomas, adfin qu'il soit tenus de prier Dieu pour Moy, tous mes hostieuls servons à mon mestier, avec ce tous patrons, papiers, et pourtraitures à moy appartenans': 22 March 1466.

[9] My translation from Sartori, 1976, pp.222–3: 'unum studium magnum in domo cum relevis desegnis et aliis rebus intus, unum studium parvum in domo dicta a relevis cum omnibus rebus intus spectantibus ad artem pictoriae et picturis existentibus in eis hic non descriptis'.

[10] Gilbert, 1980, p.36.

[11] My translation from Ludwig, 1903, p.13: 'dari volo librum designorum quod fuit prefati quondam patris nostri … dari volo Venture et Hieronimo meis garzonibus mea omnia designa retracta de Roma'.

[12] My translation from Knapp, 1903, p.275: '109 Charte dignudi di più sorte con alcuni torsi. 141 charte di teste di sancti et sancte di donne et di uomini di più foggie. 275 charte di sancti et sancte et angeli vestiti. 70 charte di bambini rossi et neri. 40 charte di paesi 10 coloriti et 30 non coloriti et disegnati con penna. 19 charte di animali et capi di animali. 55 charte di componimenti schizzati. 60 charte di schizi di varie cose. 28 charte di schizi di penna. 42 charte di bambini et figure et teste tochi di rosso. 12 Libri disegni tochi di penna et carbone, in tutti charte 180 incirca'. Another good example is that of Maso Finiguerra, who left 14 books of drawings; see Carl, 1983.

[13] Quoted in Campbell, 1981, p.53.

[14] See Dürer, 1958, pp.120–2; for Michiel see Klein and Zerner, 1966, p.29.

[15] Kurz, 1937, pp.3–5.

[16] Cennini, 1960, p.3.

[17] Ibid., pp.4–8.

[18] Ibid., p.8.

[19] Ibid., pp.8–16.

[20] My translation from Cennini, 1971, p.27: 'ritrar sempre le miglior cose che trovar puoi per mano fatte di gran maestri'.

[21] Cennini, 1960, p.15.

[22] My translation from Cennini, 1971, p.28: 'ritrarre de naturale. E questo avanza tutti gli altri essempi , e sotto questo con ardito cuore sempre ti fida, e spezialmente come incominci ad aver qualche sentimento nel disegnare. Continuando, ogni dì no manchi disegnar qualche cosa.'

[23] Cennini, 1960, p.16.

[24] Ibid., p.57.

[25] Ibid., p.123.

[26] Condivi, 1999, p.10: 'One day, when Michelangelo asked him for a sketchbook of his in which he had depicted

shepherds with their sheep and dogs, landscapes, buildings, ruins and such things, he was not willing to lend it to him.' Michelangelo was apprenticed 1488–90.

[27] Leonardo da Vinci, 1954, vol.2, p.218.

[28] Ibid., p.260.

[29] Ibid., p.260.

[30] Ibid., p.241.

[31] Ibid., pp.221–3.

[32] Alberti, 1991, p.72.

[33] Baxandall, 1971, pp.165–7.

[34] Original, emendations and translation by Dierick, 2000, p.79: 'Dat hair voren / Ocker[?]achtich [grau] grijs / Dat onderste vanden vorhoefde / Tusschen den auge sanguinachtich / Boven ten hairwair bleichachtich / Die wratte purperachtich / Den appel vanden auge / Alrenaest den swarten um / Bruyngeelachtich'.

[35] Billinge, Verougstraete and van Schoute, 2000, pp.41–8.

[36] For underdrawings in general, see Bomford, 2002, esp. pp.14–16, for the use of infrared reflectograms.

[37] Van Asperen de Boer and Faries, 1990, pp.37–50.

[38] Infrared reflectography was performed with a Grundig FA 70 television camera equipped with a Hamamatsu N 214 IR vidicon (1975); a Kodak wratten 87A filter cutting-on at 0.9 micron was placed between the vidicon target surface and the Zoomar 1:2 8/4 cm Macro Zoomatar lens. The television camera was mounted on a sturdy Linhof professional tripod with extension pieces, and a 90 cm sledge for moving the camera sideways. The monitor was a Grundig BG 12 with 875 television lines. Any documentation is done with a Nikon camera, a 50 mm macrolens, and Ilford film FP 4, ASA 125.

[39] Baxandall, 1971, p.166.

[40] Cordellier, 1996, pp.298–9.

[41] Ibid., pp.126–7.

[42] The paper has the watermark of a mountain surmounted by a cross, which was widely used by papermakers between 1380 and 1506. Information on watermarks – that is, the distinctive pattern woven into the wire mesh on which the sheet was dried by its manufacturer – may be used to date or authenticate drawings.

[43] Cordellier, 1996, pp.244–5, describes the drawing as made with pen and ink with preparatory traces of a stylus; in a monograph on the painter, Syson and Gordon, 2001, p.24, repeat this, while Popham and Pouncey, 1950, pp.134–5, cataloguing the British Museum collection, reported the media as pen and ink over black chalk.

[44] Cennini, 1960, pp.42–3.

[45] Woods-Marsden, 1989, pp.108–26.

[46] However, many drawings survive following the paintings of Rogier van der Weyden: see Sonkes, 1969.

[47] Campbell, 1994, p.8.

[48] King, 1987.

[49] Campbell, 1994.

[50] For the infrared examination of the four panels of Saint Luke in Leningrad, Bruges, Munich and Boston, see Faries, 1981, pp.93–9.

[51] The painting was examined in infrared by Rachel Billinge, Rausing Research Associate in the Conservation Department of the National Gallery, London. Infrared reflectography was carried out using a Hamamatsu C2400 camera with an N2606 series infrared vidicon tube. The camera is fitted with a 36mm lens to which a Kodak 87A Wratten filter has been attached to exclude visible light. The infrared reflectogram mosaic was assembled on a computer using Vips-ip software. For further information about the software see the Vips website at www.vips.ecs.soton.ac.uk.

[52] Watrous, 1957, pp.93–6.

[53] My translation from Giovio, 1999, p.234: 'Optices vero praeceptis nihil antiquius duxit, quorum subsidiis fretus luminum ac umbrarum rationes [diligentissime] vel in minimis custodivit. Secare quoque noxiorum hominum cadavera in ipsis medicorum scholis inhumano foedoque labore didicerat, ut varii membrorum flexus et conatus ex vi nervorum vertebrarumque naturali ordine pingerentur. Propterea particularum omnium formam in tabellis, usque ad exiles venulas interioraque ossium, mira solerta figuravit, ut ex eo tot opere [infinita exempla] ad artis utilitatem typis aeneis excuderentur' (Maffei's emendations).

[54] Cappelli, 1969, p.90. Since he was left-handed Leonardo wrote right to left in mirror writing, so that his left hand did not obscure what he was writing as he wrote.

[55] Sereni, 1989, pp.171–3. I am grateful to Dr Vicky Ley for drawing my attention to this interpretation.

[56] Quoted and translated from Vasari by Popham, 1971, p.11, in his account of these drawings. See also Ragghianti Collobi, 1974, pp.92–3, for a discussion of attributions.

[57] Kemp, 1981, pp.67–75.

[58] No painting remains of this particular subject matter, though Fra Pietro Novellara described seeing a cartoon depicting the Virgin and Child with Saint Anne and the Lamb in 1501 in Florence when Leonardo had returned from Milan; see Kemp, 1981, p.221. In 1517 Antonio de'Beatis recorded seeing three pictures at Amboise which Leonardo had taken to France, including 'a Madonna and Child seated on the lap of Saint Anne'; see Kemp and Roberts, 1989, p.41.

[59] The drawing also shows wheels, one of which is a mill wheel, and the following inscription: 'pago data ve[c]chia p[er] veder le machi[n]e de le pietre tedessce' (the payment given the old woman for seeing the machines of German stones).

[60] For discussion of cartoons which were utilised, see Bomford, 2002, pp.60–6.

[61] Kemp and Roberts, 1989, p.146.

[62] Translation by Richter from Leonardo da Vinci, 1970, vol.1, p.253.

[63] Strauss, 1974, vol.1, pp.i–vi.

[64] My translation from Bialostocki, 1986, p.17: 'Almanis pictor clarissime terris.'

[65] Camerarius (Kammermeister) was appointed Professor of Greek at the University of Nuremberg in 1526.

[66] Quoted in Dürer, 1958, p.139.

[67] Condivi, 1999, p.9.

[68] See Chapter 2 for an explanation of single-point perspective.

[69] Panofsky, 1945, vol.1, p.107.

[70] Dürer, 1958, p.64.

[71] Ibid., p.138.

[72] Ibid., p.120, 19 May 1521.

[73] Dürer, 1972b.

[74] Dürer, 1958, p.243.

[75] Ibid., p.248.

[76] Ibid., p.48.

[77] Ibid., 48.

[78] Ibid., p.117.

[79] Ibid., p.138. Conway translated *calamo aut penna* as 'pencil or pen', but I have emended it to 'reed or quill pen' for accuracy here; see Dürer, 1532, fol.Aii verso.

## Chapter 2 introduction

[1] Ames-Lewis, 2000, p.31.

[2] Kemp dates the treatise before the death of Federico da Montefeltro, Duke of Urbino. See Kemp, 1997, pp.97 and 100.

[3] Gombrich, 1976, p.20.

## Chapter 2   Constructing space in Renaissance painting

[1] Elkins, 1994, p.11.

[2] Ibid., p.247.

[3] Panofsky, 1971, p.7; Meiss, 1941, p.64.

[4] Quoted in Holly, 1984, p.152.

[5] Elkins, 1994, p.13.

[6] Gombrich, 1967, p.80.

[7] Bacon, 1962, vol.1, pp.232–4; Edgerton, 1975, pp.16–18.

[8] Edgerton, 1975; Kemp, 1978 and 1990.

[9] Quoted in Kemp, 1989, p.55.

[10] Cennini, 1960, p.57.

[11] Letter of the poet Domenico da Prato to his friend, Alessandro di Michele di Ghino Rondinelli, dated August 1413 (Codice II iv, 128, Biblioteca Nazionale di Firenze, fols 116v–117v), quoted in Tanturli, 1980, p.125: 'Se in questo luogo isterile d'ogni bene et fertile d'aspidi et di basilischi mi turbo, anzi mi ramarichi, non è da meravigliarsi, né se tu, accompagnato da magnanima volontà nel vostro Fiore ti ralegi, trovandoti alcuna volta col prespettivo, ingegnoso nomo Filippo di ser Brunelesco, raguardevole di vertudi e di fama ...'; Field, 2002, p.177.

[12] Manetti, 1970, p.42.

[13] See Trachtenberg, 1997, and his discussion of the significance of these sites as symbols of Florentine urbanism.

[14] Manetti, 1970, p.44.

[15] Trachtenberg, 1988, pp.42–3.

[16] Manetti, 1970, pp.44, 46.

[17] Kemp, 1978, pp.143–5.

[18] Massey, 2003, p.14 and section II, 'Representing perspective: problems of illustration', pp.127–257.

[19] Prager, 1968; Kemp, 1978, p.134.

[20] See Munman, 1985, for more on how sculptors made optical corrections in their works.

[21] Vasari, 1996, vol.1, p.319, 'Life of Masaccio'; Verdon, 2002, pp.158–9; Comanducci, 2003, p.15.

[22] The inscription reads: 'IO FUI GIÀ QUEL CHE VOI SIETE, E QUEL CH-IO SON VOI ANCO SARETE'.

[23] For more details on the iconography of Masaccio's *Trinity*, see Verdon, 2002, pp.160–1.

[24] Comanducci, 2003, p.17.

[25] Leonardo quoted in Kemp, 1989, pp.120–2; Jones, 2000, p.41.

[26] Alberti, 1991, p.53 (bk 1, para. 18).

[27] It could also be done by dusting the string with charcoal and snapping that onto the wall surface before the plaster was applied.

[28] Kemp, 1990, pp.17–20; Field, 2002, p.187.

[29] Verdon, 2002, pp.170–3.

[30] Antique decorated tomb chest.

[31] Field, 2003, p.64.

[32] Alberti, 1991, pp.39–40 (bk 1, para. 5).

[33] Nelson, 2000, p.7.

[34] Ibid., p.4.

[35] Leonardo quoted in Kemp, 1989, p.53.

[36] Alberti, 1991, p.42 (bk 1, para. 7).

[37] In Byzantine art 'the icon is termed a door': *Life of Saint Stephen the Younger* (d.764), quoted in Ware, 1987, p.38.

[38] Ware, 1987, p.38.

[39] Alberti, 1991, pp.65–7 (bk 2, para. 31).

[40] Ibid., p.44 (bk 1, para. 8).

[41] Ibid., p.42 (bk 1, para. 7).

[42] Ibid., p.48 (bk 1, para. 12).

[43] Ibid., p.56 (bk 1, para. 19).

[44] Vasari, 1996, vol.1, p.281, 'Life of Uccello'.

[45] The predella panels for the altarpiece are now separated from the main panel: they are *Stigmatisation of Saint Francis* and *John the Baptist in the Wilderness* (National Gallery of Art, Washington, DC); *Annunciation* and *Miracle of Saint Zenobius* (Fitzwilliam Museum, Cambridge); *Martyrdom of Saint Lucy* (Staatliche Museen, Berlin).

[46] See Kemp, 1990, pp.35–6, for a geometrical exposition of the plan and floor pattern.

[47] Edgerton, 1975, pp.56–9.

[48] Field, 2002, p.187.

[49] Field, 2003, p.63.

[50] Bertelli, 1992, p.115.

[51] Kemp, 1990, pp.30–2.

[52] Ibid., p.30.

[53] Lavin, 1972, p.78.

[54] Alberti, 1991, p.58 (bk 1, para. 20).

[55] Ibid., p.56 (bk 1, para. 19).

[56] Ahl, 2002, pp.143–4.

[57] Edgerton, 1975, p.27.

[58] Matthew 17:27.

[59] Leonardo quoted in Kemp, 1989, pp.60–2.

[60] Borsook, 1980, p.93; Bertelli, 1992, p.83.

[61] Hendy, 1968, pp.79–91; Clark, 1969, pp.38–43; Bertelli, 1992, pp.24–6.

[62] Bertelli, 1992, p.85.

[63] Clark, 1969, p.46.

[64] Cennini, 1960, p.56.

[65] Leonardo quoted in Kemp, 1989, pp.80–3.

[66] Dunkerton et al., 1991, p.296.

[67] Song of Songs 2:9.

[68] See Smeyers, 1998, pp.112–16 for a full discussion of this painting.

[69] See Kemp, 1996, pp.160–77.

[70] Panofsky, 1971, p.8.

[71] The inscription was later altered to include the foundation of a second chaplaincy.

[72] Borchert, 2002, p.234.

[73] Elkins, 1991a, pp.53–6.

[74] Upton, 1990, p.21.

[75] Panofsky, 1971, p.28.

[76] Upton, 1990, p.7.

[77] Borchert, 2002, p.80.

[78] The inscription reads: '14[5]7+PETRUS.XPI. ME.FECIT'; Schabacker, 1974, p.110; Collier, 1975, p.133.

[79] Ainsworth and Martens, 1994, p.43.

[80] Ibid., pp.45, 144.

[81] Ibid., pp.170–4.

[82] Elkins, 1991b, p.154.

## Chapter 3 introduction

[1] Ghiberti's Commentaries, c.1450, quoted in Gilbert, 1980, p.86.

[2] See Chapter 7.

## Chapter 3   The illusion of life in fifteenth-century sculpture

[1] Vasari, 1996, vol.1, p.253.

[2] Ibid., p.252.

[3] Ibid, p.254.

[4] Quoted in Krautheimer, 1970, vol.1, pp.303–4.

[5] For the text of this section of the Commentaries, see Gilbert, 1980, p.84, and Edwards, 1999, pp.102–3.

[6] Krautheimer suggested that the servants on the lower left of Ghiberti's relief are also derived from Roman sarcophagi, while Brunelleschi's Isaac resembles a kneeling prisoner from the Arch of Constantine and the servant drinking may come from a sarcophagus (Krautheimer, 1970, vol.1, pp.279, 281).

[7] Ibid., p.46.

[8] Italian Renaissance Sculpture, 1985, pp.121–2.

[9] Krautheimer, 1970, vol.1, p.105.

[10] Helms, 1998, p.30.

[11] Stone, 1981.

[12] Ibid.

[13] Krautheimer, 1970, vol.1, p.114.

[14] Gilbert, 1980, pp.82–3.

[15] Baumstark et al., 1995, p.206.

[16] The technical points that follow are taken from Baumstark et al., 1995, pp.273–305.

[17] Didier, 1993, p.15. Morand (1991, p.361) considers one of the two to be male.

[18] Both Morand (1991, ch.7) and Didier (1993, p.24) attribute the concept of the tomb more to Jean de Marville than to Sluter. Joubert (1999) argues that Marville's design was originally very much more conservative and that the three-dimensional arcade was a modification by Sluter.

[19] Such as one for the brother of Philip the Bold, Jean, Duc de Berry, by the duke's court sculptor, Jean de Cambrai, and later completed by Étienne Bobillet and Paul Mossellman in the 1450s. The tomb of Charles of Bourbon and his wife Agnes of Burgundy that French sculptor Jacques Morel was contracted to make in 1448 for a chapel in the abbey of Saint Peter, Souvigny, was also explicitly modelled on that of Philip the Bold. See Baudoin, 1983, p.61.

[20] There is no agreement on how the hydraulics for the fountain might have functioned or what the water from the well was used for, if at all. The estimate of the original height is in Didier, 1993, p.20.

[21] For an important review of the fragments remaining from the cemetery Cross and its original appearance, see Nash, 2005. Jacques Baudoin was the first to cast doubt on whether the surviving fragments of a Christ figure do in fact come from Sluter's Cross. See Baudoin, 1983, pp.239–41.

22 A papal indulgence grants remission of time the soul spends in purgatory after death.

23 Chédeau, 1999, pp.496–7.

24 This bar is mentioned in the records of the Carthusian monastery and restorers detected the lead (Chateignère, 1992, p.86).

25 In 1411 a wooden pavilion was built to shelter the Cross from the elements. See Morand, 1991, p.341.

26 Documents relating to the purchase of stone for the projects date from February 1417 (*Saint George*) and 1415 (*Four Crowned Saints*) but cannot tell us when either statue was begun. See Bennett and Wilkins, 1984, p.46, and Bergstein, 2000, p.192, doc.121.

27 Bergstein, 2000, pp.20–3 and 40–4.

28 Ibid., p.44.

29 Vasari, 1996, vol.1, p.367.

30 *Italian Renaissance Sculpture*, 1985, p.41; in the original Italian the term *disegno* could mean draw or design.

31 Vasari, 1960, ch.2, and Radcliffe, 1992a.

32 Alberti, 1972, esp. p.125. Grayson pointed out (p.140) that the dedicatory letter of the treatise must date from after 1466, when Giovanni Andrea d'Bussi (1417–75), to whom it was addressed, became a bishop. The treatise could have been written earlier, however, and is sometimes dated to the 1440s. Alberti died in 1472.

33 King, 1974.

34 This combination of scenes has been related to a particular mystery play performed at Santa Maria del Carmine, and it has been proposed that the relief was formerly the altarpiece of the Brancacci Chapel there. See Bennett and Wilkins, 1984, p.139.

35 Ibid., p.150.

36 Vasari, 1996, vol.1, pp.363–4.

37 Pernis, 1986.

38 An organ loft is the structure supporting the organ keyboard and pipes, which were often set high off the ground.

39 Bennett and Wilkins, 1984, p.107.

40 Ibid.; Vasari, 1996, vol.1, p.274.

41 See Genesis 37:12–28 and Genesis 44–5.

42 Vasari, 1996, vol.1, p.304.

43 The most recent dating of the Reinoldikirche altarpiece is in Turner, 1996, vol.20, p.688.

44 Jacobs, 1998, pp.188–90.

45 See Serck-Dewaide, 1998.

46 Jan van Eyck polychromed statues on the façade of Bruges town hall in 1434, and Rogier van der Weyden painted a votive relief and wooden tomb figures in 1439 and 1458–9, respectively.

47 Jacobs, 1998.

48 See Halsema-Kubes, Lemmens and Werd, 1980, pp.63–76, English summaries, p.43.

49 Vasari, 1996, vol.1, p.257.

50 The statues are now displayed inside the west portal, but their original location seems uncertain (Beck, 1991, pp.104–6 and 167–8). Annunciation statues now in Tournai Cathedral but from the church of the Madeleine, Tournai, dating from 1428, were also displayed across an architectural divide, and an Annunciation in Saint Kunibert, Cologne, dated by inscription to 1439, is displayed to either side of the chancel (Müller, 1966, Plates 69 and 77).

51 Janson, 1966, p.190.

52 For this and the following technical details, see Strom, 1980, and Bennett and Wilkins, 1984, pp.129–32 and 212–17.

53 Vasari, 1996, vol.1, p.365.

54 Kingery and Aronson, 1990, who correct Pope-Hennessy's assumptions about Luca della Robbia's technique.

55 Since Brunelleschi was one of those authorising the contract, it is sometimes suggested that he also might have done the drawing.

56 Kingery and Aronson, 1990, p.37.

57 The date of this sculpture has long been contested, but it is most likely that its installation dates from 1463. See Beck, 1965, and Fanti, 1989.

58 Agostini *et al.*, 1985, p.339.

59 For polychromy see ibid., pp.345–7.

60 See Radcliffe, 1992b, p.16, for Florentine monk Dominici's recommendations that images of the Virgin and Child serve as role models for children.

61 The head of the Christ Child was adapted for the design of a precisely datable well head in the Ca d'Oro, Venice (Radcliffe, 1992b, p.16, and *Italian Renaissance Sculpture*, 1985, p.90).

62 Strom, 1982.

63 *Italian Renaissance Sculpture*, 1985, p.109.

64 Pope-Hennessy, 1985, p.258 and Plate 18.

65 *Italian Renaissance Sculpture*, 1985, pp.131–2.

66 Pope-Hennessy, 1980, Plate 90A, cat.22, p.249.

67 Bennett and Wilkins, 1984, pp.122–3.

68 Leeuwenberg, 1965.

69 Bergstein, 2000, pp.36, 35, 31.

70 For such wax effigies in England, for example, see St John Hope, 1907.

71 See Baudoin, 1983, pp.134–9.

72 Ibid., p.139.

73 See Beck, 1991, vol.1, pp.55–67, and vol.2, pp.143–8.

74 Ibid., vol.1, p.61.

75 Olson, 1992, p.53.

76 Bennett and Wilkins, 1984, pp.93–4 and Figure 54.

77 Ibid., pp.180–2.

78 Ibid., p.179.

79 Ibid., p.120.

80 Pope-Hennessy, 1985, p.265, and Vasari, 1960, p.166.

[81] Vasari, 1960, pp.164–5.

[82] Svanberg and Qwarnström, 1998, pp.55–6.

[83] Ibid., pp.136–7.

[84] Lavin, 1998.

[85] Ibid., p.61.

## Chapter 4 introduction

[1] Burns, 1971.

[2] Saalman, 1958.

## Chapter 4   Architecture: theory and practice

[1] Vitruvius, 1999.

[2] Onians, 1971.

[3] For a detailed account of this exchange, see Ackerman, 1949.

[4] Quoted in Ungers, 1996, p.307.

[5] Holt, 1957, vol.1, p.247.

[6] Schuler, 1999.

[7] Vitruvius, 3.1.5 (1999, p.47). Vitruvius gives two examples of perfect numbers: 10, following the authority of Plato who pointed to the fingers of both hands, and 6, because the foot goes into a man's height six times, as well as rather obscure mathematical arguments.

[8] Ibid., 3.1.4 (1999, p.47).

[9] Ibid., 3.1.3 (1999, p.47).

[10] Vitruvius, 2.1.1, quoted in March, 1998, p.103.

[11] Vitruvius, 3.1.2 (1999, p.47).

[12] Günther, 1988, p.70.

[13] Stewering, 2000.

[14] Bucher, 1968, 1972.

[15] Ghisalberti, 1989; Romanini, 1964, 1973.

[16] Root 3 is the square root of 3: the number which, multiplied by itself, equals 3.

[17] The Milanese braccio, measuring 59.5 centimetres, was subdivided into 12 inches.

[18] Cadei, 1990.

[19] Panofsky, 1949.

[20] Wittkower, 1952.

[21] Root 2 is the square root of 2: the number which, multiplied by itself, equals 2.

[22] Frankl and Crossley, 2000, p.258.

[23] Chiaro et al., 1994.

[24] Onians, 1982.

[25] Manetti, 1970, p.50.

[26] Klotz, 1990, p.12.

[27] Ibid., pp.11–12.

[28] Vitruvius, 4.1.8 (1999, p.55).

[29] Serlio, 1996, pp.254–5.

[30] Saalman, 1993, pp.70–5.

[31] The Florentine braccio measures 58.3 centimetres.

[32] Alberti, 1988, p.200.

[33] Vasari, 1996, vol.1, p.350.

[34] Saalman, 1958.

[35] Vitruvius, 4.1.8 (1999, p.55).

[36] Saalman, 1993, pp.362–3.

[37] Ibid., pp.361–3.

[38] Mack, 1987.

[39] Mack, 1974.

[40] Mack, 1974, 1987.

[41] Saalman, 1988; Mack, 1974.

[42] Preyer, 1981.

[43] Ibid.

[44] Alberti, 1988, p.156.

[45] Ibid.

[46] Quoted in Mack, 1987, p.82.

## Chapter 5 introduction

[1] For a critique of this view, see Van Os, 1990.

## Chapter 5   Making Renaissance altarpieces

[1] Now in the state archives of Siena with dates ranging from 1355 to 1402. For an English translation by Gabriele Erasmi, see Maginnis, 2001, pp.201–24.

[2] For an indication of how Gregory's rationale continued to be used in later centuries, see the two theological texts published in Baxandall, 1972, p.41.

[3] Burckhardt, 1988.

[4] For representative examples, see Lane, 1984; Humfrey and Kemp, 1990; Borsook and Superbi Gioffredi, 1994; Limentani Virdis and Pietrogiovanna, 2002.

[5] Transubstantiation refers to the belief that – at a key point in the celebration of Mass – the bread and wine becomes the body and blood of Christ.

[6] Dunkerton et al., 1991, pp.27–9.

[7] Gardner, 1994.

[8] Christiansen, Kanter and Strehlke, 1988, cat. nos 38 a–m, pp.218–42.

[9] According to contemporary religious belief, purgatory was a place or state of punishment where those who had died could – with the help of prayer and the regular celebration of Mass – atone for their sins before being admitted into heaven.

[10] Formerly kept in the archive of San Francesco in Siena but now in the Vatican Archive, it was first published in Laurent, 1935, pp.260–1.

[11] For useful discussions of contracts, see Baxandall, 1972, pp.5–11, 14; Dunkerton et al., 1991, pp.128–35; Welch, 2000, pp.103–14; Limentani Virdis and Pietrogiovanna, 2002, pp.25–30.

[12] See the references to drawings in the contracts issued to the Paduan painter Pietro Calzetta in 1466 (Welch,

2000, pp.104–5) and the Florentine painter Ghirlandaio in 1485 (Baxandall, 1972, p.6).

[13] See the stipulation made to the Sienese painter Matteo di Giovanni in a contract of 1478 (Gilbert, 1980, pp.38–40) that he use an existing altarpiece as a model for his *Saint Barbara and Saints*. For the commission itself, see Seidel, 1994.

[14] Dunkerton *et al.*, 1991, pp.154–61; Kemp, 1997, pp.36–7; Limentani Virdis and Pietrogiovanna, 2002, pp.27–8.

[15] Laurent, 1935, pp.262–3.

[16] Ibid., pp.263–4.

[17] Ibid., pp.265–6.

[18] Transcribed in part in Pope-Hennessy, 1939, pp.50–1, n.62.

[19] A tertiary was a member of the 'third' order of religious, as distinct from the 'first' order (monks) and the 'second' order (nuns). He or she was usually a lay person, often – but not necessarily – living as part of a community.

[20] Israëls, 2003, pp.13–24, esp. pp.18–20 and Appendix I, A.II, pp.186–9.

[21] Transcribed in Israëls, 2003, p.15.

[22] Ibid., pp.39–58; cf. Gail Aronow in Van Os, 1984–90, vol.2, pp.226, 236; Norman, 2003, pp.112, 183.

[23] It appears from the cathedral inventories of 1435 and 1439 (transcribed in Israëls, 2003, Appendix I, B.I and B.II, p.199) that after the installation of the *Madonna della Neve* on the altar in 1433, this older painting was hung on the wall beside the altar. A marginal note in the inventory of 1439 then records its subsequent removal to another church in Siena, Sant'Ansano, where it remained until the mid-nineteenth century.

[24] The Latin inscription reads: 'SI CONFIDIS IN ME SENA ERIS GRATIA PLENA'.

[25] Norman, 2003, pp.76, 299, n.18.

[26] Van Os, 1984–90, vol.2, pp.169–74.

[27] Norman, 1999, pp.1–6.

[28] For further detail of the Santa Maria Maggiore altarpiece and its commission, see Joannides, 1993, pp.69–80, 414–22, who argues for a date of *c*.1424; Roberts, 1993, pp.86–98. Israëls, 2003, pp.97–126, argues that the commissioner of this Roman altarpiece was Cardinal Antonio Casini, Bishop of Siena (1408–27).

[29] For further detail on the physical structure of the altarpiece as revealed by its restoration in 1998, see Israëls, 2003, pp.57–73.

[30] Israëls, 2003, pp.48–56, also argues that there may have once been an outer frame for the altarpiece modelled in plaster on the wall behind the altar and that Sassetta decorated it and the surrounding wall.

[31] The central arch projects five centimetres from the picture plane while the side arches project only three centimetres.

[32] Sassetta had recently represented such settings in the predella of an altarpiece executed between *c*.1423 and 1426 for the Arte della Lana (the guild of wool

merchants). For illustration of these predella panels, see Christiansen, Kanter and Strehlke, 1988, cat. nos 1 a–f, pp.64–79. For a detailed reconstruction of this altarpiece's original site and function, see Israëls, 2001.

[33] See Chapter 2.

[34] The sculpted relief on the font by Donatello was completed by October 1427. It is also worth noting that in 1427 Sassetta was paid for the execution of a large drawing on the wall of the baptistery. This was probably a working plan for the final overall design of the font, in consultation with the Sienese sculptor Jacopo della Quercia, who had been appointed to complete the project. See Pope-Hennessy, 1939, pp.21–5; Israëls, 2003, p.27.

[35] For a detailed summary of the history of the Ghent altarpiece, see Dhanens, 1973, pp.128–37. This account does not include, however, the altarpiece's last move to its present, more secure location.

[36] Taken, with one minor change, from Dhanens, 1980, p.81, who also gives the original Latin text. For another, slightly different translation, see Limentani Virdis and Pietrogiovanna, 2002, p.52.

[37] Dhanens, 1973, p.24.

[38] Ibid., pp.26–36, 42–6; Dhanens, 1980, pp.14–121.

[39] For discussion of the stylistic evidence for Hubert's and Jan's share of the painting, see Dhanens, 1973, pp.112–25; Pächt, 1994, pp.135–70. For the more unlikely case that Hubert was only responsible for an elaborate sculpted frame (now lost), see Philip, 1971, pp.3–52, esp. pp.50–2.

[40] See Chapter 1, p.27.

[41] Cennini, 1960, pp.2–3, 5–6, 13, 14–15.

[42] According to sixteenth-century Ghent tradition, Jan did indeed train with Hubert.

[43] Pächt, 1994, pp.119–24, 135–6, 144–5, 170.

[44] Van Asperen de Boer, 1979.

[45] See, for example, the technical analysis of one of the predella panels from Duccio's *Maestà* (Plate 5.6) discussed in Bomford *et al.*, 1989, pp.83–9.

[46] Vasari, 1996, vol.2, p.862.

[47] The following account of the techniques of both tempera and oil painting relies on Dunkerton *et al.*, 1991, pp.162–204; the entries for 'tempera' (Dunkerton *et al.*) and 'oil painting' (Hassall and Stevenson in Turner, 1996, vol.23, pp.375–6, 748, vol.30, pp.425–8); and Campbell, 1998, pp.29–31.

[48] Dunkerton *et al.*, 1991, p.152; Israëls, 2003, pp.57–8.

[49] Cennini, 1960, pp.69–73.

[50] Baxandall, 1972, pp.15–23.

[51] See Cennino's detailed description of pigments and of the process of preparing egg tempera paint (Cennini, 1960, pp.20–39).

[52] Ibid., pp.49–50 (specifically describing painting drapery in fresco).

[53] Campbell, 1998, p.30.

54 Dhanens, 1973, pp.51–101.

55 Harbison, 1991, pp.195–7, 213, n.20, citing the doctoral research of Dana Goodgal.

56 Frequently translated as a 'sacred conversation', the name probably derives from the Latin *sacra conversatio*, meaning a holy company or gathering.

57 See Chapter 2.

58 The name of the woodworker who made the frame, Jacopo da Faenza, is inscribed on the back of the altarpiece, together with the date 1488. See Humfrey, 1993, cat. no. 38, p.348.

59 Goffen, 1986, pp.45–6. An *iconostasis* is the screen separating the sanctuary from the nave, on which the icons are placed.

60 Ibid., pp.32–4.

61 Ibid., pp.38–9.

62 Campbell, 1998, pp.387–91; Catherine Reynolds in Marks and Williamson, 2003, p.337.

63 For more detail on this altarpiece and its bibliography, see Zampetti, 1988, pp.264–5; Limentani Virdis and Pietrogiovanna, 2002, pp.264–77.

64 As Kauffmann (1970) demonstrates, the altarpiece was almost certainly commissioned by the confraternity of Valencia's municipal archers for the chapel in the confraternity's meeting house.

65 For examples of sculpted wood altarpieces, see Chapter 3.

66 For an early sixteenth-century Spanish *retablo major*, see Limentani Virdis and Pietrogiovanna, 2002, pp.380–91. For fifteenth-century Italian altarpieces combining sculpture and painting, see Humfrey, 1993, Plates 11, 117, and Welch, 2000, Plate 32.

67 Pagden, 1990.

## Chapter 6 introduction

1 Statistics are drawn from Stevenson, 1991, p.234.

2 For engravings included within handwritten books, see Weekes, 2004.

3 McDonald, 2005, p.20.

4 Bury, 1985, p.21.

## Chapter 6   The printed picture in the Renaissance

1 Landau and Parshall, 1994, p.31.

2 Ibid, pp.40–1. The proposed publication was an anthology of classical authors which seems not to have been completed. It should be emphasised that contracts were by no means standardised at the time. Landau and Parshall refer to another project that Schreyer helped finance, the *Weltchronik* published by Anton Koberger in Nuremberg in 1493, in which the artists Michael Wolgemut and Hans Pleydenwurff were allocated a share of the profits (1994, pp.38–40).

3 The case was forcefully argued by Ivins, 1929, pp.102–11. The blocks Ivins attributed to Dürer on the basis of their distinctive treatment were those for *Samson Rending the Lion* and the *Martyrdom of Saint Catherine*.

4 Dürer, quoted in Stechow, 1966, p.116.

5 Landau and Parshall, 1994, p.202.

6 Van der Stock, 1998, p.175.

7 The evidence is given in van Buren and Edmunds, 1971, pp.12–30.

8 Hyatt Mayor, 1971, unpaginated (between illus. 113 and 114).

9 See Landau and Parshall, 1994, p.49. Interesting evidence of the circulation of printing plates is provided by the reappearance of the plate for the *Large Einsiedeln Madonna* in northern Italy c.1490–1500, where it was reused for an engraving in the style of Urbino. The evidence is given in Bevers, 1986–7, pp.45–6.

10 This thesis was advanced by Wilhelm Pinder in the 1920s. It is cited in Shestack, 1967a, unpaginated.

11 Landau and Parshall, 1994, p.53.

12 Ibid., p.57.

13 Ibid., p.57. The relevant images are illustrated and discussed in *Israhel van Meckenem*, 1972 (see particularly Plates 69–72).

14 Ibid, pp.59–63.

15 Martineau, 1992. The essays in question were David Landau, 'Mantegna as printmaker' (pp.44–55), and Suzanne Boorsch, 'Mantegna and his printmakers' (pp.56–66).

16 Landau and Parshall, 1994, p.71.

17 See ibid., pp.72–3.

18 This estimate is given in Hyatt Mayor, 1971, between illus. 5 and 6.

19 See Steinberg, 1974, p.158.

20 Caution should be exercised before too close a parallel is drawn between the modern publishing profession and the activities of those who variously financed and organised the production and distribution of books, and occasionally of prints, during the Renaissance. As Lisa Pon has observed, 'No such term [as "publisher"] occurs in the sixteenth-century encyclopaediae of professions.' See Pon, 2004, p.49.

21 Landau and Parshall, 1994, p.11.

22 The principal early source for information on Lucas van Leyden is the *Schilder-boeck* of Karel van Mander, published in 1603–4, in which his date of birth is given as 1494. Lucas was clearly something of a prodigy, but it is unlikely that he was a mere 14 years of age at the time of completion of the print in question.

23 The original Italian is given in Vasari, 1976, pp.6–7. The English version is quoted in Pon, 2004, pp.39–41.

24 Quoted in Pon, 2004, p.39.

25 Quoted in Tietze-Conrat, 1957, p.241. The original text of the letter is given in Kristeller, 1902, pp.550–1, document nos 112–14.

26 Quoted in Pon, 2004, pp.39–40.

27 See Landau and Parshall, 1994, p.107.

28 Pon, 2004, p.40.

29 Ibid., p.41.

30 See ibid., pp.53–66. The principal evidence in support of Pon's argument is provided by Marcantonio's engraving of *The Glorification of the Virgin* from the *Life of the Virgin* series, on which a device appears which was used by Niccolò and Domenico Sandri del Jesus on books for which they are known to have been responsible.

31 See particularly the discussions in Landau and Parshall, 1994, pp.121–35, and in Pon, 2004, pp.118–36. While the authors of these studies are agreed on attributing both versions of the engraving to Marcantonio, they differ in their view as to the authorship of the drawing reproduced here (Plate 6.31). Landau and Parshall regard it as a study by Raphael preliminary to a final complete *modello* for the print. Pon sides with those who argue for another author, even entertaining the possibility that this might have been Marcantonio himself.

32 Various reasons have been offered for the existence of two versions of the composition. The most compelling, advanced by Landau and Parshall following information given by Vasari, is that the terms of Marcantonio's business relationship with Raphael were such that the plate for the first version would have been held by the latter's agent il Baviera, and that Marcantonio made the second version, as it were on his own time and possibly after Raphael's death, so as to be able to profit from impressions of the celebrated image. (The commercial success of the print is indicated by the existence of numerous early copies.) See Landau and Parshall, 1994, p.146.

33 Ibid., pp.123–4.

34 The meeting is mentioned by Dürer in a journal he kept of his travels in the Netherlands in 1520–1. See Conway, 1958, ch.7. It was Dürer's practice to travel with a stock of his own prints, which he used for gifts, for payments of certain expenses and for exchanges with other artists.

# Chapter 7 Making histories, publishing theories

1 Leonardo da Vinci, 1970, vol.1, p.54: the terms used for 'lord' and 'God' are *signore* (that is, a temporal ruler) and *Dio* (the maker of the universe).

2 My special thanks go to Caroline Elam for her advice.

3 Alberti, 1972, pp.3–4. This is the English translation of the Latin *De pictura*. The same translation by Cecil Grayson but with a foreword added by Martin Kemp is available in Penguin (Alberti, 1991). Kemp helpfully put into italics those passages that Alberti did not translate from the Latin when he made his own Italian translation in 1436. For the English translation of the Italian *Della pittura*, which would have been the version accessible to artists themselves, see Alberti, 1966.

4 For the theoretical and historical texts considered in this chapter, the authoritative guide is still the survey by Julius von Schlosser-Magnino in the revised edition by his former pupil Otto Kurz: see Von Schlosser-Magnino, 1956.

5 Condivi, 1998, p.61.

6 For Leonardo's lists of Latin vocabulary and grammar rules dating from *c*.1490, see Leonardo da Vinci, 1977, vol.1, p.383, and vol.2, pp.130, 248, 353, 358, 387.

7 Van Even, 1869, pp.331–3. See Gilbert, 1980, pp.43–4: there were 28 books.

8 Vasari, 1996, vol.2, p.1020.

9 Milanesi, 1969, vol.1, p.354.

10 Levine, 1974, pp.31–49.

11 Aminadeb is one of the ancestors of Christ listed at the beginning of the Gospel of Saint Matthew (Matthew 1:4).

12 My translation from Boselli, 1977, vol.1, pp.80–1: 'Aminadeb q[uondam] m[agistris] joannini de Martinengo … Magistro Joanne de flandria magistro textur[a]e figurarum.'

13 Elizabeth Gilmore Holt (1957, vol.1, pp.1, 18, 22) offers a selection of texts, such as the treatise on art by Theophilus, who is thought to have been a Benedictine monk of Greek extraction and who probably wrote in the tenth century; the writings on religious art of Saint Bernard of Clairvaux (1091–1153), founder of the Cistercian Order; and the description of the patronage of Abbot Suger (1081–1151) in his church of Saint Denis.

14 Baxandall, 1972, pp.114–53.

15 Roriczer, 1845, and for a translation into English, see Holt, 1957, vol.2, pp.95–101.

16 Brion-Guerry, 1962, p.151.

17 Dürer, 1958, p.121.

18 My translation from Barthélémy de Chasseneux, 1546, fol.213v: 'Quod mechanica ars septem habet species: Lanificium, Armaturam, Navigationem, Agriculturam, Venationem, Medicinam, et Theatricam. Et dicitur Mechanica scientia adulterina, sive non liberalis.'

19 My translation from Villani, 1997, p.153: 'antiquatam picturam … cepit ad nature similitudinem quasi lascivam et vagantem longius arte et ingenio revocare'.

20 Ibid., p.154: 'Extimantibus multis, nec stulte quidem, pictores non inferioris ingenii his quos liberales artes fecere magistros.'

21 My translation from Cennini, 1971, pp.3–4: 'dipingere, et conviene avere fantasia, e operazione di mano, … e con ragione merita metterla a sedere in secondo grado alla Scienza e coronarla di Poesia. La ragione è questa: che il Poeta, con la scienza, per una che ha, il fa degno [prima che el fa degno] e libero di potere comporre, e legare insieme sì e non come gli piace [pare], secondo sua volontà; per lo simile al dipintore dato è libertà potere comporre una figura ritta, a sedere, mezzo uomo, mezzo cavallo, siccome gli piace, secondo sua fantasia.'

22 Rossky, 1968, pp.49–73, esp. pp.43–5.

23 Cennini, 1960, p.2.

24 Ibid., p.91.

[25] See Baxandall, 1972, pp.115–18, for an account of the hybrid approach of Cristoforo Landino to writing the history of contemporary art.

[26] My translation from Villani, 1997, p.154: 'Gioctus, non solum illustris [fame decore an]tiquis pictoribus conparandus, sed forte arte [et ingenio] preferendus, in pristinam dignitatem sic nomenque maximum picturam restituit.'

[27] Cennini, 1960, p.2.

[28] Quoted and translated by Ferguson, 1963, pp.49–50.

[29] Alberti, 1991, p.34.

[30] For example, see Rucellai, 1960.

[31] Ghiberti, 1912, vol.1, p.23. Ulixe di Macedonia has not been identified.

[32] My translation from Manetti, 1970, pp.56–62, esp. pp.57–8: 'a grandi ingegnj e a giudicj degli huomini degnissimij'.

[33] Ibid., p.62 (trans. Catherine Enggass).

[34] My translation from Manetti, 1970, p.65: 'tanta cupidita aveva dello onore e della excellenzia e della gloria dello ingegnio'.

[35] Murray, 1957; it praised Brunelleschi, Donatello, Ghiberti, Masaccio, Fra Angelico, Filippo Lippi, Paolo Uccello, and Luca della Robbia.

[36] Ibid.

[37] Filarete, 1965, vol.1, p.102.

[38] For example, Filarete listed numerous Italian sculptors as well as Slavic ones and a Catalan who would be worthy to carve in Sforzinda – see Filarete, 1965, vol.1, pp.76–7. He noted goldsmiths from Italy, France and Germany (ibid., p.112). He also itemised murallists from different Italian cities, such as Filippo Lippi, Piero della Francesca, Squarcione, Cosimo Tura, and Foppa (ibid., p.116). He referred to painters beyond Italy by relating discussion of colours to the oil painting skills of Jan van Eyck and Rogier van der Weyden (ibid., p.311).

[39] Manuscripts of Pliny the Elder's (Gaius Plinius Secundus, c.23–79 CE) encyclopaedia were quite numerous; see Armstrong, 1983, pp.19–39.

[40] Quoted in Addington-Symonds, 1893, vol.1, p.154.

[41] Baxandall, 1972, pp.117–18, and Alighieri, 1481, fol.5.

[42] Gombrich, 1966, pp.1–2; the preface was addressed to Duke Federico da Montefeltro. I have translated ingeniis as 'talents' although Gombrich has 'genius'.

[43] My translation from Valla, 1999, vol.1, pp.60–2: 'illae artes, quae proxime ad liberales accedunt, pingendi, scalpendi, fingendi, architectandi aut tamdiu, tantoque, opera degeneraverint, ac pene cum litteris ipsis demortuae fuerint, aut hoc tempore excitentur ac reviviscant'.

[44] My translation from Baxandall, 1971, pp.165–7.

[45] Savonarola, 1902, p.44. Savonarola listed works by Guariento, Giusto de' Menabuoi, Giotto, Stefano da Verona, Jacopo d'Avanzi di Bologna, and Altichiero da Verona.

[46] My translation from the Italian in Baxandall, 1972, p.112. Here Raphael's father takes the image of painting as if it was a human body and asserts that Mantegna's skill meant he surpassed all other artists.

[47] Santi, 1985. He began with the Netherlanders van Eyck and van der Weyden, and then praised the work of Gentile da Fabriano and Pisanello. He commended the paintings of the Florentines Fra Angelico, Filippo Lippi, Francesco Pesellino, Domenico Veneziano, Masaccio, Andrea del Castagno, Paolo Uccello, the Pollaiuoli brothers and Leonardo da Vinci. He included artists working in the orbit of his court from Umbria (Luca Signorelli and Pietro Perugino) and Piero della Francesca of San Sepolcro in Tuscany, Melozzo da Forlì, and also Cosimo Tura and Ercole de'Roberti, who were based in Emilia. He ended by praising painters working in the Veneto (Antonello da Messina, Gentile and Giovanni Bellini).

[48] Pacioli, 1494, fol.2v.: 'Gentile Bellini and his blood brother' of Venice, the painters of Florence (Botticelli, Filippino Lippi, and Ghirlandaio), those of Perugia (Perugino), Cortona (Luca 'the worthy disciple of our Master Pietro'), Mantua (Andrea Mantegna), and Forlì (Melozzo and his pupil Marco Palmezzano).

[49] Ibid.

[50] Camillo Leonardo da Pesaro, 1502, fols XLVII–XLVIII.

[51] Ibid., fol.XLVII (my translation): 'Qui pingendi regulas geometricis arithmeticis ac perspectivis regulis miro ordine industria ac doctrina instituerunt ut ex cor [am] op[eri]bus patet; nec et[iam] hoc ab antiq[ui]s ta[men] a[m]ple p[er]tractatu[m] fuit.'

[52] Raffaele Maffei da Volterra, 1506, fol.CCC. He lists also the works of Pisanello, Ercole of Ferrara, Mantegna, Jacopo of Bologna 'who drew the whole of Trajan's Column', Leonardo da Vinci who made the Last Supper, Pietro Perugino, Melozzo da Forlì, Giovanni Bellini, Donatello, Antonio Pollaiuolo, Andrea of Cremona, Cristoforo of Mantua, and Michelangelo (especially his Pietà, his Bacchus in the house of Jacopo Galli, and his David).

[53] Gaurico, 1969, pp.254–60. The Florentines listed were Mino da Fiesole, Benedetto da Maiano, Michelangelo, Andrea Sansovino and Francesco Rustici. The Venetians were Antonio Rizzo, Pietro Lombardo and his sons Tullio and Antonio. Gaurico singled out Tullio for special acclaim, though saying that, as he was his friend, readers might consider him partial. Working in Lombardy he listed Cristoforo del Solario, Giovanni Gaspare Pedoni and Giorgio Lascaris.

[54] Ibid., p.254 (my translation): 'An quid non priora ingenia, priora et miracula rediere?'

[55] My translation from Ugolino da Verino, 1583, fols 17r–18r: 'Ioctus revocavit ab orco … picturam.' Despite never having seen any ancient Greek paintings, Ugolino confidently compared Filippo Lippi with Apelles of Cos, Leonardo with Protogenes, and Botticelli with Zeuxis, while Andrea del Verrocchio was the equal of Lysippus.

[56] Lemaire, 1549, pp.70–1. Some of the names he lists cannot now be identified.

[57] Lemaire, 1509, pp.398–401 (my translation): 'Ou Johannes qui tant fut elegant.'

[58] Brion-Guerry, 1962, pp.341–2.

[59] My translation from Rupprich, 1956–69, vol.1, p.290: 'Icones Israhelis Alemani per universam Europam desiderantur habenturque a pictoribus in summo pretio. Quid de Martino Schon Columbariensi dicam, qui in hac arte fuit tam eximius, ut eius depictae tabulae in Italiam, in Hispanias, in Galliam, in Britanniam et alia mundi loca abductae sint … Eius discipulus Albertus Türer [sic] et ipse Alemanus hac tempestate excellentissimus est et Nurenbergae imagines absolutissimas depingit, quae a mercatoribus in Italiam transportantur et illic a probatissimis pictoribus non minus probantur quam Parasii aut Apellis tabulae.'

[60] Schultz, 1869, pp.60–72, esp. p.71, where he listed Abbot Johannes of Trier, and Crisantus and Henricus of his own monastery at Bonn.

[61] Ibid., p.71 (my translation): 'Zetus … ingeniosissime pingendo ad veterem rursus dignitatem reduxisse dictur.'

[62] My translation from Rupprich, 1956–69, vol.1, p. 290: 'Cui consensus omnium et in pictura et in fictura aetate nostra principatus defertur. Qui quum nuper in Italiam redisset, tum a venetis, tum a bononiensibus artificibus, me saepe interprete, consalutatus est alter Apelles.'

[63] Ibid.: 'Sicut autem Zeusis, teste Plinio in 35, capite decimo, uvis pictis aves fefellit, et Zeusidem linteo Parrhasius, ita Albertus meus canes decepit.'

[64] Ibid., p.291: 'Tantam pingendi artem, multis saeculis intermissam, per Norimbergenses revocatam.'

[65] Ibid., p.292: 'Tibi uni, me iudice, saeculum nostrum principatum defert, ceteri Germani cedunt, Itali (alioquin laudis avidi) manus dant, Galli te consultant magistrum.'

[66] Ibid., p.294: 'probitas, facundia, comitas, facilitas, humanitas'.

[67] Erasmus, 1985, pp.398–9.

[68] Dürer, 1958, pp.136–41.

[69] Ibid.

[70] Rupprich, 1956–69, vol.1, p.296: 'Honos alit artes.'

[71] Albertini, 1510, unpaginated. For a reprint, see *Five Early Guides to Rome and Florence*, 1972.

[72] Albertini, 1909, and also for another facsimile of this guide, see *Five Early Guides to Rome and Florence*, 1972.

[73] My translation from Cesariano's edition of Vitruvius, 1981, fol.CXIIIIr–v: 'a scrivere una tanta divina e sacra scientia con poche parole. Ma questa essendo concessa per gratia de natura vel auxiliata con il studio pervene rarissima et excede ogni praecii et praemii per quelle cose imitate de la natura dimostra.'

[74] Ibid.

[75] For example, see Vitruvius, 1981, fol.XLVIIIv, where he listed artists with Lombard connections who had studied classical figural proportions as Giovanni Cristoforo Romano, Cristoforo Gobbo, Agostino Busti, Tullio Lombardo, Bartolomeo Clementi di Reggio [Emilia], Boltraffio, Marco d'Oggiono, lo Zenale, il Bramantino and Bernardino Luini.

[76] My translation from Castiglione, 1947, pp.92–3: 'Eccovi che nella pittura sono eccellentissimi Leonardo Vincio, il Mantegna, Raffaello, Michelangelo, Georgio da Castelfranco: nientidimeno, tutti son tra sé nel far dissimili; di modo che ad alcun di loro non par che manchi cosa alcuna in quella maniera, perché si conosce ciascun nel suo stil essere perfettissimo.'

[77] My translation from Barocchi, 1971, pp.7–23.

[78] Ibid., pp.7–8: 'Fuit ingenio valde comi, nitido, liberali, vultu autem longe venustissimo, et cum elegantiae omnis deliteaturumque maxime theatralium mirificus inventor et arbiter esset, ad lyramque scite caneret, cunctis per omnem aetatem principibus mire placuit.'

[79] Leonardo da Vinci, 1954, vol.2, p.258.

[80] Panofsky, 1945, vol.1, p.254.

[81] Ghiberti, 1912, vol.2, pp.26, 38–9. Said, 1979, p.264, gives details of the fourteenth-century Italian translation.

[82] Leonardo da Vinci, 1970, vol.1, p.5.

[83] Christian thinkers during the medieval period had seen the marks of God's creation in all things. The habits of animals were regarded as providing moral counsel to humans, and books called bestiaries listed their habits and the lessons to be drawn from their examples.

[84] Fiore and Tafuri, 1993, pp.358–79.

[85] Lancillotti, 1976.

[86] Dürer, 1972a.

[87] For *De statua*, see Alberti, 1972. On the difficulties of dating this treatise, see Chapter 3, note 32.

[88] Brescia, 1501, 1506, 1508; Turin, 1516; Paris, 1517; Venice, 1517. See Grapaldi, 1494; also Clarke, 2003, pp.98–100, 106–7.

[89] My translation from Gaurico, 1969, p.43: 'illi [scriptores] quidem agunt verbis, At vero hi [sculptores] rebus, illi narrant, hi vero exprimunt explicant.'

[90] Ibid., pp.32–3, 36–7, 72–3.

[91] Pacioli, 1956, pp.16–18.

[92] Alberti, 1991, p.33.

[93] Ibid., pp.59, 26.

[94] Ibid., p.63.

[95] Ibid., p.62.

[96] Baxandall, 1972, p.117.

[97] Filarete, 1965, vol.1, p.17.

[98] Ibid., p.6.

[99] Ibid., pp.297, 306–7.

[100] Piero della Francesca, 1984, pp.43–7.

[101] Brion-Guerry, 1962, pp.85–8.

[102] These variations were shown to be two different forms of the same construction by the Italian theorist Vignola in the mid-sixteenth century – see Gadol, 1969, p.51. Pélerin described perspective as one of the 'secrets of pictorial art in which Italians hold the palm' and as 'a science difficult

and subtle of understanding', which can 'represent things past and far away as if immediate and present and knowable at one glance' (my translation from Brion-Guerry, 1962, pp.218–25).

[103] See Von Schlosser-Magnino, 1956, pp.273–4, for the editions and translations of this book.

[104] Dürer, 1958, pp.241–50.

[105] Quoted in Panofsky, 1945, vol.1, p.274.

[106] Albertini, 1909, p.9.

[107] For Biondo, see Alberti, 1988, p.xvii; for Leonardo, see Leonardo da Vinci, 1954, vol.2, p.516.

[108] Alberti, 1988, p.xviii.

[109] Massing, 1999, pp.251–3, and Alberti, 1966, p.90.

[110] Tavernor, 1998, pp.127–42 (San Sebastiano) and pp.159–67 (Sant'Andrea).

[111] My translation from Lancillotti, 1976, p.16.

[112] My translation from Milanesi, 1969, vol.3, p.33: 'Si dice, spectatissimi offitiali, con debita reverentia per maestro Bernardino Pintorichia [sic], delle Signorie Vostre servidore, non già el minimo infra li altri egregi pittori; delli quali, benché come scrive Cicerone li Romani nelli primi tenpi poco sì delectassero, tamen crescente l'inperio doppo le orientali victorie, et doppo la expugnatione delle Grece città, quelli con sommo studio da tucte le parti del mondo apresso di loro accolsero, et di pictura et scultura qualunche preclara opera rapere non dubitorno: estimando la pictura essere arte peregregia, et simile all'altre liberali arti, et con la poetica concorrere.'

# Bibliography

Ackerman, J. (1949) '"Ars sine scientia nihil est": Gothic theory of architecture at the Cathedral of Milan', *The Art Bulletin*, 31:2, pp.84–111.

Addington-Symonds, J. (1893) *The Life of Michelangelo Buonarroti*, 2 vols, London, John C. Nimmo.

Agostini, G. *et al.* (1985) *Tre artisti nella Bologna dei Bentivoglio*, Padua, Nuova Alfa.

Ahl, D.C. (2002) 'Masaccio in the Brancacci Chapel', in D.C. Ahl (ed.) *The Cambridge Companion to Masaccio*, Cambridge, Cambridge University Press, pp.138–57.

Ainsworth, M.W. and Martens, M.P. (1994) *Petrus Christus: Renaissance Master of Bruges*, New York, Ludion/New York, Metropolitan Museum of Art (exhibition catalogue).

Alberti, L.B. (1966) *On Painting*, ed. and trans. J. Spencer, New Haven and London, Yale University Press (translation of the Italian *Della pittura*).

Alberti, L.B. (1972) *On Painting and On Sculpture: The Latin Texts of 'De pictura' and 'De statua'*, ed. and trans. C. Grayson, London, Phaidon.

Alberti, L.B. (1988) *On the Art of Building*, ed. and trans. J. Rykwert, N. Leach and R. Tavernor, Cambridge, MA and London, MIT Press.

Alberti, L.B. (1991) *On Painting*, ed. and trans. C. Grayson, intro. M. Kemp, Harmondsworth, Penguin (translation of the Latin *De pictura* showing passages left out from *Della pittura* by Alberti).

Albertini, F. (1510) *Opusculum de mirabilibus novae et veteris urbis Romae*, Rome.

Albertini, F. (1909) *Memoriale*, ed. H.P. Horne, London, Chatto & Windus (first published Florence, 1510).

*Albrecht Dürer: Master Printmaker* (1988) New York, Hacker Art Books/Boston, Museum of Fine Arts, Department of Prints and Drawings (exhibition catalogue).

Alighieri, D. (1481) *Divina Commedia*, ed. C. Landino, Florence.

Ames-Lewis, F. (1981) *Drawing in Early Renaissance Italy*, New Haven and London, Yale University Press.

Ames-Lewis, F. (2000) *The Intellectual Life of the Early Renaissance Artist*, New Haven and London, Yale University Press.

Ames-Lewis, F. and Wright, J. (1983) *Drawing in the Italian Renaissance Workshop*, London, Victoria and Albert Museum.

Armstrong, L. (1983) 'The illustration of Pliny's *Historia naturalis*: manuscripts before 1430', *Journal of the Warburg and Courtauld Institutes*, 46, pp.19–39.

Bacon, R. (1962) *The Opus Majus of Roger Bacon*, trans. R.B. Burke, 2 vols, New York, Russell & Russell.

Barocchi, P. (1971) *Scritti d'arte del Cinquecento*, Milan and Naples, Ricciardi.

Barthélémy de Chasseneux (1546) *Gloriae mundi*, Lyons.

Bartrum, G. (2002) *Albrecht Dürer and his Legacy*, London, British Museum.

Bartsch, A. (1970) *Le Peintre graveur*, 21 vols, reprinted edn, Nieuwkoop, de Graaf (first published 1803–21).

Bartsch, A. (1971–) *The Illustrated Bartsch*, University Park, Pennsylvania State University Press.

Baudoin, J. (1983) *La Sculpture flamboyante: Les Grands Imagiers d'occident*, Nonette, Editions Créer.

Baumstark, R. *et al.* (1995) *Das Goldene Rössl: Ein Meisterwerk der Pariser Hofkunst um 1400*, Munich, Hirmer (exhibition catalogue).

Baxandall, M. (1971) *Giotto and the Orators: Humanist Observers of Painting in Italy and the Discovery of Pictorial Composition, 1350–1450*, Oxford, Clarendon Press.

Baxandall, M. (1972) *Painting and Experience in Fifteenth Century Italy*, Oxford, Clarendon Press.

Beck, J. (1965) 'Niccolo dell'Arca: a re-examination', *The Art Bulletin*, XLVII, pp.334–44.

Beck, J. (1991) *Jacopo della Quercia*, 2 vols, New York, Columbia University Press.

Belozerskaya, M. (2002) *Rethinking the Renaissance: Burgundian Arts across Europe*, Cambridge, Cambridge University Press.

Beltrami, L. (1964) *Luca Beltrami e il Duomo di Milano: tutti gli scritti riguardanti la cattedrale, pubblicati tra il 1881 e il 1914*, ed. A. Cassi Ramelli, Milan, Ceschina.

Bennett, B.A. and Wilkins, D.G. (1984) *Donatello*, Oxford, Phaidon.

Bergstein, M. (2000) *The Sculpture of Nanni di Banco*, Princeton, Princeton University Press.

Bertelli, C. (1992) *Piero della Francesca*, trans. E. Farrelly, New Haven and London, Yale University Press.

Bevers, H. (1986–7) *Meister ES: Ein Oberrheinischer Kupferstecher der Spätgotik*, Munich, Staatliche Graphische Sammlung (exhibition catalogue).

Bialostocki, J. (1986) *Dürer and his Critics, 1500–1971: Chapters in the History of Ideas*, Baden-Baden, V. Koerner.

Billinge, R., Verougstraete, H. and van Schoute, R. (2000) 'The Saint Barbara', in S. Foister, S. Jones and D. Cool (eds) *Investigating Jan van Eyck: A Handbook of Sources*, Turnhout, Brepols, pp.41–8.

Bober, P.P. and Rubinstein, R. (1986) *Renaissance Artists and Antique Sculpture*, London, Harvey Miller/Oxford, Oxford University Press.

Bomford, D. (ed.) (2002) *Underdrawings in Renaissance Paintings*, London, National Gallery Publications (exhibition catalogue).

Bomford, D. *et al.* (1989) *Art in the Making: Italian Painting before 1400*, London, National Gallery Publications.

Borchert, T.-H. (ed.) (2002) *The Age of van Eyck: The Mediterranean World and Early Netherlandish Painting 1430–1530*, London, Thames & Hudson/ Bruges, Groeningemuseum (exhibition catalogue).

Borsook, E. (1980) *The Mural Painters of Tuscany*, Oxford, Clarendon Press.

Borsook, E. and Superbi Gioffredi, F. (eds) (1994) *Italian Altarpieces 1250–1550: Function and Design*, Oxford, Clarendon Press.

Boselli, C. (1977) *Regesto artistico dei notai roganti in Brescia dall'anno 1500 all'anno 1560*, 2 vols, Brescia, Ateneo di Brescia.

Brion-Guerry, L. (1962) *Jean Pélerin Viator: Sa place dans l'histoire de la perspective*, Paris, Les Belles Lettres.

Bucher, F. (1968) 'Design in Gothic architecture', *Journal of the Society of Architectural Historians*, 27:1, pp.49–71.

Bucher, F. (1972) 'Medieval architectural design methods', *Gesta*, 11:2, pp.37–51.

Burckhardt, J. (1988) *The Altarpiece in Renaissance Italy*, trans. P. Humfrey, Oxford, Phaidon (first published 1898 as 'Das Altarbild').

Burns, H. (1971) 'Quattrocento architecture and the antique: some problems', in R.R. Bolgar (ed.) *Classical Influences on European Culture*, Cambridge, Cambridge University Press, pp.269–87.

Bury, M. (1985) 'The taste for prints in Italy to *c.*1600', *Print Quarterly*, 2, pp.12–26.

Cadei, A. (1990) 'Cultura artistica delle cattedrali: due esempi a Milano', *Arte Medievale*, 1, pp.83–103.

Camillo Leonardo da Pesaro (1502) *Speculum lapidum*, Venice.

Campbell, L. (1981) 'The early Netherlandish painters and their workshops', in D. Hollanders-Favart and R. van Schoute (eds) *Le Dessin sous-jacent dans la peinture*, conference III (6–8 September 1979): *Le Problème Maître de Flémalle – van der Weyden*, Louvain-la-Neuve, Collège Érasme, pp.43–61.

Campbell, L. (1994) 'Rogier van der Weyden and his workshop', in *Lectures and Memoirs: Proceedings of the British Academy*, 84, Oxford, Oxford University Press for the British Academy, pp.1–24.

Campbell, L. (1998) *The National Gallery Catalogues: The Fifteenth Century Netherlandish Schools*, London, National Gallery Publications.

Cappelli, A. (1969) *Cronologia, cronografia e calendario perpetuo*, Milan, U. Hoepli.

Carl, D. (1983) 'Documenti inediti su Maso Finiguerra e la sua famiglia', *Annali della Scuola Normale di Pisa*, 13, pp.507–54.

Castiglione, B. (1947) *Il libro del cortegiano del conte Baldesar Castiglione*, ed. V. Cian, Florence, Sansoni.

Cennini, C. (1960) *The Craftsman's Handbook: The Italian 'Il libro dell'arte'*, trans. D.V. Thompson, New York, Dover (this edn first published 1933).

Cennini, C. (1971) *Il libro dell'arte*, ed. F. Brunello, Vicenza, Neri Pozza.

Cesariano, C. (1968) *Di Lucio Vitruvio Pollione de Architectura*, facsimile reprint, New York, Da Capo (first published 1521).

Chateignère, M. (1992) 'Problèmes posés par la restauration du Puits de Moise, aspects techniques', in *Actes des Journées Internationales Claus Sluter September 1990*, Dijon, Association Claus Sluter, pp.85–96.

Chédeau, C. (1999) 'Réflexions sur l'organisation des ateliers de sculpteurs en Bourgogne et en France au XVe et XVIe siècles: les modèles d'atelier', in *Pierre, lumière, couleur: Études d'histoire de l'art du Moyen Age en l'honneur d'Anne Prache*, Paris, Presse de l'Université de Paris-Sorbonne, pp.487–99.

Chiaro, C.R. *et al.* (1994) *Il Battistero di San Giovanni a Firenze*, Modena, Franco Cosimo Panini.

Christiansen, K., Kanter, L.B. and Strehlke, C.B. (1988) *Painting in Renaissance Siena, 1420–1500*, New York, Metropolitan Museum of Art (exhibition catalogue).

Clark, K. (1969) *Piero della Francesca: Complete Edition*, 2nd edn, London, Phaidon.

Clarke, G. (2003) *Roman House – Renaissance Palaces: Inventing Antiquity in Fifteenth-Century Italy*, Cambridge, Cambridge University Press.

Collier, J.M. (1975) 'Linear perspective in Flemish painting and the art of Petrus Christus and Dirk Bouts', PhD thesis, University of Michigan.

Comanducci, R.M. (2003) '"L'altare nostro de la Trinità": Masaccio's Trinity and the Berti family', *Burlington Magazine*, CXLV, pp.14–21.

Condivi, A. (1998) *Vita di Michelangelo Buonarroti*, ed. G. Nencioni, Florence, Studio per Edizioni Scelte.

Condivi, A. (1999) *The Life of Michelangelo*, trans. A. Sedgwick Wohl, University Park, Pennsylvania State University Press.

Conway, W.M. (ed.) (1958) *The Writings of Albrecht Dürer*, London, Peter Owen.

Cordellier, D. (ed.) (1996) *Pisanello: Le Peintre aux sept vertus*, Paris, Paola Marini (exhibition catalogue).

Dackerman, S. and Primeau, T. (2002) *Painted Prints: The Revelation of Color*, University Park, Pennsylvania State University Press.

De la Grange, A. (1897) 'Choix de testaments tournaisiens antérieurs au XVIe siècle', *Annales de la Société Historique et Archéologique de Tournai*, 2, pp.5–365.

Degenhart, B. (1950) 'Autonome Zeichnungen bei mittelalterlichen Künstlern', *Münchner Jahrbuch der bildenden Kunst*, 3:1, pp.93–158.

Dhanens, E. (1973) *Van Eyck: The Ghent Altarpiece*, London, Allen Lane.

Dhanens, E. (1980) *Hubert and Jan van Eyck*, Antwerp, Mercatorfonds.

Didier, R. (1993) *Claus Sluter*, Namur, Société archéologique de Namur.

Dierick, A.L. (2000) 'Jan van Eyck's handwriting', in S. Foister, S. Jones and D. Cool (eds) *Investigating Jan van Eyck*, Turnhout, Brepols, pp.79–82.

Dunkerton, J. *et al.* (1991) *Giotto to Dürer: Early Renaissance Painting in the National Gallery*, New Haven and London, Yale University Press/London, National Gallery Publications.

Dürer, A. (1532) *De symmetria partium humanorum corporum*, trans. J. Camerarius, Nuremberg.

Dürer, A. (1958) *The Writings of Albrecht Dürer*, ed. and trans. W.M. Conway, London, Peter Owen.

Dürer, A. (1972a) *Etliche Underricht von Befestigung der Stett, Schloss und Flacken*, intro. M. Biddle, Farnborough, Gregg International Publishers (first published Nuremberg, 1527).

Dürer, A. (1972b) *The Human Figure: The Complete Dresden Sketchbook*, ed. and trans. W.L. Strauss, New York, Dover.

Edgerton, S. (1975) *The Renaissance Rediscovery of Linear Perspective*, New York, Basic Books.

Edwards, S. (ed.) (1999) *Art and its Histories: A Reader*, New Haven and London, Yale University Press.

Elkins, J. (1991a) 'On the *Arnolfini Portrait* and the *Lucca Madonna*: did Jan van Eyck have a perspectival system?', *The Art Bulletin*, 73:1, pp.53–62.

Elkins, J. (1991b) 'The case against surface geometry', *Art History*, 14:2, pp.143–74.

Elkins, J. (1994) *The Poetics of Perspective*, Ithaca and London, Cornell University Press.

Erasmus, D. (1985) *Collected Works of Erasmus*, vol.26: *Literary and Educational Writings, 4: De recta pronuntiatione*, ed. J.K. Sowards, Toronto, University of Toronto Press.

Evans, H.C. (ed.) (2004) *Byzantium: Faith and Power (1261–1557)*, New Haven and London, Yale University Press/New York, Metropolitan Museum of Art (exhibition catalogue).

Fanti, M. (1989) 'Nuovi documenti e osservazioni sul compiano di Niccolò dell'Arca e la sua antica collocazione in S Maria della Vita', in G. Agostani and L. Ciammiti (eds) *Niccolò dell'Arca, seminario di studi atti del convegno 26–27 May 1987*, Bologna, Nuova Alfa, pp.59–83.

Faries, M. (1981) 'The underdrawn composition of Rogier van de Weyden's Saint Luke drawing a portrait of the Virgin in Boston', in D. Hollanders-Favart and R. van Schoute (eds) *Le Dessin sous-jacent dans la peinture*, conference III (6–8 September 1979): *Le Problème Maître de Flémalle – van der Weyden*, Louvain-la-Neuve, Collège Érasme, pp.93–9.

Ferguson, W.K. (1963) *Renaissance Studies*, Studies in the Humanities 2, London, Humanities Departments of the University of Western Ontario.

Field, J.V. (2002) 'Masaccio and perspective in Italy in the fifteenth century', in D.C. Ahl (ed.) *The Cambridge Companion to Masaccio*, Cambridge, Cambridge University Press, pp.177–201.

Field, J.V. (2003) 'Piero della Francesca's perspective treatise', in L. Massey (ed.) *The Treatise on Perspective: Published and Unpublished*, Washington, DC, National Gallery of Art/New Haven and London, Yale University Press, pp.62–77.

Field, R.S. (1965) *Fifteenth Century Woodcuts and Metalcuts*, Washington, DC, National Gallery of Art (exhibition catalogue).

Field, R.S. (1977) *Fifteenth Century Woodcuts and Other Relief Prints in the Collection of the Metropolitan Museum of Art*, New York, Metropolitan Museum of Art (exhibition catalogue).

Filarete (1965) *Filarete's Treatise on Architecture*, 2 vols, ed. and trans. J.R. Spencer, New Haven and London, Yale University Press.

Filedt Kok, J.P. (1985) *Livelier than Life: The Master of the Amsterdam Cabinet or the Housebook Master c.1470–1500*, Amsterdam, Rijksmuseum (exhibition catalogue).

Fiore, F.P. and Tafuri, M. (eds) (1993) *Francesco di Giorgio architetto*, Siena, Electa.

*Five Early Guides to Rome and Florence* (1972) intro. P. Murray, Farnborough, Gregg International Publishers.

Frankl, P. (1945) 'Secret of the medieval masons', *The Art Bulletin*, 27:1, pp.46–60.

Frankl, P. and Crossley, P. (2000) *Gothic Architecture*, New Haven and London, Yale University Press (first published 1962).

Gadol, J.K. (1969) *Leon Battista Alberti: Universal Man of the Renaissance*, Chicago, University of Chicago Press.

Gardner, J. (1994) 'Altars, altarpieces, and art history: legislation and usage', in E. Borsook and F. Superbi Gioffredi (eds) *Italian Altarpieces 1250–1550: Function and Design*, Oxford, Clarendon Press, pp.5–39.

Gärtner, P.J. (1998) *Filippo Brunelleschi 1377–1446*, Cologne, Könemann.

Gaurico, P. (1969) *De sculptura*, ed. A. Chastel and R. Klein, Geneva, Droz.

Ghiberti, L. (1912) *Denkwürdigkeiten: I Commentari*, ed. J. von Schlosser-Magnino, 2 vols, Berlin, Julius Bard.

Ghisalberti, C. (1989) 'Le chantier de la cathedrale de Milan', in R. Recht (ed.) *Les Batisseurs des cathédrales gothiques*, Strasbourg, Editions les musées de la Ville de Strasbourg, pp.113–26 (exhibition catalogue).

Gilbert, C.E. (ed.) (1980) *Italian Art, 1400–1500: Sources and Documents*, Englewood Cliffs, Prentice Hall.

Giovio, P. (1999) *Dialogus de viris et feminis aetate nostra*, Latin text in *Paolo Giovio Scritti d'arte: lessico ed ecfrasi*, ed. S. Maffei, Pisa, Scuola Normale Superiore.

Goetschalckx, P.J. (1903) 'Vier ongekonde schilders der XV eeuw', *Bijdragen tot de geschiedenis bijzonderlijk van het aloude Hertogdom Brabant*, 2, pp.239–53.

Goffen, R. (1986) *Piety and Patronage in Renaissance Venice: Bellini, Titian, and the Franciscans*, New Haven and London, Yale University Press.

Gombrich, E.H. (1966) 'The Renaissance conception of artistic progress and its consequences', in *Norm and Form*, London, Phaidon.

Gombrich, E.H. (1967) 'From the revival of letters to the reform of the arts: Niccolò Niccoli and Filippo Brunelleschi', in D. Fraser *et al.* (eds) *Essays in the History of Art Presented to Rudolf Wittkower*, London, Phaidon, pp.71–82. (Reprinted in *The Heritage of Apelles*, pp.93–110.)

Gombrich, E.H. (1976) *The Heritage of Apelles: Studies in the Art of the Renaissance*, Oxford, Phaidon.

Grapaldi, F.M. (1494) *De partibus aedium libri duo*, Parma.

Günther, H. (1988) *Deutsche Architekturtheorie zwischen Gotik und Renaissance*, ed. M. Bode *et al.*, Darmstadt, Wissenschaftliche Buchgesellschaft.

Halsema-Kubes, W., Lemmens, G. and Werd, G. de (1980) *Adriaen van Wesel: Een Utrechtse beeldhouwer uit de late middeleeuwen*, The Hague, Staatsuitgeverij (exhibition catalogue).

Harbison, C. (1991) *Jan van Eyck: The Play of Realism*, London, Reaktion Books.

Hartt, F. (2003) *A History of Italian Renaissance Art*, revised D.G. Wilkins, 5th edn, London, Thames & Hudson.

Held, J.S. (ed.) (1975) *Dürer through Other Eyes: His Graphic Work Mirrored in Copies and Forgeries of Three Centuries*, Williamstown, The Sterling and Francine Clark Art Institute (exhibition catalogue).

Helms, G.M. (1998) 'The materials and techniques of Italian Renaissance sculpture', in S.B. McHam (ed.) *Looking at Italian Renaissance Sculpture*, Cambridge, Cambridge University Press, pp.18–39.

Hendy, P. (1968) *Piero della Francesca and the Early Renaissance*, London, Weidenfeld & Nicolson.

Hind, A.M. (1963a) *A History of Engraving and Etching*, New York, Dover (first published 1923).

Hind, A.M. (1963b) *An Introduction to a History of Woodcut: With a Detailed Survey of Work Done in the Fifteenth Century*, 2 vols, New York, Dover (first published 1935).

Holly, M.A. (1984) *Panofsky and the Foundations of Art History*, Ithaca and London, Cornell University Press.

Holt, E.G. (1957) *A Documentary History of Art*, 2 vols, New York, Doubleday-Anchor.

Humfrey, P. (1993) *The Altarpiece in Renaissance Venice*, New Haven and London, Yale University Press.

Humfrey, P. and Kemp, M. (eds) (1990) *The Altarpiece in the Renaissance*, Cambridge, Cambridge University Press.

Hunter, D. (1947) *Papermaking: The History and Technique of an Ancient Craft*, London, Pleiades Books.

Husband, T.B. (1999) *The Medieval Housebook and the Art of Illustration*, New York, Frick Collection (exhibition catalogue).

Hyatt Mayor, A. (1971) *Prints and People: A Social History of Printed Pictures*, Princeton, Princeton University Press.

Israëls, M. (2001) 'Sassetta's Arte della Lana altar-piece and the cult of Corpus Domini in Siena', *Burlington Magazine*, CXLIII, pp.532–43.

Israëls, M. (2003) *Sassetta's Madonna della Neve: An Image of Patronage*, Leiden, Primavera Pers.

*Israhel van Meckenem und der Deutsche Kupferstich des 15. Jahrhunderts: 750 Jahre Stadt Bocholt* (1972) Kunsthaus der Stadt Bocholt (exhibition catalogue).

*Italian Renaissance Sculpture at the Time of Donatello* (1985) Detroit, Detroit Institute of Arts (exhibition catalogue).

Ivins, W.M., Jr (1929) 'Notes on three Dürer woodblocks', *Metropolitan Museum Studies*, 2, pp.102–11.

Ivins, W.M., Jr (1969) *Prints and Visual Communication*, Cambridge, MA and London, MIT Press (first published 1953).

Ivins, W.M., Jr (1987) *How Prints Look: An Illustrated Guide*, revised M.B. Cohn, Boston, Beacon Press (first published 1958).

Jacobowitz, E.S. and Loeb Stepanek, S. (1983) *The Prints of Lucas van Leyden and his Contemporaries*, Washington, DC, National Gallery of Art (exhibition catalogue).

Jacobs, L. (1998) *Early Netherlandish Carved Altarpieces, 1380–1550: Medieval Tastes and Mass Marketing*, Cambridge, Cambridge University Press.

Janson, H.W. (1966) *The Sculpture of Donatello*, 2 vols, Princeton, Princeton University Press.

Joannides, P. (1993) *Masaccio and Masolino: A Complete Catalogue*, London, Phaidon.

Jones, M.W. (2000) *Principles of Roman Architecture*, New Haven and London, Yale University Press.

Joubert, F. (1999) 'Illusionisme monumental à la fin du XIVe siècle: les recherches d'André Beauneveu à Bourges et de Claus Sluter à Dijon', in *Pierre, lumière, couleur: Études d'histoire de l'art du Moyen Age en l'honneur d'Anne Prache*, Paris, Presse de l'Université de Paris-Sorbonne, pp.367–84.

Kauffmann, C.M. (1970) 'The altar-piece of St George from Valencia', *Victoria and Albert Museum Yearbook*, II, pp.65–100.

Kemp, M. (1978) 'Science, non-science and nonsense: the interpretation of Brunelleschi's perspective', *Art History*, 1:2, pp.134–61.

Kemp, M. (1981) *Leonardo da Vinci: The Marvellous Works of Nature and of Man*, Cambridge, MA, Harvard University Press.

Kemp, M. (ed.) (1989) *Leonardo on Painting*, New Haven and London, Yale University Press.

Kemp, M. (1990) *The Science of Art: Optical Themes in Western Art from Brunelleschi to Seurat*, New Haven and London, Yale University Press.

Kemp, M. (1996) 'In the light of Dante: meditations on natural and divine light in Piero della Francesca, Raphael and Michelangelo', in V. Flemming and S. Schütze (eds) *Ars naturam adiuvans: Festschrift für Matthias Winner*, Mainz, P. von Zabern, pp.160–77.

Kemp, M. (1997) *Behind the Picture: Art and Evidence in the Italian Renaissance*, New Haven and London, Yale University Press.

Kemp, M. and Roberts, J. (eds) (1989) *Leonardo*, New Haven and London, Yale University Press on behalf of South Bank Centre (exhibition catalogue).

King, C.E. (1974) 'Narrative in the representation of the Four Crowned Martyrs: Or San Michele and the Doge's Palace,' *Arte Cristiana*, 743, pp.81–9.

King, C.E. (1987) 'National Gallery 3902 and the theme of Luke the Evangelist as artist and physician', *Zeitschrift für Kunstgeschichte*, 50, pp.275–8.

Kingery, W.D. and Aronson, M. (1990) 'Archeometria, the glazes of Luca della Robbia', *Faenza*, 76:5, pp.221–5.

Klein, R. and Zerner, H. (eds) (1966) *Italian Art, 1500–1600: Sources and Documents*, Englewood Cliffs, NJ, Prentice Hall.

Klotz, H. (1990) *Filippo Brunelleschi: The Early Works and the Medieval Tradition*, London, Academy Editions.

Knapp, F. (1903) *Fra Bartolomeo und die Schule von San Marco*, Halle, W. Knapp.

Krautheimer, R. (1970) *Lorenzo Ghiberti*, 2 vols, Princeton, Princeton University Press.

Kristeller, P. (1902) *Andrea Mantegna*, Berlin and Leipzig, Cosmos.

Kurz, O. (1937) 'Giorgio Vasari's libro de' disegni', *Old Master Drawings*, 11–12, pp.1–44.

Lancillotti, F. (1976) *Tractato di pictura …, Romae 1509*, ed. H. Miedema, Amsterdam, Kunsthistorisch Instituut van de Universiteit van Amsterdam.

Landau, D. and Parshall, P. (1994) *The Renaissance Print 1470–1550*, New Haven and London, Yale University Press.

Lane, B.G. (1984) *The Altar and the Altarpiece: Sacramental Themes in Early Netherlandish Altarpieces*, New York, Harper & Row.

Laurent, M.H. (1935) 'Documenti Vaticani intorno alla "Madonna della Neve" del Sassetta', *Bullettino senese di storia patria*, XLII, pp.257–66.

Lavin, I. (1998) 'On the sources and meaning of the Renaissance portrait bust', in S.B. McHam (ed.) *Looking at Italian Renaissance Sculpture*, Cambridge, Cambridge University Press, pp.60–78.

Lavin, M.A. (1972) *Piero della Francesca: The Flagellation*, London, Allen Lane.

Leeuwenberg, J. (1965) 'Die Ausstrahlung Utrechter Tonplastik', in K. Martin (ed.) *Studien zur Geschichte der europäischen Plastik: Festschrift Theodor Müller*, Munich, Hirmer, pp.151–66.

Lemaire, J. (1509) *La Plainte du desiré*, Lyons.

Lemaire, J. (1549) *Les Illustrations de Gaule …*, Lyons.

Leonardo da Vinci (1954) *The Notebooks of Leonardo da Vinci*, ed. and trans. E. MacCurdy, 2 vols, London, The Reprint Society.

Leonardo da Vinci (1970) *The Literary Works of Leonardo da Vinci*, ed. J.P. Richter, 2 vols, Oxford, Phaidon.

Leonardo da Vinci (1977) *The Literary Works of Leonardo da Vinci*, ed. J.P. Richter, commentary C. Pedretti, 2 vols, Oxford, Phaidon.

Levenson, J.A., Oberhuber, K. and Sheehan, J.L. (1973) *Early Italian Engravings from the National Gallery of Art*, Washington, DC, National Gallery of Art (exhibition catalogue).

Levine, S. (1974) 'The location of Michelangelo's *David*: the meeting of January 25 1504', *The Art Bulletin*, 56, pp.31–49.

Levy, E. (1984) 'Ideal and reality of the learned artist: the schooling of Italian and Netherlandish artists', in *Children of Mercury: The Education of Artists in the Sixteenth and Seventeenth Centuries*, Providence, Brown University, Department of Art, pp.20–7.

Limentani Virdis, C. and Pietrogiovanna, M. (2002) *Gothic and Renaissance Altarpieces*, trans. D. Wheeler, London, Thames & Hudson.

Lincoln, E. (2000) *The Invention of the Italian Renaissance Printmaker*, New Haven and London, Yale University Press.

Ludwig, G. (1903) 'Archivalische Beiträge zur Geschichte der venezianischen Malerei', *Jahrbuch der Königlich Preussischen Kunstsammlungen*, supplementary volume to vol.24, Berlin, G. Grote'sche Verlagsbuchhandlung, pp.1–176.

Mack, C.R. (1974) 'The Rucellai palace: some new proposals', *The Art Bulletin*, 56:4, pp.517–29.

Mack, C.R. (1987) *Pienza: The Creation of a Renaissance City*, Ithaca and London, Cornell University Press.

Maginnis, H.B.J. (2001) *The World of the Early Sienese Painter*, University Park, Pennsylvania State University Press.

Manetti, A. (1970) *The Life of Brunelleschi*, ed. H. Saalman, trans. C. Enggass, University Park, Pennsylvania State University Press.

March, L. (1998) *Architectonics of Humanism: Essays on Number in Architecture*, London, Academy Editions.

Marks, R. and Williamson, P. (eds) (2003) *Gothic: Art for England 1400–1547*, London, V & A Publications (exhibition catalogue).

Martineau, J. (ed.) (1992) *Andrea Mantegna*, New York, Metropolitan Museum of Arts/London, Royal Academy of Arts (exhibition catalogue).

Massey, L. (ed.) (2003) *The Treatise on Perspective: Published and Unpublished*, Washington, DC, National Gallery of Art/New Haven and London, Yale University Press.

Massing, J.M. (1999) *Du texte à l'image: La Calomnie d'Apelle et son iconographie*, Strasburg, University of Strasburg.

McDonald, M. (2005) *Ferdinand Columbus: Renaissance Collector*, London, British Museum.

McDonald, M.P. (2004) *The Print Collection of Ferdinand Columbus 1488–1539: A Renaissance Collector in Seville*, 2 vols, London, British Museum.

Meiss, M. (1941) 'A documented altarpiece by Piero della Francesca', *The Art Bulletin*, 23:1, pp.52–68.

Milanesi, G. (1969) *Documenti per la storia dell'arte Senese*, 3 vols, Holland, Davaco Publishers (facsimile of the first edn, 1854–6).

Minott, C.I. (1971) *Martin Schongauer*, New York, Collective Editions.

Morand, K (1991) *Claus Sluter: Artist at the Court of Burgundy*, London, Harvey Miller.

Müller, T. (1966) *Sculpture in the Netherlands, Germany, France and Spain, 1400–1500*, trans. E. and W.R. Scott, Pelican History of Art, Harmondsworth, Penguin.

Munman, R. (1985) 'Optical corrections in the sculpture of Donatello', *Proceedings of the American Philosophical Society*, 75:2.

Murray, P. (1957) 'Art historians and art critics IV: uomini singhularii', *Burlington Magazine*, XCIX, pp.330–6.

Nash, S. (2005) 'Claus Sluter's "Well of Moses" for the Chartreuse de Champmol reconsidered: part I', *Burlington Magazine*, CXLVII, pp.798–809.

Nelson, R.S. (2000) 'Introduction: Descartes's cow and other domestication of the visual', in R.S. Nelson (ed.) *Visuality Before and Beyond the Renaissance: Seeing as Others Saw*, Cambridge, Cambridge University Press, pp.1–21.

Norman, D. (1999) *Siena and the Virgin: Art and Politics in a Late Medieval City State*, New Haven and London, Yale University Press.

Norman, D. (2003) *Painting in Late Medieval and Renaissance Siena, 1260–1555*, New Haven and London, Yale University Press.

Oertel, R. (1940) 'Wandmalerei und Zeichnung in Italien: die Anfänge der Entwurfzeichnung und ihre monumentalen Vorstufen', *Mitteilungen des Kunsthistorischen Institutes in Florenz*, 5, pp.217–314.

Olson, R. (1992) *Italian Renaissance Sculpture*, London, Thames & Hudson.

Onians, J. (1971) 'Alberti and Philareth: a study in their sources', *Journal of the Warburg and Courtauld Institutes*, 34, pp.96–114.

Onians, J. (1982) 'Brunelleschi: humanist or nationalist?', *Art History*, 5:3, pp.259–72.

Pächt, O. (1994) *Van Eyck and the Founders of Early Netherlandish Painting*, trans. D. Britt, 2nd edn, London, Harvey Miller.

Pacioli, L. (1494) *Summa di arithmetica, geometria, proportioni e proportionalità*, Venice.

Pacioli, L. (1956) *De divina proportione*, ed. G. Masolti Biggiogero, Milan (first published Venice, 1509).

Pagden, F.S. (1990) 'From cult images to the cult of images: the case of Raphael's altarpieces', in P. Humfrey and M. Kemp (eds) *The Altarpiece in the*

*Renaissance*, Cambridge, Cambridge University Press, pp.165–89.

Panofsky, E. (1945) *Albrecht Dürer*, 2 vols, London, Humphrey Milford/Oxford, Oxford University Press.

Panofsky, E. (1949) 'An explanation of Stornaloco's formula', *The Art Bulletin*, 31:2, pp.61–5.

Panofsky, E. (1971) *Early Netherlandish Painting*, New York and London, Harper & Row (first published 1953).

Pernis, M.G. (1986) 'Greek sources for Donatello's Annunciation in Santa Croce', *Source*, 5:3, pp.16–19.

Philip, L.B. (1971) *The Ghent Altarpiece and the Art of Jan van Eyck*, Princeton, Princeton University Press.

Piero della Francesca (1984) *De prospectiva pingendi*, ed. G. Nicco-Fasola, 2 vols, Florence, Sansoni, 1942; reprinted 1984 with additions by E. Battisti, F. Ghione, and R. Pacciani, Florence, Le Lettere.

Pon, L. (2004) *Raphael, Dürer, and Marcantonio Raimondi: Copying and the Italian Renaissance Print*, New Haven and London, Yale University Press.

Pope-Hennessy, J. (1939) *Sassetta*, London, Chatto & Windus.

Pope-Hennessy, J. (1980) *Luca della Robbia*, Oxford, Phaidon.

Pope-Hennessy, J. (1985) *Italian Renaissance Sculpture*, New York, Vintage.

Popham, A.E. (1971) *The Drawings of Leonardo da Vinci*, London, Jonathan Cape.

Popham, A.E. and Pouncey, P. (1950) *Italian Drawings in the Prints and Drawings Department in the British Museum: Fourteenth and Fifteenth Centuries*, London, British Museum.

Prager, F. (ed. and trans.) (1968) 'A manuscript of Taccola, quoting Brunelleschi on problems of inventors and builders', *Proceedings of the American Philosophical Society*, CXII, pp.131–49.

Preyer, B. (1981) 'The Rucellai palace', in F.W. Kent *et al.*, *Giovanni Rucellai ed il suo zibaldone, II: A Florentine Patrician and his Palace*, London, Warburg Institute, pp.155–228.

Radcliffe, A. (1992a) 'The model in the Renaissance', in A. Radcliffe, M. Baker and M. Maek-Gérard (eds) *The Thyssen-Bornemisza Collection, Renaissance and Later Sculpture: With Works of Art in Bronze*, London, Sotheby's Publications, pp.10–15.

Radcliffe, A. (1992b) 'Multiple production in the 15th century – Florentine stucco Madonnas and the della Robbia workshop', in A. Radcliffe, M. Baker and M. Maek-Gérard (eds) *The Thyssen-Bornemisza Collection, Renaissance and Later Sculpture: With Works of Art in Bronze*, London, Sotheby's Publications, pp.16–23.

Raffaele Maffei da Volterra (1506) *Commentariorum urbanorum*, Rome.

Ragghianti Collobi, L. (1974) *Il libro de' disegni del Vasari*, 2 vols, Florence, Vallecchi.

Roberts, P.L. (1993) *Masolino da Panicale*, Oxford, Clarendon Press.

Romanini, A.M. (1964) *L'architettura gotica in Lombardia*, 2 vols, Milan, Ceschina.

Romanini, A.M. (1973) *Il Duomo di Milano*, ed. C.F. da Passano, 2 vols, Milan, Cassa di risparmio delle provincie lombarde.

Roriczer, M. (1845) *Das Buchlein von der Fialen Gerechtigkeit*, ed. U. Reichensberger, Trier.

Rossky, W. (1968) 'Imagination in the English Renaissance: psychology and the poetic', *Studies in the Renaissance*, 5, pp. 49–73.

Rucellai, G. (1960) *Giovanni Rucellai ed il suo zibaldone*, ed. A. Perosa, 2 vols, London, Warburg Institute.

Rupprich, H. (ed.) (1956–69) *Dürer schriftlicher Nachlass*, 3 vols, Berlin, Deutscher Verein für Kunstwissenschaft.

Saalman, H. (1958) 'Filippo Brunelleschi: capital studies', *The Art Bulletin*, 40:2, pp.113–37.

Saalman, H. (1988) 'Giovanni Rucellai ed il suo zibaldone: a Florentine patrician and his palace', review of *Giovanni Rucellai ed il suo zibaldone, II: A Florentine Patrician and his Palace*, by F.W. Kent etc., *Journal of the Society of Architectural Historians*, 48:1, pp.82–90.

Saalman, H. (1993) *Filippo Brunelleschi: The Buildings*, London, Zwemmer.

Said, H.M. (ed.) (1979) *Ibn al Haitham*, Karachi, Hamdard National Foundation.

Santi, G. (1985) *La vita e la gesta di Federico di Montefeltro*, ed. L. Michelini Tocci, Vatican City, Bibliotheca Apostolica Vaticana.

Sartori, A. (1976) *Documenti per la storia dell'arte a Padova*, ed. C. Fillarini, Vicenza, Neri Pozza.

Savonarola, M. (1902) *Libellus de magnificis ornamentis: regi[a]e civitatis Padu[a]e*, ed. A. Segarizzi, in *Rerum italicarum scriptores*, vol.24, Città di Castello, Tipi dell'editore S. Lapi.

Schabacker, P.H. (1974) *Petrus Christus*, Utrecht, Haentjens Dekker & Gumbert.

Schuler, S. (1999) *Vitruv im Mittelalter: Die Rezeption von 'De Architectura' von der Antike bis in die frühe Neuzeit*, Cologne, Bohlau Verlag.

Schultz, A. (1869) 'Johannes Butzbach's "Libellus de praeclaris picturae professoribus" aus der Bonnenser Handschrift veröffentlich', *Jahrbücher für Kunstwissenschaft*, 2, pp.60–72.

Seidel, M. (1994) 'The social status of patronage and its impact on pictorial language in fifteenth-century

Siena', in E. Borsook and F. Superbi Gioffredi (eds) *Italian Altarpieces 1250–1550: Function and Design*, Oxford, Clarendon Press, pp. 119–37.

Serck-Dewaide, M. (1998) 'Support and polychromy of altarpieces from Brussels, Mechlen and Antwerp: study, comparison and restoration', in V. Dorge and F. Carey-Howlett (eds) *Painted Wood: History and Conservation*, Los Angeles, Getty Conservation Institute, pp.82–99.

Sereni, E. (1989) *Storia del paesaggio agrario italiano*, Bari, Laterza.

Serlio, S. (1996) *Sebastiano Serlio on Architecture*, vol.1, trans. V. Hart and P. Hicks, New Haven and London, Yale University Press.

Shelby, L.R. (ed.) (1977) *Gothic Design Techniques: The Fifteenth-Century Design Booklets of Mathes Roriczer and Hanns Schmuttermayer*, Carbondale, Southern Illinois University Press.

Shestack, A. (1967a) *Master E.S. Five Hundredth Anniversary Exhibition*, Philadelphia, Philadelphia Museum of Art (exhibition catalogue).

Shestack, A. (1967b) *Fifteenth-Century Engravings of Northern Europe from the National Gallery of Art*, Washington, DC, National Gallery of Art (exhibition catalogue).

Shoemaker, I.A. and Broun, E. (1981) *The Engravings of Marcantonio Raimondi*, Lawrence, Spencer Museum of Art (exhibition catalogue).

Smeyers, M. (1998) *Dirk Bouts: Peintre du silence*, trans. N. Toussaint, Tournai, La Renaissance du Livre.

Sonkes, M. (1969) *Dessins du XVè siècle: Groupe van der Weyden*, Les Primitifs Flamands III, Contribution à l'étude des Primitifs Flamands, 5, Brussels, Centre National de Recherches Primitifs Flamands.

Sperling, C.M. (1992) 'Donatello's bronze "David" and the demands of Medici politics', *Burlington Magazine*, CXXXIV, pp.218–24.

St John Hope, W. (1907) 'On the funeral effigies of the kings and queens of England', *Archaeologia*, 60:2, pp.517–70.

Stechow, W. (1966) *Northern Renaissance Art, 1400–1600: Sources and Documents*, Englewood Cliffs, Prentice Hall.

Steinberg, S.H. (1974) *500 Years of Printing*, Harmondsworth, Penguin.

Stevenson, A. (1991) 'The problem of the blockbooks', in *Blockbücher des Mittelalters: Bilderfolgen als Lektüre*, Mainz, Philipp von Zabern/Mainz, Gutenberg Museum, pp.229–62 (exhibition catalogue).

Stewering, R. (2000) 'Architectural representations in the "Hypnerotomachia Poliphili" (Aldus Manutius, 1499)', *Journal of the Society of Architectural Historians*, 59:1, pp.6–25.

Stone, R.E. (1981) 'Antico and the development of bronze casting in Italy at the end of the Quattrocento', *Metropolitan Museum Journal*, 16, pp.87–116.

Strauss, W.L. (1974) *The Complete Drawings of Albrecht Dürer*, 6 vols, New York, Abaris Books.

Strom, D. (1980) 'A new chronology for Donatello's wooden sculpture', *Pantheon*, 38, pp.239–48.

Strom, D. (1982) 'Desiderio and the Madonna relief in Quattrocento Florence', *Pantheon*, 40, pp.130–5.

Svanberg J. and Qwarnström, A. (1998) *Saint George and the Dragon*, Stockholm, Rabén Prisma.

Syson, L. and Gordon, D. (eds) (2001) *Pisanello: Painter to the Renaissance Court*, London, National Gallery Publications (exhibition catalogue).

Tanturli, G. (1980) 'Rapporti del Brunelleschi con gli ambienti letterari fiorentini', in *Filippo Brunelleschi: La sua opere e il suo tempo*, vol.1, Florence, Centro Di, pp.125–44.

Tavernor, R. (1998) *On Alberti and the Art of Building*, New Haven and London, Yale University Press.

Tietze-Conrat, E. (1957) *Mantegna*, London, Phaidon.

Trachtenberg, M. (1988) 'What Brunelleschi saw: monument and site at the Palazzo Vecchio in Florence', *Journal of the Society of Architectural Historians*, 47:1, pp.14–44.

Trachtenberg, M. (1997) *Dominion of the Eye: Urbanism, Art, and Power in Early Modern Florence*, Cambridge and New York, Cambridge University Press.

Turner, J. (ed.) (1996) *Dictionary of Art*, 34 vols, London, Macmillan.

Ugolino da Verino (1583) *De illustratione urbis Florentiae libri tres*, Paris.

Ungers, O.M. (1996) 'Ordo, fondo et mensura: the criteria of architecture', in H. Millon (ed.) *Italian Renaissance Architecture from Brunelleschi to Michelangelo*, London, Thames & Hudson.

Upton, J.M. (1990) *Petrus Christus: His Place in Fifteenth-Century Flemish Painting*, University Park, Pennsylvania State University Press.

Valla, L. (1999) *De linguae latinae elegantia*, ed. S. López-Moreda, 2 vols, Extremadura, Universidad de Extremadura.

Van Asperen de Boer, J.R.J. (1979) 'A scientific re-examination of the Ghent altarpiece', *Oud Holland*, XCIII, pp.141–214.

Van Asperen de Boer, J.R.J. and Faries, M. (1990) 'La Vierge au Chancelier Rolin de van Eyck: examen au moyen de la réflectographie à l'infrarouge', *La Revue du Louvre et des Musées de France*, XL, pp.37–50.

Van Buren, A.H. and Edmunds, S. (1971) 'Playing cards and manuscripts: some widely disseminated fifteenth-century model sheets', *The Art Bulletin*, 56:1, pp.12–30.

Van der Stock, J. (1988) *Printing Images in Antwerp: The Introduction of Printmaking in a City, Fifteenth Century to 1585*, trans. B. Jackson, Rotterdam, Sound and Vision International.

Van Even, E. (1869) 'Monographie de l'ancienne école de peinture de Louvain', in A. van Lokeren and Kervyn de Volkaersbeke (eds) *Messager des sciences historiques, ou archives des arts et de la bibliographie de Belgique*, Ghent, pp.277–341.

Van Os, H. (1984–90) *Sienese Altarpieces 1215–1460*, 2 vols, Groningen, Bouma's Boekhuis and Egbert Forsten Publishing.

Van Os, H. (1990) 'Some thoughts on writing a history of Sienese altarpieces', in P. Humfrey and M. Kemp (eds) *The Altarpiece in the Renaissance*, Cambridge, Cambridge University Press, pp.21–33.

Vasari, G. (1960) *Vasari on Technique*, trans. L.S. Maclehose, ed. G. Baldwin Brown, New York, Dover.

Vasari, G. (1976) *Le vite de' più eccellenti pittori, scultori e architettori: Nelle redazioni del 1550 e 1568*, vol.5, ed. P. Barocchi and R. Bettarini, Florence, Sansoni.

Vasari, G. (1996) *Lives of the Painters, Sculptors and Architects*, trans. G. du C. de Vere, intro. and notes D. Ekserdjian, 2 vols, Everyman's Library, London, David Campbell (this edn first published 1927 by Dent).

Verdon, T. (2002) 'Masaccio's *Trinity*: theological, social and civic meanings', in D.C. Ahl (ed.) *The Cambridge Companion to Masaccio*, Cambridge, Cambridge University Press, pp.158–76.

Villani, F. (1997) *De origine civitatis Florentiae et de eiusdem famosis civibus*, ed. G. Tanturli, Padua, Antenore.

Vitruvius (1684) *Les dix livres d'architecture de Vitruve, corrigez et tradvits nouvellement en francois, avec des notes et des figures ... par M. Perrault ...*, Paris, J.B. Coignard.

Vitruvius (1981) *De architettura, Vitruvio*, ed. A. Bruschi, A. Carugo and P.F. Fiore, Milan, Il Polifilo (facsimile of Cesariano's 1521 edn).

Vitruvius (1999) *Ten Books on Architecture*, ed. I.D. Rowland and T.N. Howe, Cambridge, Cambridge University Press.

Von Schlosser-Magnino, J. (1956) *La letteratura artistica*, ed. O. Kurz, Florence, Olschki.

Ware, K. (1987) 'The theology and spirituality of the icon', in M. Acheimastou-Potamianou (ed.) *From Byzantium to El Greco: Greek Frescoes and Icons*, Athens, Byzantine Museum of Athens/London, Royal Academy of Arts, pp.37–9 (exhibition catalogue).

Watrous, J. (1957) *The Craft of Old Master Drawings*, Madison, University of Wisconsin Press.

Weekes, U. (2004) *Early Engravers and their Public: The Master of the Berlin Passion and Manuscripts from the Convents in the Rhine-Maas Region c.1450–1500*, Turnhout, Harvey Miller.

Welch, E. (2000) *Art in Renaissance Italy 1350–1500*, 2nd edn, Oxford, Oxford University Press.

Wittkower, R. (1952) *Architectural Principles in the Age of Humanism*, 2nd edn, London, Tiranti.

Wolf, G. (2000) 'The body and antiquity in Alberti's art theoretical writings', in A. Payne, A. Kuthner, and R. Smick (eds) *Antiquity and its Interpreters*, Cambridge, Cambridge University Press, pp.174–90.

Woods-Marsden, J. (1989) *The Gonzaga of Mantua and Pisanello's Arthurian Frescoes*, Princeton, Princeton University Press.

Zampetti, P. (1988) *Carlo Crivelli*, 2nd edn, Fermo, Nardini.

# Index